Images in Asian Religions

ASIAN RELIGIONS AND SOCIETY SERIES

A Buddha Dharma Kyokai Foundation Book on Buddhism and Comparative Religion

General Editor: Neil McMullin

Also in the series:
Pilgrims, Patrons, and Place: Localizing Sanctity in Asian Religions
Edited by Phyllis Granoff and Koichi Shinohara

Edited by Phyllis Granoff and Koichi Shinohara

Images in Asian Religions: Texts and Contexts

UBCPress · Vancouver · Toronto

10 09 08 07 06 05 04 5 4 3 2 1

Printed in Canada on acid-free paper

Library and Archives Canada Cataloguing in Publication

Images in Asian religions: texts and contexts / edited by Phyllis Granoff and Koichi Shinohara.

(Asian religions and society series)

Includes bibliographical references and index.

ISBN 0-7748-0948-5 (bound); ISBN 0-7748-0949-3 (pbk.)

1. Idols and images – Asia – Worship. 2. Asia – Religious life and customs.
3. Asia – Religion. I. Granoff, P.E. (Phyllis Emily), 1947-
II. Shinohara, Koichi, 1941- III. Series.

BL1033.I432004 291.3'5'095 C2004-903599-1

This book has been published with the help of the Buddha Dharma Kyokai Foundation of Canada.

UBC Press gratefully acknowledges the financial support for our publishing program of the Government of Canada through the Book Publishing Industry Development Program (BPIDP), and of the Canada Council for the Arts, and the British Columbia Arts Council.

All photographs are by the authors unless otherwise indicated.

Book layout and production by Kaleidoscope
Toronto, Canada, www.kveinc.com
Printed in Canada by Friesens
Copy editor: Frank Chow
Proofreader and indexer: Deborah Kerr

UBC Press
The University of British Columbia
2029 West Mall
Vancouver, BC V6T 1Z2
604-822-5959 / Fax: 604-822-6083
E-mail: info@ubcpress.ca
www.ubcpress.ca

Contents

Contributors

Hans T. Bakker is Gonda Professor of Hinduism in the Sanskrit Tradition and Indian Philosophy at the University of Groningen. His research focuses on the history and religions of classical and early medieval India. He is currently engaged in producing a critical edition of the early *Skandapurāṇa* with a team of scholars.

Daniela Berti holds a PhD in Research Methodology in Ethno-Anthropology from the University of Sienna. She is currently a fellow attached to the research centre Milieux, Cultures et Sociétés en Himalaya, Paris. She has conducted field research in the Himalayas since 1989 and is the author of numerous publications on the religion and culture of the region.

Robert L. Brown is a professor in the Department of History of Art, University of California, Los Angeles, and a curator in South and Southeast Asian art at the Los Angeles County Museum of Art. His research interests are in Indian and Southeast Asian art.

Gérard Colas is Directeur de recherche at the CNRS, France (Centre National de la Recherche Scientifique). His major interests include Sanskrit religious and philosophical literature and Indian paleography.

Robert M. Gimello is professor emeritus of East Asian Studies at University of Arizona, now serving as a long-term visiting professor of Buddhist Studies at Harvard University. His interests and publications focus principally on Chinese Buddhism of the Tang and Song periods.

Phyllis Granoff is a professor in the Department of Religious Studies, McMaster University, where she teaches Sanskrit and Indian religions. She is currently working on the development of early Śaivism and the beginnings of image worship.

Chari Pradel is a lecturer of Asian art history at California State University at Northridge for the 2003-2004 academic year. She is currently working on a monograph on the Tenjukoku Shūchō Mandara.

Elizabeth Horton Sharf is an independent scholar living in Berkeley, California. Her PhD dissertation is a study of Ōbaku Zen portrait painting, and she is continuing her research on Japanese Buddhist portrait traditions.

Koichi Shinohara is a professor in the Department of Religious Studies, McMaster University, where he teaches East Asian religions. His research focuses on early medieval Chinese Buddhism. He is currently working on the writings of the Buddhist vinaya master Daoxuan.

Gilles Tarabout is a senior fellow (social anthropology) at the CNRS (Centre National de la Recherche Scientifique), a member of the Centre for Indian and South Asian Studies (Paris), and currently the director of the Indo-French exchange program in social sciences at the Maison des Sciences de l'Homme, Paris. His area of specialization is the religion of Kerala and he has co-edited a series of volumes on South Asia.

Foreword

Since the middle of the last century, beginning with the dream of my late father, the Reverend Dr. Yehan Numata, the *Bukkyo Dendo Kyokai* (BDK) – Society for the Promotion of Buddhism – has been involved with the dissemination of the Buddhist teachings throughout the world.

Our mission to share the teachings of the Buddha with anyone and everyone who wishes to hear the Wisdom of the Compassionate One has enabled us to undertake projects such as the BDK English Tripitaka Series, in which we will eventually translate all the teachings of the Buddhist Canon into the English language so that Buddhism may continue its westward spread throughout the world. Our book *The Teaching of Buddha* now appears in more than forty different languages and over 6.5 million copies have been distributed free of charge throughout the world.

In major universities in North America and Europe, we have established the Numata Program in Buddhist Studies, which enables these schools to have chairs in Buddhist Studies, special speakers, and specialists in residence. These opportunities might not have been possible otherwise.

At the Numata Program in Buddhist Studies at the University of Toronto in Mississauga, Ontario, Canada, our dedicated coordinators, Professors Neil McMullin, Koichi Shinohara, and Phyllis Granoff, recently published a volume entitled *Pilgrims, Patrons, and Place: Localizing Sanctity in Asian Religions*. The volume originated in a conference sponsored in part by the Numata Program in Buddhist Studies.

We have decided to fund a series called "BDK Foundation Books on Buddhism and Comparative Religion." It is our hope that through these publications the information and knowledge gained from the

Numata Program in Buddhist Studies at the University of Toronto can be shared with everyone throughout the world, thereby expanding knowledge of Buddhism.

We offer our deepest appreciation to all the contributors and staff who have made this series possible, and we extend our heartfelt gratitude to Professors McMullin, Shinohara, and Granoff for their dedication and foresight, which have enabled this series to become a reality.

May the Wisdom and Compassion of the Enlightened One shine to all corners of this earth.

Numata Toshihide
Chairman
Bukkyo Dendo Kyokai
Society for the Promotion of Buddhism

Acknowledgements

We wish to acknowledge the assistance of the BDK (Buddha Dharma Kyokai) Canada and the Social Sciences and Humanities Research Council of Canada, which funded the conference out of which this volume developed. The conference was held at McMaster University and the University of Toronto, Mississauga, in May 2001. We also acknowledge the generous support of the BDK Canada in the publication of this volume.

Images in Asian Religions

Introduction

Images in Asian Religions:
Texts and Contexts

PHYLLIS GRANOFF AND KOICHI SHINOHARA

The study of images in Asian religions has tended to emphasize the centrality of image worship in both Hinduism and Buddhism. The chapters in this volume offer a challenge to any simple understanding of the role of images by looking at aspects of the reception of image worship that have only begun to be studied. For example, there has been little or no attention paid to arguments within Asian religious traditions that make a case against image worship. There has also been little scholarly work done on apologetics for image worship, and the ways in which either Hinduism or Buddhism attempted to make a place for image worship. As this volume demonstrates, both of these are important. We need to consider the strategies that Asian religious texts used to make room for image worship; this can throw light on how images were socially and ritually constructed. A study of the arguments against image worship can help to place such worship within its proper context, by showing that image worship was more problematic than we may have realized. Its centrality did not go unquestioned by certain groups. The chapters in this volume look critically at many of the assumptions with which we have comfortably lived. We have all assumed that we know what we mean when we are talking about images, or that we are all talking about the same thing. Several chapters in this volume will ask us to question what is an

image, and probe more deeply into what Asian religions considered objects of worship.[1]

Perhaps the best-known debate about the nature and origin of images in an Asian religion was conducted around the Buddha image and the transition from aniconic to iconic. The scholarly studies have focused on the moment of change and tended to conclude that the contest between aniconic objects of worship and anthropomorphic images was settled at an early point in history.[2] It is often assumed that after this crucial turning point, anthropomorphic images became the normative objects of worship, with non-anthropomorphic objects, such as pots, figuring mainly as temporary supports in a ritual context or relegated to the margins of orthodox worship. This issue is revisited in several chapters here, which show how anthropomorphic images coexist with other sacred objects; in fact, anthropomorphic images are not unique in the ritual treatment they receive or the ways in which they function in cultic practices. Much of the evidence accumulated here challenges the primacy we tend to accord anthropomorphic images. The "image" of a deity may even be an assemblage of objects, in which an anthropomorphic element is the least important in determining its identity, while the focus of a ritual may be the mantra or sound pattern that is thought to constitute the body of the deity.[3]

The authors come from different disciplines and bring to the discussion divergent perspectives; they are art historians, anthropologists, historians of religion and philosophy, Sinologists, Indologists, and Japanologists. We share the desire to re-evaluate received assumptions in search of more nuanced ways of understanding how images were received and conceived in Asian religious traditions. Our varied fields of specialization enable us to consider in our discussions both Buddhism and Hinduism, and to take into consideration the evidence of contemporary field observations as well as archeological and textual sources. It is our hope that breaking out of our disciplinary boundaries will afford us new ways of understanding. Despite the diversity of our training, these chapters show that we are all grappling with similar questions. Indeed, we may not agree on every point; strong cases are made here for different interpretations of the evidence available, allowing for lively and productive discussion. Our fundamental diversity of methods and primary data is reflected in the broad scope of the chapters, while our common concerns are clearly highlighted by the subheadings under which the chapters are grouped.

We have arranged the chapters in three parts that make clear their

shared questions. The first, "Defining Images: The Sacred Objects of Indian Religions," consists of three chapters, all of which grapple with the question, "What do we mean when we speak of 'images' in the context of Asian religions?" All three authors suggest that the term "image" covers a wide range of sacred objects and that the boundaries between "images" and other ritual objects are fundamentally fluid. These chapters confront head-on the issue of the primacy of the anthropomorphic image and suggest that the easy progression scholars see in Buddhist art that leads ultimately to the centrality of the Buddha image was only one solution to the problem of how or what to worship.[4] The focus of all three chapters in Part 1 is India. One of the issues they explore is the significance of the observation that sacred objects are so diverse: can this tell us anything about the origins of image worship and its history, particularly its relationship to Brahminic orthodoxy? We shall see that the answers to this question are complex; they also lead us naturally to the next part, "Images and the Elite Intellectual Culture: Accommodations and Ambiguities."

The three chapters on China and India found in Part 2 focus on how images were received in erudite circles. Dealing with Hinduism and Buddhism, the authors study the disjunction between the cult of images and certain genres of learned texts, in an effort to understand how elite circles participated in the formation of the cult of images or later made a place for established image cults. These chapters make clear the complexity of the task; learned authors often had to struggle to make a place for image worship and account for its efficacy. The chapters also demonstrate that the problems crossed religious boundaries, while the solutions were many, even within a single religious group. Considered together, these chapters show clearly that responses to images were not uniform; different groups promoted different strategies to accommodate image worship.

This need to pay attention to specific groups and historical contexts leads us to Part 3, "Re-creating the Context of Image Worship: Four Case Studies," which includes chapters on Japan and Southeast Asia. The four chapters all emphasize the fact that we can best appreciate traditional religious images by recovering the specificity of their original context. In each chapter, the author endeavours to uncover the religious and cultural setting of a particular image or group of images. These four chapters show that the meaning of an image cannot be separated from its ritual and cultural setting. In what follows, we discuss briefly the individual chapters in each part.

Phyllis Granoff's chapter, "Images and Their Ritual Use in Medieval India: Hesitations and Contradictions," begins by raising the question of whether image worship was really central to Indian religions, particularly Hinduism. She focuses on two general cases in which rituals seem to deny what is most fundamental about images as unique objects of worship. In the first, rituals that we normally consider as specific to images are conducted for other objects, such as rosary beads. This practice leads Granoff to question whether images can really be said to have a special status as the focus of a unique cult. The second complex of rituals she examines are healing rituals, in which images figure primarily as objects of monetary value that are to be given to the officiating priests. This, too, she argues, denies them any special status. Their value is in the precious material out of which they are made, which, in turn, allows them to function as appropriate gifts to the priests. Granoff's chapter builds on an earlier study, in which she reviewed the evidence of early Sanskrit texts to argue that image worship was not at all at home in early Indian religions.[5] This earlier essay focused on anomalies that were created when Brahminic ritual patterns were grafted onto image worship. The present chapter looks at the problem from a slightly different direction, examining cases in which either images or rites focusing on images are used in situations that somehow seem to deny the traits specific to them as images. In doing so, the chapter also raises the question of what defines an image in the ritual context, a question that Daniela Berti and Gilles Tarabout take up in their contributions. Granoff suggests that because Brahmin priestly circles were not entirely comfortable with images, images had no preferred status in their rituals. Thus, images were only one of many possible objects that could be the focus of a cult. Granoff's chapter raises a number of questions about the relationship between image worship and rituals in certain priestly circles; it also indirectly raises the question of what is an "image" of a deity, questions that are also dealt with in many of the chapters. Indeed, Gilles Tarabout's chapter deals directly with these issues and questions Granoff's hypothesis that image worship must have begun outside the elite Brahmin priestly circles. Here was one example of plausible cases made for apparently conflicting hypotheses on the basis of different bodies of evidence.

In Chapter 2, "Theology as History: Divine Images, Imagination, and Rituals in India," Tarabout presents an argument that offers a challenge to many of Granoff's assumptions. He asks us to consider

the evidence of contemporary practice in our discussions of the origins of image worship in India. He proposes that contemporary evidence supports a hypothesis that image worship is in fact more at home in Brahmin and high-caste circles than it is among other, lower-caste groups. Tarabout begins by saying that much of the discussion of the origins of image worship in India has been marred by mistaking theological statements for historical reality. Thus, he contends, the many statements in classical texts and those made by worshippers today, in which image worship is said to be something for the masses, or the lower castes, should not be accepted as a valid description of how image worship actually began.

He then presents the results of his fieldwork in Kerala, which vividly illustrates his contention that while low-caste groups worship odd assemblages of objects in which divine power is either said to reside or has been ritually made to reside, it is Brahmin temples that are more likely to house anthropomorphic images of deities. Contrary to the assertions of the theologians, it is these upper-caste circles in which image worship predominates. This suggests to him that the received model in which image worship, originally popular among the masses, was later accepted by the Brahmins, cannot be correct. He notes that the old model has already been discarded by scholars of Buddhism, and argues that it should now also be set aside by historians of Hinduism.[6] Both Granoff and Tarabout leave open the large question of the circles in which image worship was originally at home; while Granoff suggests that it was not Brahmin priestly circles, Tarabout argues that it was nonetheless some elite group. Tarabout's chapter also raises the question of what we are talking about when we speak of "images" in Indian religions; while art historians have focused their attention on anthropomorphic images or the representations of Śiva liṅgas in the classical cults, the evidence of the anthropologist demands that we accept an assemblage of diverse objects such as a stool, coconut, and sword as an "image," that is, a representation of the divine. These objects, like the rosary beads Granoff discusses, suggest that the image is only one of many objects in Indian religions that can become the focus of cults. They urge us to broaden our concept of just what an "image" of a deity can be.

The issue of what constitutes the embodiment of the god and his/her distinctive identity is the central question for Daniela Berti in Chapter 3, "Of Metal and Cloths: The Location of Distinctive Features in Divine Iconography (Indian Himalayas)." Berti's evidence comes

from the observation of contemporary cults in the Indian Himalayas. She has studied the *pālkī*, or palanquins, of village deities. These structures are elaborately adorned with cloth, jewellery, and metal faces, called *mohrā*. Each palanquin has its own personality; it is identified with a particular deity and receives worship as that deity. Surprisingly, Berti shows that what confers this identity on the palanquin is not the metal faces, the only anthropomorphic element in the assemblage. She notes that it is in fact the shape of the frame that is the first indication of the identity of the deity. The *mohrā* are highly stylized and offer little or no clue as to the identity of the god; Berti suggests that historically the *mohrā* may have represented the donors rather than the deity and were never intended to represent the god. Furthermore, *mohrā* of the same god can differ from each other and be identical to those of another god. The rituals surrounding the construction and storing of the various parts of the palanquin lead to a similar conclusion: pieces of jewellery and other items that we might consider purely "decorative" receive the same ritual treatments as those offered to the frame and the *mohrā*. Here, then, is another case in which anthropomorphism is not the essential mark of the representation of the deity. Berti also makes the point that unlike the case of the traditional image in the temple, where a single object is the support of the cult, the palanquin is a diverse collection of objects, which together are the seat of the god. Like Tarabout's assemblages of coconuts, swords, and leaves, these palanquins challenge our conceptions of "images" of the divine. They suggest the complexity required for a proper understanding of what constitutes physical supports of religious cults.

All three of these chapters, in fact, stress that diverse objects, subjected to the proper rituals, are regarded in Hinduism as the appropriate focus for a cult; the anthropomorphic image or liṅga in the temple has no particular claim to that special status. In all such cases, it is difficult to isolate any particular feature of the "image" that determined its appropriateness for a given ritual. Granoff's rosary beads, Tarabout's coconuts, and Berti's palanquins might all be considered cases in which the actual physical appearance of the support is not obviously connected with the iconography or personality of the god as these are known from other sources. Granoff and Tarabout further attempt to draw conclusions about the relationship between image worship and the elite ritual or intellectual culture, a question that is also studied in the three chapters in Part 2.

For Granoff, this fluidity implied that images somehow did not fit into Brahminic ritual patterns; their ritual function and their being "images" or "likenesses" of a god seemed to have nothing to do with one another. Tarabout's evidence from contemporary practice provided cases in which the worship of anthropomorphic images was in fact observed to be more at home in Brahmin circles. We are left with the impression that the relationship of image worship to Brahminic orthodoxy is complex indeed.

The first chapter in Part 2, Hans Bakker's "At the Right Side of the Teacher: Imagination, Imagery, and Image in Vedic and Śaiva Initiation," as if to mediate between these two positions, offers an unusual example in which Brahminic ritual patterns and image worship have converged and mutually enriched each other. The chapter explores the origins and meaning of an unusual form of Śiva known as Dakṣiṇāmūrti, "The South-facing God," who is regarded as the divine teacher. It concludes that image worship belonged initially outside of Brahminic circles, but that Brahminic patterns of thinking ultimately transformed not only the worship of images but also its own rituals through the creation of new and iconic forms. Bakker argues that Dakṣiṇāmūrti offers us a case in which we may trace how a concrete visual image of God actually arose among literate Śaiva Brahmins. The process was many-stepped and involved a transformation of a vision of God as teacher, at whose right side (dakṣiṇataḥ) the student sat, into the God who faces South (Dakṣiṇāmūrti). Bakker painstakingly reconstructs the process through a close consideration of a number of key texts. He begins with the Śatapathabrāhmaṇa and ritual texts known as the Gṛhyasūtras and then moves on to texts of the early Pāśupata school of Śaivism. On the basis of this cumulative evidence, he argues that a wide range of texts detailing rituals of initiation specify that the student is to be at the right of the teacher. Furthermore, he argues, in the Pāśupata initiation ritual, the student was enjoined to regard his teacher as the god Śiva. Thus the student "sits at the right side of Mahādeva's visual manifestation and sees Him, His rūpa, His benign epiphany, in front of him." Bakker argues that it is this ritual that gave rise to the iconographic form known as Dakṣiṇāmūrti. The teacher, who turned to his right, towards his student, has become the God who faces South, for the word dakṣiṇa can mean both "right" and "south." Bakker supports his arguments with examples of the earliest sculpted representations of Dakṣiṇāmūrti. His chapter offers the first concrete evidence we have for an iconic form of a deity clearly

originating in Brahmin ritual circles. It suggests that the relationship between Brahmins and images is also far more complex than can be described merely by a single theory of the origins of image worship, or by looking at any single genre of texts. There seems to have been a continuing and mutually fructifying relationship from a very early period.

Despite their obvious differences in focus, these four chapters on India all concentrate for the most part on the ritual context of images. Gérard Colas's chapter, "The Competing Hermeneutics of Image Worship in Hinduism (Fifth to Eleventh Century AD)," offers us a very different and much-needed perspective from the Indian philosophical tradition. Colas considers three representative schools of Indian philosophy: the Mīmāṃsā, the school of Indian philosophy most closely linked with the rituals of the Vedic sacrifice; the Advaita Vedānta, known best from the works of the ninth-century philosopher Śaṅkara; and the Nyāya or realist school, which was to a large extent responsible for formulating rules of logic and debate in classical India. Colas takes the eleventh-century philosopher Udayana as an example of Nyāya speculation on the nature of images. For philosophers from all three groups, Colas notes that image worship was not a major topic of interest; we must often infer their attitudes towards image worship from offhand comments they make in the context of other discussions. Finally, he offers as a contrast some remarks on the Vaikhānasas, a group of Vaiṣṇavas who were temple priests, and thus for whom images and their worship were a main concern.

What emerges from Colas's study is the remarkable sense of how diverse the attitudes towards images were among the intellectual elites. While many of the papers on images in India spoke loosely of "Brahmins" or the "Vedic imagination," Colas looks specifically at the philosophical writings of two leading intellectuals of that Vedic tradition as it had been transmitted in the fifth century AD and later. It is not difficult to see from their basic premises that the proponents of the Mīmāṃsā should have found image worship problematic, for, as Colas notes, they rejected the idea that the gods have bodies and that the gods were the central focus of ritual. Orthodox opinion denied that the gods appeared at the sacrifice in bodily form and denied that they ate the offerings. For the orthodox Mīmāṃsā philosopher, the rite itself remained paramount and the deity was made subordinate to the rite. At the same time, as Colas shows, remarks in their texts indicate that the Mīmāṃsā philosophers were aware of public rituals performed for images in temples and accorded them limited sanction. The Advaita

philosopher similarly shows an awareness of the cult of images, although he clearly does not regard the image as god. For Śaṅkara, worshipping an image involves a deliberate act of imputing to the image divine identity. But perhaps the most intriguing evidence that Colas discusses comes from Udayana, for whom an image's status as an object of worship seems to depend not solely on human effort but equally on divine effort. An image is an object of worship when a god makes the deliberate mental effort of identifying himself with the image in question; a role for humans is provided in that gods prefer to do this with regard to images that have been appropriately consecrated.

Colas's chapter illustrates the variety of ways in which intellectuals regarded image worship. It is important evidence from texts usually ignored by scholars who study images, and has much to tell us about the reception of image worship in intellectual circles in medieval India. It also shows us that even within a category like the "Brahmin priests" that Granoff discusses or the "intellectual and social elite" of Tarabout's paper, there was likely to have been a wide range of opinions on images and very different rationales for those opinions.

With Koichi Shinohara's chapter, "Stories of Miraculous Images and Paying Respect to the Three Jewels: A Discourse on Image Worship in Seventh-Century China," we turn from India and Hinduism to Buddhism and East Asia. Like Colas, Shinohara highlights the gap between the well-attested popularity of images in practice and the relative neglect of the subject in medieval scholarly written sources. His main focus is similarly to map out for us how such scholarly circles sought to understand the practice of image worship. Shinohara argues that the discourse on images in medieval Chinese Buddhism evolved only gradually and in several directions that were ultimately never harmonized to allow for the formation of a coherent understanding of the place of image worship. To illustrate this central hypothesis, he examines the treatment of images in the writings of the seventh-century *vinaya* masters Daoxuan and Daoshi.

These two monks were close collaborators at the Ximingsi monastery in the capital city and compiled several major collections of historical records and scriptural passages. Among these, two related collections of image miracle stories are of particular interest. The very fact that Daoxuan and Daoshi were motivated to collect such stories attests to the popularity of the image cult. A close examination of the way in which both these monks framed the stories enables us to reconstruct their attitudes towards image worship; Daoshi's encyclopedic anthology

The Jade Forest in the Dharma Garden is particularly instructive in this connection. Throughout their active careers, both Daoxuan and Daoshi appear to have been preoccupied with a specific apologetic agenda; arguments made against the Buddhist monastic community compelled them to defend the refusal of monks to pay respect to secular authorities of any sort, from family elders and parents to rulers of the kingdom. Instead, Daoxuan and Daoshi argued, monks and nuns pay respect to images and to those who stand above them in the monastic hierarchy.

Shinohara's chapter traces how this argument, first articulated in Daoxuan's *vinaya* commentary, was elaborated in Daoshi's anthologies. In the course of the discussion, he notes that image worship, treated initially as "paying respect to the Buddha," increasingly came to be connected with the practice of Buddha visualization. Thus, by the time of the later and abbreviated version of Daoshi's collection, *Essential Teachings of Scriptures*, the connection between image worship and the arguments surrounding the behaviour of the Buddhist monastics towards secular authorities had receded in importance. At the same time, Shinohara notes, scriptural passages on Buddha visualization and image miracle stories remain only loosely integrated. The conclusion seems inescapable that the popular image cult eluded the efforts of these scholar monks, who sought to secure for it a solid scriptural foundation. Shinohara concludes his exploration by suggesting that the gradual evolution of the discourse surrounding images may well have its parallel in a similarly gradual evolution of the actual practices centring around images. He offers one case, the ritual of bathing images, as an example.

Part 3 of this volume, "Re-creating the Context of Image Worship: Four Case Studies," opens with Robert Gimello's chapter, "Icon and Incantation: The Goddess Zhunti and the Role of Images in the Occult Buddhism of China." Gimello explores the nature and role of icons in Mijiao or esoteric Buddhism in China, in which certain deities are thought to be fully present to their devotees as consecrated and visualized images and as sacred verbal formulas. The Tantric goddess Zhunti (Sanskrit Cundī or Cundā) was the object of popular occult practice in Chinese Buddhism from the Tang dynasty and continues to be popular today. Gimello takes her as representative of an important class of *dhāraṇī* deities, who exist, as it were, at the very intersection of speech and vision. *Dhāraṇīs* are sacred formulas or mantras, and the goddess Zhunti is both mantra and image. The chapter utilizes the earliest documents of the Zhunti cult, texts translated into Chinese in

the late seventh and early eighth centuries, and an eleventh-century Chinese treatise critical to the later development of the cult. It examines these documents against the background of contemporary theory about the significance of "images" in religion, to elucidate a fascinating and little-known aspect of Chinese Buddhism and show its relevance for broader discussions of the nature and function of image cults.

Chari Pradel's chapter, "The Tenjukoku Shūchō Mandara: Reconstruction of the Iconography and Ritual Context," also deals with the complex history of the reception of images, but in this case, Pradel is studying a very specific image said to date from the seventh century in Japan. The object in question is one of the most famous products of early Japanese art. Known as the Tenjukoku Shūchō Mandara, it consists of fragments of embroidered cloth in the possession of the Buddhist nunnery of Chūgūji. The fragments are what remain of a pair of curtains said to have been commissioned by Princess Tachibana, one of the consorts of Prince Shōtoku (AD 574-622), and of a replica made in the thirteenth century.

Pradel explores the interpretation of the images represented on the curtain both in medieval Japan and by modern scholars. The understanding of what the curtains depicted was intimately connected with the reverence accorded Prince Shōtoku as a patron of Buddhism. In fact, as Pradel explains, Prince Shōtoku became the focus of a cult not long after his death; he was the subject of numerous hagiographies, in which he was celebrated as the "father of Japanese Buddhism." The cult began as early as the eighth century and resulted in the creation of both texts and art. Pradel argues that the traditional depiction of Prince Shōtoku has biased scholars in their efforts to understand the work; since Prince Shōtoku was a pious Buddhist, modern scholars assumed that the curtains must also be Buddhist in significance. The curtains originally contained a text, embroidered on the backs of the turtles depicted there. The text has been fully reconstructed, and clearly indicates that the curtains were meant to portray the postmortem fate of the prince. Thus it has been assumed that the curtains depict the rebirth of Prince Shōtoku in some Buddhist paradise, the exact identity of which has been the subject of considerable scholarly debate. As Pradel indicates, the interpretation of the scene on the curtains as the Buddhist Paradise of the Buddha Amida dates at least as far back as the thirteenth century, when the original curtains were discovered by a nun at the Hōryūji temple and a replica was made.

Through a meticulous examination of the pictorial motifs on the curtains and a comparison with contemporary funerary art in Korea, Japan, and China, Pradel comes to the conclusion that the scene on the curtains is in fact not a representation of a Buddhist paradise at all. Indeed, the curtains were not conceived as a Buddhist icon. Pradel here grapples with the gap between written sources and visual object. In this case, an original written text on the icon itself has undergone a re-evaluation by the tradition. In the course of that re-evaluation, a funerary object of non-Buddhist significance has become not only an image of a Buddhist paradise but also an important relic associated with Prince Shōtoku. Shinohara's chapter suggests that traditional scholarly discourse about images in medieval Chinese Buddhism struggled unsuccessfully to develop a coherent discourse about images; here, in this example from medieval Japan, the successful achievement of a consensus about a single image is shown to obscure more than it reveals. Pradel's chapter illustrates another theme that is common to many of the other chapters: the cultural and ritual construction and ultimate fluidity of the meaning of an image.

Elizabeth Sharf's chapter, "Ōbaku Zen Portrait Painting and Its Sino-Japanese Heritage," concerns a body of early modern portrait paintings of eminent Chan and Zen Buddhist monks associated with a Chinese émigré monastic community in Japan known as Ōbaku. The better-known portraits are executed in a bold, colourful style featuring a heavily applied modelling method. As these differ dramatically from traditional medieval East Asian portraits of eminent Buddhist monks, modern scholars have focused on identifying their Western (Indic and/or European) stylistic sources, in the process overlooking their ritual uses and religious meanings. It is this question that is central to Sharf's investigation. She gives special attention to the late Ming portraitist Zeng Jing (1564-1647), whose manner is believed to have established the style of early Ōbaku portrait paintings. She argues that the rhetoric of Western influence, while used to elevate Zeng Jing's achievement, is also employed to marginalize Ōbaku portraiture. Building on the work of Nishigori Ryōsuke, Sharf re-examines extant early portraits in order to identify internal developments freed of the legacy of the better-known, later portraits. She concludes by linking the Ōbaku material to "ancestor portraiture," and returns it squarely to the fold of medieval Chan and Zen Buddhist portraiture known as *chinzō*. Sharf's chapter highlights the need for future research into the textual evidence of the recorded sayings of eminent monks to help

understand the meanings and functions of this body of imagery. Her work makes clear the importance of understanding how these images functioned as ritual objects, a question that is central to many of the chapters in this volume.

The volume concludes with a chapter by Robert Brown, "Ritual and Image at Angkor Wat," and with a discussion in the context of Southeast Asia of many of the themes that the other chapters explore. Brown endeavours to discover the religious context for the magnificent sculptures at Angkor Wat by asking how they were meant to be viewed. He focuses primarily on the reliefs on the south wall of the lowest gallery, identified by inscription as depicting the builder of Angkor Wat, King Sūryavarman II. The king is before four lords, each identified as well by inscription, and Brown suggests that they are taking an oath of fealty to the king. He argues convincingly against the standard interpretation that the monument as a whole was meant to be ritually circumambulated. He also rejects the more specific theory that the reliefs of Sūryavarman II were intended to be "read" as a continuous historical narrative. Instead, he proposes that, much like the Zen Ōbaku portraits, these portraits of the king were meant to place the subject among a recognized group worthy of reverence. For the Ōbaku portraits, this consisted of the ancestors in the monastic lineage; for Sūryavarman II, Brown argues that it was the gods. In both cases, it is only by careful efforts to understand the original context and function of the images that we can appreciate their full meaning.

Together the chapters in this volume suggest the complexity of the worship of images in Asian religions. They highlight the ambiguities that lay behind the acceptance of image worship in Buddhism and Hinduism and the need for scholars to be sensitive to the various contexts and texts that give images their power.[7] These contributions should also make clear that to understand those contexts requires the collaborative effort of scholars working from very different perspectives. Textual scholars and anthropologists, art historians and historians of religion, can indeed engage in meaningful dialogue on the scholarly issues that concern all of us.

End Notes

1 For example, Diana L. Eck, *Darśan: Seeing the Divine in India*, 2nd
 enlarged ed. (Chambersburg, PA: Anima Books, 1985); Joanne Punzo
 Waghorne and Norman Cutler, *Gods of Flesh, Gods of Stone: The
 Embodiment of Divinity in India* (New York: Columbia University Press,
 1996). For a different point of view, and one which accords more with
 the findings of scholars in the present volume, see Richard Davis,
 "Indian Image Worship and Its Discontents," in *Representation in
 Religion: Studies in Honor of Moshe Barasch*, ed. Jan Assmann and Albert
 Baumgarten (Leiden: E.J. Brill, 2000), 107-33. A fine study of attitudes
 towards Indian images is Richard Davis, *Lives of Indian Images*
 (Princeton: Princeton University Press, 1997). See also the articles cited
 by Phyllis Granoff in her essay in this volume. André Padoux, *L'Image
 Divine: Culte et meditation dans l'Hindouisme* (Paris: Éditions du Centre
 National de la Recherche Scientifique, 1990), introduces much-needed
 depth into the discussion of images in Hinduism by highlighting the
 interplay between physical images and visualized images in rituals. The
 recent book *Living Images: Japanese Buddhist Icons in Context*, ed. Robert
 H. Sharf and Elizabeth Horton Sharf (Stanford: Stanford University
 Press, 2001), studies the centrality of images in Japanese Buddhism. In
 the introduction, Robert Sharf discusses the paucity of serious
 scholarship on images and their reception in Buddhism.
2 An excellent overview of the scholarly debate on the origins of the
 Buddha image and the issue of the iconicity/aniconicity can be found in
 Vidya Dehejia, *Discourse in Early Buddhist Art: Visual Narratives of India*
 (Delhi: Munshiram Manoharlal, 1997).
3 A recent thesis by Madhuvanti Ghose, "The Origins and Early
 Development of Anthropomorphic Indian Iconography," School of
 Oriental and African Studies, University of London, 2002, explores the
 origins and role of anthropomorphism in Indian religions. Ghose notes
 the coexistence of anthropomorphic and non-anthropomorphic images
 and emphasizes the complexity of the issue. On mantras and deities, see
 Francis X. Clooney, "What's a God? The Quest for the Right
 Understanding of devatā in Brāhmaṇical Ritual Theory (mīmāṃsā),"
 International Journal of Hindu Studies 1, no. 2 (August 1997): 337-85. The
 concept of the deity as a sacred formula will be discussed by Colas and
 Gimello in this volume.
4 While none of the authors of the chapters in this volume specifically
 mentions Hans Belting's monumental study *Likeness and Presence: A*

History of the Image before the Era of Art, trans. Edmund Jephcott (Chicago: University of Chicago Press, 1994), in many ways we share his central concern of seeking to understand how images functioned in the context in which they were originally made and worshipped.

5 Phyllis Granoff, "Reading between the Lines: Colliding Attitudes towards Image Worship in Indian Religions," a paper that was delivered at the École des Hautes Études en Science Sociales in June 2000 at a seminar organized by Gilles Tarabout and Gérard Colas, who have contributed to the present volume.

6 Gregory Schopen, "Monks, Nuns and 'Vulgar' Practices: The Introduction of the Image Cult into Indian Buddhism," *Artibus Asiae* 49, nos. 1-2 (1989): 154.

7 In this, we argue for a very different understanding of the power of images than David Freedberg did in his path-breaking study *The Power of Images: Studies in the History and Theory of Response* (Chicago: University of Chicago Press, 1989). Here the "power" of an image is in the created meaning that is achieved through ritual and social interactions rather than in the strictly visual confrontation between image and viewer.

Part 1

Defining Images:
The Sacred Objects of Indian Religions

1

Images and Their Ritual Use in Medieval India: Hesitations and Contradictions

PHYLLIS GRANOFF

Images are one element in a continuum of ritual objects, the worship of which was ultimately made to fit into Brahminic patterns of ritual that had been developed in an essentially aniconic context. There are many indications that Indian religious traditions were often ambivalent about images and their worship, despite the abundant rules for image worship and the many miracle stories about image worship that are to be found in the *purāṇas*.[1] The basic elements of purāṇic image worship – offerings of flowers, fruits, and incense; bathing and anointing of the image – may well go back to the worship of the earliest images that we know, those of yakṣas. The *Mahābhārata*, which is on the whole curiously reticent on the subject of images and their worship, has a vivid description of a temple to a yakṣa named Sthūṇa in the *Udyoga parvan*, V. 192-93. The description occurs in the odd story of Śikhaṇḍin, the princess raised as a boy, promised in marriage to another woman, and eventually turned into a man through the force of the yakṣa's boon. Śikhaṇḍin seeks the aid of the yakṣa when the deceit about her gender is revealed in a rather difficult situation; she has been promised in marriage to another princess who discovers that she is in fact a woman! In her distress at the calamities that now threaten her father and mother from her would-be in-laws, Śikhaṇḍin goes to the deserted forest that is the preserve of the yakṣa

Sthūṇa; no one else dares to go there for fear of the yakṣa. Here is how the temple that she sees is described:

> The temple was covered in a coat of white-wash; it was filled with fragrant smoke that announced the presence of *lāja* and it had a high wall around it and a lofty gate. Śikhaṇḍin, the daughter of king Drupada, went into the temple, O king, and fasted there for days, until she became nothing but skin and bones. The yakṣa Sthūṇa, of alluring eyes, revealed himself to her and said, "Why are you doing all of this? Tell me and I will do what you wish without delay."[2]

A second description of the temple appears in the next chapter, when the yakṣa king Kubera is passing by the temple:

> The protector of wealth, travelling over the temple, saw the abode of the yakṣa Sthūṇa, well-adorned and ornamented with various garlands of flowers. In it worship was performed with *lāja* and fragrant substances and with canopies of cloth; incense was burned in that temple that was adorned with flags and banners, and the *homa* oblation that was offered consisted of food and drink and meat.[3]

We are told further that when Śikhaṇḍin returned from the yakṣa temple to the city, she made offerings of costly fragrant garlands to the Brahmins, the gods, the caityas, and the crossroads. These last two terms may give us some further clue as to the identity of at least some of the beings whom Śikhaṇḍin worshipped; caityas are commonly the abode of yakṣas, while crossroads are the haunts of yakṣas and related creatures, often malevolent, such as rākṣasas and gaṇas.

There are a number of curious features to this account of Śikhaṇḍin in the yakṣa shrine. While the temple and the accoutrements of worship are described in detail, nothing at all is said about any image there. Śikhaṇḍin performs asceticism and the yakṣa reveals himself to her. In an earlier passage, V. 188, Śikhaṇḍin, in a previous birth, had proclaimed to a group of ascetics her disgust with being a woman and her desire to take revenge on Bhīṣma, who had rejected her as his wife. Suddenly, Śiva had revealed himself to her, there in the midst of those ascetics. There is no question in this passage of any image, yet the language of this revelation (188.7) is identical to that in 192.23.[4] It is almost as if this revelation of the yakṣa in the temple takes place despite the image one assumes is there, although it is never explicitly mentioned.

It is not only yakṣas whose images seem to be curiously divorced from the true form of whoever it was that the image represents. There is a curious passage in the *Lalitavistara*, a biography of the Buddha that may well be contemporary to some parts of the *Mahābhārata*. When the Buddha is taken into the temple, the images of Śiva, Skanda, Nārāyaṇa, Kubera, Candra, Sūrya, Vaiśravaṇa, Śakra, Brahman, and the Lokapālas moved from their place and fell at the feet of the Buddha. But it is the next statement that is perhaps even more remarkable in the context of the present discussion. The text tells us, "And the gods whose images these were all showed their true forms and proclaimed these verses."[5] The verses are of course praises of the Buddha. What is so intriguing about this statement is the distinction it makes between the image and the true form of the deity. While the images are animated, they are still not the real thing. Gods reveal themselves in this passage as in the *Mahābhārata* sections cited above in a manner that seems to have nothing to do with their images. They show themselves at will to their devotees or, in this case, they show themselves at will as devotees. The parallel between the *Lalitavistara* and the *Mahābhārata* on this point suggests that there was more than a slight hesitation about the status of images and their worship among the orthodox circles of all of India's classical religions.[6]

To complete our picture, there is also the evidence of the *Antagaḍadasāo*, one of the Śvetāmbara Jain *Upāṅgas*.[7] The sixth chapter tells the story of a garland-maker named Ajjuṇa in the city of Rājagṛha. There was a shrine dedicated to the yakṣa Moggarapāṇi in a garden of Rājagṛha. The shrine housed an image of Moggarapāṇi holding a solid iron club. The shrine had been under the care of the garland-maker's family for generations, and every day Ajjuṇa and his beautiful wife would take offerings of flowers to the shrine. One day they are surprised at the shrine by a gang of young men who tie up Ajjuṇa and rape his wife. In his horror, Ajjuṇa cries out, "If the yakṣa Moggarapāṇi were actually present here, would he stand by and watch this disaster that has befallen me? No, surely the yakṣa Moggarapāṇi is not present here."[8]

The words stir Moggarapāṇi into action, but the ensuing events need not concern us here. What does concern us is the split between image and the deity it represents; the image is surely present in the shrine, but the question is raised whether the yakṣa is present in the image. It is possible for the image to be there and the yakṣa to be absent. Images do not necessarily imply or ensure the presence of the deity. The same

split is reflected in Jain monastic rules, where a monk is warned not to stop in a temple with an image. There are different problems and different punishments, depending on whether the deity is present in the image or not. If the deity is present (and female), she may well attempt to seduce the monk or otherwise tempt him away from his vows.[9]

The split between image and deity persists into later medieval times, as can be seen from the famous prose tale of Dhanapāla, the *Tilakamañjarī*, composed in the tenth century in North India. The prince Meghavāhana, in his desire for a child, builds a temple to the royal goddess of his dynasty and has her image installed there. He worships her daily until one day he is confronted by a terrifying ghoul, a vetāla, who identifies himself as one of the servants of the goddess and demands that the king worship him too, if he is to obtain his wish. The ghoul wants the king's head, and when the king bravely attempts to decapitate himself, his hand is suddenly frozen in mid-air. He hears the sound of divine women approaching. The goddess has come. It is interesting to contrast the elaborate description of the goddess with the few meagre words said of her image. The flesh-and-blood deity is described in a long, complicated passage, just as other supernatural beings the king had encountered are described. By contrast, her image had been dealt with in a few short phrases. It is clear that for this author as well, the goddess and her image are very different indeed.[10] We shall see that this split would have profound implications for how images were regarded and used in ritual contexts. It reveals, I believe, a profound hesitation about the worship of images and their significance.

One of the most obvious consequences of what I have called here the split between image and its subject can be found in the ritual treatment of both the newly made image and the established image in daily worship. The god, who is independent of the image, has to be coaxed or invited into the new image in an elaborate ceremony of consecration, or *pratiṣṭhā*. In addition, there remains the possibility, not without its own interesting contradictions, that the deity, once settled in the image, might not stay there. At the start of every worship ceremony, the deity is thus invited anew into the image in the ritual of *āvāhana*. At the conclusion of the worship, the deity is dismissed. Permanent images are treated ritually as though they were temporary ritual objects.[11] Perhaps even more striking is the fact that there is nothing unique about images as places into which one invites a god in the ritual culture that develops in the Āgamas and Tantras, and that

paradoxically governs the worship of images in the temple. Thus, gods are often invited to reside in special pots rather than in images. In some rituals, an image is even placed on top of a pot or in a pot, suggesting its secondary role in the ritual.[12]

There were many consequences of regarding an image as merely one of many possible places into which to summon a god. On the one hand, it allowed ritual objects other than images to be sacralized like images and to have the same ritual potency of the image. On the other hand, it implied that images were not absolutely necessary to a ritual. What was essential was the presence of the god, which could be secured in many ways, from summoning the god into objects other than images or summoning the god through the power of meditation. This emphasis on god as distinct from the image could, in turn, mean that one could dispense with images entirely; indeed, a perusal of rituals in a *purāṇa* like the *Matsyapurāṇa* or in a medieval compendium like the *Caturvargacintāmaṇi* suggests that vratas and other rituals in which images did not play a role greatly outnumbered those that centred on images. I have argued elsewhere that images were not at home in the world of Brahminic ritual, that is, in the world of ritual controlled by Brahmin priests, and it is that world that is reflected in many of the rituals of the *purāṇas*. That images do not necessarily play a role in such rituals is not surprising.

In addition, this curiously ambiguous status of images allowed ritual specialists to seek other roles for them in their rituals. One role was that an image, usually of precious metal or gems, was made for a ritual as basically one gift among many to the officiants of that ritual, the Brahmin priests. In this chapter, I would like to look at one example of each of these two possibilities, of the sacralization of an object that serves as an image-substitute, and of the construction of a new role for images in rituals. My example of the first will be the sacralization of the rosary beads. For the second, I consider images as gifts in the context of medieval healing rituals.

Alternative Images: The Case of the Rosary Beads

We have seen that in the ritual culture of medieval India, images were only one of the many possible places in which a god could be made to reside. The same rituals used to summon the god into the image were efficacious for other objects as well. *Rudrākṣas* or rosary beads provide an excellent example of this phenomenon; they are described in the

same language as images could be described and could be treated with the same rituals as those applied to images.[13] Thus the worshipper conducts the ritual of *mātṛkanyāsa* for the *akṣamālā* or string of rosary beads, touching each bead and mentally superimposing on it a syllable of a mantra. This ritual is used in the worship of an image, both to divinize the body of the worshipper and to divinize the object of worship, the image itself.[14] The worshipper conceives of each bead as having three parts, corresponding to the three gods Brahman, Viṣṇu, and Śiva. He then summons the god he wishes to worship, his *iṣṭadevatā*, into the rosary beads with exactly the same series of rituals that one uses to summon a god into his image.[15]

The analogy between rosary beads and images operates on many levels. Just as seeing images (and the holy sites their presence empowers) frees the sinner from the most heinous of sins, like the sin of *brahmahatyā*, slaying a Brahmin, or the sin of adultery, so wearing the *rudrākṣa* releases the sinner from sin.[16] Dying with the *rudrākṣa* on the body, like dying at Vārāṇasī in the presence of Śiva, ensures that the deceased goes immediately to heaven. The wearer of the *rudrākṣa* redeems his ancestors from hell, just as offering the *śrāddha* ritual at a particular holy site does.[17]

Interestingly, rosary beads also participate in the same multiplicity of discourse that is found with images. On the one hand, they are spoken of as suitable seats for the god, into which he must be ritually summoned; on the other hand, they can also be described as the god himself, the *svarūpa*. In the origin story told of the *rudrākṣa*, which literally means "the eye of Rudra," it is said that the beads come from trees that are the hardened tears of Śiva. They are thus by their very nature a part of the body of god, a kind of sacred bodily relic.[18] In another account, found in the *Sṛṣṭikhaṇḍa* of the *Padmapurāṇa*, the tree of which the *rudrākṣa* bead is the seed was formed during Śiva's destruction of the Triple Cities, when beads of sweat fell from Śiva and congealed to become the trees.[19] The closest parallels to these accounts are in the stories of the origin of liṅga worship, where it is the actual liṅga or phallus of the god that falls to earth and then receives worship, or the origin of sacred *pīṭhas* from the dismembered body of Satī. Both of these, the liṅgas and the *śākta* centres, have been regarded by the orthodox tradition with no small degree of ambivalence. In Vaiṣṇavism, a parallel is provided by the image of Jagannātha at Puri. Oriya accounts of its origin tell how the image is really the corpse of Kṛṣṇa, which floated to Puri and was then discovered in the water

there. It seems to be a unique version of the origin of Jagannātha that was not told in the Sanskrit sources.[20]

One might also recall here the Vaiṣṇava notion of *arcāvatāra*, in which the god willingly descends among mortals as an image, a notion that can be seen to remove the taint of impurity that clings to the other "foundation" myths of the origins of image worship. That "taint" is clear in the purāṇic stories, where something dangerous and terrifying accompanies the transformation of the divine body or body part into an object of worship. Thus when Śiva's liṅga falls, the world is thrown into chaos; the dismemberment of Satī is also an act with destructive consequences, and the death of Kṛṣṇa follows upon the slaughter of his entire clan. In a parallel manner, the creatures who are formed from Śiva's sweat or the fire of his angry third eye in the myths are decidedly ambivalent in nature; hideous, demonic, and fearsome, they too seem to share in some of the taboos concerned with bodily substance and bodily fluid.

The origin story of the *rudrākṣa* brings it close to this mythic world of multiplying gods and lost body parts turning into objects of worship. Substances that are tools of worship as opposed to objects of worship often had a different type of story told of them, a type of story that can be regarded as a device to preserve the purity of the object in question. The following accounts illustrate the ambiguity attached to a substance that comes from the body of a god, and indicate a possible strategy for describing a potent substance that remains free of such ambiguities. These are stories told of the origins of a healing substance, garlic, and of some of the appurtenances of worship: ashes and incense.[21]

That there is a decidedly negative aspect to a substance that originates from close contact with a body, even a divine body, is abundantly clear from the stories told about garlic, which was regarded in early medical texts as both a powerful medicine and as divine in origin. In the *Kāśyapasaṃhitā*, a medical text devoted primarily to diseases of children and women, there is a section dedicated to the benefits of garlic, the *laśuna kalpa*. This is how garlic is said to have originated:

The story is told that when after hundreds of years Indrāṇī had still not become pregnant, Indra fed her the drink of immortality, *amṛta*. He lovingly put his handsome left arm around her and encouraging his wife, who was feeling shy, he made her drink *amṛta*. She was young and felt embarrassed in front of her husband; besides, the drink was too strong for her, and so she vomited it up. By chance it fell in a dirty spot. Indra

then said to Śacī, "You will have many sons, and this will be an elixir of wondrous powers here on earth. But because of the fault of the place where it fell, it will smell and will be prohibited to Brahmins."[22]

The story of the origin of garlic is told differently in an even earlier medical text from the Bower manuscript discovered in Central Asia and dating from the fourth to fifth century.[23] There, the reason for garlic being off limits to the Brahmins is specifically said to be because it is associated with the body. The king of demons had consumed the drink of immortality that came out of the ocean when the gods and demons together churned the ocean. Viṣṇu decapitated the demon and drops of the drink fell to the earth. They became garlic. The text goes on to say, "So Brahmins will not eat it, because it is something which flowed from contact with a body."[24]

It is instructive to contrast these accounts of the origin of garlic with stories told of other substances that are also associated with worship and considered to have medicinal value. These are ashes and incense. In the purāṇas, the wearing of the rudrākṣa beads is likened to smearing the body with ashes. The ashes, however, have a different origin from the rudrākṣa beads. They are derived from the sacrificial fires and are considered to be as pure as a substance can get (Śivapurāṇa, Vidyeśvarasaṃhitā, 24). In the medical texts, which often recommend fumigation as a means of treatment, dhūpa or incense, is also associated with the purity of the sacred fires. Thus, in the Kāśyapasaṃhitā we are told:

The children of the sages were carried off by demons as soon as they were born. The sages performed austerities, recited mantras and made offerings into the fire. Satisfied, Agni told them, "Take this smoke that I give you and use it. You will never have to be afraid of rākṣasas, bhūtas or piśācas again."[25]

Neither ashes nor the incense becomes an image-substitute as do the rudrākṣa beads. The rudrākṣas stand out, then, in being both instrument of worship and object of worship. In the text passages that describe and extol them, rudrākṣas can be ritually treated in the same manner as images are treated; subject to consecration ceremonies, they serve as the vessel into which the presence of the deity is invoked and they accord the worshipper the same fruit as images themselves.[26] At the same time, as objects that can perform the same function as images, they share in a second discourse that we associate with images, the image as derived from the body of a god. I further suggest that this

second discourse was nuanced. Images, I would argue, have the same paradoxical nature as garlic; both divine *(amṛta)* and somehow so stained that contact with them was forbidden Brahmins. While in the ritual sphere they become objects that are manipulated by the priestly circle, in the mythic sphere they retain something of their more ambivalent and complex origins.

Despite these many similarities, *rudrākṣas* differ in one important way from images. Although their name clearly connects them with Śiva, *rudrākṣas* have a flexible identity. Since they have no obvious iconographic traits that would connect them with a particular god, they may be one of many gods. There is in fact an elaborate classification of rosary beads according to the number of faces that they have. The rarest is the "one-faced," or *ekamukhī, rudrākṣa,* of which only a few are said to exist. The *dvimukhī,* or "two-faced," bead is considered by some texts to be Śiva and Gaurī-*svarūpa,* that is, the true form of Śiva and Gaurī, while the *Padmapurāṇa* considers this type to be Agni. The *trimukhī,* or "three-faced," bead is Agni, while the *caturmukhī,* or "four-faced," one is Brahman. The five-faced *pañcamukhī* is Rudra according to one text and Brahman according to another. Both of these gods in their iconic form have five heads. The six-faced or *ṣaṇmukhī* is Kārttikeya, who has six heads in his iconic form. It may also be considered to be Gaṇeśa.[27] It is clear that an effort is made to connect these beads with some trait of the iconic image, namely, the number of heads, but that this trait alone is not sufficient precisely to delimit their identity. Rosary beads as the embodiment of a god are characterized by a variable identity.

I would like to suggest that this is the nature of ritual objects other than images that can serve as the locus of the deity summoned into them. Thus in the *Matsyapurāṇa,* 281, there is a ritual that is basically dedicated to the sun god Sūrya. It is a ritual of expiation for the removal of sin, and consists in making a gold cart led by horses. This is the chariot of the sun. It is to be decorated with a flagstaff of gold topped by a pot made of sapphire and is to be ornamented with rubies. Above the chariot is a canopy made of the finest cloth. Alternatively, the chariot may have a golden flagstaff with a lion on it. The chariot is enlivened with the presence of a deity, as an image is enlivened. But here the text says something that must strike the reader as unusual. It is not Sūrya who is installed in the chariot, but any god that the person performing the ritual wishes to have there: "A person should summon by name and worship that god to whom he is devoted, whoever that may be."[28] Curiously, what follows is a prayer to Sūrya.

This ritual seems to me somehow discordant. The petitioner makes the chariot of Sūrya and prays to Sūrya, but installs there his *iṣṭadevatā*, the god to whom he is devoted, in the same way the worshipper installs in his rosary beads the god of his devotion. This ritual seems to negate or at least transcend the iconic aspects of the ritual object; the chariot of Sūrya becomes the chariot of every god. What is distinctive about the icon is denied or ignored. I see in this an indication that the world of ritual that surrounded images and other objects is often fundamentally inconsistent with what is most basic about an image. The ritual treatment of objects creates for them new and potentially unbounded identities, while images with their specific iconographies have above all fixed identities. The ultimate fate of the chariot of Sūrya in this ritual suggests to me an answer to the question of why the ritual treatment seems at first to be so at variance with the ritual object. The chariot of the sun god, made of precious materials, is given to the Brahmins who participated in the ritual. What is most important about it is its monetary value, which lies in the material out of which it is fashioned, the gold and jewels, rather than the identity of the god who drives it.

I turn now to consider an entire group of rituals in which the ritual object is made of precious materials and given to the Brahmin priests who officiate at the ritual. The existence of this type of role for an image, the image as gift to the Brahmins, suggests to me again that in the Brahminic ritual world, images had an uncertain status. Their role as objects of worship could well be assumed by things that were not images, and the rituals created for them new roles, not as objects of worship but as gifts of value, similar to the cows and the costly cloth and gold that were given to the Brahmin priests during the course of a ritual. That images could play this role, as objects of monetary value, is clear from the rituals in which they figure as gifts and from other sources. One such source, a collection of medieval Jain stories, suggests that images in Hinduism were regarded, at least by outsiders, as one means of storing and transferring wealth. I consider this story briefly in the next section before I turn to the discussion of some rituals.

The Image as Expensive Gift: From Jain Parodies to Rituals for Healing in the *Madanamahārṇava*

The *Bṛhatkathākośa* of Hariṣeṇa (AD 931-32) is a collection of edifying tales.[29] Tale 105 is a typical Jain karma tale, which describes the

intertwining fates of several characters. The story begins with a merchant, Lubdhaka, "Greedy." His main treasures seem to be images, of animals and deities, made of precious metals and gems. The text tells us, "The merchant Lubdhaka had two gold horses, two gold elephants, two gold deer, two gold yakṣas and two gold Goddesses of Fortune that he kept in his house. He made one marvellous bull of rubies and then day and night spent all of his efforts on trying to make another like it."[30]

We shall see that these are exactly the kinds of images that figure in ritual texts, although the greedy merchant seems most interested in them as emblems of wealth. The text never tells us that they are worshipped. As the story develops, the merchant sets out to sea in search of precious stones so that he can make the second bull. He dies in a shipwreck and, on account of his greed, is reborn as a snake guarding his former wealth. In one of his many rebirths, he wishes to marry his cousin, but her father demands as a bride-price that the suitor make a gold image of the girl and give it to him. Only with divine intervention does our merchant succeed. Ultimately the former merchant becomes a Jain and renounces the world. The story is illustrative of Jain attitudes towards non-Jain images made of precious materials. They are simply a form of wealth; the prospective bride's father could have asked not for an image of gold but for gold bullion; the greedy merchant could have kept his jewels as uncut gems in his storehouse. Images are a form of currency. We shall see that such an attitude towards images is no doubt a parody of Hindu treatment of images, and like all parodies is based on some measure of truth. I turn now to a particular class of rituals, rituals to cure disease, in which images do function primarily as gifts, as a means to transfer money and, as we shall see, sin as well from one party to another.

The *Madanamahārṇava* is a fourteenth-century text on diseases, their causes, and their ritual remedies.[31] The basic premise of the text is that disease is a retribution for sin and that its removal necessitates a ritual of expiation. This is by no means a new idea or a notion unique to this text. Some diseases had long been regarded as caused by karma; leprosy and consumption were foremost among the diseases regarded as the result of sin. This is clear from the *Dharmaśāstras* and the early medical texts.[32] The *Yājñavalkyasmṛti*, in its section on rituals of expiation, *prāyaścittas*, chapter 5, verse 209, tells us that the person who kills a Brahmin will have consumption, while the one who drinks alcohol will have hideous teeth. A person who steals gold will have

diseased nails, while the man who violates his teacher's bed will suffer from skin disease.[33] The *Viṣṇusmṛti*, chapter 45, is devoted to diseases, which it says are *lakṣaṇas*, inferential marks, by means of which you can infer sin.[34]

By contrast to these *Dharmaśāstras*, the medical texts consider sin to be only one of several causes of illness, and thus they consider ritual to be only one of several means to health. The *Madanamahārṇava* is closer to the *Dharmaśāstras* in its exclusive consideration of karma as the cause of disease. It belongs to a genre of text that is called a *karmavipāka* and deals with the retribution of sin.[35] It differs from the *Yājñavalkyasmṛti* and *Viṣṇusmṛti* in the exact details of the rituals that it prescribes. At the centre of the rituals in the *Madanamahārṇava* is the injunction to fashion an image of the disease that is troubling the patient. In most cases, the image is to be fashioned according to a detailed description that the text quotes from elsewhere, usually from the *Śātatapīyakarmavipāka*.[36] There is also a general description of a disease image that is to be followed in those cases when no specific description is provided. The image is to be of precious substances and it is to be given to the Brahmin priest along with other gifts at the conclusion of the ritual.

It is not entirely clear when images were brought into rituals for curing diseases. The *Mahābhārata*, II.219.43, in its lengthy description of Skanda, his hordes, and the harm they cause, tells us that they can be warded off by bathing, incense, unguents, *bali* rituals, and offerings. It particularly recommends a sacrifice, or *ijyā*, to Skanda. In the next verse, the text goes on to say that if Skanda and his host are worshipped, they ensure long life and strength for the worshipper. This accords well with what we find in the early medical texts. The early medical texts by Caraka, Suśruta, and the slightly later Vāgbhaṭa have similar instructions for curing diseases, particularly diseases that were thought to be caused by the very demonic agents that appear in this *Mahābhārata* passage, Skanda and his hordes. These diseases strike unborn or newborn children. These rituals may involve such things as making *bali* offerings, preparing amulets, rubbing special unguents on the patient, fumigating the sickroom and the patient with incense, and reciting mantras. There is no explicit mention of images in any of the passages in these medical texts. Thus, for example, we see in the *Suśrutasaṃhitā Śārīrasthāna*, 3.30, that one is to make an offering of rice and meat to Nairṛta when the mother is in the eighth month of pregnancy. This is the time when Nairṛta is likely to seize a fetus,

which will then be born dead.[37] In the *Uttaratantra*, chapters 27-36, we are given rituals for the treatment of infants seized by the different *grahas*. For example, in chapter 27 we are told that the physician *(vaidya)* is to rub the child with old ghee and then sprinkle mustard seeds around him. He is to make a lamp fuelled by mustard seed oil and then make offerings into the fire of seeds of herbs and fragrant substances. The commentary tells us that this means aromatic herbs such as cardamon. The offering is to be made to the Kṛttikās and Agni (27.18-19). To ward off Skanda, the *vaidya* is to perform rituals for the newborn child every day. He is to offer the following prayer:

> May that eternal God Skanda, who is the treasure house of asceticism, of power, glory and physical forms, be merciful to you.
> May the omnipresent god, the Blessed Guha, leader of the army of seizers, vanquisher of the foes of the gods, protect you.
> May the son of the great God of Gods and of Fire, of the Kṛttikās, Umā and Gaṅgā grant you well-being.
> May the Glorious God, the destroyer of Krauñca, who wears red clothes and has red garlands, whose body is painted with red sandal paste and whose divine form is red, protect you.[38]

I have cited this prayer in full for several reasons. Although early images of Skanda, including metal images, are known, this text does not specify that an image is to be made or used at all in the ritual. Nonetheless, as we see from the last verse, the prayer concludes with a description of the god that suggests, if not an image, at least perhaps a painted representation of the god.

This is not the only ritual to Skanda in which an image is conspicuous by its absence, and yet mantras and prayers accompanying the ritual do indeed suggest a developed iconography. The *Atharvavedapariśiṣṭa*, chapter 20, has a ritual to Skanda that it calls *Dhūrtakalpa*.[39] The ritual includes making a *maṇḍapa*, or pavilion, in which are placed a garland, a bell, flags, mirrors, and a special string, which at the conclusion of the ritual will be tied on the petitioner as an amulet to ward off danger from demons and humans. The worshipper then summons Skanda, who is described as having a *śakti*, or lance, a bell, and a flag (5). He rides horses or peacocks, elephants, lions, or tigers (2, 3). He is six-faced and eighteen-eyed, the colour of gold, with a gentle glow (8). He is accompanied by the Mothers (6). The worship also incorporates offerings that we tend to associate with those made to images, such as

flowers and incense. These offerings are followed by a typical *homa*, or oblation, into the fire. It is clear that image worship has influenced the ritual actions and the mantras in the *Dhūrtakalpa*, but there is no explicit proof that an image was used. To the contrary, the details provided indicate that no image was made or employed in the ritual.[40]

Returning to the *Suśrutasaṃhitā*, we find other chapters that describe rituals against the demonic agents of childhood disease similarly offer descriptions that suggest visual representations, although there is no injunction to make an image of the agent of disease. Thus in the chapter on Pūtanā, chapter 32, we find this description, also as part of a prayer:

> May the goddess Pūtanā, who wears dirty clothes, is filthy and has unkempt hair; the goddess Pūtanā who lives in abandoned buildings, protect this son. 32/10
> May the goddess Pūtanā, difficult to look upon, stinking, hideous, dark like the rain clouds, who dwells in broken down buildings, protect this son. 32/11[41]

These prayers suggest that even if these rituals did not use likenesses of the disease-causing agents, there did exist at the time standard descriptions of them, which in turn might lead us to infer that likenesses of diseases, either images or paintings, were made in other contexts. There is some evidence to corroborate this. The account of Śiva's destruction of the demon Andhaka that figures in the *Matsyapurāṇa*, 179, tells of the appearance of a goddess, Śuṣkarevatī, who kills the demons that are born from Andhaka. In the end, Śuṣkarevatī goes wild and must be brought under control. This is done by guaranteeing her worship. Women who desire children are to worship Śuṣkarevatī.[42] Revatī and Śuṣkarevatī are known in the medical texts as killers of children. The *Suśrutasaṃhitā*, *Uttaratantra*, chapter 31, deals with Revatī, who is described as "the goddess who is dark and wears variegated clothing, has garlands of many colours, is anointed with different unguents, and has earrings that shake."[43] Śuṣkarevatī figures in the *Kāśyapasaṃhitā*, *Bālagrahacikitsā*, and the *Aṣṭāṅgahṛdaya* of Vāgbhaṭa, *Uttarasthāna*, although no description of her is given.[44]

Although visual representations of this goddess are not explicitly mentioned, an interpolation in the *Mahābhārata* suggests that paintings of these child-destroyers/child-protectors were indeed

made. To the story of the odd birth of Jarāsamdha, who is born in parts and then put together by the demonness Jarā, was later added the prescription that one should paint the demonness Jarā along with her children on the walls of the house and offer her worship to prevent any calamities from befalling the children of the household.[45] As mentioned above, early images of Skanda are known from all over India. Images of another disease-causing agent, Ṣaṣṭhī, are also known from Kushan Mathura.

Another probably early medical text, the *Bhelasaṃhitā*, combines rituals with other means of healing.[46] This text has a distinctively Śaiva bent. In its ritual treatment of fever, for example, we are told how fever originated from the anger of Śiva, and to cure it one must worship Śiva, who is called here Vṛṣabhadhvaja, "the one with the bull banner" (*Cikitsāsthāna*, chapter 11, verses 47-48). The text recommends sacrifices, *iṣṭis*, oblations into the fire, or *homa*, rituals called *vratas*, and yogic restraints, *yama* and *niyama* (48). In the next chapter, it recommends *bali* offerings as well as *homas* and prayers, or *svastyāyana* (12.39). The *vaidya* is to go to the cemetery and worship Śiva, the lord of the Bhūtas (40). The next verse tells us that he is to destroy the fever by means of rituals practised in the science to combat demons or *bhūtas*, by means of oblations *(homa)*, and *bali* offerings (41). Although the word used for worship, *pūjā*, might suggest an image, there is no explicit mention of images and when the rituals to be done are specifically enumerated, they are rituals known from other texts as those that do not involve images. The only possible exception is the rituals that are grouped under the heading "rituals known from the science of combating *bhūtas*," about which we unfortunately know very little.

Another relatively early text, the *Harivaṃśa*, describes a ritual for procuring children in its account of the destruction of the demon Bāṇa in the *Viṣṇuparvan*, chapter 112. Bāṇa, struck by the wheel of Kṛṣṇa, is dripping blood and about to lose consciousness. Nandin tells him he will be fine, if only he would dance. Desperate to save his own life, Bāṇa complies. Śiva grants him some boons, and as the second boon he chooses the following: "O Bhava! May your devotees who dance like me, covered with blood, in terrible pain, suffering from my wounds, be granted the birth of a son." To this Śiva replies: "This will surely come to pass for those devotees of mine who dance, abstaining from food and endowed with fortitude, devoted to righteousness and truth."[47]

The last boon that Bāṇa chooses may also be relevant; he asks to be the chief of the gaṇas, known as Mahākāla (verse 125). This suggests, then, the ritual propitiation of Śiva through dance in order to gain children. The patron of this dance is Mahākāla, a figure known through later iconography and ritual. There is no indication, however, that in this text the ritual itself involves any iconic representation of either Śiva or Mahākāla.

By contrast, the Jain evidence indicates that images of at least one god thought to be responsible for the welfare of children and live births were made and worshipped. In chapter 3 of the *Antagaḍadasāo*, we find a distinctively Jain version of the Kṛṣṇa story. We learn that six of Devakī's children had died at birth. The reason for this is that another woman, Sulasā, had made an image of Harinaigameṣin and worshipped it fervently. In answer to her prayers, the god had made Sulasā and Devakī conceive at the same time. He had then taken Sulasā's children, who were born dead, and given them to Devakī in exchange for Devakī's live sons. This story is explicit about the worship of images of Harinaigameṣin to ensure live births, and suggests a clear ritual context for the extant images of the god known from Mathura and other sites.

Given the evidence presented here, the silence of the early medical texts on the subject of images is striking. One suspects that their adherence to a pattern of worship developed in Brahminic priestly circles and documented in some sections of the *purāṇas* and *gṛhyasūtras*, such as the *iṣṭis* and *homas*, is at least in part responsible for this silence. The only early text that explicitly requires the presence of images in a ritual to protect children from demonic agents of harm is the *Kāśyapasaṃhitā*.[48] In this case, the ritual protects the unborn child and is performed around the pregnant woman. The priest/*vaidya* prepares the things necessary for the ritual and then makes and consecrates images of the gods Skanda, Ṣaṣṭhī, and Viśākha, another figure associated with Skanda and with diseases of the unborn and newly born. The images are to be of either gold, silver, or grasses.[49] Despite the presence of these images, however, they are by no means the centre of the ritual. Rather, they seem more like passive observers of the oblations into the fire and the recitation of the mantra known as the *Rudramātaṅgavidyā* and the binding of an amulet around the neck of the pregnant woman. Although the *Kāśyapasaṃhitā* gives images a place in its ritual, they are by no means its main focus. This is markedly different in the *Madanamahārṇava*, to which I now turn.

The centrepiece of the rituals in the *Madanamahārṇava* is the fashioning of an image, usually of gold, and usually of the disease that is afflicting the patient on whose behalf the ritual is performed. It is not entirely clear when images were introduced into this type of ritual; the *Yājñavalkyasmṛti*, discussed above, has expiation rituals for diseases, but they do not require images. The *Īśānaśivagurudevapaddhati*, a text of the eleventh century, in part 1, chapter 41, dealing with the cure of childhood diseases caused by the *grahas* or seizers, prescribes a ritual in which an image of some kind figures.[50] The ritual involves preparing the ritual ground and a particular vessel in which an image, called a *puttalī*, or effigy, is placed. After making offerings to the leader of the hindrances, Vighnanāyaka, the officiant is to summon the *mātṛkas*, or Mothers, who are also associated with Skanda and with disease both in the *Mahābhārata* and the *purāṇas*. He is to worship them and then worship Vīrabhadra and Gaṇeśa. This is followed by offerings to Vīrabhadra and the Mothers and to other deities, all known from other texts to be agents of childhood disease, particularly those afflicting the newly born. The ritual continues with fumigation of the child and a special bath. The chapter continues with slightly different rituals for different disease-causing agents, some of whom, like Pūtanā, we have already met. In each case, a *puttalī* is to be made. There is no question that the term *puttalī* would be an unusual choice for the image of a deity; indeed, the text does not mention images when it comes to the *mātṛkas*, Vīrabhadra, or Gaṇeśa. Filliozat, in his discussion of this and other texts, interpreted the image to be that of the sick person, and his reading is supported by a Chinese translation of a text on childhood diseases in which it is explicitly stated that the likeness is that of the sick child.[51]

In contrast, on the basis of his study of the *Īśānaśivagurudevapaddhati* and other texts on childhood disease, Maheśvara Umānātha Bahādur concluded that the images in these rituals, made from clay taken from a riverbank, were to be of the *grahas*, or agents of disease.[52] In light of the rituals in the *Madanamahārṇava*, which centre on an image of disease, this also seems possible.[53] If we assume that the images of the *Īśānaśivagurudevapaddhati* are of the agents of disease, it would make this eleventh-century text the earliest datable example I know of healing rituals that involve the explicit injunction to fashion an image of the disease.[54] Unlike the images in the *Madanamahārṇava*, however, they were not meant to outlast the ritual and had no monetary value. As we shall see, the costliness of the material out of which the images

in the *Madanamahārṇava* are made is essential to their function in the ritual, as gifts for the priests who perform the ceremony.

The rituals in the *Madanamahārṇava* conform to a standard pattern. As the text states, "In order to eradicate the cause of the disease in question, those with symptoms of such diseases as consumption, must perform rituals such as the twelve year penance and the giving of an image of the disease."[55] The cause of the disease in all cases is *apūrva*, the traces left by a former sin. Terrible sins manifest their consequences over many births; it is never possible to know if a disease is the first or final consequence of a sin. In all manifestations of a disease except its final manifestation, there is still residual *apūrva* that can be eradicated by these rituals. If a ritual does not produce the desired effect, one assumes either that the ritual was flawed or that the *apūrva* has already been exhausted, the disease being its final result. In such a case it can be removed only by experiencing it.

The *Madanamahārṇava* quotes from a number of sources, including some of the standard *purāṇas*. As a general rule, it states that images used in the rituals are of two kinds: they are of the specific disease and of the superintending deity, the *adhidevatā*.[56] The text further explains that in most cases the superintending deity is Sūrya, to whom the sacred texts say one must pray for health. In all of the rituals to combat the cause of disease, an image of Sūrya is to be worshipped as well as the image of the specific disease. The text also gives details about who is to conduct the rituals. The sick person or the family of the sick person must choose a Brahmin who knows the Vedas and the *śāstras*, who is married, of good conduct, compassionate, and poor.[57] The details of the framework of the ritual then follow. First, a sacred enclosure, or *maṇḍapa*, is constructed and an altar, or *vedikā*, is made inside that enclosure. A *maṇḍala* is to be drawn with cow dung on the *vedikā*. An eight-petalled lotus is then drawn in this *maṇḍala*. Next, sesame seeds are placed on the centre of the lotus. On top of these sesame seeds is placed a copper pot filled with rice grains. On top of this are placed the images of Sūrya and the disease. On the petals are to be placed images of some of the planets and asterisms. There follow oblations into the sacred fire, after which the body of the sick person is massaged with ghee. This is followed by an ablution with consecrated water from five vessels and a rubdown with a cloth in which are stalks of ritual darbha grass. The culmination of this elaborate series of rituals is the gift of the image of Sūrya and the image of the disease to the Brahmin priest who has overseen the rituals. Giving the image is

accompanied by this prayer: "May the lord of all the world, the one born from the lotus, who holds a lotus in his hands, the one who rides a chariot driven by seven horses, be satisfied by this gift of an image. May he remove the sin that was done in this birth or in another birth, the sin that was done knowingly or unknowingly."[58] This prayer concludes the ritual and the sick person is to return home. This general framework is meant to apply to all of the specific rituals for specific diseases that are the subject of much of the rest of the book.

Most images that are given to remove the cause of a particular disease are anthropomorphic, although in some cases other images can be given. For example, in the case of one form of the wasting disease *kṣaya*, the text quotes Baudhāyana as recommending the fashioning of a Kadalī tree out of gold. The sick person is to give a feast for the Brahmins and then have one of the Brahmins perform oblations into the fire *(homa)*. He is to give the golden Kadalī tree to the Brahmin after festooning it with jewels and cloth.[59] Cloth was considered a valuable object in classical and medieval India; its value was no doubt commensurate with that of the jewels that also adorned the tree.[60] In another case, a jewelled garland is given, and in another a representation of the earth is made, with all of its mountains and forests, and then the nine jewels are set into it.[61] In most cases, however, the image is of the disease itself. Thus, in the case of *rājyayakṣma*, the image is of the personified disease. It is described in this way: "Rājyayakṣma is skinny and holds in his hands an arrow, a bow, and a sword, making a threatening gesture with his other hand. He is three-eyed and bites his lips with his fangs. He is poised to strike." The text also offers this formula to accompany the gift of the image and this statement of the responsibility of its recipient: "'O best of Brahmins, with this image take those diseases which afflict my body.' And the Brahmin, agreeing, should take the image along with the diseases. Thus the sick person who has made the gift achieves long life."[62]

This brings us into a religious world slightly different from the earlier prayer that accompanied the gift of the images in the general description of the rituals. There, it is to be recalled, the prayer was addressed to Sūrya, and the purpose of the gift was to please the god, who would then respond favourably to the gift and help the petitioner. Here the gift serves as a surrogate for the diseases or the sins themselves; the Brahmin is asked to take away the petitioner's sin along with the gift.[63] This, I think, indicates that the image has now been made part of a ritual, namely, a ritual of making gifts to Brahmins

as a means of expiation from sin, that belongs to an entirely different world from that to which we assume images normally belong.

It is clear from other medieval ritual texts that this is regarded as an auspicious event for the giver and an inauspicious one for the recipient. There are in the *Caturvargacintāmaṇi*, for example, rituals of expiation, or *prāyaścitta*, that a Brahmin is to perform if he accepts gifts of gold, very much like the gift of a gold chariot enjoined in the *Matsyapurāṇa* and mentioned earlier.[64] Quoting from a number of *purāṇas* and the *Mahābhārata*, the author tells us that the Brahmin who accepts such a gift becomes a rākṣasa, or demon, unless, of course, he does the requisite rite of expiation. Stories are told to explain why the gift is unpropitious; the chariot, either a horse chariot or an elephant chariot, was made at the time of a battle between the gods and the demons. Its power was such that it alone killed the demons. Because it is connected with this act of violence, it is an unfit gift for a Brahmin to receive.[65] In another account, an elephant chariot was made by the artisan of the gods, Viśvakarman, for Prajāpati, who mounted it and slew the demons. Prajāpati then enjoined that if kings were to worship and give away this chariot to Brahmins, they would be free from all sin, but to the Brahmin who received it would accrue great sin.[66]

It is clear that these gifts, like the gift of the golden image of disease in the *Madanamahārṇava*, are essentially exchanges of sin. The recipient must perform further rituals of expiation lest the sin result in his own bad rebirth.[67] This seems a very different world indeed from that of the pious donations of images in the inscriptions that record them and in the literary texts that describe them.

If we look, for example, at inscriptions that record donations of images or at texts like the *Rājataraṅginī*, the medieval chronicle of the kings of Kashmir, we see images donated as general acts of piety, as acts of filial piety, to ensure the welfare of a parent, child, or spouse (usually deceased), as marks of a king's conquest, or even as efforts of a donor to create lasting fame for himself, but never as a gift to a Brahmin, bearing the donor's sins. Thus, for example, we have a stone inscription of the eleventh century in which building temples and excavating lakes are acts of piety listed alongside the performance of sacrifices;[68] in another inscription, the golden dome on the top of a temple is said to be the king's glory, resembling the full moon.[69] In a twelfth-century inscription, a donor makes a lake for the merit of his parents.[70] In the *Rājataraṅginī*, kings often mark their conquests with the donation of a temple or the founding of a city (4.181); a mother

makes a temple in order to redeem her sinful son who has died or simply to increase the merit of her deceased son (4.659; 6.299); in another case, a wife makes a temple to increase the merit of her husband (6.301).[71] The disease images in the *Madanamahārṇava* are fundamentally different in their function from any of these images or temples. I attribute this difference to their being assimilated to Brahminic rituals such as the *prāyaścittas* or expiation rituals in the *Dharmasūtras*, which originally did not use images.[72] This revaluation of the image, turning it effectively into a gift in a ritual of expiation, in turn led to images being understood as only one among many possible means of transferring sin. In some sense, this is parallel to what we observed earlier in the discussion of rosary beads as effectively image-substitutes. The ritual culture that revolves around images in medieval Indian texts to some extent erases what is unique about images, allowing them to function as one class of objects among many such objects, which can serve the same ritual function. The new status of images as ritual gifts also led to an emphasis on the value of the materials out of which the images are to be made. Images in the *Madanamahārṇava* are of jewels and gold. Even the weight of the gold is specified.

It should be noted, in addition, that even the rituals of the *Madanamahārṇava* are not entirely consistent in what they imply about how the images used in the rituals were thought to function. This is most clearly apparent in the different forms that the prayer accompanying the ritual takes. Thus, in the case of Vātaroga, chapter 16, widely thought to be caused by Vāta, the wind as a god, as well as by a superfluity of wind as a bodily constituent, the image called for is of a deer, the vehicle of the god Vāta. The text quotes Baudhāyana saying that deer should be made of copper with horns of gold. The sick person begs Vāta to be pleased with the gift of his vehicle and to take away the disease. Here the gift seems to be to the god, just as offerings and oblations could be offered in healing rituals to a deity in the tradition of healing rituals or offerings of propitiation that develops from the *Atharva* and *Ṛg Veda*.[73] It needs to be stressed that such a ritual is incompatible with the basic theory of the *Madanamahārṇava*, which holds that disease comes not from the act of any god but from a person's own karma, his past sins that manifest themselves as illness.

In another case, the text in chapter 12 quotes *Vṛddha* or "Old" Baudhāyana as saying that for the disease *śopha* one should offer oblations to Agastya with a prayer for him to take away the disease.

One might also worship fine cloth, which is said to have Agastya as its superintending deity. The cloth is eventually to be given to the Brahmin priest, but the prayer is for Agastya to remove the disease. I would suspect that the original ritual was the one cited from Baudhāyana; it was the oblation to Agastya, a ritual that would be entirely in keeping with early healing rituals of the Vedic type. I also suspect that the gift of the expensive cloth associated with Agastya to the Brahmin was only later added to this original ritual. A final stage of development would be what we see in general in the *Madanamahārṇava*, namely, the gift of an image of the disease as an explicit transfer of sin.

There are also many cases in the text when the disease itself is asked to destroy the patient's disease. This happens, for example, in the case of *śūla*, indigestion, chapter 9. Here the text cites from the thirteenth-century *Caturvargacintāmaṇi*, in which the sick person is instructed to make a *śūla*, here probably a *triśūla* or trident. The *śūla*, identified with the weapon that Śiva used to destroy the Triple Cities, is asked to destroy the patient's *śūla*. This is also reminiscent of earlier practices, in which, for example, Rudra is asked to withdraw his arrows, the cause of disease.[74] One might also argue here that the prayer to *śūla* is not entirely consistent with the understanding of disease as it is explicitly given at the beginning of the *Madanamahārṇava*. The description of the anthropomorphic image of the disease that follows the making and worship of the *śūla* appears to be taken from another source.

The *Madanamahārṇava* thus knows and draws upon a variety of earlier rituals. The offerings and petitions to gods of disease have clear precedents in the healing rituals of the Vedic tradition. Gifts to the Brahmins formed part of expiation rituals in the *Dharmasūtras*. Gifts to Brahmins of manmade objects as opposed to the more usual gift of money and cattle also occur in the purāṇic texts. The gifting of an image of the disease in the *Madanamahārṇava* can also be understood as a development of all of these earlier rituals, particularly of the gift of manmade objects in a text like the *Matsyapurāṇa*. Indeed, rituals in which images are fashioned of precious substances and then given to the Brahmins are common in medieval texts.[75] We have seen earlier that in the *Matsyapurāṇa*, chapter 281, a horse-drawn chariot is made of gold and given to the Brahmin officiant. In an earlier chapter, 96, the ritual of giving fruits, or *phala tyāga*, is described. In this ritual, the fruits are to be made of silver and copper. In addition, images of Rudra, Rudra's bull, and Yama are to be made of gold. They are all to

be given to a Brahmin at the conclusion of the ritual. The gift is accompanied by prayers that ensure the giver steadfast faith in Śiva and ask that the gods Rudra and Yama grant the giver boons. In chapter 280, a golden horse is made and given with other gifts to a Brahmin priest. A prayer accompanies the gift. The prayer asks Sūrya to protect the worshipper. I see in this ritual, as in some of the rituals in the *Madanamahārṇava* itself, a mingling of distinct ritual traditions, not entirely compatible with each other; the one is the fashioning of the vehicle for the god, the other is the gift to the Brahmin. A measure of consistency is restored in the *Madanamahārṇava* when the prayer accompanying the gift asks the Brahmin to take away the disease and the sin that has caused it.

In my estimation, this shows the total assimilation of images into a ritual structured by the rules of the Brahminic ritual world. The *Madanamahārṇava* is by nature a compilation from other texts; we are thus fortunate to see in it these different rituals with their distinctive prayer formulas that I feel enable us to gain some insight into the historical process of the incorporation of images into healing rituals.

In closing this section, I would like to say something about the images themselves. All of the disease images in the *Madanamahārṇava* are multi-armed and ferocious. Their attributes are weapons and they are often shown advancing to strike. One of the unusual features of these images is that they often have an odd number of arms. Thus, the image for Śopha has five arms, which the text explains are distributed so that three are on the right and two on the left. It holds a knife, bell, *vajra*, and bow and arrow.[76] The tradition of associating disease with an odd number of limbs is in fact quite ancient. The *Harivaṃśa Viṣṇuparvan*, 110-11, describing the battle of Kṛṣṇa with the demon Bāṇa, has already been mentioned. Fever, Jvara, fights on Bāṇa's side. It is described as three-headed, three-legged, and three-armed (verses 66 and 70). In fact, images with an odd number of arms are a rarity and I know of none that can be identified as an image of disease made for rituals such as the ones described in the *Madanamahārṇava*.[77] It is conceivable that such images were quickly melted down for the gold out of which they were made; it is also possible, but I think less likely, that they were never made and these rituals were never carried out as they are described here. They fit into the rituals we see in the *purāṇas*, and there seems to me to be no reason to suspect that they were never performed.

Conclusion

This chapter began from the premise that in one of the dominant discourses about images in Indian religions, images were seen to be something apart from the god that they depicted. They were objects into which the god could be summoned by an elaborate ritual process. A second premise of this chapter is that this understanding is based on what I have called a "Brahminic" paradigm of worship, derived from Vedic ritual discourse and eventually imported into the ritual world of images. I then discussed two cases in which I attempted to show that such an understanding of how images function has led to interesting treatments of images and other ritual objects. In the first case, since an image is merely the locus into which one summons the deity, it leads to the possibility that things other than images can serve the same functions and with the same results. This is what I argued texts tell us about rosary beads, which are not simply a tool for worship but become the object of worship itself. This is most clearly seen in the stories told of the origin of the beads themselves from the tears of Śiva. I have argued that such stories are closer to those told about the origins of images as cult objects than those recounted of the origins of things merely used in worship.

My second case study concerned how images could be used in a group of specific rituals in which they did not originally figure. I argued that in a medieval text of healing rituals, images serve as one more valuable gift made to Brahmins, in a context of rituals such as those described in the *Dharmasūtras*, where oblations followed by gifts to Brahmins are effective as means to expiate sin. Paradoxically, as gifts, the images embody the sins of the giver, which are transferred to the recipient. In this case, however, the images are already images of the manifestations of sin and we are tantalizingly close to what I have called a second discourse about images in which the image and the god are identified. The history of image worship in India, I suspect, is a history of the tension and oscillation between these two poles, one in which the image is the god himself, and another in which the image is simply one of many possible supports for the god. Unravelling that history remains a challenge for the future.[78]

End Notes

1 See my paper "Reading between the Lines: Colliding Attitudes towards Image Worship in Indian Religions," delivered at the École des Hautes Études en Science Sociales, June 2000, forthcoming in a volume edited by Gérard Colas and Gilles Tarabout; Richard Davis, "Indian Image Worship and Its Discontents," in *Representation in Religion: Studies in Honor of Moshe Barasch*, ed. Jan Assmann and Albert Baumgarten (Leiden: E.J. Brill, 2000), 107-33; and Ronald Inden, "Changes in the Vedic Priesthood," in *Ritual, State and History in South Asia: Essays in Honour of J.C. Heesterman*, ed. A.W. Van den Hoek, D.H.A. Kolff, and M.S. Oort (Leiden: E.J. Brill, 1992), 556-78. See also the remarks by Marlene Njammasch, *Bauern, Buddhisten und Brahmanen: Das frühe mittelalter in Gujarat* (Wiesbaden: Otto Harrassowitz, 2001), xix, where she clearly distinguishes image priests from Brahmins and notes that image priests are never identified as Brahmins in inscriptions of the early medieval period. She dates Brahmin interest in cooperating with or co-opting the image priests to around the tenth century AD.

2 *tatra sthūṇasya bhavanaṃ sudhāmṛttikalepanam /*
 lājollāpikadhūmāḍhyam uccaprākāratoraṇam / / 21
 tat praviśya śikhaṇḍī sā drupadasyātmajā nṛpa /
 anaśnantī bahutithaṃ śarīram upaśoṣayat / / 22
 darśayām āsa tāṃ yakṣaḥ sthūṇo madhvakṣasaṃyutaḥ /
 kimartho 'yaṃ tavārambhaḥ kariṣye brūhi mā ciram / / 23 (192)
 Lāja normally means parched grain; Nīlakaṇṭha glosses it with the word *uśīra*, which is a fragrant root. The compound, in which smoke makes the presence of *lāja* known, does suggest that here *lāja* is some kind of fragrant substance that is burned.

3 *sa tadgṛhasyopari vartamāna*
 ālokayām āsa dhanādhigoptā
 sthūṇasya yakṣasya niśāmya veśma
 svalaṃkṛtaṃ mālyaguṇair vicitram / / 31
 lājaiśa ca gandhaiśca tathā vitānair abhyarcitam /
 dhūpanadhūpitaṃ ca /
 dhvajaiḥ patākābhir alaṃkṛtaṃ ca
 bhakṣyānnapeyāmiṣadattahomam / 32 (193)

4 *svena rūpena darśayām āsa* in 188.7 and *darśayām āsa tām* in 192.23.

5 *yeṣāṃ ca devānāṃ tāḥ pratimāḥ te sarve svasvarūpam upadarśyemā gāthā abhāṣanta. Lalitavistara*, ed. P.L. Vaidya, Buddhist Sanskrit Series vol. 1 (Darbhanga: Mithila Institute of Post-Graduate Studies and Research in

Sanskrit Learning, 1958), ch. 8, 84.

6 I have argued elsewhere that it was primarily in orthodox Brahminic
 circles that images were seen to be problematic. See my paper "Reading
 between the Lines," cited in n. 1. There is no question that this is not the
 only discourse about image worship in classical and medieval India.
 Images were also spoken of as god, and I would argue that this was
 always the case in those circles in which image worship was at home.
 My theory is that it was the priestly circles that problematized image
 worship, which was originally a non-Brahminic practice.

7 Edited in the *Āgamasudhāsindhu* series vol. 4 (Saurastra, 1976), 332-42;
 The Antagaḍadasāo and Aṇuttarovavāiya-dasāo, trans. L.D. Barnett (London:
 Oriental Translation Fund New Series, 1907), vol. 17, 85-93.

8 *taṃ jati ṇaṃ moggarapāṇi jakkhe iha samnihite homte se ṇaṃ kiṃ mama
 eyaṃrūvaṃ āvaiṃ pāvejjamāṇaṃ pāsaṃte? Taṃ natthi ṇaṃ moggarapāṇī jakke
 iha saṃnihite.*

9 The word used is *saṃnihita*, the same word used in the *Antagaḍadasāo*.
 Niśītha Sūtra, ed. Upadhyaya Kavi Shri Amar Chandji and Muni Shri
 Kanhaiya Lalji Maharaj Kamal, Āgama Sāhitya Ratnamālā no. 4 (Delhi:
 Bharatiya Vidya Prakashan, 1982), 1-18.

10 *Tilakamañjarī* (Saurashtra: Śrīvijayalāvaṇyasūriśvarajñānamandira, 1921),
 104, 141-44.

11 On this ritual and the problems that it entails, see my paper "Reading
 between the Lines." Hélène Brunner in her many articles on the Śaiva
 Āgamas has discussed the ritual of *pratiṣṭhā*. See, for example, "Jñāna
 and Kriyā: Relation between Theory and Practice in the Śaivāgamas," in
 Ritual and Speculation in Early Tantrisim: Studies in Honor of André Padoux,
 ed. Teun Goudriaan, Sri Garib Dass Oriental Series no. 163 (Delhi:
 SriSatguru Publications, 1993), 1-61.

12 Several examples may be found in P.V. Kane, *History of Dharma Śāstra*,
 vol. 5, pt. 2 (Pune: Bhandarkar Oriental Research Institute, 1977), 783.
 The *Madanamahārṇava*, which has rituals to cure diseases, includes
 rituals in which the image made is then placed in a pot.
 Madanamahārṇava of Śrī Viśeśara Bhaṭṭa, ed. Pandit Embar
 Krishnamacharya and M.R. Nambiyar (Baroda: Oriental Institute, 1953),
 vol. 117. See also the comments of Richard Davis, *Ritual in an Oscillating
 Universe: Worshipping Śiva in Medieval India* (Princeton: Princeton
 University Press, 1991), 120. Davis quotes from the *Kāmikāgama*, 4.270-72,
 to the effect that a number of different objects can serve as liṅgas,
 including a circular diagram, a painting on cloth, fire, water, the guru,
 and so on.

13 I have benefited greatly from reading Niśāntaketu, *Rudrākṣadhāraṇa aur*

Japayoga (Delhi: Munshiram Manoharlal, 1991). In particular, this book brings together many of the relevant purāṇic passages.

14 For this and other rituals, see the description in Davis, *Ritual in an Oscillating Universe*.

15 *Rudrākṣadhāraṇa*, 58.

16 One amusing story told in the *Tāpī Khaṇḍa* of the *Skandapurāṇa* is of an image in a temple that frees sinners from adultery. For this reason, the temple becomes a preferred trysting place for lovers. I have translated the story in my article "When Miracles Become Too Many: Stories of the Destruction of Holy Sites in the *Tāpī Khaṇḍa of the Skanda Purāṇa*," *Annals of the Bhandarkar Oriental Research Institute* 77 (1992): 47-71.

17 *Rudrākṣadhāraṇa*, 80-84.

18 See Ruprecht Geib, *Indradyumna Legende: Ein Beitrag zur Geschichte des Jagannātha Kultes* (Wiesbaden: Otto Harrassowitz, 1975), 136. I consider the origin account of the *rudrākṣa* as petrified tear to be somewhat different from the many stories told of the origin of creatures from Śiva's sweat or the fire of his eye (Vīrabhadra, Jvara or fever, etc.). In the case of the *rudrākṣa*, the story is explaining the origin of a physical object of worship. The accounts would be parallel if what emerged from Śiva's sweat were not Vīrabhadra himself but an image of Vīrabhadra.

19 *Rudrākṣadhāraṇa*, 158.

20 Geib, *Indradyumna Legende*, 136f.

21 As in many such cases, it is not possible to draw a precise line and argue that only images or objects of worship originate in divine body parts while tools of worship have other origins. The *Antyakarmadīpakā* of Mahāmahopadhyāya Paṇḍita Nityānandaparvatīya, in describing the gift of *kuśa* grass and *tila* (sesamum), which are among the ten gifts a dying person presents to Brahmins, cites verses in which both substances come either from the body of the god Viṣṇu or from the body of the sage Kaśyapa (*Antyakarmadīpakā*, Kāshī Sanskrit Series no. 66 [Varanasi: Caukhamba Sanskrta Pustakālaya, 1952], 8-9). The *Padma Purāṇa Uttara Khaṇḍa*, ch. 72, contains a healing ritual that begins by having the practitioner turn himself into Viṣṇu through the ritual of *nyāsa*, touching the body and reciting mantras. He is then to wipe himself with *kuśa* grass. The text says that the *kuśa* grass has come from the body of Viṣṇu and that the practitioner is already Viṣṇu; by becoming Viṣṇu he dispels his sin and disease, just as Viṣṇu kills various daityas, or demons. The fact that *kuśa* has come from the body of Viṣṇu is of particular significance in this rite, which in addition emphasizes the horrific form of the god, Narasiṃha. It would be interesting to study the contexts in which the origin of *kuśa* from the body of the god is stressed

to see whether there is a parallel between something that comes from
the body of a god and potentially destructive power.

22 *na lebhe garbham Indrāṇī yadā varṣaśatād api /*
tadaināṃ khādayām āsa śakro 'mṛtam iti śrutiḥ / / 7
savyena parirabhyaināṃ bāhunā cāruṇā snihā
vrīḍatīṃ sāntvayan devīṃ patir bhāryām apāyayat / / 8
tasyās tu saukumāryena hriyaṃ patisannidhau /
amṛtasya ca sāratvād udgāra udayad yadā / / 9
yadṛcchayā ca gām āgād amedhye nipapāta ca
tato 'bravīc chacīm indro bahuputrā bhaviṣyasi / / 10
etac cāmṛtaṃ bhūmau bhaviṣyati rasāyanam /
sthānadoṣāt tu durgandhaṃ bhaviṣyaty advijopagam

Kāśyapasaṃhitā, ed. Paṇḍita Hemarājaarman, Nepala Saṃskṛta
Granthamālā vol. 1 (Bombay: Nirnaya Sagara Press, 1938), 137. As Hans
Bakker pointed out, the *amṛta* in this passage is very likely the god's
semen. The impurity of garlic in this case has to do with its being the
product of semen that has been vomited up and, even worse, vomited
up on an impure spot. The obvious parallel to this strange birth is the
birth of Skanda, who is also born from the vomited-up semen of Śiva.
Skanda has a similarly ambiguous character; associated with the *mātṛkas*,
or Mothers, and other agents of childhood disease, Skanda at first goes
berserk and begins to destroy the universe. He must be pacified so that
the danger he represents can be controlled. My student Richard Mann
has just completed a PhD dissertation on "The Early Cult of Skanda in
North India: From Demon to Divine Son," McMaster University, 2003.

23 For translations, see Dominik Wujastyk, *The Roots of Ayurveda* (Delhi:
Penguin, 1998), 195-207.

24 Wujastyk, *The Roots of Ayurveda*, 201.

25 *jātā jātā ṛsisutā hriyante rākṣasair yadā /*
tadā maharṣayaḥ sarve vahniṃ śaraṇam anviyuḥ / /
homajāpatapoyuktās tatas tuṣṭo 'gnir abravīt /
imān dhūpān prayacchadhvaṃ prayuṅgdhvaṃ ca madarpitān
rakṣobhūtapiśācebhyo na bhayaṃ vo bhaviṣyati.
Kāśyapasaṃhitā, 136.

26 The rituals are given in excerpts from the *Akṣamāllikopaniṣad*, the
Mantramahārṇava, and other texts cited in *Rudrākṣadhāraṇa*.

27 *Rudrākṣadhāraṇa*, 75ff.

28 *yo yadbhaktaḥ pumān kuryāt sa tannāmnādhivāsanam. 7*

29 *Bṛhatkathākośa*, ed. A.N. Upadhye, Singhi Jain Series no. 17 (Bombay:
Bharatiya Vidya Bhavan, 1943).

30 *lubdhaśreṣṭhī punaḥ svārṇau dvau hayau dvau gajau mṛgau dvau yakṣau dvau*

śriyau vidhāya svagṛhe nyadhāt / / 6
kṛtvāikaṃ vṛṣabhaṃ divyaṃ padmarāgavinirmitaṃ dvitīyaṃ tatsamaṃ kartuṃ
cakre yatnam aharniśam / / 7

31 *Madanamahārṇava,* ed. Pandit Embar Krishnamacharya and M.R.
 Nambiyar, Gaekwad's Oriental Series vol. 117 (Baroda: Oriental
 Institute, 1953).

32 See Ludo Rocher, "Karma and Rebirth in the Dharmaśāstras," and
 Michael G. Weiss, "*Caraka Saṃhitā* on the Doctrine of Karma," in *Karma*
 and Rebirth in Classical Indian Traditions, ed. Wendy O'Flaherty (Berkeley:
 University of California Press, 1980), 61-90 and 90-116.

33 *Yājñavalkyasmṛti,* ed. Dr. Umesh Chandra Pandey, Kashi Sanskrit Series
 no. 178 (Varanasi: Caukhamba Sanskrit Sansthan, 1983).

34 *Viṣṇusmṛti* with the commentary of Nandapaṇḍita, ed. Pandit V.
 Krishnamacharya (Adyar: Adyar Library and Research Center, n.d.).

35 For more on this genre, see P.V. Kane, *History of Dharma Śāstra,* vol. 1, pt.
 2 (Poona: Bhandarkar Oriental Institute, 1946), 795ff. See also David
 Pingree, "Two *Karmavipāka* Texts on Curing Diseases and Other
 Misfortunes," *Journal of the European Ayurvedic Society* 5 (1997): 46-52.

36 The text was published in the *Dharmaśātrasaṃgraha* of Vidyāsāgara in
 1876. It is in the *uttarārdha,* 435-56. It is interesting to note that the
 Śātātapa does not mention making images of the disease itself; its rituals
 include images of Brahmā, Viṣṇu, Gaṇeśa, Kubera, Varuṇa, and other
 gods, but not specifically of the diseases, which are the core of the rituals
 of the *Madanamahārṇava.* The *Madanamahārṇava* does seem to be quoting
 from the text in the *Dharmaśātrasaṃgraha.* Another medical text with a
 section on *karmavipāka,* or diseases as the result of ripening of karma, the
 Vīrasiṃhāvalokaḥ, ed. Pandit Radhakrishna Prashara, Krishnadas
 Ayurveda Series no. 59 (Varanasi: Krishnadas Academy, 1999), also has
 rituals involving gifts of images, but again these are not images of the
 diseases. See, for example, 470. One of the texts that Pingree cites even
 recommends making a gold image of the man the sufferer killed in a
 previous life. It is clear that there existed a wide variety of practices
 associated with these healing rituals.

37 References are to the edition with the commentary of Dalhaṇa, ed.
 Vaidya Jādavjī Trikamjī Āchārya (Bombay: Nirnaya Sagara Press, 1938).

38 *tapasāṃ tejasāṃ caiva yaśasāṃ vapuṣāṃ tathā /*
 nidhānaṃ yo 'vyayo devaḥ sa te skandaḥ prasīdatu 28.11
 grahasenāpatir devo devasenāpatir vibhuḥ
 devasenāripuharaḥ pātu tvāṃ bhagavān guhaḥ / / 28.12
 devadevasya mahataḥ pāvakasya ca yaḥ sutaḥ /
 gaṅgomākṛttikānāṃ ca sa te śarma prayacchatu / / 28.13

raktamālyāmbaraḥ śrīmān raktacandanabhūṣitaḥ /
raktadivyavapur devaḥ pātu tvāṃ krauñcasūdanaḥ / / 28.14

39 *Atharvavedapariśiṣṭa*, ed. George Melville Bolling and Julius von
Negelein, Caukhamba Pracyavidyā Granthamālā no.1 (Varanasi:
Caukhamba Orientalia, 1976), ch. 20, 85-90.

40 This should be contrasted with the same ritual as it is described in the
Baudhāyanagṛhyasūtrapariśiṣṭa, caturthapraśnaṃ tṛtīyakhaṇḍa (Karnatak:
Subrahmaṇya Prācya Vidyāpīṭha, 1989), 60-66. This explicitly calls for
the making of an image. The worshipper first plants a branch of the
Udambara tree and then makes an image of Skanda out of darbha grass.
The image is fixed onto the Udambara branch and tied to it with a cord,
a *pratisara*. It is the absence of instructions such as these that lead me to
interpret the *Atharvavedapariśiṣṭa* ritual as not involving an image. While
it is possible to argue that the *Atharva* does not mention the image as it
was so well known, these texts tend to be explicit in their instructions
rather than to abbreviate them. Gérard Colas was kind enough to check
several editions of the *Atharvapariśiṣṭa* for me. In a written communication,
he mentioned one done by Ch. J. Goodwin, *Journal of the American
Oriental Society Proceedings* (May 1890), v-xiii, with a translation, as well
as the original edition of G.M. Bolling and J. Von Negelein (Leipzig,
1909). All of these authors assume the presence of an image. Colas
informs me that of the manuscripts, only one explicitly mentions an
image. The mention appears in what the editors call "a condensed
version of the whole Pariśiṣṭa." On the basis of this information, I am
inclined to view the ritual in the *Atharvavedapariśiṣṭa* as not involving an
image. Perhaps the mention of the image in the one manuscript indicates
the influence of the *Baudhāyanagṛhyasūtrapariśiṣṭa*. Baudhāyana frequently
mentions images in its rituals, which the *Atharvavedapariśiṣṭa* does not do.

41 *malināmbarasaṃvītā malinā rūkṣamūrdhajā /*
śūnyāgārāśritā devī dārakaṃ pātu pūtanā / / 32.10
durdarśanā sudurgandhā karālā meghakālikā /
bhinnāgārāśrayā devī dārakaṃ pātu pūtanā / / 32.11

42 I have written about this story in my paper "Paradigms of Protection in
Early Indian Religious Texts, or an Essay on What to Do with Your
Demons," in *Essays in Jaina Philosophy and Religion*, ed. Piotr Balcerowicz
(Delhi: Motilal Banarsidass, 2002), 181-212.

43 *nānāvastradharā devī citramālyānulepanā / calatkuṇḍalinī śyāmā*

44 *Kāśyapasaṃhitā*, ed. Vaidya Jādavjī Trikamjī Āchārya and Somanāth
Śarma (Bombay: Nirṇaya Sāgara Press, 1938); *Aṣṭāṅgahṛdaya*, ed. Rahul
Peter Das and Ronald Eric Emmerick (Groningen, Netherlands: Egbert
Forsten, 1998).

45 The story of Jarāsamdha is in 2.16-17. I have discussed it in my paper "Paradigms of Protection."

46 *Bhelasaṃhitā*, Vidyābhavan Āyurveda Granthamālā Series no. 25 (Varanasi: Caukhamba Vidyabhavan, 1959). On the date of the text, see G.J. Meulenbeld, *History of Indian Medical Literature*, vol. 2, A and B (Groningen, Netherlands: Egbert Forsten, 2000), 24. Meulenbeld suggests that between AD 400 and 750 an earlier text developed into what we know from the extant manuscript.

47 *yathāhaṃ śoṇitadigdho bhṛśārto vraṇapīḍitaḥ /*
 bhaktānāṃ nṛtyatām evaṃ putrajanma bhaved bhava / / 120
 nirāhārāḥ kṣamāyuktāḥ satyārjavaparāyaṇāḥ /
 madbhaktā ye hi nṛtyanti teṣām evaṃ bhaviṣyati / / 121

48 Meulenbeld dates this text to the Gupta period (*History of Indian Medicine*, 2: 41), although Dominik Wujastyk, *The Roots of Ayurveda*, 208, has suggested that the passage in which this ritual occurs uses archaic language that may indicate a much earlier date.

49 *Kāśyapasaṃhitā*, 166. The passage is translated in Wujastyk, *The Roots of Ayurveda*, 230-35.

50 *Īśānaśivagurudevapaddhati*, ed. M.M.T. Gaṇapati Sāstrī (Delhi: Bharatiya Vidya Prakashan, 1988), 2: 288-98.

51 Jean Filliozat, *Étude de Démonologie Indienne: le Kumāratantra de Rāvaṇa* (Paris: Impremerie Nationale, 1937), 68. The Chinese translation is Taisho 1330.

52 Dr. M.U. Bahādur, *Bhūta Vidyā*, Kelādevī Sumatiprasāda Granthamālā no. 11 (Delhi: K.S. Foundation, 1996), 160. The *Hārītasaṃhitā*, 3, has rituals to get rid of the Pūtanās. These include making images of clay (*mṛṇmayī pratimā*, verse 38). Again, I would argue that the image is of the Pūtanā, although no iconographic details are given. The text is edited by Kālīprasāda Tripāṭhī (Bombay: Śrī Vekatevara Press, 1927). I would support the interpretation of the *puttalī* as a likeness of the agent of disease and not the patient on the basis of later rituals in the *Īśānaśivagurudevapaddhati*, in which it is said that if a demonic agent of disease will not leave the patient by gentle means, then rougher means are necessary. A *puttalī* is to be made and the *graha* is to be summoned into it; the effigy is to be enlivened and then destroyed. With this, the offending agent leaves the patient (*mantrapāda*, 43.6ff). You can also draw the offending *graha* and beat it to death (43.13). The word *puttalikā* is used in the *Brahmavaivartapurāṇa Prakṛtikhaṇḍa* (44.48), in a description of how one is to worship Ṣaṣṭhī, the goddess connected with the death of children and infertility. One is to make a *puttalikā* of the goddess. This evidence suggests that in the other texts *puttalī* may well refer to a likeness of the agent of disease and not the patient.

53　It is of course conceivable that the effigy was both. I. Nabokov, working on contemporary healing rituals, highlighted the way in which multiple meanings were given to such effigies. To the ritual specialist, the effigy was the sick victim, who is destroyed during the ritual. To the victim in the particular case studied, it was her relationship to her husband. See I. Nabokov, "Deadly Power: A Funeral to Counter Sorcery in South India," *American Ethnologist* 27, no. 1 (February 2000): 147-69. I thank David Shulman for bringing this article to my attention.

54　It is true that the *Madanamahārṇava* quotes some *purāṇas* as enjoining the gift of an image of a disease. For example, on p. 260 it quotes the *Brahmāṇḍapurāṇa* as enjoining the gift of an image of the disease *rājayakṣma*. I have not succeeded in locating the quote in the printed edition of the *Brahmāṇḍapurāṇa*. There are also numerous problems in dating different parts of the *purāṇas*. At this stage of my research, I therefore remain hesitant about reconstructing the chronological development of the use of disease images.

55　*tatra nidānocchedāya kṣayitvādilakṣaṇarogayuktair*
　　dvādaśavārṣikādiprāyaścittavyādhipratikṛtidānādi kartavyam //
　　　　　Madanamahārṇava, 4.

56　Ch. 4, 40.

57　Ch. 4, 41.

58　*padmodbhavaḥ padmakaraḥ saptāśvarathavāhanaḥ /*
　　pratimānena dattena tuṣyet sarvajagadguruḥ //
　　ihajanmani yat pāpam anyajanmani vā kṛtam /
　　Sapratyayāpratyayābhyāṃ tat sarvaṃ śāmayatv asau //
　　p. 61.

59　*Madanamahārṇava,* ch. 8, 259-60.

60　The monetary value of cloth is clear from a number of sources. The Jain story of Śālibhadra, which was told and retold in medieval story collections, tells of a merchant so wealthy that he was able to use a certain type of precious cloth, to wipe his feet, too costly even for the King to afford, (*Ākhyānikamaṇikośa*, ed. Muni Shri Punyavijayji, Prakrit Text Society Series no. 5 (Varanasi: Prakrit Text Society, 1962), 30-35; *Triśaṣṭiśalākāpuruṣacarita* of Hemacandra, trans. Helen Johnson, Gaekwad's Oriental Series no. 140 (Baroda: Oriental Institute, 1962), 6: 254-59. Cloth often figures among the objects a king gives to a monk or to another king whom he wishes to honour. Thus, in the *Rāṣṭrauḍhavaṃśamahākavya* of Rudrakavi, ed. Embar Krishnamacharya (Baroda: Oriental Institute, 1917), ch. 19, when Akbar wants to enlist the aid of King Nārāyaṇa, he sends his son with a gift to him. The gift consists of two cloths, which are said to be very valuable, and a white horse.

61 *Madanamahārṇava*, chs. 13 and 15.

62 *rājyayakṣmā kṛśatanḥ śāracāpāsitarjanīḥ /*
 dadhat trinetro dāṃṣṭrābhyāṃ daṣṭoṣṭho hantum udyataḥ //
 ye māṃ rogāḥ prabādhante dehasthāḥ satataṃ tataḥ /
 gṛhṇīṣva pratirūpeṇa tān rogān dvijasattama
 bāḍham ityeva tadrūpaṃ gṛhṇīyād vyādhibhiḥ samam /
 tataḥ sa rogī dātā ca dīrghāyuṣyaṃ prapadyate.
 Madanamahārṇava, 260.

63 On the notion of gifts to Brahmins, see Gloria Goodwin Raheja, *The Poison in the Gift: Ritual Prestation and the Dominant Caste in a North Indian Village* (Chicago: University of Chicago Press, 1988).

64 *Caturvargacintāmaṇi*, ed. Paṇḍita Pramathanātha Tarkabhūṣaṇa, Kashi Sanskrit Series no. 235 (Varanasi: Chaukhamba Sanskrit Sansthan, 1985), 4: 596-605.

65 Ibid., 601, quoting from the *Bhaviṣyottara Purāṇa*.

66 Ibid., 605, quoting from the *Liṅga Purāṇa*.

67 The connection between a gift of gold and the exchange of sin has been noted in death rituals, where a gift of gold to the officiating priests is permitted as a substitute for expiation rituals. See Klaus-Werner Müller, *Das Brahmanische Totenritual nach der Antyeṣṭpaddhati des Nārāyaṇabhaṭṭa* (Stuttgart: Franz Steiner Verlag, 1992), 33.

68 *Epigraphia Indica*, Vol. I, Deopara inscription of Vijayasena, 305.

69 Ibid., II, "Harsha stone inscription of the Chahamana Vigraharaja, Vikrama year 1030," 116, v. 17.

70 Ibid., II, "Govindpur stone inscription of the poet Gangadhara," 330.

71 *Rājataraṅginī*, ed. Vishva Bandhu (Hoshiarpur: Vishvveshvaranand Vedic Research Institute, 1963). On filial piety and the donation of images and temples, see the recent PhD dissertation by Jack Laughlin, "Āradhakamūrti/adhiṣṭhāyakamūrti: The Jain Monastic Portrait," McMaster University, 1999. See also Gregory Schopen's articles on the transfer of merit and filial piety in Indian Buddhism, reprinted in *Bones, Stones, and Buddhist Monks: Collected Papers on the Archaeology, Epigraphy, and Texts of Monastic Buddhism in India* (Honolulu: University of Hawai'i Press, 1997).

72 The assimilation of rituals for diseases to the *prāyaścittas* was clearly made at an early date. Thus, Manu includes his discussion of sins and disease in the section on expiation, as does Yājñavalkya. See also Ludo Rocher, "Karma and Rebirth in the Dharmaśastras," in *Karma and Rebirth in Classical Indian Traditions*, ed. Wendy Doniger O'Flaherty (Berkeley: University of California Press, 1980), 85.

73 On these rituals, see Kenneth Zysk, *Religious Healing in the Veda with*

Translations and Annotations of Medical Hymns from the Ṛgveda and the
Atharvaveda and Renderings from the Corresponding Ritual Texts
(Philadelphia: American Philosophical Society, 1985).

74 For example, in the famous *Śatarudrīya* of the *Taittirīyasaṃhitā*, 4.5.1.
 There are also examples from the *Atharva Veda*; see, for instance, VI, 57.

75 See, for example, the many rituals in P.V. Kane, *History of Dharma Śāstra*,
 vol. 5, pt. 1 (Poona: Bhandarkar Oriental Institute, 1974).

76 *Madanamahārṇava*, 286.

77 A special exception would be the group of images of the androgynous
 Śiva or Ardhanārīśvara in the Tamil region, which are three-armed; the
 male half has two arms and the female half has one arm. The images are
 discussed in Marguerite E. Adiceam, "Les Images de Śiva dans l'Inde du
 Sud VI. Ardhanārīśvara," *Arts Asiatiques* 17 (1968): 143-72.

78 I must confess that while my assumption in this chapter has been that
 many of the hesitations about image worship that we see in Indian
 religious texts can best be explained by the hypothesis that image
 worship originated outside the circle of Brahmin ritual specialists, Gilles
 Tarabout's chapter has made me vividly aware of much that I had not
 considered in my historical reconstruction of the process by which
 image worship comes into Indian religions. Nonetheless, I do believe
 that the evidence of the medieval texts, some of which I have presented
 here, indicates deep-seated ambivalence about image worship in
 Brahmin priestly circles. What were the circles in which image worship
 was initially at home is a question I cannot answer. I would agree with
 Gilles that the old model, in which image worship was a lay or vulgar
 practice later accepted by a religious and social elite, needs to be
 discarded. At this point, I would only suggest that image worship
 belonged to a different "elite," about whom we need to know more.

Bibliography

Primary Sources

Ākhyānikamaṇikośa. Edited by Muni Shri Punyavijayji. Prakrit Text Society Series no. 5. Varanasi: Prakrit Text Society, 1962.

Antagaḍadasāo. Edited in the *Āgamasudhāsindhu* series, vol. 4, Saurastra, 1976. The *Antagaḍadasāo* and *Aṇuttarovavāiya-dasāo*, trans. L.D. Barnett. London: Oriental Translation Fund New Series, 1907, vol. 17.

Antyakarmadīpakā. Kāshi Sanskrit Series no. 66. Varanasi: Caukhamba Sanskrta Pustakālaya, 1952.

Aṣṭāṅgahṛdaya. Edited by Rahul Peter Das and Ronald Eric Emmerick. Groningen, Netherlands: Egbert Forsten, 1998.

Atharvavedapariśiṣṭa. Edited by George Melville Bolling and Julius von Negelein. Caukhamba Prachyavidya Granthamala no. 1. Reprint. Varanasi: Caukhamba Orientalia, 1976.

Baudhāyana Gṛhya Sūtra Pariśiṣṭa, caturthapraśnam tṛtīyakhaṇḍa. Karnatak: Subrahmaṇya Prācya Vidyāpīṭha, 1989.

Bhelasaṃhitā. Vidyābhavan Āyurveda Granthamālā Series no. 25. Varanasi: Caukhamba Vidyabhavan, 1959.

Bṛhatkathākośa. Edited by A.N. Upadhye. Singhi Jain Series no. 17. Bombay: Bharatiya Vidya Bhavan, 1943.

Caturvargacintāmaṇi. Edited by Paṇḍit Pramathanātha Tarkabhūṣaṇa. Kāshi Sanskrit Series no. 235. Varanasi: Caukhamba Sanskrit Sansthan, 1985.

Hārītasaṃhitā. Edited by Kālīprasāda Tripāṭhī. Bombay: Śrī Veṅkateśvara Press, 1927.

Īśānaśivagurudevapaddhati. Edited by M.M.T. Gaṇapati Śāstri. Delhi: Bharatiya Vidya Prakashan, 1988.

Kāśyapasaṃhitā. Edited by Pandita Hemarājaśarman. Nepala Saṃskrta Granthamālā vol. 1. Bombay: Nirnaya Sagara Press, 1938.

Lalitavistara. Edited by P.L. Vaidya. Buddhist Sanskrit Series vol. 1. Darbhanga: Mithila Institute of Post-Graduate Studies and Research in Sanskrit Learning, 1958.

Madanamahārṇava of Śrī Viśveśvara Bhaṭṭa. Edited by Pandit Embar Krishnamacharya and M.R. Nambiyar. Gaekwad's Oriental Series vol. 117. Baroda: Oriental Institute, 1953.

Mastyapurāṇa. Puṇe: Ānandāśrama Press, 1981.

Niśitha Sūtra. Edited by Upadhyaya Kavi Shri Amar Chand ji and Muni Shri Kanhaiya Lal ji Maharaj Kamal. Āgama Sāhitya Ratnamālā no. 4. Delhi: Bharatiya Vidya Prakashan, 1982.

Rājataraṅginī of Kalhaṇa. Edited by Vishva Bandhu. Hoshiarpur:
Vishveshvaranand Vedic Research Institute, 1963.
Rāṣṭrauḍhavaṃśamahākāvya of Rudrakavi. Edited by Embar Krishnamacharya.
Baroda: Oriental Institute, 1917.
Śātātapīyakarmavipāka. In *Dharmaśāstrasaṃgraha* of Vidyāsāgara, 1876.
Suśrutasaṃhitā. Edited with the commentary of Dalhaṇa by Vaidya Jaṃdavjī
Trikamjiī Āchārya. Bombay: Nirṇaya Sāgara Press, 1938.
Tilakamañjarī of Dhanapāla. Saurashtra:
Śrīvijayalāvaṇyasūrīśvarajñānamandira, 1921.
Triśaṣṭiśalākāpuruṣacarita of Hemacandra. Translated by Helen Johnson.
Gaekwad's Oriental Series no. 140. Baroda: Oriental Institute, 1962.
Vīrasiṃhāvalokaḥ. Edited by Pandit Radhakrishna Prashara. Krishnadas
Ayurveda Series no. 59. Varanasi: Krishnadas Academy, 1999.
Viṣṇusmṛti with the commentary of Nandapaṇḍita. Edited by Pandit V.
Krishnamacharya. Adyar: Adyar Library and Research Center, n.d.
Yājñavalkyasmṛti. Edited by Dr. Umesh Chandra Pandey. Kashi Sanskrit
Series no. 178. Varanasi: Caukhamba Sanskrit Sansthan, 1983.

Secondary Sources

Adiceam, Marguerite E. "Les Images de Śiva dans l'Inde du Sud. VI.
Ardhanārīśvara." *Arts Asiatiques* 17 (1968): 143-72.
Bahādur, M.U. *Bhūta Vidyā.* Kelādevī Sumatiprasāda Granthamālā no. 11.
Delhi: K.S. Foundation, 1996.
Brunner, Hélène. "Jñāna and Kriyā: Relation between Theory and Practice in
the Śaivāgamas." Pp. 1-61 in *Ritual and Speculation in Early Tantrisim, Studies
in Honor of André Padoux*, edited by Teun Goudriaan. Sri Garib Dass
Oriental Series no. 163. Delhi: SriSatguru Publications, 1993.
Davis, Richard. *Ritual in an Oscillating Universe: Worshipping Śiva in Medieval
India.* Princeton: Princeton University Press, 1991.
–."Indian Image Worship and Its Discontents." Pp. 107-33 in *Representation in
Religion: Studies in Honor of Moshe Barasch*, edited by Jan Assmann and
Albert Baumgarten. Leiden: E.J. Brill, 2000.
Filliozat, Jean. *Étude de Démonologie Indienne: le Kumāratantra de Rāvaṇa.* Paris:
Impremerie Nationale, 1937.
Geib, Ruprecht. *Indradyumna Legende: Ein Beitrag zur Geschichte des Jaganātha
Kultes.* Wiesbaden: Otto Harrassowitz, 1975.
Granoff, Phyllis. "When Miracles Become Too Many: Stories of the
Destruction of Holy Sites in the Tāpī Khaṇḍa of the Skanda Purāṇa."
Annals of the Bhandarkar Oriental Research Institute 77 (1992): 47-71.

–. "Reading between the Lines: Colliding Attitudes towards Image Worship in Indian Religions." Paper read at the École des Hautes Études en Science Sociales, June 2000. Forthcoming in a volume edited by Gérard Colas and Gilles Tarabout.

–. "Paradigms of Protection: Jain, Buddhist and Hindu Stories." Pp. 181-212 in *Essays in Jaina Philosophy and Religion*, edited by Piotr Balcerowicz, Warsaw. Delhi: Motilal Banarsidass, 2002.

Inden, Ronald. "Changes in the Vedic Priesthood." Pp. 556-78 in *Ritual, State and History: Essays in Honour of J.C. Heesterman*, edited by A.W. Van den Hoek, D.H.A. Kolff, and M.S. Oort. Leiden: E.J. Brill, 1992.

Kane, P.V. *History of Dharma Śāstra*, vol. 5, pt. 2. Pune: Bhandarkar Oriental Research Institute, 1977.

Laughlin, Jack. "Āradhakamūrti/adhiṣṭhāyakamūrti: The Jain Monastic Portrait." PhD dissertation, McMaster University, 1999.

Meulenbeld, G.J. *History of Indian Medical Literature*, vol. 2, A and B. Groningen, Netherlands: Egbert Forsten, 2000.

Müller, Klaus-Werner. *Das Brahmanische Totenritual nach der Antyeṣṭipaddhati des Nārāyaṇabhaṭṭa*. Stuttgart: Franz Steiner Verlag, 1992.

Nabokov, I. "Deadly Power: A Funeral to Counter Sorcery in South India." *American Ethnologist* 27, no. 1 (February 2000): 147-69.

Niśāntaketu. *Rudrākṣadhāraṇa aur Japayoga*. Delhi: Munshiram Manoharlal, 1991.

Njammasch, Marlene. *Bauern, Buddhisten und Brahmanen: Das frühe Mittelalter in Gujarat*. Wiesbaden: Harrassowitz Verlag, 2001.

Pingree, David. "Two *Karmavipāka* Texts on Curing Diseases and Other Misfortunes." *Journal of the European Ayurvedic Society* 5 (1997): 46-52.

Raheja, Gloria Goodwin. *The Poison in the Gift: Ritual Prestation and the Dominant Caste in a North Indian Village*. Chicago: University of Chicago Press, 1988.

Rocher, Ludo. "Karma and Rebirth in the Dharmaśāstras." Pp. 61-90 in *Karma and Rebirth in Classical Indian Traditions*, edited by Wendy Doniger O'Flaherty. Berkeley: University of California Press, 1980.

Schopen, Gregory. *Bones, Stones, and Buddhist Monks: Collected Papers on the Archaeology, Epigraphy, and Texts of Monastic Buddhism in India*. Honolulu: University of Hawai'i Press, 1997.

Weiss, Michael G. "Caraka Samhitā on the Doctrine of Karma." Pp. 90-116 in *Classical Indian Traditions*, edited by Wendy Doniger O'Flaherty. Berkeley: University of California Press, 1980.

Wujastyk, Dominik. *The Roots of Ayurveda*. Delhi: Penguin, 1998.

Zysk, Kenneth. *Religious Healing in the Veda with Translations and Annotations of Medical Hymns from the Ṛgveda and the Atharvaveda and Renderings from the Corresponding Ritual Texts*. Philadelphia: American Philosophical Society, 1985.

2

Theology as History: Divine Images, Imagination, and Rituals in India

GILLES TARABOUT

There is in India a widespread theological view according to which the limitations of human beings make it necessary for them to practise image worship in order to approach the divine. Such an assertion, however, is not confined to theology. It often pretends to "explain" actual practices in relation to society, and has spilled over into both art history and that part of general historiography that seeks to reconstruct the early developments of image worship on the subcontinent. Ethnographic evidence, on the contrary, suggests that observable practices provide a markedly different picture from the one that could be expected to follow from the "theological view" when it is applied to society. Moreover, today's observations impose on any theory of the past a set of empirical constraints that it should have to meet. I will thus argue in favour of a thorough reconsideration of some frequently made assumptions about the sociology and the early history of image worship, suggesting eventually a few perspectives that could orient further research and discussion.

Kaliyuga

Over the years, I have had many discussions with K.P.C. Anujan Bhattattiripad, a Kerala expert in temple and image consecration (a *tantri*), editor, and commentator of the main āgamic text followed in

the region, the *Tantrasamuccaya*. During our exchanges, I was regularly told by him that sages *(muni)* can realize divinity in themselves without external support. Twice-borns have to do it through the fire cult. Only inferior beings need to rely on "idols" (his word). This was thus not only a theological statement but a "sociological" one as well. It was combined with a historical perspective: in olden days, fire was the only agent used in the worship, "but later people could no more understand." Hence, the "preceptors" of that time "devised a more visual method": this is why temples and images were created.

Relying on a Kerala devotional text of the sixteenth century, the *Nārāyaṇīyam*, he explained, for instance (abstract of a discussion we had on 7 April 1994):

> At the time of the first perfect age *(kṛtayuga)*, worship was only in the mind. Lord Viṣṇu was imagined with two arms, white coloured, with long hair, seated, in ascetic position – this was correlated to the state of purity of our ancestors.
>
> In the following age *(trētāyuga)*, worship was through the fire sacrifice. God was thought of as a person himself doing such sacrifices, with two hands holding sacrificial implements, slightly reddish in colour, in a state of desire and emotions – linked to our ancestors' quality of heart.
>
> In the *dvāpara* age, Viṣṇu was four-handed, holding discus, conch, mace and a thousand-petal lotus. The presence of weapons was due to the fact that, at that time, man's mind was affected by evil thoughts: men needed to be protected from enemies. This is the time when temple and idol worship started, the time of distinguishing between the various gods and goddesses. For, previously, there were no separate deities. Thus [he concluded] "idol-worship is very recent in India."

During another discussion (in 1997), he insisted again on the contrasts opposing sages, twice-borns, and "those without intelligence,"[1] the latter being the only ones to use divine images *(pratimā)*.

Such assertions are definitely not isolated in contemporary India. During my first years of fieldwork in Kerala, in the early 1980s, I was repeatedly told by educated people that "idols" are in fact only symbols. Nobody should worship the image as such, but only the god behind it. God is formless. But the human mind, unable to imagine such an abstract reality, needs a material support for mental concentration. According to my interlocutors, therefore, divine images, especially anthropomorphic ones, were to be understood as a kind of pedagogic

device. Their ultimate purpose was to lead today's low-standard devotees (especially in this present *Kaliyuga*) to the understanding that God was beyond form and characterization. If imagination had to be at work, it was for imagining that what you saw was *not* God. Idols were there in order that the mind may see beyond them.[2]

This is not without textual background. The *Yoga Vāsiṣṭha*, for instance, insists that worshipping images is for those with an "underdeveloped intellect" and a "childlike mind."[3] That this belief was put into practice is also attested: in an episode in Rāmakṛṣṇa's life, the saint receives a statue of Rāma from an ascetic who does not need it anymore for realizing God.[4] And even if such a perspective does not end in discarding idols, it certainly adds, at least for some devotees, to the complexity with which the idol is regarded, making for an extremely rich mental process bridging the distance between effective physical manipulations (gestures made on, or in front of, the image) and what happens "really" to the deity at an invisible level.[5]

But this might not be the end of the tale. As suggested at the beginning of this chapter this *theological* position, whatever its elaboration in texts and its real impact on practice, is not confined to the justification of image worship. It seems also to lie behind some developments in art history and in the historiography of early image worship in India, this time at the purely *academic* level, and this is the point that I want to address.

In the case of art history, at least, theology has clearly influenced academic practice since the end of the nineteenth century. Let me quote a few examples. According to historian Ravi Varma, there is no real "image" worship in India: "The Hindu who does not conceive a form for God cannot have any idol of God; to him a *vigraha* is not the 'image' of God, but a 'symbolic representation' of the nameless, formless, qualityless Absolute, on whom qualities are superimposed ... to suit the natural qualities and leanings of the *sādhaka* (worshipper), in order to enable him to conceive and meditate upon the Absolute."[6]

The art historian B.C. Bhattacharya concurs, and suggests moreover that the religious iconography found in India is visually of the meditative kind – another obviously counterfactual statement: "From all directions, the Hindus have tried to render a meditative prayer to God ... To add to their attention – being at the very heart of prayer – they have tried to have such images made as would appeal to their religious sentiments and sympathies and would evoke various emotions to enable them to perform the sacred journey towards the

supreme being. In most cases the images have been represented in a meditative posture."[7]

Positions like these are not the product of an "India" versus "the West" pseudo-divide. Some Western scholars writing on India have been of a similar opinion. For Alain Daniélou, for instance, "the image of a god is thus a form used for the concentration of the mind on an abstraction."[8] And the art historian B. Rowland writes: "There is nothing corresponding to idolatry in the narrow sense, since the worship is never paid to the image of stone or brass, but to what the image stands for, the prototype. The image, in other words, as a reflection of the godhead, is as the diagram of the geometrician in relation to the great diagram in the beyond."[9] Even a scholar like T.A. Gopinatha Rao, author of a treatise on Indian iconography that is still a standard reference book today, establishes a link between the form of divine images and spiritual progress: "His [the devotee's] God may or may not be conceived as anthropomorphic; the form of the conception depends upon the stage of advancement of the worshipper in the culture of divine knowledge and spiritual wisdom."[10]

Indeed, Indian experts writing in the early twentieth century and their later Western counterparts had deep and well-founded motives for adopting what may be termed an idealistic stand: they strongly felt the necessity to refute accusations of "idolatry" (in the pejorative sense of the word) or of "monstrosity" that were so often, and for such a long period, attached to divine representations in India, at first in the gaze of Muslim sensibility, then during the colonial period.[11] For reaching such a goal, claiming that divine images are not images but symbols was a main discursive strategy. It could also be done in a subtler way. In a recent article,[12] Parul Dave Mukherji has shown how the well-known art historian A.K. Coomaraswamy aimed at revalorizing Indian art and aesthetics by denying any "naturalism" in it, and by claiming for Indian art a transcendental nature. Although there were voices of dissent against Coomaraswamy's argument at the time (for instance, the Sanskritist V. Raghavan), this was to become for a long time a canonical framework for interpretations in Indian aesthetics. I would suggest that such a stand, at the academic level of art history (but not for all art historians, many of them being currently engaged in a critical reconsideration of this attitude), relies heavily on the kind of theology about image worship that we met previously. And this idealistic approach to art might have contributed, in turn, to reinforcing this pre-existing theology, now accepted knowledge among the educated elite in India.

Let us turn now to the main topic of this chapter, which bears on the historical reconstruction of the initial developments of temple and image worship. Here, too, we seem often to meet a historicized version of the theological argument. It runs more or less as follows, in two variants. According to one, the generalization of image worship comes from pre-existing popular cults, assimilated and integrated later on into a Brahminic world, which came thus to recognize progressively a new pantheon and to adhere partly to new, popular practices. According to another view, at a certain stage, due to the foresight of "thinkers," Vedic abstract figures came to be put into stone for the sake of a wider, more popular audience.

Max Müller asserted, for instance, that "the worship of idols in India is a secondary formation, a later degeneration of the more primitive worship of ideal gods."[13] With a less idealistic stand, but along the same general line of historical argumentation, G.-D. Sontheimer suggested that "probably the performance of Vedic sacrifices had become too complex and expensive and were eventually symbolic offerings. *Devapūjā*, the worship of deities, the creation of temples, became more favoured by the Brāhman."[14] The same author, in a later study, classified image worship as "folk religion," conceding that "in practice the Brāhman would nevertheless often participate in folk-religion."[15] A partisan of the theory of the foresight of ancient thinkers, Gopinatha Rao asserts, for his part, that "the images of the Hindu gods and goddesses are representations of divine attributes. It is plain that the thought of thinkers is made manifest and concretised by various means, such as speech, pictorial and sculptural representations, and signs, and symbols. All these means have been utilised in the history of humanity for bringing divinity down to the level of the common man and lifting him up gradually to the sublime height of true divine realisation. This is indeed what the seers of India have done."[16]

Whatever the differences between these positions, they all tend to present image and temple worship as "popular" developments conceded (or brought) to the masses by an enlightened elite, a process seen either as a "degradation" of purer cults or as an uplift of the masses. This, of course, cannot but remind us of the theological affirmation that "weak-minded" people cannot do without idols. It recalls, too, an explanatory model commonly held about image worship in early Christianity and early Buddhism, according to which the beginnings of religious iconography originated as a result of an interaction between two broad strata in society, the "elite" and the

"vulgar," and developed more specifically in response to the needs of "the vulgar." This position has been convincingly criticized, first by Peter Brown for Christianity, then by Gregory Schopen for Indian Buddhism, and will be presented with more details in the last part of this chapter.[17] Suffice it to say for now that both authors showed that such beginnings did not result (as the model would have seen it) from an evolution resulting from "concessions" to popular needs, but as a consequence of profound social and mental changes within the religious elite itself.

The purpose of the present discussion is to explore a similar possibility in the case of early Hindu iconography. For this, it is necessary to have a look at what so-called weak-minded human beings effectively do in this *Kaliyuga*.

Invisibility, Divine Presences, and Ritual

We may first notice that even for those who affirm that idols are symbols meant to help humans in their spiritual quest, things are not always so clear. Gopinatha Rao, for one, whom we have seen summing up Hindu religious iconography as a means of progressing towards the true realization of the (formless) divine, can speak at the same time about the *śālagrāma* (the ammonite fossil figuring Viṣṇu's discus) in these terms:

- It is considered a representation of the discus.
- It is "a representative" of the God.
- Some *śālagrāmas* are said to be "very efficacious," granting "all the desires of the worshipper," but defective ones bring "only misery."[18]

In such a statement, the symbolic nature of images seems well forgotten, and the "experience" of the divine, which is said to be the purpose of religious iconography, has to be taken quite literally! As a matter of fact, the belief in the effective presence of deities in their representations is so widely and diversely attested throughout India that there is no point in multiplying examples: nearly all the ritual procedures and the interactions between idol and devotees are based on such an assumption. True, this is a focus of long-standing and intense debate among religious specialists and thinkers (as other chapters in this book underline). For the immense majority of devotees, however, God is altogether (made) present in his images, a

fact that generates a tension between what can be represented and what cannot,[19] and relies on a voluntarily blurred distinction between the object and the deity[20] and the simultaneous presence and absence of the invisible within the tangible.[21]

What needs to be pointed out, as far as India is concerned, is that such a tension has a relevance that extends much further than the particular case of statues of gods and goddesses, the latter constituting, as a matter of fact, a small minority of the tangible supports used for manifesting the divine. This fundamental point will be illustrated through some ethnography. My argument here will be that anthropomorphic figurations of deities do not characterize in any way observable "popular" cults; in fact, it appears that quite the opposite is the case.

If an ethnographer had to rely on books on Indian iconography when studying cults, he would be in for some surprise. Not that such books are not good: indeed, many are excellent. But most of them, by vocation, will limit themselves to "interesting" iconography, that is, to statues, bas-reliefs, or paintings. Fieldwork provides a radically different picture. In the very first festival I witnessed in Kerala, in 1981, it took me some time to understand that the stool, the coconut placed on it, and the sword on its side, around which many temple servants were proceeding to offer worship, were the tangible outdoor figuration of the main deity of the place, goddess Bhadrakāḷi. I was to learn that, far from being exceptional, similar ritual objects for manifesting the divine were the rule (see Figures 2.1-2.9).

Here are a few examples. In a festival observed in 1981 and 1982 in Tiruvanantapuram (Trivandrum), the capital city of Kerala, goddess Bhagavati was represented by two figurations. One was an assemblage consisting of a ritual pot filled with paddy, in which was inserted a cloth bearing the image of the goddess and a metal mirror, all being tightly fixed by a rope to a wooden stool; an iron sword rested against the assemblage. It was installed in a temporary shrine built for the celebrations. The other figuration, in the same shrine, was a wooden painted statue of the goddess with four arms, placed in front of the assemblage and masking it. Devotees faced the statue, but it was the assemblage that was said to be the real support of the goddess's power, which had been ritually infused in it (in fact, many of the elements involved in this assemblage may be separately infused with divine presence in other contexts: the stool, as a throne on which the god or the goddess is invited; the metal mirror or the sword, as a

material "body"). At the end of the ceremonies, the assemblage was also at the centre of a specific ritual outside the shrine, this time without the metal mirror: it figured then the fierce form of Bhagavati, Bhadrakāḷi. A substitute of blood sacrifice was offered to this Bhadrakāḷi and to her army. This army, composed of a multitude of subordinate violent deities and ghosts, was made present by empty palm shrines with bits of banana leaves for placing offerings and by a diagram of 4 x 4 squares made from the stem of a banana tree, in which offerings were also put: in a way, the offerings themselves were the most conspicuous sign of the deities' presence. A few particularly dangerous ghosts did not get any specific place, even temporarily. They were said to be hovering invisibly all around the area, and were placated by bits of offerings thrown up in the air (they were also expected to wander for a few days more on the scene and to "eat" the remains). True, during the festival the devotional attention of people (mostly Nāyars, a local high-ranking caste) was directed towards the wooden "anthropomorphic" statue of Bhagavati, and subsidiary cults to other deities did not evince much interest. But there did not seem to be any difficulty in imagining and giving offerings to a host of presences that remained invisible.[22]

The fact that there is a statue inside the sanctum does not therefore necessarily entail that this statue will be the main recipient of divine power, or that it will be the only way to represent the main deity: many non-anthropomorphic supports might be used as well for that purpose. In addition, subsidiary deities may not get a statue, and many get only a very elementary support, if any at all. These cases are not "strange," isolated cases. They appear to be the rule.

As another example illustrating typical ways of marking divine presences in mid-sized Kerala temples, let us look at a temple in central Travancore whose patrons are high-caste Naṃpūtiri Brahmins and Nāyars. Bhagavati, the main deity, is figured by a stone "anthropomorphic" statue installed in the sanctum. Her violent form, Bhadrakāḷi, is present in a sword, in a metal belt with sleigh bells, and in a pair of bronze anklets. She is incorporated at times by an institutional medium wearing these consecrated objects. She is also asked to reside in temporary colour *maṇḍalas* at festival times. Subsidiary deities and divinized ancestors of this local pantheon are figured by simple pebbles; one god is figured by an iron trident. All are placed outside the shrine proper but within the temple compound. At a distance from the temple, in the middle of paddy fields, a "cock-

mound" is the place where, once a year, low-status Pulayars (a former "untouchable" caste of agricultural labourers) sacrifice cocks to their own dangerous deities and ghosts, which are all figured by packs of stones strewn on the mound, amidst long grown grass cut only at festival time. On the border of the paddy fields, a tree inhabited by a Yakṣi receives a sacrifice at its foot once a year.[23] Such a combination of various ways for figuring and marking the presence of deities is absolutely typical of what can be observed in the majority of Kerala temples, whose patrons are landed castes of locally mid or high status. Moreover, cults addressed to deities made present by a combination of stones and specific trees assembled in a "grove" (kāvu) are widespread at all levels of society in the region.

Up to now, we have seen examples of divine figurations found in "ordinary" temples at the middle and upper levels of society. In the great centres of devotional pilgrimage, many more statues will be noticeable, be they for worship or for "decoration," but there will also always be places for subordinate deities marked only by stones, and some of the divine presences thought to be within the temple compound will remain invisible, with no specific place attributed to them. If we turn now to shrines kept by former untouchable people, we find still less frequent and less elaborate anthropomorphic figurations of deities. When there is a temple, it may harbour movable, small images in metal or wood. But such temples are in fact quite rare. In most cases, ritual will be directed to open-air platforms or altars, where a few pebbles may be fixed: either a stone for each deity or a group of three or four pebbles for a single one. Quite often, there is not even a stone on the platform but only an oil lamp, occasionally lighted. There is thus nothing like an anthropomorphic figuration of the deities worshipped, except that an institutional medium may impersonate the main ones. At festival times, there might be small ritual diagrams drawn on the platforms, on which (or on the side of which) the ritual implements of the medium (weapon, bells, clothes) will be put. Subordinate deities and ghosts will receive worship on rough stones placed directly on the ground. The most dangerous beings might not have any permanent location at all, and will get only an occasional sacrifice on a temporary diagram-cum-altar elaborated specifically for the occasion and destroyed after the sacrifice is over.

These facts are of general relevance not only for Kerala but for the whole of India. Kerala might present peculiarities in the details of performing worship, but the main characteristics that have been

described are found absolutely everywhere: gods can be, and do remain, invisible, "hidden," as it is said in Maharashtra.[24] Most often their "residence" will be marked by a tree or a simple stone, or by various implements. It is only in the case of main cults (and not necessarily in all) that the deity gets a temple. And it is only in some temples that it is figured by an anthropomorphic image.

These facts are indeed already well known, and do not really come as a surprise, even if, by their very nature, the corresponding religious objects (when they exist) would not fill art museums. It appears, however, that they have not been taken seriously enough, and that their implications for the history of image worship have not been fully exposed. A few important consequences may be noted in particular.

We have seen that the theological view under discussion assumes that images are for "weak-minded" people. We have also seen that when translated in the sociological field, this view takes an elitist, Brahminic flavour, by equating caste status and strength of mind: low-status castes are deemed to be "weak-minded" (among other derogatory adjectives) compared with twice-borns. Empirical evidence shows, on the contrary, that the so-called "weak-minded" ones have definitely much less recourse to divine anthropomorphic images than higher castes, and especially than Brahmins. In fact, anthropomorphic figurations seem to occur in a very limited set of circumstances, mostly for some of the main deities among middle- and high-ranking castes. "Weak-minded" people manage very well indeed with invisible beings remaining invisible.

As a matter of fact, the theological view does not fit much better with observed rituals within the Brahminic world itself. First, the various texts followed nowadays for conducting temple worship impose on the priest an impressive work of mental imagining: his own ritual preparation requires that he meditate on the supreme formless God *before* proceeding to imagine him/her "with divisions" (thus in a reverse order of the "pedagogic" steps); then the cult of the image supposes a great number of mental visualizations implying a disjunction between the divine forms and the shape of the physical support (especially, but not only, in the case of an aniconic image like the liṅga; in the case of statues, as well, a given image might represent different deities according to the mantras recited, and the dress, makeup, and external implements used). Second, as Hélène Brunner has shown well, there is no strict correspondence between the complex pantheon mentally and ritually installed and the divine

images concretely found in a temple.[25] Thus, in Brahminic temples, too, invisible beings ritually installed far outnumber (and differ from) physical images: so much for the assertion that statues aim at helping devotees to concentrate on the divine through a direct sight of its forms.

If we consider that when a divine presence has a physical support, the latter is mostly aniconic (whether a liṅga, a simple stone, a tree, a weapon, or any other implement), and it becomes difficult to say that their only function is to "represent" the concerned deity: clearly, they are largely meant to provide a tool for ritual operations. This would apply as well (though in a lesser way) to anthropomorphic figurations for which, in addition to the reciprocal "vision" (darśan) hoped for by devotees, an essential dimension is to "play" with them and to "care" for them. In a word, these are not only images but also, in a crucial way, supports for human manipulations and actions. As Jean-Pierre Vernant remarked for ancient Greece, they are "made for being shown and hidden, taken for a walk and fixed, dressed and undressed, washed. The figure needs ritual for representing divine power and action."[26] The whole matter of "representing" the divine appears therefore in a very different light from the one given by the theology discussed above.

Most supports of the divine, when they do exist, are not "images" in the sense of "imitations." They do not pretend or aim (except in the case of anthropomorphic statues) to create an illusion, a resemblance. Instead, they possess many other simultaneous qualities and purposes: fixing the divine in a place, providing a support for meditation (as a variant of the idealistic stand has it), as well as for mental imagining, for ritual action, for offerings and sacrifices, etc. They do not "show" an image of the divine, however. Paraphrasing Jean Bazin, we may say that they aim less at a *representation* than at an *individuation*, becoming the body around which a space and its corresponding social practices are organized.[27]

Let us recapitulate. The majority of divine beings in India remain invisible, undepicted. In their immense majority, objects signifying the presence of deities are not anthropomorphic statues and do not aim at imitating forms of the divine. Such objects, including anthropomorphic statues, cannot be separated from the ritual actions applied to them. Anthropomorphic statues in temples tend to be found at higher levels of society for higher levels of the pantheon. At all the social levels, the mental imagining of gods overwhelms by far their effective figurations.

A theological affirmation that divine images are necessary for weak-minded people to concentrate on the Absolute is therefore interesting at the theological level, but appears very far from giving any clue to actual observed practice, even among Brahmins. Still, since it is so widely expressed, not only in current-day conversations but also in various texts over a long period of time, we have to try to understand its existence: why was it felt necessary to express such a view? What could have been its purpose? What does it tell us about society and religion in India?

An important hint may be taken from an analysis by Alexis Sanderson of the process of visualization of deities according to the Trika's tantric tradition. The author recalls that there, too, "the forms of the deities in ritual and devotion are merely provisional, to be abandoned at higher levels of practice."[28] He quotes in support the *Vijñānabhairavatantra*, 12: "For [all] these [forms] are strictly for the unenlightened. I have taught them only as a means of setting people on the right path, as a mother uses threats and sweets to influence her children's behaviour."[29] According to Sanderson, commentators in this tradition have discussed "how this gross level of practice, which after all was crucial to the institutional identity and hierarchy of these traditions, could still be seen as an effective means of liberation ... for those incapable of purely cognitive or immediate methods."[30]

The explicit pedagogy attributed to the cult of images appears here to be a contestation of an argument condemning the cult of images as an obstacle in the path of liberation. Within a general debate on the soteriological consequences of (ritual) acts, image worship is said to be a pedagogical device, at least for the "unenlightened." This also provides a means for a commentator like Abhinavagupta to rank various Śaiva cults "according to the degree to which their methods approach ultimate, non-sequential intuition,"[31] even though, in effect, a purely iconless cult seems never to have been realized. As Sanderson writes, "Abhinavagupta's icon-less Anuttara cult never was and never could be a reality in action. His exegesis of the *Parātriṃśikā* is an exercise in translating ritual into pure thought, and ultimately into a metaphorical description of an absolute reality that cannot descend without distortion even into the sequence of ratiocination. The purpose of such writing was no doubt to prescribe an attitude of transcendence to be cultivated while performing rituals."[32]

In this context, the kind of theological view under discussion makes sense as part of a crucial and long-lasting debate pertaining to

soteriology among a religious elite, and specifically among ascetics. It entails, at the same time, a hierarchy within groups, all practising, nevertheless, various forms of image worship. But it does not pretend to be sociology or history, and it does not say that images are symbols: the debate bears only on the proper ritual means for attaining salvation. It seems worth exploring whether such a perspective can shed some light on the possible circumstances of early image worship in India and on its subsequent characterization in idealistic terms.

A Story of Beginnings

An ethnographer is certainly not in the best position to advance hypotheses on developments supposed to have taken place more than two thousand years ago. Still, any historical reconstruction has to take into account a few constraints, and there ethnography might be of some use. For instance, if it is recognized, as I suggest, that today's cults are overwhelmingly non-figurative, especially at "popular" levels, it becomes very difficult to subscribe to any theory that would explain the development of image worship in terms of Brahminic concessions to the masses, such as the following one: "There remains the possibility, important for its effects on the later development of images, that some of the lower strata of the population worshipped images in human or animal form and that this practice gradually spread upwards to other sections of society."[33] As a matter of fact, such a theory would have as a consequence that the "vulgar," once staunch image worshippers, evolved in such a way that they are not image worshippers anymore, as is shown by ethnography. At the same time, an opposite evolution would have led the "other sections of society" to image worship. Such a crisscross seems definitely a most implausible assumption. Of course, comparison with present-day ethnography will never bring certainty. But since the effective popular worship of deities imagined to have "human or animal form" is very seldom made through statues, it makes any bottom-to-top pressure in the past rather unlikely.

Similarly, a variant model that would suggest that Vedic-inspired cults imbibed progressively Dravidian ones, the latter being of course "idolatric,"[34] would meet with the same objections: today's cults in South India (claimed often to have remained a region of "Dravidian culture," whatever the expression might mean) do not exhibit at a popular level any particular emphasis on anthropomorphic image

worship. No archeological evidence substantiates any specific link between ancient inhabitants of the subcontinent and anthropomorphic cults. True, since the time of the Indus civilization, small humanlike figures were known; however, their ritual use has yet to be understood. At any rate, such figures, often not very different from those made today by so-called tribals or low-status castes, for whom they are mostly offerings or ex-votos, do not seem to be in a position to explain image worship in temples, in the sense implied by the theology under discussion. We know next to nothing about ancient non-Vedic cults in India, but it is difficult to see any reason why they should have been necessarily focused on anthropomorphic statues.

These observations are consistent with what others have already noted, and concur, for instance, with Diana L. Eck's statement: "India has ancient traditions of both iconic and aniconic image-making. The terracotta female 'deities' of the Indus Valley, for example, are certainly full-bodied representations of the female form, although it is not clear how they were utilized ritually ... The most ancient non-Vedic cultus of India was almost certainly aniconic. Stones, natural symbols, and earthen mounds signified the presence of a deity long before the iconic images of the great gods came to occupy the *sancta* of temples and shrines. Much of India, especially rural India, still designates its local deities in this way."[35]

The possibility that the origin and early development of image worship in India took place within the Brahminic world itself, or at least within a social elite, has therefore to be taken seriously. As already mentioned, such a hypothesis is akin to (and is inspired by) the analysis formulated by historian Peter Brown concerning the rise of the cult of saints in Latin Christianity.[36] Brown criticizes a widespread frame of explanation, the "two-tiered model," according to which the change in religious attitude, corresponding to the rise of the cult of saints in late antiquity, was the consequence of a "capitulation" of Christian elites before modes of thought limited up to then to "the vulgar."[37] This model relies on a presupposition, namely, that "the views of the potentially enlightened few are thought of as being subject to continuous upward pressure from habitual ways of thinking current among the 'vulgar.'"[38] Brown suggests that this perspective in Western historiography comes directly from Hume's *Natural History of Religion*, and stresses that "the result has been a tendency to explain much of cultural and religious history of late antiquity in terms of drastic 'landslips' in the relation between the elite and the masses. Dramatic

moments of 'democratization of culture' or capitulation to popular needs are held to have brought about a series of 'mutations' of late-antique and early medieval Christianity."[39] According to Brown, such an interpretation in terms of a "dialog" between elite and masses is of poor analytical return, and had better be replaced by an enlarged approach giving importance to localizing new forms of imagination, sensibility, and veneration within a changing set of social and political relations.

Drawing inspiration from this analysis, Gregory Schopen has shown, through a close scrutiny of early inscriptional evidence, that the early image cult in Indian Buddhism did not appear by virtue of a pressure from "the vulgar." According to available documentation, images were the gifts of "learned nuns and monks": "The earliest dated images in the Northwest were the gifts of learned monks ... it was learned monks who introduced images of the Buddha into the monastic cave complexes ... Though images were introduced at different times at different sites they were almost always introduced by the same group: everywhere either monks or nuns. It would appear that the image and its attendant cult were a major preoccupation of nuns and monks; that they everywhere introduced the cult and everywhere disproportionately supported it."[40] Schopen concludes therefore that "changes in cult practice came from, and were supported by, learned 'ascetic circles.'"[41]

Whatever might have been the exact interactions between early Buddhist image worship and the "Hindu" one (they are usually believed to have been quite close, or that the latter took shape in the steps of the former), there is no reason to suppose that the dynamics of their development should be in one case the obverse of the other. If Schopen is not misled, the evidence he uses and the conclusions he draws would point towards a development of "Hindu" iconography within a Brahminized social elite too, if not among ascetic circles.

It is usual, and certainly partly true, to explain the development of image worship as being rooted in a new mental disposition taking shape in the late Vedic age, as early as the seventh century BC. This period, marked by a kind of religious "ebullition" (mostly in the Ganges basin), saw, for instance, the birth and expansion of Buddhism, Jainism, the Ajivika movement, and the progressive elaboration of what would be later recognized as Brahminic "Hinduism." These developments are usually thought to be linked to the expansion of agriculture and the emergence of new rural and urban elites and of new forms of political centralization. Among other characteristics, the

religious activities of the period had in common that they all differed from the logic operating in Vedic rituals by proposing new perspectives on salvation and a pronounced personalization of the relationship between worshipper and deities. This personalized relationship has been characterized as an attitude of devotion including interaction with a god made easily accessible (in the contemporary context, it has been noted, for instance, that "the more the desire to draw nearer to God, the more the image is anthropomorphic").[42] Such evolutions in mentality are clearly perceptible in the late Vedic literature, especially in the *Upaniṣads*, where man is definitely in a new individual and internalized relation to the cosmos and to the Absolute as compared with his place as an element in the older world of sacrifice.

This could well have been the general context in which image worship developed. But devotion, *bhakti*, might not be the sole answer to the problem, since it evolved and reached the forms we know today *through* the very development of image worship. We should therefore be cautious not to project in ancient times forms of devotion evolved in later cults. I would suggest that *bhakti* was not necessarily the only, or the main, force behind early image worship, and that at least a few other factors should be considered.

Possibly the first to mention explicitly such a cult, Pāṇini (fourth century BC) says that one worships the images for his maintenance.[43] Similar perspectives are reasserted time and again in many later texts. For instance, according to Varāhamihira's *Bṛhat Saṃhitā* (sixth century AD), "an image, made of wood or clay, confers longevity, prosperity, strength and victory; one made of precious stones leads to the weal of the world; one of gold bestows health or growth; one of silver, fame; one of copper, increase or prosperity, of children; and an idol or Emblem of Śiva made of stone, influx of landed property."[44] On the contrary, if damaged, the image brings destruction.[45] For Abhinavagupta (eleventh century AD), the details of iconographic visualizations of gods and goddesses are of special relevance for those who are performing desiderative rites.[46] And according to the Śaiva Āgamas studied by Hélène Brunner, "the cult is not a gratuitous act of worship. Whether executed by a private adept, in the solitude of any shelter, or by a priest officiating in a temple in the name of a human group more or less large, the cult aims at obtaining from the deity a favour, or a set of favours, perfectly well-defined and generally of a mundane order."[47]

Such attitudes still prevail today. An astrologer I met in Kerala in

1999, after regaling me with the usual pedagogic function of the idol, asserted that "God is considered as man [in his image] in order to make him work for the devotees." Obviously, if devotional feeling was, and is, important in image worship, a very pragmatic dimension has also been crucial since early times, and remains so today. The image, even anthropomorphic, cannot be separated from the ritual practised on it or with it, as well as from the material interests of the devotees. In this respect, in the first stages of its development, image worship might have shared with the former Vedic sacrifice a contrast with the ascetic search for liberation from the cycle of rebirths. The relationship between Vedic rites and temple rites poses its own problems, and has been widely debated in Brahminic circles.[48] But we should ponder whether image worship at its beginnings, in a new set of perceived relationships between man and cosmos, and in the context of speculations on the soteriological consequences of actions, was not felt like the sacrifice to be opposed to the pursuit of the Absolute because it was seen, fundamentally, as a *mundane* activity.

That images were not only meant to be seen but were also there to do things with, and to have things done through them, would accord better not only with observed practice but also with their relative theological devaluation in ancient times. The worship done for mundane results could not but be seen as alienating, keeping one in the bonds of successive rebirths: indeed a proof of "weak-mindedness" for ascetic-minded people, but still necessary. As Sanderson remarked, this was a good way to introduce a hierarchy of practices as well as of those who followed them. Paradoxically, then, the human-centred religious world of the late Vedic period and its visions of transcendence among new social elites can be seen as the crucible out of which both image worship and the development of asceticism have arisen, in a dialectic implying the concomitant depreciation of the former along with an admission of its usefulness.

It is commonly recognized that a private form of image worship preceded the public one in temples. Such an evolution may have had important consequences for the nature of the attitudes involved, and especially for the visual dimension of the cult. To again use Vernant's words, in a public temple the image, like the temple itself, "bears a character of full publicity." The house of god is no longer closed on a family or lineage but "open to the exterior, turned to the public." Vernant writes: "Stopping from being anymore a privilege for the one in whose house he comes to reside, the god reveals his presence in a

directly visible way to the sight of everybody: under the City's gaze, he becomes form and spectacle ... Of the statue, we could say that all its *'esse'* consists in a *'percipi'*, all its 'being' in a 'being perceived.' It has no other reality than its appearance, no other ritual function than to be seen ... Freed from ritual and placed under the impersonal gaze of the City, the divine symbol has transformed itself in an 'image' of the god."[49]

Indian images in temples have not become "freed from ritual." But the suggestion that by becoming public their visual dimension has acquired a new importance seems illuminating for explaining the development of the fundamental notion of *darśan*, "vision" (and for the development of narrative iconography in sculptures as well, from a very early stage). This visual dimension, as I have just argued, was probably less at the heart of private worship, and therefore not necessarily involved in the introduction of anthropomorphic figures in the manner an explanation in terms of *bhakti* alone might suggest. But the development of temples may be seen to have provoked by itself a decisive shift in the way statues were considered, by putting a special emphasis on the visual interaction with devotees. Certainly, today's observations point towards a close connection between the construction of temples (as contrasted with open-air altars) and the tendency to use anthropomorphic statues of the divine.

Vernant's remarks also call attention to the social and political settings of such transformations. Public temples, and the statues therein, have been constructed in India through donations, and their various rituals have been initiated and supported through endowments. As Appadurai and Breckenridge observed for South Indian temples in modern times, this endowment basis of the temples' existence and development has had profound repercussions on public life, generating a complex system of economic redistribution, dispensing social prestige, and testifying to social power.[50] This is certainly linked to a dimension of "popularization," in the sense that their expansion has relied on their capacity to mobilize social forces outside the Brahminic fold. But this is a very relative popularization, since donors have been for long (and are still largely) a social elite, kings, chieftains, merchants, and rural and urban notables. Clearly, it cannot be in any way conceived of as a concession to "the vulgar."

Conclusion

To conclude, let me recall the limits of the present exercise and the sequence of arguments. We were first faced with a theological view according to which images are necessary as a pedagogical device for "weak-minded" people. This could be interpreted as meaning either all humans in the *Kaliyuga* or a section of society only, let us say "the vulgar." In this second interpretation, the theological view becomes a sociological and historical view. A second step has been to suggest that many academics, in the fields of art history and ancient history, seemed to hold views similar in content to the preceding one: images are symbols, and their origin should be ascribed to concessions to "the vulgar." At this point, the chapter has become an exercise in *constraints*, ethnography being used to state which requirements any historical explanation would have to satisfy: contrary to the above views, low-status castes use many different objects for making the divine present among them but seldom use images as such (and there will often be no figuration at all); conversely, anthropomorphic statues will be found mostly in temples whose patrons are middle- and high-status castes. A model that would place "the vulgar" at the origins of image worship seems implausible, therefore. What follows, in the last section of this chapter, should be taken as a tentative demonstration that alternative models are *possible*. Some suggestions reproduce already well-known interpretations, others are indeed conjectural. But should the hypotheses put forward prove wrong, any other set will nevertheless have to accord with the constraints put into evidence.

Thus, the theological proposition that "idols are made for the weak-minded as a first step for grasping the Absolute" should not be allowed to bear in any way on historical reconstructions. Instead, there is the need to replace the fragmentary archeological and textual evidence that we have in the context of what can be surmised of the economic and political transformations of ancient society, and particularly in the context of the intellectual and religious developments that took place among the elites of the period.

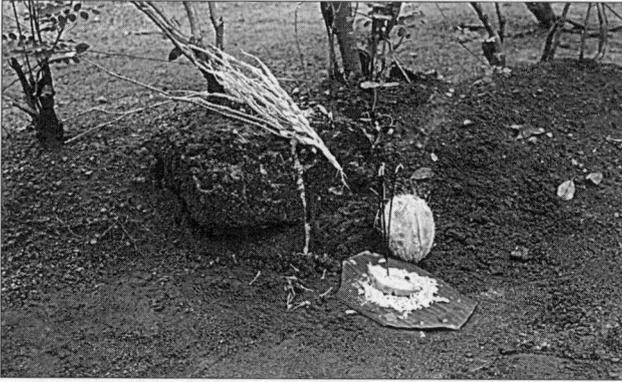

Figure 2.1.
Block of laterite
for Serpent-Gods'
cult (Central
Kerala, former
"untouchable"
caste).

Figure 2.2.
Altar for
Bhadrakāḷi (left
side in the
photo) and an
ancestor (right
side) (Central
Kerala, former
"untouchable"
caste).

Figure 2.3.
Liṅga as goddess
Bhūvanēśvari
(Central Kerala,
toddy-tappers
caste).

Figure 2.4.
Bhairava as
guardian deity
(Śrī Śantadurgā
temple, Kavalem,
Goa).

Figure 2.5. Altar for a male
god (Central Kerala, former
"untouchable" caste).

Figure 2.6. Sword as
Bhadrakāḷi (South Kerala,
Sarkara temple).

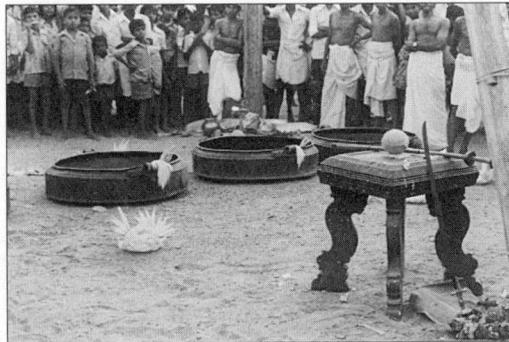

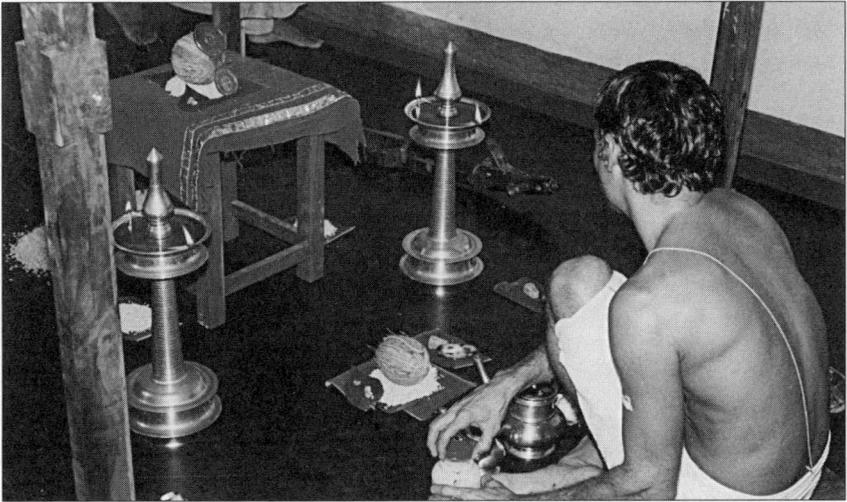

Figure 2.7.
Metal mirror as Bhagavati (on the coconut placed on the stool); the officiant
is a Brahmin (Central Kerala).

Figures 2.8-2.9.
Worship on small *maṇḍala* (Central Kerala, former "untouchable" caste).

Acknowledgements

I wish to express my thanks for their remarks to the participants of the conference on "Images in Asian Religions: Texts and Contexts," held in Hamilton and Toronto in May 2001 at the initiative of Phyllis Granoff and Koichi Shinohara, whose warm hospitality was a decisive factor in the congenial and stimulating atmosphere of the discussions. I feel particularly indebted to Daniela Berti, Robert Brown, Gérard Colas, and Phyllis Granoff for their thorough and informed reading of a preliminary version of this chapter. I am also grateful to the anonymous reader of UBC Press for a careful reading and for suggesting a few valuable additional references.

End Notes

1 Twice-borns do not always have the chance to be distinguished from "those without intelligence." For instance, according to the *Vāstusūtra Upaniṣad* studied by Bettina Bäumer, "the ritual which is pure is the one which confers liberation: in the case of Brahmins this is sacrifice, and for the three other classes image worship." See Bettina Bäumer, "L'image divine, sa raison d'être et son effet selon la Vāstusūtra Upaniṣad," in *L'image divine: Culte et méditation dans l'Hindouisme,* ed. André Padoux (Paris: CNRS éditions, 1990), 146. The translation into English, here as in further instances, is mine.

2 Compare with M.-J. Mondzain's analysis of "idol" as a categorization of the way an image is looked at, as a "distinction in the imaginary relationship with invisibility": the idol, according to her, can be defined as "an image that has to be killed." See Marie-José Mondzain, *Image, icône, économie: Les sources byzantines de l'imaginaire contemporain* (Paris: Éditions du Seuil, 1996), 227-28. Although the author studies a much different context, the development of icons in Byzantium, this could apply to some extent to the "theological view" expressed at the beginning, but certainly not, I would argue, to most of actual practice in India.

3 *Yoga Vāsiṣṭha,* VIa.30.5, quoted in François Chenet, "L'Hindouisme, mystique des images ou traversée de l'image?" in *L'image divine,* ed. Padoux, 161.

4 Catherine Clémentin-Ojha, "Image animée, image vivante: L'Image du culte hindou," *L'image divine,* ed. Padoux, 118 n. 6.

5 Ibid., 121.

6 Ravi Varma, "Rituals of Worship," in *The Cultural Heritage of India*, 4: 453, quoted in Clémentin-Ojha, "Image animée, image vivante," 115 n. 2.

7 B.C. Bhattacharya, *Indian Images: The Brāhmanic Iconography, Based on Genetic, Comparative and Synthetic Principles* (1921; reprint ed., New Delhi: Cosmo Publications, 1978), xviii.

8 Alain Daniélou, *Le polythéisme hindou* (Paris: Buchet-Chastel, 1975), 542.

9 Benjamin Rowland, *The Art and Architecture of India: Buddhist, Hindu, Jain*. The Pelican History of Art (1953; new ed., London: Penguin Books, 1970), 28.

10 T.A. Gopinatha Rao, *Elements of Hindu Iconography*, 2 vols. (1914; reprint ed., Delhi: Indological Book House, 1971), 1: 26.

11 Partha Mitter, *Much Maligned Monsters: A History of European Reactions to Indian Art* (1977; new ed., Chicago: University of Chicago Press, 1992); Catherine Weinberger-Thomas, "Le crépuscule des dieux: regards sur le polythéisme hindou et l'athéisme bouddhique (XVIIe-XIXe siècle)," *History and Anthropology* 3 (1987). The opposition between an enlightened Indian elite rejecting the cult of idols, and other people, was already explicit in European texts of the eighteenth century. See Sylvia Murr, "Indianisme et militantisme protestant. Veyssière de la Croze et son *Histoire du Christianisme des Indes*," *Dix-huitième siècle* 18 (1986): 309.

12 Parul Dave Mukherji, "The Career of a Classical Aesthetic Text: The *Citra Sutra* in Modern India," communication presented at the International Conference on "The Politics of Authenticity: The Case of Visual Modern Arts in India," Paris, 7-9 February 2001.

13 Quoted in Gopinatha Rao, *Hindu Iconography*, 1: 4. Compare with: "It may well be asked how it came to pass that Hinduism, Buddhism, and Jainism alike became 'idolatrous' religions. The answer to this question was admirably expressed by Jacobi over forty years ago: 'I believe that this worship had nothing to do with original Buddhism or Jainism, that it did not originate with the monks, but with the lay community, when the people in general felt the want of a higher cult than that of their rude deities and demons.'" A.K. Coomaraswamy, "The Origin of the Buddha Image," *Art Bulletin* 9 (1927): 297, quoted in Gregory Schopen, "On Monks, Nuns and 'Vulgar' Practices: The Introduction of the Image Cult into Indian Buddhism," *Artibus Asiae* 49, nos. 1-2 (1989): 154. For a critical historiography of the question, see Ronald Inden, *Imagining India* (Oxford: Basil Blackwell, 1990), ch. 3.

14 Günther-D. Sontheimer, "Religious Endowments in India: The Juristic Personality of Hindu Deities," *Zeitschrift für Vergleichende Rechtswissenschaft* 87 (1964): 45.

15 Günther-D. Sontheimer, "Hinduism: The Five Components and Their

Interaction," in *Hinduism Reconsidered*, ed. G.-D. Sontheimer and H. Kulke (Delhi: Manohar, 1989), 204.

16 Gopinatha Rao, *Hindu Iconography*, 1: 27.

17 Peter Brown, *The Cult of Saints: Its Rise and Function in Latin Christianity* (Chicago: University of Chicago Press, 1981); Schopen, "Monks, Nuns and 'Vulgar' Practices."

18 Gopinatha Rao, *Hindu Iconography*, 1: 10-11.

19 Chenet, "L'Hindouisme."

20 Clémentin-Ojha, "Image animée."

21 This formulation draws on Jean-Pierre Vernant, "De la présentification de l'invisible à l'imitation de l'apparence," in *Mythe et pensée chez les Grecs: Etudes de psychologie historique*, rev. and augm. ed. (Paris: La Découverte, 1985).

22 A detailed ethnography of this festival is provided in Gilles Tarabout, *Sacrifier et donner à voir en pays malabar: Les fêtes de temple au Kérala (Inde du Sud), approche anthropologique* (Paris: École Française d'Extrême–Orient, 1986), ch. 3.

23 Ibid., ch. 6.

24 Bernard Delfendahl, "Les dieux dans les champs d'un village du Maharashtra (Inde): Essai d'ethnographie religieuse," PhD dissertation, École des Hautes Études en Science Sociales, 1968, 106.

25 Hélène Brunner, "L'image divine dans le culte āgamique de śiva: Rapport entre l'image mentale et le support concret du culte," in *L'image divine*, ed. Padoux, 18-19. On the mental visualizations that the temple priest has to perform for worshipping images, see also Gérard Colas, "Le yoga de l'officiant vaikhānasa," *Journal Asiatique* 276 (1988); André Padoux, "Image mentale, méditation et culte dans la Śrīvidyā (Quelques exemples tirés du Yoginīhṛdaya)," in *L'image divine*, ed. Padoux.

26 Jean-Pierre Vernant, "De la présentification de l'invisible à l'imitation de l'apparence," in *Mythe et pensée*, 344.

27 Jean Bazin, "Retour aux choses-dieux," in *Corps des dieux*, ed. Charles Malamoud and Jean-Pierre Vernant, Le temps de la réflexion 6 (Paris: Gallimard, 1986), 264.

28 Alexis Sanderson, "The Visualization of the Deities of the Trika," in *L'image divine*, ed. Padoux, 74.

29 Ibid., 75.

30 Ibid., 77.

31 Ibid., 78.

32 Ibid., 82.

33 A.G. Mitchell, *Hindu Gods and Goddesses* (London: Her Majesty's Stationery Office, 1982), v.

34 See particularly Inden, *Imagining India*, 119-21.
35 Diana L. Eck, *Darśan: Seeing the Divine in India*, 2nd enlarged ed.
 (Chambersburg, PA: Anima Books, 1985), 32-33.
36 Brown, *Cult of Saints*.
37 Ibid., 16-17.
38 Ibid., 17.
39 Ibid., 17-18.
40 Schopen, "Monks, Nuns and 'Vulgar' Practices," 166.
41 Ibid., 167.
42 Clémentin-Ojha, "Image animée," 132.
43 N.R. Bhatt, "Development of Temple Rituals in India," in *Śiva Temple and
 Temple Rituals*, ed. S.S. Janaki (Madras: Kuppuswami Sastri Research
 Institute, 1988), 33.
44 Varāhamihira, *Bṛhat Saṃhitā*, ed. and trans. M. Ramakrishna Bhat, 2
 vols., 2nd rev. ed. (New Delhi: Motilal Banarsidass, 1987), 2: 568-69 (ch.
 60, 4-5).
45 Ibid., 569 (ch. 60, 6).
46 Sanderson, "Visualization of the Deities," 67-68.
47 Brunner, "L'image divine," 13.
48 I am of course aware of the very strong opposition voiced for centuries
 by orthodox Brahmin circles against image service in temples, which is
 often taken by scholars as proof of the non-Brahmin origin of image
 worship. In line with my argument, I would submit that Brahmins did
 not necessarily present a homogeneous front in that respect. This was
 pointed out, for instance, by Ronald Inden, "Changes in the Vedic
 Priesthood," in *Ritual, State and History in South Asia: Essays in Honour of
 J.C. Heesterman*, ed. A.W. Van den Hoek, D.H.A. Kolff, and M.S. Oort
 (Leiden: E.J. Brill, 1992), and by Heinrich von Stietencron, "Orthodox
 Attitudes towards Temple Service and Image Worship in Ancient India,"
 Central Asiatic Journal 21, no. 2 (1977). The latter, specifically, underlines
 that "the reasons for the controversy can certainly not be reduced to a
 caste conflict. It was not merely a question of defence of Brāhmanic
 privileges against a new group of religious specialists rising from lower
 strata of society. The texts rather suggest that the conflict was mainly
 within the Brāhman class" (126).
49 Vernant, "Présentification de l'invisible," 347.
50 Arjun Appadurai and Carol Breckenridge, "The South Indian Temple:
 Authority, Honour and Redistribution," *Contributions to Indian Sociology*,
 n.s. 10, no. 2 (1976). See also Burton Stein, "Temples in Tamil Country,
 1300-1750 A.D.," *Indian Economic and Social History Review* 14, no. 1
 (1977), where the author shows how temples in Tamil Nadu were

crucial stakes in the competition for landed dominance among Tamil landed groups.

Bibliography

Appadurai, Arjun, and Carol Breckenridge. "The South Indian Temple: Authority, Honour and Redistribution." *Contributions to Indian Sociology*, n.s. 10, no. 2 (1976): 187-211.

Bäumer, Bettina. "L'image divine, sa raison d'être et son effet selon la Vāstusūtra Upaniṣad." Pp. 143-49 in *L'image divine: Culte et méditation dans l'Hindouisme*, edited by André Padoux. Paris: CNRS, 1990.

Bazin, Jean. "Retour aux choses-dieux." Pp. 253-73 in *Corps des dieux*, edited by Charles Malamoud and Jean-Pierre Vernant. Le temps de la réflexion 6. Paris: Gallimard, 1986.

Bhatt, N.R. "Development of Temple Rituals in India." Pp. 24-45 in *Śiva Temple and Temple Rituals*, edited by S.S. Janaki. Madras: Kuppuswami Sastri Research Institute, 1988.

Bhattacharya, B.C. *Indian Images: The Brāhmanic Iconography, Based on Genetic, Comparative and Synthetic Principles*. 1921. Reprint. New Delhi: Cosmo Publications, 1978.

Brown, Peter. *The Cult of Saints: Its Rise and Function in Latin Christianity*. Chicago: University of Chicago Press, 1981.

Brunner, Hélène. "L'image divine dans le culte āgamique de Śiva: Rapport entre l'image mentale et le support concret du culte." Pp. 9-29 in *L'image divine: Culte et méditation dans l'Hindouisme*, edited by André Padoux. Paris: CNRS, 1990.

Chenet, François. "L'Hindouisme, mystique des images ou traversée de l'image?" Pp. 151-68 in *L'image divine: Culte et méditation dans l'Hindouisme*, edited by André Padoux. Paris: CNRS, 1990.

Clémentin-Ojha, Catherine. "Image animée, image vivante: L'image du culte hindou." Pp. 115-32 in *L'image divine: Culte et méditation dans l'Hindouisme*, edited by André Padoux. Paris: CNRS, 1990.

Colas, Gérard. "Le yoga de l'officiant vaikhānasa." *Journal Asiatique* 276 (1988): 245-83.

Daniélou, Alain. *Le polythéisme hindou*. Paris: Buchet-Chastel, 1975.

Dave Mukherji, Parul. "The Career of a Classical Aesthetic Text, the *Citra Sutra* in Modern India." Paper read at the International Conference on "The Politics of Authenticity: The Case of Visual Modern Arts in India," Paris, 7-9 February 2001.

Delfendahl, Bernard. "Les dieux dans les champs d'un village du Maharashtra (Inde): Essai d'ethnographie religieuse." PhD dissertation, École des Hautes Études en Science Sociales, Paris, 1968.

Eck, Diana L. *Darśan: Seeing the Divine in India*. 2nd enlarged ed. Chambersburg, PA: Anima Books, 1985.

Gopinatha Rao, T.A. *Elements of Hindu Iconography*, 2 vols. 1914. Reprint. Delhi: Indological Book House, 1971.

Inden, Ronald. *Imagining India*. Oxford: Basil Blackwell, 1990.

–. "Changes in the Vedic Priesthood." Pp. 556-77 in *Ritual, State and History in South Asia: Essays in Honour of J.C. Heesterman*, edited by A.W. Van den Hoek, D.H.A. Kolff, and M.S. Oort. Leiden: E.J. Brill, 1992.

Mitchell, A.G. *Hindu Gods and Goddesses*. London: Her Majesty's Stationery Office, 1982.

Mitter, Partha. *Much Maligned Monsters: A History of European Reactions to Indian Art*. 1977. Rev. ed. Chicago: University of Chicago Press, 1992.

Mondzain, Marie-José. *Image, icône, économie: Les sources byzantines de l'imaginaire contemporain*. Paris: Seuil, 1996.

Murr, Sylvia. "Indianisme et militantisme protestant: Veyssière de la Croze et son *Histoire du Christianisme des Indes*." *Dix-huitième siècle* 18 (1986): 303-23.

Padoux, André. "Image mentale, méditation et culte dans la Śrīvidyā (Quelques exemples tirés du Yoginīhṛdaya)." Pp. 89-98 in *L'image divine: Culte et méditation dans l'Hindouisme*, edited by André Padoux. Paris: CNRS, 1990.

Rowland, Benjamin. *The Art and Architecture of India: Buddhist, Hindu, Jain*. The Pelican History of Art. London: Penguin Books, 1970.

Sanderson, Alexis. "The Visualization of the Deities of the Trika." Pp. 31-88 in *L'image divine: Culte et méditation dans l'Hindouisme*, edited by André Padoux. Paris: CNRS, 1990.

Schopen, Gregory. "On Monks, Nuns and 'Vulgar' Practices: The Introduction of the Image Cult into Indian Buddhism." *Artibus Asiae* 49 (1989): 153-68.

Sontheimer, Günther-D. "Religious Endowments in India: The Juristic Personality of Hindu Deities." *Zeitschrift für Vergleichende Rechtswissenschaft* 1 (1964): 45-100.

–. "Hinduism: The Five Components and Their Interaction." Pp. 197-212 in *Hinduism Reconsidered*, edited by Günther-D. Sontheimer and Herman Kulke. Delhi: Manohar, 1989.

Stein, Burton. "Temples in Tamil Country, 1300-1750 A.D." *Indian Economic and Social History Review* 14, no. 1 (1977): 11-45.

Stietencron, Heinrich von. "Orthodox Attitudes towards Temple Service and Image Worship in Ancient India." *Central Asiatic Journal* 21, no. 2 (1977): 126-38.

Tarabout, Gilles. *Sacrifier et donner à voir en pays malabar: Les fêtes de temple au Kérala (Inde du Sud), approche anthropologique.* Paris: École Française d'Extrême-Orient, 1986.

Varāhamihira. *Bṛhat Saṃhitā.* Edited and translated by M. Ramakrishna Bhat. 2 vols. 2nd rev. ed. New Delhi: Motilal Banarsidass, 1987.

Vernant, Jean-Pierre. "De la présentification de l'invisible à l'imitation de l'apparence." Pp. 339-51 in *Mythe et pensée chez les Grecs: Etudes de psychologie historique.* Rev. and augm. ed. Paris: La Découverte, 1985.

Weinberger-Thomas, Catherine. "Le crépuscule des dieux: regards sur le polythéisme hindou et l'athéisme bouddhique (XVIIe-XIXe siècle)." *History and Anthropology* 3 (1987): 149-76.

3

Of Metal and Cloths:
The Location of Distinctive Features in
Divine Iconography (Indian Himalayas)

DANIELA BERTI

Les nobles sont groupés autour du trône comme un ornement et disent à celui qui y prend place ce qu'il est.[1]

– E. Le Roy-Ladurie, L'Etat royal, 1987

In most Hindu temples in contemporary India, the statue of the deity to which the cult is offered can be seen undressed, without any ornamentation, only when the deity is awakened in the morning to be washed, beautified by makeup, dressed, and embellished with jewellery and flowers. Such a preparation will sometimes be concealed from the devotees' sight by drawing the curtains of the sanctum, so that the deity may be "seen" only when completely ready – often almost invisible under cloths, jewellery, and colourful garlands. For instance, during the Rām Sītā cult in the royal temple of Sultanpur in Kullu (Himachal Pradesh), the statue of the goddess Sītā can be seen by devotees only during the morning worship, when the priest has to wash the image before dressing it; once the priest has finished her makeup she is completely wrapped up in her sari and covered by pearl necklaces (Figure 3.1). Her husband, the god Raghunāth, to whom the temple is dedicated, is also presented to devotees completely submerged under flowers. In fact, nearly every ritual image, even

Figure 3.1. The god Raghunāth and, on his left, the goddess Sītā, completely wrapped up in her sārī, seated on the throne after the daily cult (Kullu).

aniconic (such as the diagrams drawn by Brahmin priests at the time of fire oblations), is often completely hidden by cloths or flowers.

References to this peculiar way of honouring the deity and of presenting it to devotees are found in Sanskrit literature. According to texts on Hindu iconography, the beauty of an image depends on the choice of the material or on the respect for canonical proportions, and is a crucial element in fostering the deity's desire to enter a statue and inhabit it.[2] In addition, the care with which the image is prepared and made beautiful is a central phase of the daily worship, detailed in ancient texts as well as in modern manuals of rituals.[3] At the end of the preparation of the deities, the customary act of making them look at themselves in a mirror also suggests that the deity must check and appreciate the work done by the priest.

In cults performed in contemporary India, the idea of beauty appears to be especially related to the important Hindu notion of *darśan* (seeing), implying the auspiciousness of seeing the god's image and of being seen by it. As D.L. Eck wrote, Hindus go to the temple to see the image of the deity "especially at those times of day when the image is most beautifully adorned with fresh flowers and when the curtain is drawn back so that the image is fully visible."[4] Gérard Colas, in his study of

Vaiṣṇava temple images, both in texts and in contemporary Tamil Nadu practice, has pointed out that their beauty is one of the means "to seduce the devotee and to stimulate his devotion."[5] He notes also that the beauty of an image is in direct relation to its celebrity, which means also its power (śakti) – all notions that will be discussed in this chapter.

In spite of these considerations, whenever we deal with a given temple statue, even if the elements of its decoration seem to be essential to the worship, divine presence and power are mostly concentrated in the consecrated image itself. By contrast, in the case I would like to discuss here, the localization of the deity's presence is much more ambiguous, and the representation of a deity cannot be said to be concentrated in a single figure, such as a statue or a symbolic object: it is composed of different elements assembled together. This is particularly the case for some mobile representations of village gods in the Kullu valley: they consist of wooden palanquins on which are affixed many metal faces (mohrā) figuring the deity concerned (and sometimes its attendants), and which are "decorated" with many other items – cloths, jewellery, "hair," and so on.

The problem that this kind of representation poses to a study of ritual iconography is that, in this case, the divine presence does not seem to be concentrated in a unique object (for instance, the mohrā), but is delocalized and distributed throughout the various components – the wooden frame, the mohrā, as well as the other items with which the palanquin is prepared. This differs from palanquins and chariots elsewhere in India, in which a figure of the deity, concentrating in it all the divine power, is put on a mobile support. Here, by contrast, the deity's power is present in the whole assemblage of the representation. The assemblage is the deity.

The palanquins we are going to consider are built according to a general standardized model over a large area. Such a structural standardization does not preclude the possibility that village people may immediately recognize a deity's identity when looking at the palanquin. We will therefore also have to examine how a deity is iconographically constructed so that it may be identified at first glance.

Village Gods' Iconography

The village gods and goddesses in the Kullu valley are called devī-devtā, literally, "goddess-god." Devī-devtā is a large category of deities that have a temple in the village and are linked to a specific territory over

which they exercise their influence. This area may cover one village as well as a group of villages.[6] *Devī-devtā* have their cult organized in a characteristic way, relying on the intervention of various functionaries – priest, medium, administrator, musicians; besides the main temple image, fixed and immovable, there exist various mobile figurations including the one I will analyze: the palanquin.

Some local intellectuals have published booklets intended to create a repertoire of the *devī-devtā* for different districts.[7] Each deity is depicted on a page organized on the model of an identity card, with a photo of the deity's palanquin at the top and various short factual statements on the side or below, under standardized headings: name of village or jurisdiction, names of temple functionaries, description of palanquin, and so on, and, under the heading "other information," specific powers or competences (Figure 3.2). For example, Bālākāmeśvar is characterized as "god of rain, frees from diseases";[8] Dharaks "gives a son, takes out malevolent spirits *(bhūt)*, takes the animal sacrifice during *Navarātrī* ["nine nights," a festival]; people go to him on Monday, Friday and Sunday in order to ask questions to prevent their sufferings."[9] And so on.

Devī-devtā have three different ways to be present among villagers.

Figure 3.2. Some "identity cards" of village gods and goddesses published in the *Mandi dev milan.*

Inside the temple, the deity is in the form of a *mūrti* (a statue, a stele, a metal face, or a *piṇḍā*).[10] Although the *mūrti* can be one important element contributing to the fame of a temple, this representation is not the one that is closest to the villagers. In fact, in most temples villagers do not even have the right to go inside and have the *darśan* of the *mūrti* (the possibility to see – and to be seen by – the deity). Low-caste villagers do not enter the temple, and in many places women, even of high-caste status, will not enter the inner room where the *mūrti* is. Thus, apart from a small percentage of high-caste men, most villagers will never go in front of the *mūrti* and will never interact with it in a particular expression of devotion that privileges an individualistic and intimate interaction with the deity. Moreover, the *mūrti* is almost unknown to people who come from other villages. Outsiders will know the deity only through the medium and/or the palanquin that is taken out during village festivals.

Another way for a *devī-devtā* to be present among its devotees is to manifest itself in a medium, locally called *gur*. The *gur* is said to be the human receptacle of the deity through whom the deity communicates with the villagers. Seances are regularly held at the temple, where villagers ask the deity about their problems or about decisions that need to be taken at the village or individual level. The *gur* at the moment of possession, when he is the deity, can assume some iconic aspects. For instance, the *gur* of goddess Kālī may open his ("her") mouth wide and pull out his ("her") tongue, a clear sign of the divine incarnation: the spectators say, "This is Kālī!" or "Kālī has come!" and then perform some gestures of devotion. The kind of devotion this particular manifestation of the deity provokes is not exactly the same as the one shown during the *darśan* of the *mūrti*, however. This is due to the fact that the devotional attitude in front of the *gur* is mixed with the high expectations villagers have vis-à-vis the deity they consult: the gestures of devotion are associated here with a direct and lively dialogue, displaying contrasting and intense feelings that do not usually emerge in front of the statue. Besides, seances are public and often take the form of a general debate, people talking among themselves and at times addressing the deity.

A third way for village deities to be present is in the form of what is locally called *pālkī* (palanquin) or *rath* (literally "chariot," but it is a palanquin). This is a wooden frame, with four legs for placing it on the ground and two long poles for carrying it on the shoulders. The frame supports metal faces, called *mohrā*, and various "decorative items"

such as umbrellas, sceptres, brocaded silk and cotton cloths, jewellery, flowers, yak hairs, garlands, sometimes "ritual money," and other "ornaments." The words *pālkī* and *rath* refer not only to the frame but to the whole assemblage.

I will first analyze what I will call the "ritual identity" of such palanquins, an identity based on the way in which the various components of the representation – particularly the frame and the *mohrā* – are made and consecrated. I will then turn to what might be termed its "social identity," which has to do with the choice and disposition of the various components that build up a distinctive visual individuality for each of the hundreds of *devī-devtā* of the region.

The Wooden Body of the Deity

The wooden frame is not just a support. It is, in itself, a receptacle of the particular power of the deity for which it has been constructed. The decision to build a *rath*, or to replace an old one, is not a decision that villagers take without consulting the deity itself through its medium, the *gur;* alternatively, the deity might express directly during a seance the wish to have a new *rath*. In both cases, the deity will be also consulted in order to decide all the procedure's details.[11]

I will briefly describe the procedures of construction in order to show how, by the very fact that these procedures are said to be established and controlled by the deity itself, the divine power is already installed at this stage in the wooden frame, even before a subsequent Brahminic ritual of installation *(pratiṣṭhā)*, commonly used in India to install divine power in images,[12] takes place.

The god or the goddess, through the *gur*, first has to indicate from where the wood has to be selected. He/she will then name the woodcutters and the person whose axe will be the first to cut into the selected tree, name the carpenters who will work afterwards, indicate how many animals need to be sacrificed, fix the day on which the work has to start, decide the various timings of the operations, and so on.[13]

At the end of the consultation, the men selected to do the work will receive consecrated herbs from the temple and will be blessed by the *gur* with the deity's bell upon their shoulders. On a chosen day, the *gur* will incarnate the deity and, blindfolded with a bandage on his eyes, will run and touch a tree, showing it to be the selected one. The woodcutters, after purifying themselves with a bath in holy water, wearing silk turbans on their heads, will then proceed to cut the trunk.

The pieces of wood will be tied and transported down to the temple for the second part of the work (Figure 3.3). The work in the temple may last many days, during which those working are not allowed to go back home; they will spend the night in the temple precincts and will eat only once a day, when the day's work is over. During this entire period, any problem that might occur needs to be interpreted by the deity during specific consultations. Once the wood has been prepared, it will be buried in the earth somewhere near the temple, and will remain there for at least six months in order to become more "resistant." When this period is over and the wood is eventually taken out, it has to be purified with cow dung and put inside the temple to await the final work.

The procedures followed for the construction of the frame are necessary to ensure a crucial characteristic of the *rath:* its capacity to be animated. In particular, the wood chosen for the construction should

Figure 3.3. The carpenters are preparing the wood for the palanquin in the presence of neighbouring *rath*-deities and deities' musicians (Dungri).

be a specific wood, considered to be filled with the presence of *jognī*, powerful goddesses dwelling inside the trees.[14] The importance of the *jognī* in animating the *rath* has been stressed by H. Diserens: "Hiḍimbā

Devī's devotees asked the *jognī* to give the new *rath* the power needed so that the deity may use it. The villagers' anxiety of seeing the *rath* remaining inanimate or, on the contrary, running out of control due to a surcharge in energy, was real."[15]

As soon as the tree is selected, the *jognī* living there have to be pacified for all the subsequent procedures of cutting and so on. When the palanquin construction is completed, the *jognī*'s power will be transformed into the specific deity's power. *Jognī* are supposed, in fact, to act as mediators between the greatest gods (like Śiva, Viṣṇu, Durga) and the village *devī-devtā*. They represent an indeterminate power (*śakti*) that, once transmitted to the *devī-devtā* of the different temples, will become personalized. This was explained to me by a priest in the following words:

> The palanquin is like a *mūrti* because it is made in a special wood. This wood comes from the trees belonging to *jognī*, so that the *jognīs'* power becomes the power of a particular god. For instance, if we make the *rath* for [goddess] Śravaṇī, the *jognī* become Śravaṇī or whatever other god. Nevertheless, the power is given by the *jognī*, which receive it from the great gods and give it to the local *devī-devtā*.

The way in which a palanquin has been constructed is sometimes an argument for proving a special link between two different local deities, and consequently between two villages. For instance, the goddess Śravaṇī of Shuru village, through her medium, once asked for a new palanquin whose wood had to be taken from the same forest used for making the palanquin of her brother, Sandal Ṛṣi, of a nearby village. The two deities were already considered to be in a close relationship. According to a myth, Śravaṇī first stepped in Sandal Ṛṣi's village before going to her actual village. For her new palanquin, the goddess also specified that it had to be made along with her brother's, during the same ritual and by the same people. Since the two deities now have their palanquins coming from the same forest, the relations between the two villages have become closer. If a dispute arises between them, the *gur* of the two deities immediately state angrily: "You can't separate us! We are brother and sister! We come out from the same tree!" alluding to the common origin of their palanquin wood. A *rath*'s ritual identity starts, therefore, at the moment of its construction, independently of later practices of consecration. This is confirmed by the fact that even before the palanquin is fully decorated, when the frame is still empty,

people will touch it with a sign of devotion and might make little offerings; incense is also burned in front of it[16] (Figure 3.4).

Figure 3.4. The wooden frame of goddess Hiḍimbā's palanquin before "decoration" (Dungri).

When the frame has been made, it is ready to be prepared whenever the occasion arises to bring out the deity. This preparation is called *sajnā*, which in Hindi means not only "to be adorned, embellished, beautified" but also "to be arranged" and "to be equipped." Outside of these occasions, the wooden frame is kept in the temple. It has an ambiguous status. It is not considered to be really a *mūrti*, since it has received no worship (even if it is kept just near the statue that the priest worships every day). Nevertheless, when it has to be decorated, it will be taken out of the temple with musical honours, to the sound of the drums. Once fully assembled, the *rath* will be considered to be a real *mūrti* and will receive a cult by a *pujārī* with the deity's bell and censer. After the worship, the palanquin will be carried by devotees on their shoulders so that it may manifest, by its movements, the deity's will: fully decorated, the *rath* is not only an object of worship but also a means by which the deity will engage in a direct communication with its devotees, just as the deity's medium does.

The Multiple Faces of the Deity

On the frame of the palanquin is fixed a variable number of metal faces (*mohrā, mukh*). These faces can be of silver, bronze, or sometimes of an alloy of eight metals[17] commonly used for making ritual objects (Figure 3.5). All the local deities that have a *rath* have many *mohrā* to fix on it.[18] Some may be quite old. For instance, goddess Hiḍimbā, said to be "the founder" of the royal family, has a few *mohrā* that were donated by a king of the fifteenth century.[19] New *mohrā* are regularly made, sometimes in order to add to the faces displayed on the palanquin, more often in order to renew those that have become old. A quite common practice in the region, at least today, is to melt down old *mohrā* to make new ones, although this is usually frowned upon. A goldsmith told me, for instance, that his uncle agreed to the demand of a temple administrator to melt down some *mohrā*, but died in the course of the same year, as did the administrator. This was interpreted by him as being caused by the anger of the temple deity for having melted down its old images.

In the construction of a new *rath*, the decision to make a new *mohrā* is made either by the deity itself through the medium or at least with the deity's consent. The deity will also decide the details of the procedure. In the past, each deity had its own traditional goldsmiths. They cultivated the land of the deity and in exchange had to fabricate and repair the deity's metal items. Nowadays, many goldsmiths have left their traditional occupation, and those who still pursue it are employed by different temples. Nevertheless, the link between a deity and a particular goldsmith's family still exists. Many stories tell how during the fabrication or the repair of some deity's *mohrā*, the metals did not melt properly – an incident explained by the fact that the goldsmiths were not the deity's personal goldsmiths.

The procedure of fabrication of a

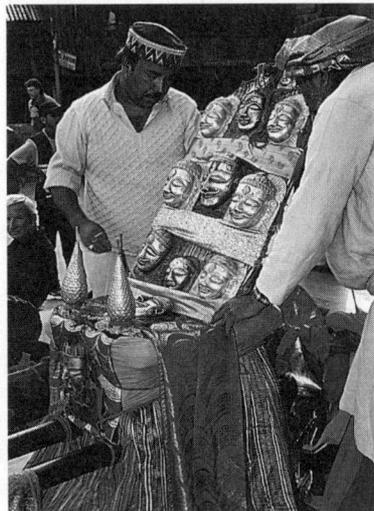

Figure 3.5. Installation of *mohrā* in the goddess Hiḍimbā's palanquin (Dungri).

mohrā is in itself a ritual. The goldsmiths and the main temple functionaries (*pujārī*, administrator, medium) have to sleep in the temple and can eat only once a day. Important phases are punctuated by temple drummers. Once the *mohrā* is finished, the deity is asked if it is satisfied. The *mohrā* is then brought to a place famous for its holy water. The Brahmin priest purifies the *mohrā* and performs the ceremony of *jīv denā*, "to give life" (or *prāṇ pratiṣṭhā*, "installation of breath") by anointing it with sacred substances and reciting mantras. At the end, the deity is asked again if the procedures have been done correctly. During the *jīv denā*, the name of the *mohrā*'s deity is invoked. The whole process, starting from the deity's demand for a new *mohrā* and ending with its acceptance of the *mohrā*, gives the *mohrā* its individuality. Even when the *mohrā* has not been requested by the deity but has been offered by someone, only the final acceptance will identify the *mohrā* as belonging to the deity.[20]

The identity of a *mohrā* can sometimes be "discovered" *a posteriori;* in such a case, the *mohrā* is said to be a deity's self-revelation. Stories associated with self-manifested *mohrā*[21] are widespread all over the region. Usually the tale is that a cow, or a villager, or a palanquin "found" the *mohrā* buried in the earth. Immediately, someone started to tremble and to speak on behalf of the deity: "I am such and such deity! I want you to build a temple for me! I want to be honoured in such and such a way!"

The "discovery" of a *mohrā* can add new powers to the deity's previous ones. For example, in Larakelo village the deity is Śiva. Among the many *mohrā* of his palanquin, people say that there is a special one, recently found, which has given the god the power to bring rain. In addition, another little *mohrā* was added some years ago, allowing the god now to perform more and more exorcisms. Until recently, Śiva Mahādeo was a pacific form of the deity and was not asked to expel malevolent spirits *(bhūt)*. A few years ago, however, a *pujārī* found a *mohrā* and asked the temple administrator to put it on the palanquin. The medium started to tremble and said that the *mohrā* should be put on the palanquin whenever an exorcism was needed. Since that time, this *rath* has become famous locally for practising exorcisms. Such a practice has also increased the number of animal sacrifices performed, occasionally transforming Śiva from a peaceful into a violent deity.

A deity might commonly have on its palanquin along with its own *mohrā* one or two *mohrā* belonging to other deities. Gāyitrī Devī of Jagatsukh village, for instance, has among her *mohrā* one of Dhvāṅgro

Ṛṣi and one of goddess Kālī. Both are considered to be the recipients of the sacrifices people used to offer in front of the *rath*. For this occasion, the *mohrā* of the "pure" and vegetarian goddess Gāyitrī are covered by a cloth, marking her non-participation in the sacrifices.[22] Similarly, in the palanquin of the meat-eating goddess Hiḍimbā, there is a little *mohrā* of Manu Ṛṣi, a deity considered to be particularly pure; devotees frequently offer sacrifices to the goddess, and in this case it is Manu Ṛṣi's *mohrā* that is covered by a small piece of cloth.

Assembling the God

When the palanquin is not in active use, it is dismantled. The wooden structure is usually kept inside the temple. The metal faces, the jewellery, the cloths, and various "decorative" items are all kept in closed baskets, inside a locked treasure-house (Figure 3.6). For some deities, the warden performs an abbreviated rite of homage in front of the closed door every day; otherwise there is no direct worship. *Mohrā* are very rarely put in a shrine as *mūrti*. Their normal use is only to be carried on the palanquin, in which they are elements – indeed, crucial ones – in a composite ritual representation. They receive worship only as parts of this assemblage, when all the pieces are put together. The deity then *exists* as a *rath* only when the wooden structure is completely adorned.

When the occasion comes to take the palanquin out of the temple, people ask the deity, through its medium, if this is its wish, and when

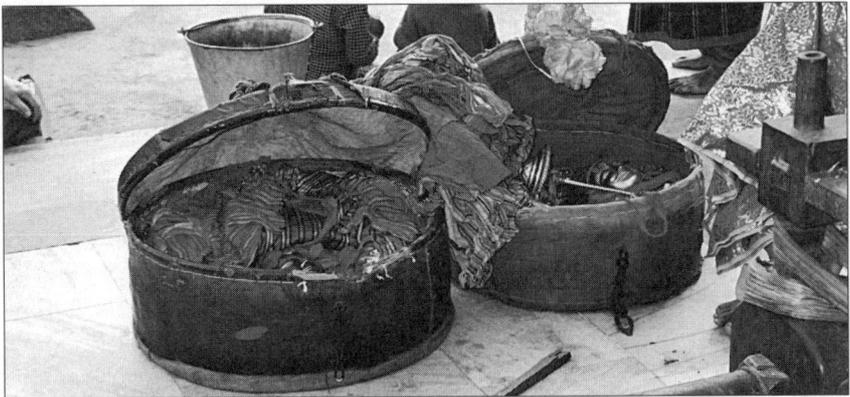

Figure 3.6. Baskets in which the decoration is kept when the palanquin is not assembled.

to prepare the palanquin. On the day that has been fixed, people gather in front of the temple. All the necessary items are brought from the treasure-house in their baskets. In the Gāyitrī temple at Jagatsukh village, a special man *(dod)* has the hereditary right to be the first to touch the baskets and to bring them to the temple. The wooden frame is taken out of the temple with a few beats of the drums. Assembling the components of the *rath* is done with extreme attention to all the details. If something is wrong, the deity will show its disagreement at the next consultation. To prepare the *rath*, as well as to assist at the process, is seen as an act of devotion. The assembling results in a gradual augmentation of the deity's presence and power. At the beginning of the process, the deity receives just a little incense in front of its wooden structure. As the assembling goes on, the deity's censer and bell will also be presented. Some elements in the assemblage are more marked by divine presence than others, as shown by the fact that they need to be installed on the wooden structure with a special rhythm of one of the deity's many drums, the *dhaunsī*.[23] These crucial parts of the deity are not only some special *mohrā* but also some jewellery or items of clothing. The end of the whole procedure is said

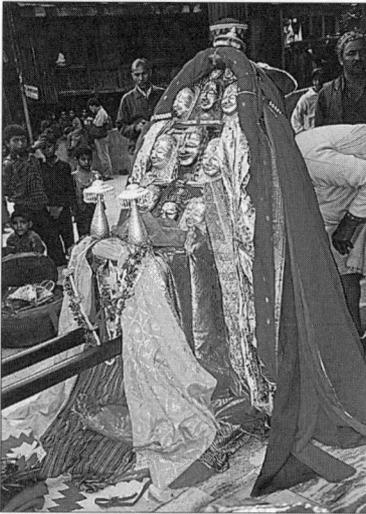

Figure 3.7. The goddess Hiḍimbā's palanquin after it has been completed (Dungri).

to be the "accomplishment of the *devtā* in its full *śakti*." Only when the *rath* has been completed is it taken on the shoulders by the villagers (Figure 3.7). The bell is now rung and the censer waved with circular gestures by the priest. All the drums are played loudly and in a different, specific rhythm.

By directing the movements of its bearers, so it is said, the deity expresses its feelings and will. The movements of the palanquin are codes interpreted by devotees. If the *rath* is swaying from side to side, for instance, the deity manifests its happiness; running here and there can be seen as a sign of wrath. The *rath*'s movements can also be a reply to specific questions put by the villagers.

Thus, through his *rath* (as well as his *gur*), the *devtā* is a social participant in the villagers' affairs; he is someone who lives there and with whom villagers regularly communicate and interact.[24]

The *rath*-gods look and behave like individuals, each with its own specific personality. Villagers show them respect, but can also treat them as though they were children unable to control their passions and feelings. It is usual to see temple functionaries trying to calm down a deity whose palanquin's movements appear to them too wild. They touch the *rath* in an affectionate way, saying to stay calm and to "sit down" (the frame is put on the ground on its four legs) in its assigned place. Such a language of emotion also characterizes the relations between the different *rath*-gods, who regularly display their feelings towards each other. For instance, when Gatotkach's *rath* is meeting his mother's *rath*, he shows his excitement by jumping and by making circles around her, covering her with "gestures" of tenderness, lowering one side so as to touch her *rath*, demonstrating his desire not to leave her. Similarly, as Takṣak Nāg's *rath* was once leaving the *rath* of his sister, Gāyitrī Devī, whom he was to see again the next day at another festival, he suddenly made a U-turn and showed his decision to sit with his sister all night long and to go along with her to the festival the following morning.

The "*Rath*-Deities" as Social Actors

The most important occasions for preparing the god's *rath* are the various village festivals, when the deity has to be brought somewhere to meet other gods or when it has to receive neighbouring gods as guests in his/her own village. This also is an opportunity to display the relationship that exists between different villages. Once, the *rath* of Phal Nāg of Prini village had to be decorated to go to the festival of Banara village, where the temple of his brother, Takṣak Nāg, is situated. People of both villages, who had been engaged in a dispute for a whole year, were avoiding each other, however. Every effort to reach a compromise had proved fruitless. Following established usage, the administrator of Phal Nāg temple nevertheless gave the order to prepare the god's *rath*, to bring it to the Banara festival. As soon as the men put the *rath* on their shoulders, the "god made a sudden and violent movement and turned back," so they said, "and faced again the treasury-house." The god was refusing to go to the festival. Banara villagers accused the villagers of Prini of having

forced the *rath*'s movements (and the god's will), while the temple administrator exonerated the villagers of Prini, citing the wish clearly expressed by their god. Such moments of tension are occasions for contrasted local interpretations of a *rath*'s movements. As a *devtā* once put it through his medium, in a similar dispute about the movements made by a *rath*, "We came as *devtā* and you are treating us as if we were mere wooden puppets."

Having a *rath* provides the villagers a way to assert the existence and power of their own sovereign deity. This in turn provides an incentive for them to try to acquire more importance for their deity in the local pantheon. The process is well in evidence in the case of so-called new deities. At the origin of such new cults is usually the "discovery" of a *mohrā* and the subsequent possession of a medium: the deity declares his/her name and asks for regular worship in a temple. The consequences of such discoveries vary from case to case. The cult may remain private or it may become the cult of a local group, a caste, or a subcaste. It can even assume a larger dimension. This is what happened to the goddess Cāmuṇḍā, an instance of a "new deity." Her *mohrā* was "found" some years ago by a low-caste man in a village. The man built himself a shrine where he used to sit the whole day worshipping her, reading and reciting hymns and receiving people who wanted to ask the goddess personal questions. The shrine started to attract many devotees, increasing the goddess's popularity. After some years, the goddess was able to get the complete equipment of the traditional village deities, including a palanquin with many *mohrā* and a personal group of musicians. Cāmuṇḍā started to participate in village festivals and now participates in the big royal festival for the whole district, the Daśerā, where all the *devī-devtā* of the region are invited and gather (175 came in October 2000), a mark of her progressive recognition.

At this annual festival, many disputes arise concerning rights of precedence, that is, to determine which deities have the right to be placed in the most important positions in the ritual scene. For instance, one of the most disputed positions every year is the right to walk on the right side of the royal deity, Raghunāth, during his chariot procession. Many other positions provide occasions for disputes among villagers. In the context of such rivalries, it is essential that the deities be marked and immediately recognizable, even from afar.

The Visibility of the Gods

We have seen that the procedure of construction as well as the Brahminic rituals confer on the palanquin a specific divine identity. It remains to be seen, however, how the various elements assembled in the palanquin work together to give to the "deity-*rath*" what we can call its social identity. This is what allows a deity to be recognized in a public context, to be differentiated from the many other gods or goddesses of the neighbouring villages, and to gain what people call the deity's "renown."

The shape of the frame is the first element of visual identification. During big festivals such as Daśerā, in which the *rath* of a great number of *devī-devtā* from different parts of the district gather, the overall shape is the first and most obvious element for recognizing the geographical origin of the deity: four-sided *rath* come from Sutlej region; one-sided *rath* belong to the Beas region (Figure 3.7). Although the frame is completely hidden under the many cloths and other things that are put over it, you can immediately make out its shape simply by the way the different items are disposed on it. A first sign of distinction is provided by the length of the poles enabling the structure to be carried on the bearers' shoulders – in palanquins coming from the Sutlej region, they are much longer and more flexible than in those coming from Beas. Another typical shape is what is

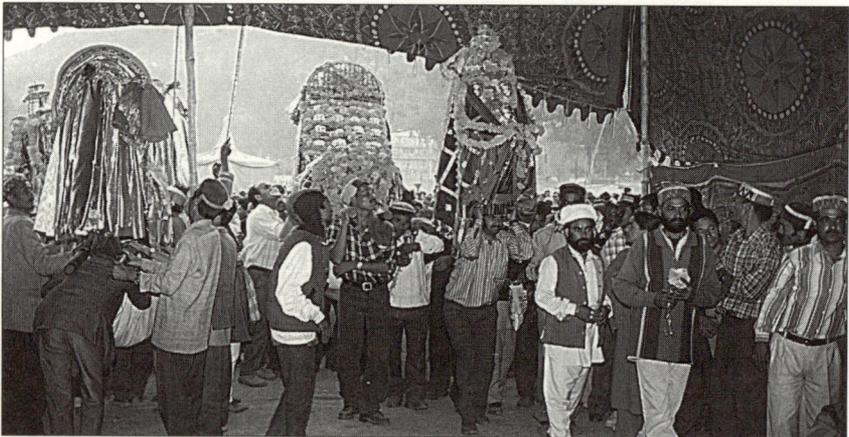

Figure 3.8. On the right, a god in his basket *(karḍū)* is carried on the head of a man (Kullu Daśerā).

called *karḍū* ("basket"), which, it is said, existed before the actual *rath*: *karḍū* have no poles and are carried on the head of a single man (Figure 3.8).

One would think that *mohrā* would constitute an easy way of identifying the corresponding deity. This is not the case, for many reasons. Old *mohrā* are sometimes iconographically well individualized, but they probably depicted the donor, generally a king,[25] and were thus never intended to be the "portrait" of the deity. *Mohrā* that are produced nowadays are, on the contrary, quite stereotyped. Nevertheless, villagers claim that *mohrā*, especially the oldest ones, represent specific traits of each particular deity. It is claimed, for instance, that goddesses are without moustaches, and gods with moustaches. But even such a broad categorization does not work well, and the presence of a moustache is not a significant mark distinguishing gods from goddesses. Indeed, a goddess may have a moustache (Hiḍimbā, Figure 3.5), while a god may be without. Confronted with the fact that *mohrā* of the goddess Hiḍimbā had quite long moustaches, her *pujārī* improvised an ad hoc reply: I had just to look around and see for myself how many local women themselves have moustaches! Another explanation given was that the *devī* was showing herself in a violent form.

In fact, *mohrā* belonging to a single deity might differ from each other

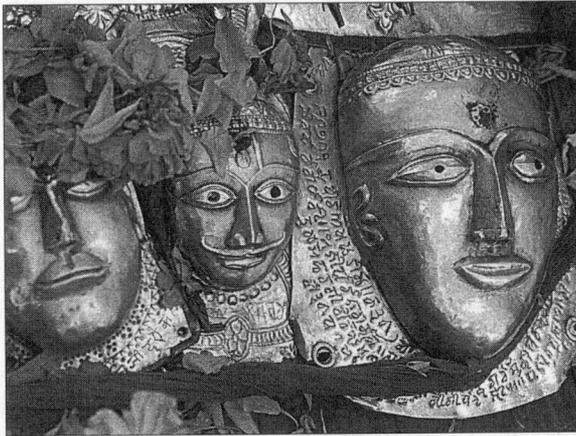

Figure 3.9. Three different *mohrā* in a *rath*, for a single deity (from M. Postel, A. Neven, and K. Mandodi, *Antiquities of Himachal* [Bombay: Franco-Indian Pharmaceutical Private Ltd., 1985]).

(Figure 3.9), although there will exist groups of two or three similar *mohrā*. Their features can be quite diverse, and, in the same *rath*, there might be more resemblance between *mohrā* of two different deities than between those of the same one. Take, for instance, Gośāl Nāg's *rath* (Figure 3.10). This palanquin contains three different gods, each represented by three *mohrā*: Beas Ṛṣi at the top, Gotam Ṛṣi in the middle, and Gośāl Nāg at the bottom. Two *mohrā* of Gośāl Nāg are alike, but the third looks more like one of the *mohrā* belonging to Gautam Ṛṣi; one *mohrā* of this god is similar to those of Beas.

Moreover, unlike the shape of the frame, *mohrā* are not visible from afar. Even close up, they are difficult to sight as they are almost entirely covered by cloths and flowers. This suggests that the visual identification of the god or goddess by focusing on the traits of the *mohrā* pertains more to the level of discourse than to any real usage of the deity's metal faces. In fact, as Diserens points out, a *mohrā* never "illustrates" the deity: it "materializes it only if it [the deity] declares that it has become 'incorporated' [in the *mohrā*] and if it animates it with its presence."[26]

How, then, can villagers make out the difference between various *rath*? How can they immediately recognize a deity among many others? The priest of Hiḍimbā had this answer:

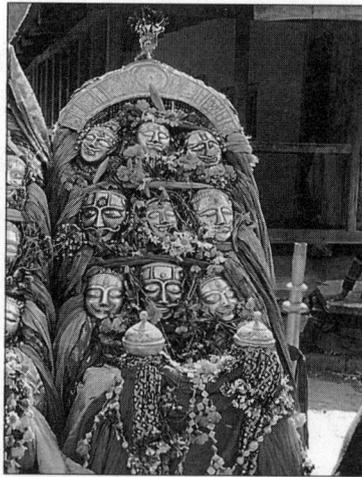

Figure 3.10. Palanquin of three deities. At the top is Beas Ṛṣi, in the middle is Gotam Ṛṣi, and at the bottom is Gośāl Nāg (Gośāl village; photo by Hélène Diserens, 1979).

The difference is made, for instance, by decorating *(sajna)* a palanquin with cloths; for some gods the cloths hang down, some [other] people turn them in a twisted way. Some people tie the cloths of *devtā* [with a free end] covering [the knot], some put peacock's feathers in the palanquin. Hiḍimbā is the only one to have all the cloths on the back tied to a single [bowlike] cloth. Moreover, by the form of the palanquin you can make out where the *devtā* is coming from: in Parol they have one-sided *rath*; in Saraj [*mohrā* are put] all around; in Rupi they have both. In Parol, the umbrella is only for *rath* of goddesses; gods have the *kalgi* [headband or diadem]. In Saraj, goddesses and gods can both have the umbrella, but gods also have hair, which goddesses do not have.

The way to distinguish a *rath* depends, then, not so much on the identification of the metal faces of the deity but rather on everything that the villagers call "decorations" *(saj, alamkāra):* cloths, jewellery, umbrellas, hair, flowers, and so on that are put on the palanquin and assume therefore the role of a code enabling the onlookers to identify immediately each and every deity.

Observation shows, for instance, first a distinction between gods and goddesses, located differently on the *rath* depending on its provenance. If the *rath* comes from the upper side of the Kullu valley, the difference will be in some of the silver items: goddesses have silver umbrellas fixed at the front and at the top of the palanquin, supported by silver cones (Figure 3.7); in this part of the valley, a god never has umbrellas but possesses instead silver sceptres and, at the top, a band of silver or of silk, sometimes adorned with jewellery or with a peacock's feather (Figure 3.10). In palanquins coming from the lower part of the valley, the "gender code" is different but also relies on "decoration": both gods and goddesses have umbrellas, but goddesses wear a large silk cloth that entirely covers their back, whereas gods do not have this cloth.

Apart from this general gender categorization, other elements in the decoration are indicative of more individual or personal identities. Not all the deities have a strong visual characterization, however; in some cases, only people belonging to a restricted area will be able to identify their own deities. In other words, the degree of "visibility" of a god or a goddess is not the same in all cases.

To anyone leafing through the books of repertoires of *devī-devtā* that have been published in the region, differences between palanquins of the same type are obvious. An important element in the characterization of different goddesses is the way the cloths are tied. In the upper

valley, some *rath* of goddesses have a cloth that covers them partly and which is tied with a silver belt, whereas in others this cloth falls more freely on the sides or hangs completely on the back (Figure 3.11). The way flowers are arranged can be also specific. For some gods, a distinctive sign will be the way to arrange the hair: one will have long hair hanging down the back, another will have short hair all around the umbrella; some will have a headband, and so on (Figure 3.12). A god like Śiva Mahādeo is immediately recognizable by his specific pink diadem-like top supporting jewellery (Figure 3.13).

Such extreme variations in the decoration are apt to reveal the villagers' desire to make their own god stand out, while conforming to a few iconographical models.[27] This desire for ostentation at festivals was also noticed by Diack in his description of the Daśerā festival at the time of the British Empire: "The followers of each particular idol do their best to show to advantage, and every banner, trumpet and drum that is available is put into requisition."[28]

Conclusion

In contrast to a temple icon, which is the single support into which the ritual installs the deity's power, the god's presence in the *rath* seems more fragmented, distributed in different elements that have to be

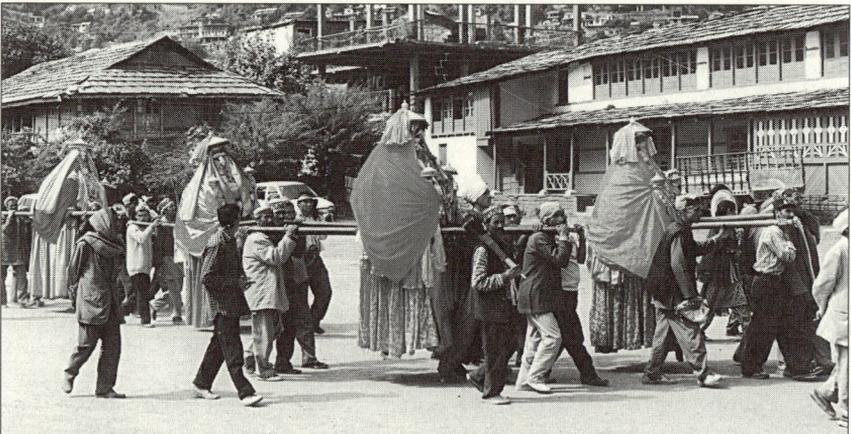

Figure 3.11. Goddesses of the low valley, easily distinguishable from upper valley deities with their cloths that fall freely on the sides (Kullu Daśerā).

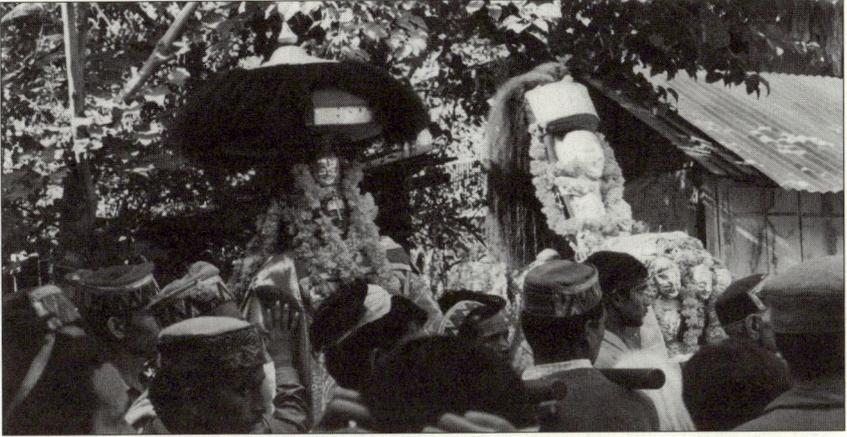

Figure 3.12. Gods with hair hanging down the back (Kullu Daśerā).

Figure 3.13. Śiva Mahādeo, recognizable by his pink diadem-like top (Kullu Daśerā).

assembled every time the deity has to be taken out in the form of the palanquin. Some parts can be "surcharged" by a ritual process of consecration, but none has an autonomous existence as a separate object of worship. This applies even in the case of the frame and of the *mohrā*, whose procedures of fabrication and of consecration are the closest to those followed for temple icons. By contrast, as soon as the *rath* is adorned, all its parts are considered to complete each other and to contribute to the display of the deity's physical and "social" existence among the villagers. This is not without ambiguity, as is shown by the declarations of some villagers: in their deity's palanquin, only some *mohrā* are said to be really "true" and powerful, whereas others, newer, are just put on "for the show" or "for their own sake." This suggests that there is a hierarchy in the assemblage, and that some parts might be thought to be less essential

than others in the total composition. They are "decorative" in the sense of just being "embellishments." What is striking is that this status of being merely "decorative" is applied to what, following a Western way of thinking, might easily have been thought to be central to the deity's identity: its faces.

On the other hand, "decorations" that appear to be there only to make the deity more beautiful assume, in fact, a decisive part in the elaboration of the *rath*'s total power. It should be noticed in this respect that they are subjected to the same ritual treatments applied to the frame and the metal faces. Together with the *mohrā* they receive a daily homage at the treasure-house. Repairing or renewing the silver jewellery has to be done inside the courtyard of the temple, with the continuous presence of the temple functionaries, who fast during the day and regularly ask the deity for instructions. Each decorative item also receives the ritual mark of auspiciousness (*ṭīkā*) separately. Even the cloths of the god-palanquin need to be consecrated and accepted by the deity before they can be "worn."

The *rath* appears therefore as an integrated whole in which the "decoration" is ritually constitutive of the deity's identity and power.[29] This is underlined by a codified sentence that mediums say during seances whenever there is a need to emphasize the close relationship existing between two village deities (as in the case of Śandal Ṛṣi and Śravaṇī). The alliteration makes the declaration even more impressive:

ek dhup ek tapot ek pedu ek pālkī! [one incense, one censer, one decoration, one palanquin] We are one!

Thus, the meaning of "decoration" that emerges here seems to differ from the one we usually have in mind in English. After the pioneering work of A.K. Coomaraswamy in 1939,[30] the Western notion of ornamentation has been recently discussed in the field of figurative arts by J.-C. Bonne,[31] a historian of Western medieval art, who pointed out the fact that the meaning and function of this notion have changed in the course of history. Taking as a starting point a modern definition from a dictionary of arts and "Arts décos," where ornamentation is "the accessory part of a composition which could be taken out without affecting the principal subject," the author showed how this definition did not fit the medieval functions of ornamentation, which were not only decorative but could appear "on the forefront, and even become the composition itself."[32] In a similar vein, O. Grabar reflected on the

functions of ornamentation in Arabic iconography: "Decoration seems to complete an object, a wall or a person, by providing it with quality ... [and all the terms for decoration] imply effective completion and even transfer of meanings from one form to the other."[33] The author compared the Arabic notion of decoration with the Sanskrit notion of *bhūṣati* (to adorn): "It too implies the successful completion of an act, of an object, or even of a state of mind or soul." As he put it: "Something is clearly wrong with ... nearly all definitions of ornament found in manuals of art, as they simultaneously imply the secondary side of ornament and, almost as a result of that, its singular and exclusive attribute of beauty."[34]

The verb *sajnā* (to decorate) is used locally to indicate the process of preparing the *rath*. Being the very act that brings the god into existence, it definitely points to something more than the completion of the image, a conclusion that is in line with what was suggested by Bonne in the case of Western medieval art. This may not be limited to palanquins. Consider an important god in the royal pantheon of the former Kullu kingdom: Narsīngh, said to be the real owner of all the royal symbols. Even the throne of the god Raghunāth, to which the kingdom has been dedicated since the seventeenth century, belongs to Narsīngh. The representation of Narsīngh is peculiar. At the time of Raghunāth's worship, the royal priest takes out a specific symbol, a *śālagrāma* (small ammonite fossil considered to be a symbol of the god Viṣṇu's discus) from its container, and starts to "decorate" it. Using a special paintbrush, he draws on the surface of the *śālagrāma* a mouth, teeth, a moustache, and a nose. He adds readymade "eyes" and a crown, taken from another container. He then paints a little diagram on a small golden leaf, which becomes Narsīngh's tongue. He ends the operation by putting a flower on the crown. The god now has a "figurative" face, ready to receive offerings and respect from his devotees (Figure 3.14). True, the *śālagrāma* is by itself powerful, but it is the so-called decoration that precisely enables the god to exist in full form. Then, when the worship of Raghunāth is about to end, the priest removes the crown, the eyes, and the tongue of Narsīngh, puts them back in their container, washes the "makeup" from the *śālagrāma*, and returns it to its own container until the next time.

Like Narsīngh, *rath*-gods may be said to exist only through the whole operation of "decoration," at the time they meet each other and participate in the village social life.

Figure 3.14. *(Top)* The god Narsīngh in his form of undecorated *śālagrāma* (Kullu). *(Bottom)* The god Narsīngh's face during the worship, after the *śālagrāma* has been "decorated" (Kullu).

Acknowledgements

This research has been financed by the program ACI "Médium, lignages et territoires," coordinated by M. Lecomte-Tilouine. I wish to thank Gérard Colas, Phyllis Granoff, Robert Sharf, Gilles Tarabout, and Mimi Yiengpruksawan for their inspiring remarks and suggestions.

End Notes

1 "Nobles are grouped round the throne like an ornament and tell the one who takes his place thereupon just who he is."

2 Gérard Colas, *Viṣṇu: Ses images et ses feux. Les métamorphoses du dieu chez le vaikhānasa* (Paris: EFEO, 1996), 30; Diana L. Eck, *Darśan: Seeing the Divine Image in India*, 2nd enlarged ed. (Chambersburg, PA: Anima Books, 1985), 51.

3 N.R. Bhatt, "Development of Temple Rituals in India," in *Śiva Temple and Temple Rituals*, ed. S.S. Janaki (Madras: Kuppuswami Sastri Research Institute, 1988), 36; Colas, *Viṣṇu*, 295-96; Carl Gustav Diehl, *Instrument and Purpose: Studies on Rites and Rituals in South India* (Lund, Sweden: C.W.K. Gleerna, 1956), 107-8; Jackie Assayag, *La colère de la déesse décapitée: Traditions, cultes et pouvoir dans le sud de l'Inde* (Paris: Éditions du Centre National de la Recherche Scientifique, 1992), 394-95; Christopher J. Fuller, *Servants of the Goddess: The Priests of a South Indian Temple* (1984; new ed., New Delhi: Oxford University Press, 1991), 172-73; Paul B. Courtright, "On This Holy Day in My Humble Way: Aspects of Puja," in *Gods of Flesh, Gods of Stone: The Embodiment of Divinity in India*, ed. Joanne Punzo Waghorne and Norman Cutler (Chambersburg, PA: Anima Publications, 1985), 48.

4 Eck, *Darśan*, 3.

5 G. Colas, "Le dévot, le prêtre et l'image vishnouite en Inde méridionale," in *L'image divine: Culte et méditation dans l'hindouisme*, ed. A. Padoux (Paris: Éditions du Centre National de la Recherche Scientifique, 1990), 110. This accords with what has been pointed out by Gell in his study of European and "ethnographic" art: "it is only in a very parochial (blinkered) Western, post-Enlightenment point of view that the separation between the beautiful and the holy, between religious experience and aesthetic experience, arises." Alfred Gell, *Art and Agency: An Anthropological Theory* (Oxford: Clarendon Press, 1988), 97.

6 The territorial criteria distinguish the group of *devī-devtā* from other forms of gods honoured by villagers – for example, from the gods invoked by *purohit* during the rituals they perform for high-caste people, or from the gods invoked during exorcistic rituals.

7 See, for Mandi district, S. Vashist, *Mandi dev milan* (Shimla: Himachal kala sanskriti bhasha akadmi, 1997), and for Kullu district, S. Vashist, *Kullu: dev samagam* (Shimla: Himachal kala sanskriti bhasha akadmi, 1995).

8 Vashist, *Mandi dev milan*, 71.

9 Ibid., 64.

10 The word *piṇḍā* (lit. "ball") refers usually in a ritual context to the little ball made of rice or flour that is offered to the manes. In the present context, the word indicates locally any aniconic representation of the deity.

11 That the construction must follow ritual rules (dictated here by the deity itself) is also attested in ancient texts. The Vaikhānasa Āgama include a chapter on the ritual collection of the wood necessary for the construction of a temple and other ritual purposes: T. Goudrian, "Deities of the Tree-Cutting Ceremony in Vaikhānasa Āgama," *Brahmavidyā: The Adyar Library Bulletin* 37 (1973): 75-86.

12 By contrast, compare Gérard Colas's description of the installation of power in the statue according to the Vaikhānasa vishnuite tradition: "The temple's image is the receptacle not only of the [divine] presence but also of the divine power. The installation of the divine power *(śakti)* in the image ... is done during the ritual called the "installation" *(pratiṣṭhā)* of the image": "L'instauration de la puissance divine dans l'image du temple en Inde du sud," in *Revue de l'Histoire des Religions* 206 (1989): 134.

13 A *purohit* might be called upon too, in order to select three auspicious days from his astrological almanac, from which the deity, through the *gur*, will choose one.

14 H. Diserens, "Les *yogini* de la haute vallée du Kulu (Himachal Pradesh)," *Bulletin d'études indiennes* 9 (1991): 70.

15 Ibid., 69.

16 H. Diserens suggests that the *rath* is the very essence of the deity even when "unadorned" (Diserens, "Les *yogini*," 69).

17 Gold, silver, iron, tin, lead, mercury, copper, and zinc.

18 *Mohrā* are said to have been previously transported in baskets called *karḍū*. Local people often ascribe to the seventeenth century the replacement of *karḍū* by palanquins, at the time when King Jagat Singh introduced the Daśerā festival. During this festival, all the village *devī-devtā* had to come to the king's capital to pay their homage to the king and to the royal divinity. Nowadays, almost all the *devī-devtā* have palanquins, and only a very few are figured by a *karḍū*. Although the palanquins are carried by at least two men, the *karḍū* is held on the head of a single man. See also Hélène Diserens, "Images et symboles des déesses de la haute vallée de Kullu," *Bulletin d'études indiennes* 13-14 (1995-96), 101.

19 Ibid., 105.

20 There are various means for ascertaining the deity's acceptance (ibid., 104). Apart from the *mohrā* donated in the past by rajas and proving in

devotees' eyes the importance and ancient existence of their *devtā, mohrā* donated today can be bought from the market and offered to the *devtā* as a token of gratitude for a desire that has been fulfilled. This kind of *mohrā* does not usually need a consecration by a *purohit*, but only the deity's approbation. *Mohrā* of this kind are not considered as important as the old ones or as those made by traditional goldsmiths. For these *mohrā*, people say that they are just like "decoration," a way to show off. Before the acceptance by the deity to whom the *mohrā* is donated, *mohrā* bought from the market are likely to be used for any *devtā* as they are not marked by specific identification signs. A *mohrā* seller, asked who was the deity represented by a *mohrā*, replied, "Whomever you want."

21 Similar beliefs in the concretization of the deity in an image are widespread all over India. Ritual texts deal with the distinction between this kind of image and manmade ones (Colas, "L'instauration de la puissance divine"; Catherine Clémentin-Ojha, "Image animée, image vivante: L'image du culte hindou," in *L'image divine: Culte et méditation dans l'Hindouisme*, ed. André Padoux [Paris: Éditions du Centre National de la Recherche Scientifique, 1990]). The discovery of a representation of a deity, even if not necessarily interpreted as a self-manifestation, is never without consequences at the cult level. In the town of Makarsa (Kullu district), a previous royal capital with many archeological temple ruins, the inhabitants recommend that visitors not accidentally turn over ancient stones with their feet while walking, lest they reveal divine representations, even fragments, because that would force them to build new temples (H. Diserens, pers. comm.)!

22 Usually the *mohrā* of other deities in a *rath* are smaller than those of the main deity. The deities they represent are seen in this context as assistants. They can, however, also be the main deities in another village, and therefore have their own *rath*.

23 The *doms* is the most important drum among the three or four kinds belonging to the deity. During a village festival, when the *rath* is taken out, the drummer playing the *doms*, the *domsi*, decides when the rhythm has to be changed according to the different phases of the ceremony. The *domsi* feels himself emotionally very close to the deity, and it is upon hearing the rhythm of the *doms* that the deity will enter the *gur*'s body.

24 Denis Vidal, *Le culte des divinités locales dans une région de l'Himachal Pradesh* (Paris: ORSTOM, 1988), 97; Daniela Berti, *La parole des dieux: Rituels de possession en Himalaya indien* (Paris: Éditions du Centre National de la Recherche Scientifique, 2001), 56.

25 Diserens, "Images et symboles des déesses."

26 Ibid., 104.

27 These distinctions may also have political implications. The *rath* of Jamlu *devtā* of Pej, a village near the royal capital of Kullu, was constructed according to the will of Raja Bhagvan Singh, at the beginning of the twentieth century. According to tradition, the *rath*'s should have been a one-sided *rath* corresponding to the upper valley style, but the raja ordered that it had to be constructed as a four-sided *rath*, similar to those of Saraj. This was because during Bhagvan Singh's reign, and as a consequence of some political and economic changes, *rath* from Saraj were no longer coming to the annual festival of Daśerā, when deities from all the ancient kingdom have to pay homage to the raja and to the royal deity. During the festival, *rath* from Saraj have to take their position on the right of the royal deity (whereas the upper valley's *rath* stay on the left side). As no *devtā* from Saraj was present to be on the right, Bhagvan Singh gave this honour to an influential *devtā* of another area, but to do that he had to make its *rath* in Saraj's style. Thus, Bhagvan Singh could ensure the alliance with all the devotees belonging to the god's area. That the *rath* style could have political implications was noticed by W.H. Emerson, a British administrator of the region, who reported a case in which people of one particular *devtā* had to ask the raja of Mandi for permission to change the structure of their *devtā*'s *rath* (Emerson, *Mandi State Gazetteer* [Lahore: Government Printing, 1920], 63). Denis Vidal suggests that, in this case, this might have been a way to avoid a situation whereby a change in a *rath*'s style would mark a new alliance between villagers and one of the neighbouring princes – since the structures of different *rath* corresponded to different kingdoms (Vidal, *Le culte des divinités locales*, 234).

28 A.H. Diack, *Gazetteer of the Kangra District. Parts II to IV: Kulu, Lahul and Spiti* (New Delhi: Indus Publishing, 1897), 43.

29 The emphasis on ornamentation as "location" of the sacred is underlined also by Joanne P. Waghorne, *The Raja's Magic Clothes: Re-Visioning Kingship and Divinity in England's India* (University Park, PA: Pennsylvania State University Press, 1994), 254.

30 In this article, the author showed how most of the words denoting "ornamentation" or "decoration," used in a modern sense of "something of adventitious and luxurious, added to utilities but not essential to their efficacy," originally implied a "completion or fulfilment of the artifact or other object in question": Ananda K. Coomaraswamy, "Ornament," *Arts Bulletin* 21 (1939): 375-82.

31 Jean-Claude Bonne, "De l'ornemental dans l'art médiéval (VIIe-XIIe siècle): Le modèle insulaire," in *L'image: Fonctions et usages des images dans l'Occident médiéval*, ed. Jérôme Baschet and Jean-Claude Schmitt,

Cahiers du Léopard d'or 5, (Paris: Le Léopard d'or, 1996).

32 Ibid., 208.

33 Oleg Grabar, *The Mediation of Ornament* (Oxford: Princeton University Press, 1992), 25-26.

34 Ibid., 25. Gell also refuses to attribute a mere aesthetic function to decoration. He notices that "most non-modernist, non-puritan civilizations value decorativeness and allot it a specific role in the mediation of social life, the creation of attachment between persons and things": *Art and Agency*, 83.

Bibliography

Assayag, Jackie. *La colère de la déesse décapitée: Traditions, cultes et pouvoir dans le sud de l'Inde*. Paris: Éditions du Centre National de la Recherche Scientifique, 1992.

Berti, Daniela. *La parole des dieux: Rituels de possession en Himalaya indien*. Paris: Éditions du Centre National de la Recherche Scientifique, 2001.

Bhatt, N.R. "Development of Temple Rituals in India." Pp. 24-45 in *Śiva Temple and Temple Rituals*, edited by S.S. Janaki. Madras: Kuppuswami Sastri Research Institute, 1988.

Bonne, Jean-Claude. "De l'ornemental dans l'art médiéval (VIIe-XIIe siècle): Le modèle insulaire." Pp. 207-50 in *L'image: Fonctions et usages des images dans l'Occident médiéval*, edited by Jérôme Baschet and Jean-Claude Schmitt. Cahiers du Léopard d'or 5. Paris: Le Léopard d'or, 1996.

Colas, Gérard. "L'instauration de la puissance divine dans l'image du temple en Inde du sud." *Revue de l'Histoire des Religions* 206 (1989): 129-50.

–. "Le dévot, le prêtre et l'image vishnouite en Inde méridionale." Pp. 99-114 in *L'image divine: Culte et méditation dans l'hindouisme*, edited by André Padoux. Paris: Éditions du Centre National de la Recherche Scientifique, 1990.

–. *Viṣṇu: Ses images et ses feux. Les métamorphoses du dieu chez le vaikhānasa*. Paris: EFEO, 1996.

Coomaraswamy, Ananda K. "Ornament," *Arts Bulletin* 21 (1939): 375-82.

Courtright, Paul B. "On This Holy Day in My Humble Way: Aspects of Puja." Pp. 33-50 in *Gods of Flesh, Gods of Stone: The Embodiment of Divinity in India*, edited by Joanne Punzo Waghorne and Norman Cutler. Chambersburg, PA: Anima Publications, 1985.

Diack, A.H. *Gazetteer of the Kangra District. Parts II to IV: Kulu, Lahul and Spiti*. New Delhi: Indus Publishing, 1897.

Diehl, Carl Gustav. *Instrument and Purpose: Studies on Rites and Rituals in South India*. Lund, Sweden: C.W.K. Gleerna, 1956.

Diserens, Hélène. "Les *yogini* de la haute vallée du Kulu (Himachal Pradesh)." *Bulletin d'études indiennes* 9 (1991): 61-73.

–. "Images et symboles des déesses de la haute vallée de Kullu." *Bulletin d'études indiennes* 13-14 (1995-96): 91-115.

Eck, Diana L. *Darśan: Seeing the Divine Image in India*. 2nd enlarged ed. Chambersburg, PA: Anima Books, 1985.

Emerson, W.H. *Mandi State Gazetteer*. Lahore: Government Printing, 1920.

Fuller, Christopher J. *Servants of the Goddess: The Priests of a South Indian Temple*. 1984. Reprint. New Delhi: Oxford University Press, 1991.

Gell, Alfred. *Art and Agency: An Anthropological Theory*. Oxford: Clarendon Press, 1988.

Goudrian, T. "Deities of the Tree-Cutting Ceremony in Vaikhānasa Āgama." *Brahmavidyā: The Adyar Library Bulletin* 37 (1973): 75-86.

Grabar, Oleg. *The Mediation of Ornament*. Oxford: Princeton University Press, 1992.

Vashist, Sudarshan. *Kullu: dev samagam*. Shimla: Himachal kala sanskriti bhasha akadmi, 1995.

–. *Mandi dev milan*. Shimla: Himachal kala sanskriti bhasha akadmi, 1997.

Vidal, Denis. *Le culte des divinités locales dans une région de l'Himachal Pradesh*. Paris: ORSTOM, 1988.

Part 2

Images and the Elite Intellectual Culture:
Accommodations and Ambiguities

4

At the Right Side of the Teacher: Imagination, Imagery, and Image in Vedic and Śaiva Initiation

HANS BAKKER

Then shall the King say unto them on his right hand, Come, ye blessed of my Father, inherit the kingdom prepared for you from the foundation of the world.

– Matthew 25:34 (cf. Ecclesiastes 10:2)

The transformation of the Vedic religion into new systems of belief and practice, early Hinduism for short, is a process of cultural change that, despite two centuries of research, has been only partly understood. The replacement of the sacrificial fire by images of wood and stone is among the most obvious innovations. As has been convincingly argued by Phyllis Granoff,[1] this innovation was only reluctantly accepted in some circles of Brahminic orthodoxy. On the other hand, there can be little doubt that Vedic imagination informed the concept of God and His image (*mūrti*) in the newly emerging religions. It found expression in the Sanskrit texts of early Hinduism. The confrontation of this textual evidence with the material images of the archeologist is often perplexing, however.

An example of such a conundrum is the so-called Dakṣiṇāmūrti, mentioned in the Pāśupata texts, the *Mahābhārata*, and the later Śaiva literature of the Mantramārga. In this chapter, we will examine the Vedic origins of the imagery of the Dakṣiṇāmūrti. This *mūrti* appears

first and foremost to be an ideal image embedded in the ritual of initiation. The Vedic *upanayana* ceremony laid the structural foundations for the initiation rites of the later religious orders. The Dakṣiṇāmūrti appears to be a token of the theistic transformation of the Vedic imagination. It illustrates how literate Śaiva Brahmins took the Hinduistic turn. At first, material images played, if at all, only a secondary role in this transformation. However, in a religious world that was increasingly pervaded by material images of the divine, it was bound to happen that the visionary image became an archetype of visual representation, the Dakṣiṇāmūrti as an iconographic category. In this process, an essential characteristic of the vision of God as revealer was reinterpreted: His right side became interpreted as His southern face. The incongruity of this representation with the age-old religious idea of the south as being terrifying, inauspicious,[2] was to make a conundrum.

The Sitting Position of Teacher and Pupil in the Vedic *Upanayana* Ritual

Śatapathabrāhmaṇa

The *Śatapathabrāhmaṇa* 11.5.4 is our earliest source for the ancient *upanayana* ritual. A brief summary will highlight its major features.

(1) The pupil approaches a teacher and expresses the wish for apprenticeship by saying: "I have come for *brahmacarya* (*brahmacaryam āgām*)." He commits himself to be a *brahmacārin*.
(2) The teacher (*ācārya*) asks his name. The question implies the answer "who" (*ka*), conceived as another name of Prajāpati.
(3) The teacher takes the pupil by the hand, implying that he accepts him as a student, saying *indrasya brahmacāry asy, agnir ācāryas tavāham ācāryas tavāsāv iti*. Thus the *ācārya* and Agni are seen as homologous.
(4) He consigns the student to Prajāpati and Savitṛ and to all beings on heaven and earth.
(5) He consigns him to *brahman*, that is, he makes him a *brahmacārin* by saying *brahmacāry asi*, while he lets him sip water, which embodies the elixir of life (*amṛta*). Thus the pupil is initiated into the life eternal, and becomes a "wanderer in *brahman*."
(6) After this initiation – with or without delay (see n. 12) – the *ācārya* teaches the Veda by making him repeat its quintessence, the *Sāvitrī*.

The importance attached to the position of pupil and teacher during the Veda instruction is apparent from the fact that it is singled out for specification in the Brāhmaṇa. There appear to be two different traditions. According to one tradition, the student sits or stands at the right side *(dakṣiṇatas)* of the teacher, who, as is understood, is facing east. The position of the pupil is characterized by the term *bulva/bulba*. This word, apparently a hapax legomenon, is given by Mayrhofer (EWA) s.v. as 'etwa "seitwärts"' (with the remark: 'nicht klar'). Because of this sideways position, this tradition is rejected in the Brāhmaṇa, which opts for the alternative: the student should sit opposite the teacher looking at him from east to west.[3]

Which direction, we may ask, does the pupil face in the situation that is rejected? The commentary of Sāyaṇācārya does not resolve the question.[4] There can be little doubt that the teacher, homologous to Agni, is facing east;[5] the student, on the other hand, may be thought to be looking at his teacher in profile, that is, he may be facing north, for that is the region of the gods,[6] the region of living men as opposed to that of the deceased.[7] Or, he may face the northeast, since standing towards that direction Prajāpati created the creatures; there the gate of heaven is believed to stand.[8] The northeast may be particularly appropriate in the present case, because it is not only the direction into which Prajāpati issued the beings – Prajāpati to whom the student has just been consigned – but also the point of the compass where the sun (Sāvitṛ) rises at the summer solstice to begin a new year, the sun to whom the student has just as well been consigned and into whose mantra *(Sāvitrī)* he is actually being initiated, that is, whose mantra he is reciting. If directed to the northeast, the student is seated obliquely, not transversely, with respect to the teacher. It is difficult to determine whether *bulva* means "oblique" or "transverse."

Consequently, the first of the two alternatives discussed in the *Śatapathabrāhmaṇa*, the one that is rejected by the Brāhmaṇa itself, namely, that the student is sitting at the right side *(dakṣiṇatas)* of the teacher, allows for two interpretations: (1a) teacher is facing east and student is facing north, or (1b) teacher is facing east and student is facing northeast. (1b) is clearly a variant of (1a) and a combination of both is perfectly feasible: the pupil faces north, but, if appropriate, may look towards the northeast.[9]

That the Brāhmaṇa prefers alternative (2) – teacher and pupil sitting opposite to one another, directed to the east and west, respectively – may above all have practical reasons, since the teacher bestows more

than only learning upon the neophyte at this occasion; a change of position may have been thought to be cumbersome.[10] The first alternative (1a-b), on the other hand, because it makes sense in terms of the mystique of the quarters, may have preserved original traits. Moreover, the right side of the teacher has symbolic meaning: "There is ample evidence that the right hand or the right side of the body was decidedly preferred to the left."[11] We will return to this below.

The *Śatapathabrāhmaṇa* does itself refer to earlier modalities of the ritual recitation of the *Sāvitrī*, when it reads: "In former days, however, they recited that same verse (the *Sāvitrī*) at the end of the year (*saṃvatsare*), thinking 'being as old as a year, indeed, children are born; as soon as born, we impart speech to him.'"[12] The appropriate direction in this ritual is, or so it seems, the northeast, in which direction Prajāpati gave birth, Prajāpati who is equated with the year.[13]

The Gṛhyasūtras

The two traditions indicated briefly in the *Śatapathabrāhmaṇa* can be followed in the *Gṛhyasūtra* literature. As one would expect, the only *Gṛhyasūtra* that belongs, like the *Śatapathabrāhmaṇa*, to the White Yajurveda, the *Pāraskaragṛhyasūtra*, follows the accepted tradition of the Brāhmaṇa, although it mentions the alternative. The place where the teaching takes place is specified: north of the sacrificial fire.

> After (the pupil) has made a *pradakṣiṇa* around the fire he takes his seat. The teacher, touched (by the pupil), pours oblations of ghee into the fire; when the remains have been eaten, he instructs him: "you are a *brahmacārin*, drink water, do your service, may you not sleep in the daytime, restrain your speech, put fuel on the fire, drink water." Then he recites to him the *Sāvitrī*, north of the sacrificial fire, while (the pupil) is sitting near him with his face turned west, looking (at him) and being looked at. Some: "to him while standing or sitting to his right side."[14]

The *Gṛhyasūtras* of the Ṛgveda, the *Āśvalāyana-* and *Śāṅkhāyana-gṛhyasūtras*, although different in details and sequence, seem basically to follow the accepted tradition of the White Yajurveda with regard to the place of teaching, to the north of the fire, and the vis-à-vis position of teacher and pupil.[15] The same goes for the *Gobhilagṛhyasūtra* of the Sāmaveda.[16]

The other tradition, rejected in the *Śatapathabrāhmaṇa*, we find in

some *Gṛhyasūtras* affiliated with the Black Yajurveda, though not in all.[17] For an assessment of the *upanayana* ritual according to this tradition, we turn to the elaborate description in the *Bhāradvājagṛhyasūtra*. (BhGS). Its procedure may be epitomized (with cross-references to the *Hiraṇyakeśigṛhyasūtra* [HirGS]).

The teacher prepares for the *homa* sacrifice by consecrating the implements, etc. (BhGS 1.3). He prepares west of the sacrificial fire a seat of grass *(kūrca)*, of which the grassblades are turned to the north. There the teacher takes his seat, his face turned to the east; the pupil *(kumāra)*, who has put on the *yajñopavīta* and sipped water, takes his seat at the right side of his teacher *(dakṣiṇatas)*.[18]

The teacher performs the *homa* sacrifice (BhGS 1.4), then he gives the pupil a new cloth, a girdle of muñja grass *(mauñjī mekhalā)*, and a skin of the black antelope *(ajina)* (BhGS 1.5-6). Next (BhGS 1.7), (the teacher) strews to the west of the sacrificial fire darbha grasses, on which the two (teacher and pupil) take their stand, one facing east, the other facing west. The one facing east takes the hand of the one facing west and vice versa. A servant fills the *añjalis* of both with water. By his *añjali* (the teacher) transfers the water into the *añjali* (of the pupil).[19]

A formal interview takes place in which the teacher asks for the name of the pupil and subsequently leads him *(upanayāmi)* to Prajāpati (Ka) (BhGS 1.7). The teacher consigns the pupil to several other deities, and asks him to step on a stone *(aśman)* and to put fuel on the fire (BhGS 1.8).

Then the pupil makes a *pradakṣiṇa* around the fire, takes his seat at the right side *(dakṣiṇatas)*, scil. of the teacher, while he turns to the north, touches (the feet of the teacher), and asks: "O lord, recite the *Sāvitrī*."[20] The place where the teacher is seated is again not specified, but presumably he is still seated west of the fire facing east, that is, the place where he performed the *homa* sacrifice, took the interview accompanied by the *añjalis*, and consigned the pupil to Prajāpati, etc. This is corroborated by the *Hiraṇyakeśigṛhyasūtra*.[21]

The Sitting Position of the Preceptor and His Audience

Veda study is of course not restricted to the *brahmacārin*. Outside the village, retreated into the wilderness *(araṇya)*, Brahmins devoted themselves to study and, if they became known for their learnedness, attracted students. In this way, we conceive of the origin of the different Upaniṣad teaching traditions and of other early Indian

schools of philosophy. The subject of study and teaching may have changed, but the setting is traditional and has had a long life. We find such an idyllic setting, for instance, in the *Śāṅkhāyanagṛhyasūtra*, where it describes "the rules for the forest-dweller regarding his (Veda) study."[22]

For this study *(svādhyāya)*, the forest-dwellers should go to a pure spot in the northeast that is open at the eastern side. The site is circular or marked by a circle with an entrance to the east or the north. After some preliminary rites, they may take up their studies.[23] The following describes the teaching situation.

atha praviśya maṇḍalam / prāṅmukha ācārya upaviśyaty udaṅmukhā dakṣiṇata itare yathāpradhānam / asaṃbhave sarvatomukhāḥ / pratīkṣerann udayam ādityasya / vijñāya cainaṃ dīdhitimantam / adhīhi bho3 iti dakṣiṇair dakṣiṇaṃ savyaiḥ savyaṃ dakṣiṇottaraiḥ pāṇibhir upasaṃgṛhya pādāv ācāryasya nirṇiktau /

Then, after having entered the circle, the teacher is seated with his face turned to the east; the others sit with their faces turned to the north at the right side (of the teacher), according to rank; if this is impossible [i.e., if there is not enough space] they may face all directions. They should wait for the rising of the sun. And when they have seen it (rise) in all its splendour, they say: "Sir, recite," while touching with their right and left hands the hallowed feet of the teacher – his right (foot) with their right, his left (foot) with their left hands. (ŚāṅGS 6.3.1-6)[24]

The *Śāṅkhāyanagṛhyasūtra,* which, as we have seen, agreed with the tradition of the White Yajurveda in opting for the face-to-face position of teacher and pupil north of the sacrificial fire in the *upanayana* ritual (see n. 15), reserved the alternative position, in which the student sits at the right side of the teacher facing north, for the traditional school of the hermitage.

It is to be expected that this time-honoured traditional setting of religious education may be met again in the *Mahābhārata*. The practice of standing with one's face turned to the east when making a solemn pronouncement or to reveal a secret is attested in the great epic, as the following example may show:

But then, when Kṛṣṇa, haven of Brahmins, heard the cause of Pārtha's [i.e., Arjuna's] sorrow, he touched water and stood still, his face turned to

the east; and the mighty lotus-eyed one spoke this word for the benefit of
Pāṇḍu's son, intent upon killing the army of Jayadratha: "O Pārtha, there
is a supreme unfailing weapon called 'Pāśupata,' by which god Maheśvara
killed all the Daityas in battle."[25]

However, I have not found in the *Mahābhārata* an exact parallel of the
situation described in the *Śāṅkhāyanagṛhyasūtra,* in which the position
of the audience is specified.

The Sitting Position of *Guru* and Novice in Early Śaiva Initiation Ritual

We may investigate next whether the tradition of Vedic initiation and
instruction informed similar rites in the emerging religious
communities. In his *Change and Continuity in Indian Religion,* J. Gonda
elaborates the theme of the book with regard to the Vedic *upanayana*
and the initiation *(dīkṣā)* in the monastic orders:

> Instead of *upanayana* and the renewable *dīkṣā* we find in the monastic
> orders an ordination proper – sometimes called *dīkṣā* – which is to be
> preceded by a noviciate beginning with a ceremony which is a parallel
> of the *upanayana,* and in various Hindu sects and communities an
> admission to full membership, to priesthood or guruship, which is also
> known as *dīkṣā.*[26]

Describing the initiation ritual of ascetics, he remarks:

> *dīkṣā.* This term is translated by "consecration" and "renouncement of the
> world." On this occasion one is *inter alia* given a new name. During
> important acts, such as study, confession, one has to turn east- or
> northward; as is well known these directions are of special importance in
> brāhmanic rites, the "door of heaven being in the North-east."[27]

We shall confine ourselves here to the Śaiva orders and investigate
whether these traditional directions of teacher and student can
actually be found in their early texts.

The earliest text of a Śaiva order that we have is the *Pāśupatasūtra*
with the commentary of Kauṇḍinya. The initiation in the order is
briefly described by Kauṇḍinya when he explains the future tense
used in the first Sūtra *(vyākhyāsyāmaḥ,* "we shall expound"):

"Shall" *(syā)* refers to the time required, namely the time that is required (before the exposition can begin) by the *ācārya* to consecrate a Brahmin at Mahādeva's "southern *mūrti*," with ashes that are consecrated with the (five) mantras "Sadyojāta," etc., and to initiate him in the mantra, after he has made him discard the signs of his origins – a Brahmin whose (antecedents) have earlier been screened, as follows from the word "therefore" *(ataḥ)* in the Sūtra, who comes (to him) from amongst the householders, etc., and who has (already) engaged himself in fasting and observances.[28]

The other Pāśupata text that has survived is the *Gaṇakārikā*. The *Ratnaṭīkā*, commenting on *Gaṇakārikā* 5, in which the elements of the initiation are summed up – the (right) materials, the (right) time, the ritual (of consecration), the image *(mūrti)*, and the preceptor *(guru)*[29] – explains what in the context of the consecration ritual *(saṃskāra)* is meant by *mūrti*. It reads:

> The word image *(mūrti)* in the Kārikā aims at the spot a little to the right of that which [by Kauṇḍinya] in [his commentary on] the "Sūtra on offering" [i.e., PS 1.8-9] is described as the focus of worship of Mahādeva being characterized by the erect phallus, etc. – a spot not separated from it by a wall or the like.[30]

Mūrti is to be interpreted here as a locative, "at the *mūrti*," referring to the site of consecration, said to be by the right side of *(dakṣiṇā)*, close to and not separated from that which in *Pāśupatasūtra* 1.8-9 is qualified as Mahādeva's manifestation *(rūpa)*. If we assume that the commentator of the *Gaṇakārikā* and Kauṇḍinya both describe the same initiation tradition, we may deduce from the Ṭīkā that the words of Kauṇḍinya *ad* PS 1.1, *mahādevasya dakṣiṇasyāṃ mūrtau*, are to be understood as saying that the novice is seated on the right side of Mahādeva.[31]

Although the esoteric intention of both authors clearly hampers our understanding, I would hazard the conjecture that the *guru*, who initiates the student into the Pāśupata observance *(vrata)* by communicating to him the doctrine as revealed by Śiva himself in the *Pāśupatasūtra*, embodies Śiva. The novice is seated next to him on his right-hand side, that is, he is situated "at the *mūrti*"; and this designation is understandable as it refers to a situation in which the neophyte envisages the image *(mūrti)* of the divine preceptor in his guru, that is, he sits at the right side of Mahādeva's visual manifestation

and sees Him, His *rūpa*, His benign epiphany, in front of him.[32] The two natures of the teacher, the learned and pious person of flesh and blood, and the divine archetype, are explicitly stated in the Ṭīkā on the word "guru":

> "Guru" is the preceptor *(ācārya)*; he has two forms, on account of the distinction supreme and not-supreme. With regard to these (two forms) not- supreme is he as being circumscribed by the knowledge of the five categories. The supreme guru is the lord Maheśvara, who empowers the former.[33]

If we turn to the *Svacchandatantra,* describing the *samayadīkṣā,* we find the above interpretation confirmed:

> After he has performed the (preliminary) rites, he [i.e., the guru], rejoiced at heart, makes the pupil, whose eyes are full of joy, stand up and, taking him by his hand, leads him towards the "southern *mūrti*": Having made a circle there into a seat (consisting) of the syllable *om* with the help of a flower, he places the pupil upon it, his body erect, his face turned to the north. After the guru has installed himself whilst facing east, he performs the sprinkling and subsequent rites.[34]

The Dakṣiṇāmūrti

From the place of initiation where Śiva manifests himself to the novice for the first time in that he assumes the form of *guru*, we now proceed to the public domain of the temple. In that context, the word *mūrti* is used to refer to the physical object of veneration. This connotation underlies the Ṭīkā's description of the daily worship of the initiated Pāśupata, who, after his bath in ashes,

> enters slowly the sanctum. Then he falls to his knees on a spot to the right of the image *(mūrtidakṣiṇe bhūpradeśe),* makes an *añjali* before his heart, and looks at Śiva in the image as if He were there in His very person,

and which means that

> he, fully concentrated and with his head turned towards the north, practises *japa* with the aim of that *(viśeṣa)* detachment from the sensual

world, after which *japa* he sinks into meditation on Śiva; only then *(eva)* he should burst into repeated boisterous laughter.[35]

Analogous to the situation of initiation, the Pāśupata envisages Śiva in front of him, this time, however, in the physical object of worship. It is towards this manifestation of God that the Pāśupata turns and in whom he is sunk, an idea we also find in the following passage of the Southern Recension of the *Mahābhārata* where broad-minded Vāsudeva teaches:

> The holy man who has reached Me [i.e., Vāsudeva] fixes himself upon My body *(mūrti)*, or on Rudra's Dakṣin(ā)mūrti, especially on the fourteenth *(tithi)*. He, the great ascetic, while he is venerated by Siddhas, Brahmarṣis and celestial folk, and while his praises are sung by Gandharvas and choirs of Bhūtas, he of great splendour enters either Me or Śaṃkara.[36]

We thus observe that the term *mūrti* in the Pāśupata context on the one hand refers to the "image" (meaning bodily manifestation) and, on the other hand, when used in the locative (or when the locative is meant), may refer to a particular spot near the image. Both meanings are, as we will argue, comprehended by the technical term *dakṣiṇāmūrti*, literally "southern/rightward image/body/figure." This term is explained by Kauṇḍinya when he comments on *Pāśupatasūtra* 1.9: *mahādevasya dakṣiṇāmūrteḥ /*.

> *"devasya"* is a genitive. The relation is one of owner and owned; it bears reference to (His) grace *(parigraha)* only. *"Dakṣiṇā"* in the Sūtra has the meaning of a spatial division; the sun divides the quarters and the quarters divide the *mūrti*. (That) which the word *"mūrti"* designates is this form *(rūpa)* which is seen in (His) proximity by one who is facing north while standing at God's right side *(dakṣiṇe pārśve)*, (a form) that is characterized by the bull-banner, lance in hand, Nandin, Mahākāla, erect phallus, etc., or it is (that) to which the laymen resort, "the sanctuary of Mahādeva." The object of worship is there.[37]

For the initiated Pāśupata like Kauṇḍinya, the term *dakṣiṇāmūrti* thus seems rather to refer to a situation or state than to a particular "spot" or "image," namely, the state in which God appears to him

who sits or stands at His right side and sees Him in front of him (for instance, in the temple image). It is the state in which Śiva reveals himself "towards him who is at His right side" (dakṣiṇā),[38] namely, by turning His auspicious, gracious side towards him who is facing north – the sitting position of the novice since Vedic times. The strength of this tradition obviously rests on the religious idea of the right side. To turn one's right side upon someone is an auspicious act; in the case of God, it is an act of grace in which He reveals Himself and His doctrine "unto them on his right hand." It happens to the blessed ones in His proximity, that is, in heaven on the Himavat, and as such to the initiated Pāśupata in his yoga with God, who may be represented either by the image or by the guru. In sum, the Pāśupata Dakṣiṇāmūrti is a state in which God reveals one quarter of Himself, the form to which He grants access, that is, yoga; it is Śiva's body/ form of grace.[39]

In spite of the use of the word mukha, used here in a figurative sense, I think the Śvetāśvatara Upaniṣad 4.21 expresses this very idea:

"Unborn is He," so saying, Let a man in fear approach Him: O Rudra [show] thy right [auspicious] cheek, Protect me with it ever![40]

In the direct vision that is granted to the Pāśupata, the ideal image of Mahādeva is visualized as being accompanied by his acolytes Nandin and Mahākāla, the bull-banner, and so on, in short, a tableau de la troupe. The physical image in the sacred compound is not defined. If our interpretation is correct, it may be any image, most likely a liṅga, considered by the Pāśupata laymen as "the image" (mūrti) of Mahādeva, a designation that for the initiate is true only in a metaphorical sense.[41]

The concept of dakṣiṇāmūrti thus comprises the manifested form (rūpa) of God, the (physical) image or body (mūrti) in which it may be envisaged, and the right side (dakṣiṇe pārśve), which indicates the Pāśupata's position with respect to Mahādeva and his embodiment. As such, the term is applicable to every situation in which the Pāśupata enters into contact with his object of worship. And this appears to have been the intention of the author of the Pāśupatasūtra when we read PS 1.8-9 coherently (as also the author of the Ṭīkā seems to have done: upahārasūtra, above p. 124): "He should worship with offerings of laughter, singing, dancing, bellowing, obeisance, and muttering to the gracious form/body (dakṣiṇāmūrti) of Mahādeva."[42] The same idea underlies the Ratnaṭīkā at Gaṇakārikā 7 (p. 18) where it

says that the Pāśupata should consecrate the ashes with mantras in the temple "at Śiva's Dakṣiṇāmūrti,"[43] or the *Skandapurāṇa* when it advises that one should offer rice pudding with ghee at the "southern *mūrti*" during one year in order to become like Nandin.[44]

It seems obvious that the same idea underlies the initiation rite, in which the place of the physical image, i.e., the *mūrti,* may be taken by the *guru* who represents Śiva (as the *ācārya* represents Agni in the *upanayana*). In fact, it appears most likely that the concept of *dakṣiṇāmūrti* originated from this ritual in which Śiva as supreme teacher reveals himself. To this primordial figure – a god who is facing towards the east but who confers his blessings, namely, his "right" side, on his creatures, be they gods, Siddhas, or worshippers in Bhāratavarṣa – the pseudo-Śaṃkara pays homage:

tasmai śrīgurumūrtaye nama idaṃ śrīdakṣiṇāmūrtaye //

This obeisance is to Him who has the illustrious form of the teacher, to Him who has the illustrious form of grace.[45]

The Dakṣiṇāmūrti and Iconography

Having thus established the original meaning of Dakṣiṇāmūrti, we may proceed to its current iconographic denotation.

Among the earliest texts that describe the *dakṣiṇāmūrti* in iconographic terms may be the two Upajāti verses that are quoted by Gopinatha Rao, which he ascribed to the *Viṣṇudharmottarapurāṇa,* but which are not found in the printed text of that name:

His right (lower) hand shows the *(jñāna)* mudrā and in his (right) upper (hand) he (holds) a white rosary; in his left (lower hand) he is holding a book comprising all the Āgamas and more, and with his upper (left hand) he holds the cup with nectar; he is seated on a white lotus, his colour is white, powerful, with white cloth and ointment, and crowned by the crescent, teaching knowledge to the sages: that is what they call his *dakṣiṇā-mūrti.*[46]

On this and other, predominantly late South Indian texts Rao based his description, which was repeated without any significant change by almost all later indological writing on this subject. It may be significant to note that in the above passage the southern orientation of the image

is not mentioned. To substantiate his view, however, Rao wrote:

> One account gives an explanation regarding the etymology of this name; it states that because Śiva was seated **facing** south when he taught the *ṛishis yōga* and *jñāna* he came to be known as Dakshiṇāmūrti. This aspect of Śiva is always invoked by students of science and arts.[47]

Unfortunately, however, we are not informed about this "account,"[48] but Rao, without any doubt, was following an Indian iconographic convention, which prescribes "that in all Hindu temples, both Śaiva and Vaiṣṇava, the niche on the south wall of the central shrine should have the figure of Dakshiṇāmūrti enshrined in it."[49] Bruce Long, who devoted an article to the subject, relied heavily on Rao, but he put his finger on the problem when he professed that he was puzzled

> as to why the southern direction, which is believed almost everywhere in India to be sinister and inauspicious, should in this instance be evaluated as auspicious and benign.
>
> It is not beyond reason that we explain this curiously positive evaluation of the southern direction on the basis of the same religious principle by which the Furies in Greece came to be called the "Eumenides," and Rudra, the ferocious Howler, came to be addressed as Śiva, the Auspicious. Perhaps the worshippers of Śiva hoped that by having the Divine Preceptor face the southern direction, that area would, thereby, lose its sinister qualities and become benign.[50]

Although I shall not deny that considerations such as the above may have played some role, at least in coming to terms with the apparent incongruity once established, it is important to recognize that, if they played a role, they did so in retrospect. The cause of the alleged incongruity, I would argue, is a reorientation of the tradition. A cult concept was transposed to iconography. Part of the original meaning was retained – Śiva as the source of knowledge – part of it was reinterpreted, namely, the direction God faces when expounding His wisdom: His "right side" became His "southern face." The southern temple walls were consequently thought most suitable for showing images of Śiva in his role of teacher.[51] Thus the *dakṣiṇāmūrti* entered the textbooks of Indian architecture, for instance the *Mayamata*, which divided Kauṇḍinya's vision into two:

À chacun des paliers des temples il faut disposer aux points cardinaux des (images des) dieux. Au rez-de-chaussée on place à l'Est les deux guardiens de la porte, Nandi et Kāla; au Sud c'est la Dakṣiṇāmūrti à l'Ouest Acyuta ou Liṅgasambhūta et au Nord Pitāmaha.[52]

Finally the question of when and where this cult concept turned into an iconographic one must be briefly addressed. This development may actually have had two phases:

(1) an anthropomorphic (iconic) representation of Śiva, who through attributes, a book, for instance, a *mudrā (vitarka-, vyākhyāna-mudrā)*, or some other gesture, or because he sits alongside a pupil, is identifiable as the supreme teacher. This image, or at least Śiva as its main character, should face east.

(2) an anthropomorphic representation of Śiva, two- or four-armed, with or without the attributes of (1), but one whose characteristic is that he is directed to the south without showing his terrifying aspect.

The transition of (1) to (2) calls forth the "incongruity." This incongruity may be considered to have been solved when the image of the Dakṣiṇāmūrti began to evolve an autonomy of its own, next to and independent of that of Bhairava. Given the fact that the central image in the *garbhagṛha* is orientated towards the east, the image at the southern wall may be seen as an original "visualization" of the right side, expressing the one aspect of the god enshrined, from whom it became spatially detached. Buddhist influences (e.g., the deer at Śiva's feet, the tree above his head) are discernible in this process of iconographic composition.[53] The genesis of the iconic representation of the teaching Śiva thus ended with its "banishment" outside the cultic sphere. The idea of the *guru* as the support of divinity was transferred onto the central cult object in the sanctum, the liṅga. Therewith the Dakṣiṇāmūrti on the southern outer temple wall lost its original ritual setting. It became part of the decoration program of the Śiva temple.

The process of transformation from cult to iconographic concept seems to have been completed (in South India at least) by the tenth century (i.e., the early Coḷa period), but may have started much earlier. An early textual testimony of this process is found in the original *Skandapurāṇa*, which we date to the sixth or seventh century. It tells the myth of Tilottamā. When the nymph arrives at Śiva's right – that is, in the *pradakṣiṇa* context to be conceived of as his southern side – the following happens:

atha sā dakṣiṇāṃ mārtiṃ praṇeme cārudarśanā /
nirjagāma tadā dīptaṃ mukhaṃ suraguros tataḥ // 18 //

Then she bowed to the southern figure / body with her luscious appearance; hereupon sprung forth the shining face of the *guru* of the gods. (SP 62.18)

The "incongruity" is not yet solved, since the text continues in the following verse with the description of this face in terms that suit only the figure of Bhairava, not that of the teacher.[54]

To assess the above-sketched development properly requires an art-historical scrutiny of the available archeological material examined for the above features; this cannot be done here. Material representing phase 2 is not hard to find. A relatively early example dating from the late Pallava period (AD 875-900) is illustrated, for instance, in a volume by Jacques Dumarçay and Françoise l'Hernault.[55] It shows a four-armed Śiva as teacher on the southern wall of the *garbhagṛha* of the Vīraṭṭāneśvara Temple in Tiruttani. His hands hold *vitarkamudrā*, rosary, lotus, and book.

The question of when and where exactly this type of "southern image" is found for the first time is more difficult to establish, partly for the same reasons that the material representing phase 1 proves so hard to identify. It is often difficult to establish which direction the teaching Śiva is facing if the image or relief is no longer part of a spatial construction or has been re-employed. It may even be doubted whether our phase 1 is a historic reality at all; possibly the teaching Śiva, the Dakṣiṇāmūrti as an iconographic category, was from the beginning conceived of as facing the south.

To conclude, I wish to present an image that may alleviate our doubts somewhat. It concerns a crossbar found in Nagarī (Rajasthan) illustrated in J.G. Williams's *The Art of Gupta India*, Plate 216. On page 140f., this scholar gives the following description:

> The most impressive carvings at Nagarī are the remains of a gigantic gateway or *toraṇa* that must belong to the early sixth century on the basis of its relationship to works from Mandasor.

The lintel has sculptures on both sides. The reliefs on what appears to be the reverse (mistakenly said on page 141 to be illustrated in Plate 216) are identified by Williams as scenes from "the story of the encounter between Arjuna and the *kirāta* or hunter." After his

fight with Śiva incognito, Arjuna receives the Pāśupata weapon, a scene that is unfortunately missing, but may have been depicted in a relief that belonged to the part of the crossbar that has broken off and is missing.[56]

About the other side of the lintel (Figure 4.1), Williams observes:

> The subjects of the reverse (obverse in Plate 216) of this same crossbar remain to be identified. The third panel from the right (not the center of the lintel) shows a seated figure with twisted locks in meditation, surrounded by four worshippers; despite the lack of the club, this might represent Lakulīśa. If so, the remaining scenes are presumably Śaiva.[57]

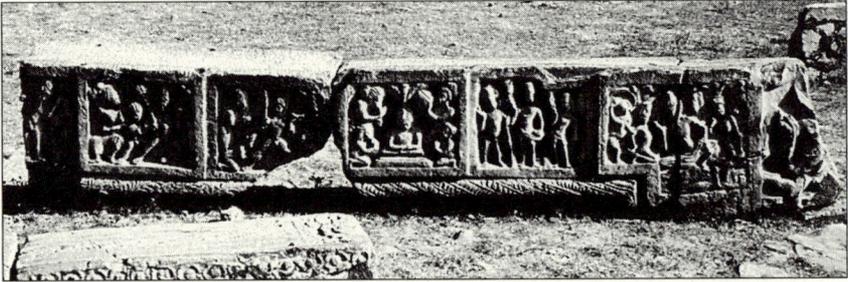

Figure 4.1. Crossbar found in Nagarī (Rajasthan) (courtesy of J.G. Williams).

I think this identification may be correct. In a letter (e-mail dated 10 March 2001), Joanna Williams informed me that she "wonders whether the scene at the left end of this face might not represent the destruction of Dakṣa's sacrifice." This too seems to me to be right, and I may adduce some further evidence for this identification on the basis of the photographs that Professor Williams has so kindly put at my disposal.

The story of Śiva's destruction of Dakṣa's sacrifice is told in MBh 12 App. I, no. 28 (= Northern Recension). Vīrabhadra and Bhadrakālī and others destroy Dakṣa's sacrifice in Gaṅgādvāra. Dakṣa takes refuge with Maheśvara (lines 123ff.). Devadeveśa himself appears (lines 140ff.). Dakṣa begs that not all his sacrificial toil shall have been in vain (line 151). This is granted by Hara. Then the text reads (lines 154f.):

jānubhyām avanīṃ gatvā dakṣo labdhvā bhavād varam /
nāmnām aṣṭasahasreṇa stutavān vṛṣabhadhvajam //

Dakṣa fell to his knees, having received (this) boon from Bhava; then he praised Vṛṣabhadhvaja by his Thousand-and-eight Names.

The stotra of Śiva's thousand-and-eight names follows (lines 160-389). Śiva expresses his satisfaction and promises Dakṣa that he will gain the benefit of a thousand Aśvamedha and a hundred Vājapeya sacrifices, thanks to his grace (lines 390-94). Then Mahādeva bestows upon him another boon (lines 395-406): the *vrata*, based on the Veda with its six *aṅgas* and the Sāṃkhya-yoga, arduous on account of its *tapas*, which is transgressive of, in some cases conformable to, the ordinary *dharma*, which is practised by those who are nearing the end, and which is beyond the (ordinary four) stages of life *(atyāśrama)*.[58] Mahādeva promises him the reward of this *vrata* (lines 407-9):

mayā pāśupataṃ dakṣa yogaṃ utpāditaṃ purā /
tasya cīrṇasya tat samyak phalaṃ bhavati puṣkalam /
tac cāstu te mahābhāga tyajyatām mānaso jvaraḥ //

Long ago, O Dakṣa, the Pāśupata *yoga* was created by me; that *(yoga)* is the eminent, proper reward of practising that *(vrata)*, and that *(yoga)* shall be yours, O blessed one. Throw off the fever of (your) soul![59]

In other words: Mahādeva instructs/initiates Dakṣa in the Pāśupata observance; this is the boon that will lead him eventually to the end of suffering *(duḥkhānta)*, the Pāśupata *yoga* or union with God, and this salutary instruction, it would seem to me, is depicted in the first panel from the right on the lintel, in which a bountiful Mahādeva leans towards the right (Figure 4.2). If we assume that the *toraṇa* was facing east and that this is the obverse side of the lintel, Maheśvara faces east. He is accompanied by his wife.[60] Dakṣa is on his knees (see above), facing north, and is held by one of the *gaṇas*. It thus appears that the central theme of both sides is the acquisition of a Pāśupata good. The *toraṇa* may have stood at the entrance of a Pāśupata *āyatana*, and the depiction of the teaching scene, the Dakṣiṇāmūrti or Śiva's gracious form, would therefore be appropriate, if our analysis is correct.

Figure 4.2. First panel from the right on the crossbar found in Nagarī.
Mahādeva instructs Dakṣa in the Pāśupatavrata (courtesy of J.G. Williams).

Acknowledgements

This chapter elaborates upon an earlier article, Hans Bakker, "Dakṣiṇāmūrti," in *Essays in Honour of Asko Parpola*, ed. K. Karttunen and P. Koskikallio (Helsinki: Finnish Oriental Society, 2001), 41-53. The chapter owes much to the critical readings of earlier drafts by Drs. P. Granoff, G. Colas, and H. Isaacson.

End Notes

1 Phyllis Granoff, "Reading between the Lines: Colliding Attitudes towards Image Worship in Indian Religious Texts," ed. Gilles Tarabout and Gérard Colas (forthcoming).

2 Cf. Henk W. Bodewitz, "Classifications and Yonder World in the Veda," *Wiener Zeitschrift für die Kunde Südasiens* 44 (2000): 19-59.

3 ŚB 11.5.4.14: *átha haíke dakṣiṇatáh* [/] *tiṣṭhate vā́sīnāya vā́nvāhur ná táthā kuryād yó hainaṃ tátra brūyād bulbáṃ nv ā́ ayám imám ájījanata bulbo bhaviṣyatī́tīśvaró ha táthaivá syāt tásmāt purástād evá pratī́ce samī́kṣamāṇāyā́nubrūyāt* // 14 //. "Now some recite (to the pupil) while the latter is standing or sitting at the right side (of the teacher). One should not do so. One would be able to say to him in that case: 'Yes, indeed, he (the teacher) has begotten him (the student) sideways, and sideways [i.e., wayward] he (the student) will be'; and so, indeed, it will come to pass. Therefore he should recite to (the pupil) sitting in front of him, while the former is westward looking.'"

4 Sāyaṇa glosses: *ayam ācārya imam śiṣyam atha bulvaṃ tiraścīnaṃ prāṅmukham ajījanat tathā cāyaṃ [b]ulvah parāṅmukho bhaviṣyatīti* /. I take *prāṅmukham,* like *bulvaṃ tiraścīnaṃ,* as an adverb qualifying *ajījanat:* "*bulva,* i.e., transversely, while facing forward/eastward (*prāṅmukham*), he has begotten (the pupil)"; this adverb, referring to the position of the teacher, serves to emphasize the contrast with the pupil, who will turn away (*parāṅmukha*), will be adverse. *Bulva* thus means transverse (*tiraścīna*), adverse (*parāṅmukha*), which, again, suggests that teacher and pupil sit at right angles.

5 This is the default position. "In the domestic rites the sacrificer stands to the west of the fire facing the east": Jan Gonda, "Vedic Ritual: The Non-Solemn Rites," *Handbuch der Orientalistik* (Leiden-Köln: Brill, 1980). Cf. Bodewitz, "Classifications and Yonder World," 25, 49.

6 ŚB 12.7.3.7: *úttaro vaí devalokó, dákṣiṇah pitṛloká[h].*

7 ŚB 13.8.1.6: *údīcī vaí manuṣyā̀ṇāṃ dík.* Cf. Gonda, "Vedic Ritual," 53; Bodewitz, "Classifications and Yonder World," 23.

8 ŚB 6.6.2.2-4: *údaṅ prā́ṅ tíṣṭhan* / *údaṅ vaí prā́ṅ tíṣṭhan prajā́patih prájā asṛjata* // 2 // *yádve(v)ódaṅ prā́ṅ tíṣṭhan* / *eṣā́ hobháyeṣāṃ devamanuṣyā̀ṇām díg yád údīcī prā́cī* // 3 // *yádvevódaṅ prā́ṅ tíṣṭhan* / *etásyāṃ ha diśí svargásya lokásya dváraṃ tásmād údaṅ prā́ṅ tíṣṭhann ā́hutīr juhoty údaṅ prā́ṅ tíṣṭhan dákṣiṇā nayati dvāraìva tát svargásya lokásya vittám prápādayati* // 4 //. Cf. Gonda, "Vedic Ritual," 53; Bodewitz, "Classifications and Yonder World," 24.

9 Gonda, "Vedic Ritual," 54, gives a confusing rendering of this position:

"On the other hand, the *brahman* (priest) is placed or sits south ... The same position is prescribed to the boy who is to be initiated before a girdle is tied round his waist, which is to protect him against evil influences." The boy is not said to sit in or face the south, but to sit at the right side of the teacher. That this coincides with the south is secondary and as such does not play a symbolic role, as I will argue in this chapter (cf. Bodewitz, "Classifications and Yonder World," 26).

10 According to the Grhyasūtras, the pupil receives, among other things, a girdle and a staff, to which the sacred thread may be added. All three items are missing in the ŚB account. It seems that bestowing the *yajñopavīta* upon the novice at this occasion is a relatively late addition (see Ram Gopal, "India of the Vedic Kalpasūtras," Delhi, 1959, 296). There is obviously a loss of symbolic significance in this second position of the pupil compared with the first alternative. Surveying the meaning of the western direction in Vedic ritual, Gonda, "Vedic Ritual," 55, observes: "It follows that facing eastwards whilst standing in the west [as does the *ācārya*] results in a desired effect, so that in the west one can be prosperous; facing the west does not however produce results."

11 Jan Gonda, "The Ritual Sūtras," *A History of Indian Literature*, vol. 1, fasc. 2 (Wiesbaden: Harrassowitz, 1977), 624; Gonda, "Vedic Ritual," 57-60. "In the case of male beings the right side was auspicious, most probably because it was the 'male' side. *Atharvavedaparisiṣṭa* 70 c 25, 5 a royal sacrificer seeing that the flame of a (sacrificial) fire points to the right will be victorious. The side of strength and auspiciousness is also widely regarded as that of benignity, allegiance, benediction": Gonda, "Vedic Ritual," 60.

12 ŚB 11.5.4.6: *tā́ṃ ha smaitā́ṃ purā́ saṃvatsé, 'nvāhuḥ saṃvatsarásaṃmitā vaí gárbāḥ prájāyante jātā́ evā́smiṃs tád vā́caṃ dadhma íti.* Sāyaṇa (ad loc.) takes this to mean that the teaching of the student of the *Sāvitrī* took place a year after the initiation (or after a shorter period, as specified in the following paragraphs).

13 Jan Gonda, "Prajāpati and the Year," *Verhandelingen der Koninklijke Nederlandse Akademie van Wetenschappen*, Afd. Lett., N.R., Deel 123 (Amsterdam: North-Holland Publishing Company, 1984).

14 PārGS 2.3.1-4: *pradakṣiṇam agniṃ parītyopaviśati // 1 // anvārabdha ājyāhutīr hutvā prāśanānte 'thainaṃ saṃśāsti // 2 //* **brahmacāry asy apo 'śāna karma kuru mā divā suṣupthā** *vācaṃ yaccha* **samidham ādhehy apo 'śāneti** / / 2 / / *athāsmai sāvitrīm anvāhottarato 'gneḥ pratyaṅmukhāyopaviṣṭāyopasannāya* **samīkṣamāṇāya** *samīkṣitāya //* 3 *//* **dakṣiṇatas tiṣṭhata āsīnāya vaike** / / 4 / /. Words in **boldface** are literal quotations from the ŚB 11.5.4.5, 14. Stenzler, in his translation (1878, 306),

leaves *dakṣiṇatas* out altogether. Oldenberg, in his translation (1886, 306), takes *dakṣiṇatas* as referring to the fire: "to the south (of the fire)," which, since we are here concerned with a literal quote from the ŚB, is certainly wrong.

15 The *Āśvalāyana* gives the following procedure. The teacher, touched (by the pupil), after having poured (oblations of ghee into the fire), stands to the north of the fire, his face turned east; opposite him, with his face turned west, the other (ĀśvGS 1.20.2-3: *samanvārabdhe hutvōttarato 'gneḥ prāṅmukha ācāryo 'vatiṣṭhate // 2 // purastāt pratyaṅmukha itaraḥ // 3 //*). Then, while pouring the water of his *añjali* into that of the pupil, the teacher consigns the pupil to Savitṛ and to Prajāpati. After this, the pupil puts on fuel and touches the fire. Then, without mentioning another position, the text continues by saying that the pupil, while reciting mantras, "approaches (the teacher), bends his knee, touches (the feet of the teacher), and should say: 'O lord, teach the *Sāvitrī*, O lord, recite'" (ĀśvGS 1.21.4: *upasthāya jānv ācyopasaṃgṛhya brūyād adhīhi bho sāvitrīm bho3 anubrūhīti // 4 //*). Cf. *Śāṅkhāyanagṛhyasūtra* 2.5.8-12: *uttareṇāgnim upaviśataḥ / prāṅmukha ācāryaḥ pratyaṅmukha itaro / adhīhi bho3 ity uktvā / ācārya oṃkāram prayujyāthetaram vācayati sāvitrīm bho3 anubrūhīti / athāsmai sāvitrīm avāha tat savitur vareṇyam ity etām paccho 'rdharcaśo 'navānam // 5 //*.

16 GoGS 2.10.31-35: *udaṅ agner utsṛpya prāṅ ācārya upaviśaty udagagreṣu darbheṣu // 31 // pratyaṅ māṇavako dakṣiṇajānvakto 'bhimukha ācāryam udagagreṣv eva darbheṣu // 32 // athainam triḥ pradakṣiṇam muñjamekhalām pariharan vācayatīyam duruktāt paribādhamāneti ṛtasya goptrīti ca // 33 // athopasīdaty adhīhi bhoḥ sāvitrīm me bhavān anubravītv iti // 34 // tasmā anvāha paccho 'rddharcaśa ṛkśa iti // 35 //*.

17 Not, for instance, in the ĀpGS 4.11.7-8: *pariṣecanāntam kṛtvāpareṇāgnim udagagram kūrcam nidhāya tasminn uttareṇa yajuṣopanetopaviśati // 7 // purastāt pratyaṅṅ āsīnaḥ kumāro dakṣiṇena pāṇinā dakṣiṇam pādam anvārabhyāha sāvitrīm bho anubrūhīti // 8 //*. The commentator Sudarśanārya, reading *pratyaṅāsīnaḥ*, glosses: *pratyaṅmukhaḥ*. Similarly the *Baudhāyanagṛhyasūtra* 2.5.38-39: *apareṇāgnim udagagram kūrcam nidhāya tasmin prāṅmukha ācārya upaviśati – rāṣṭrabhṛd asy ācāryāsandī mā tvad yoṣam iti // 38 // tasyāgreṇa kumāro darbheṣu pratyaṅmukha upaviśya pādāv anvārabhyāha – sāvitrīm bho anubrūhīti // 39 //*. Although the site of the teaching is said to be to the west side of the sacrificial fire, the pupil is said to sit opposite (i.e., east) of the teacher while facing west, that is, he sits with his back towards the fire, blocking the teacher's access to it. This evidently hybrid version of the ritual appears to be a conflation of the tradition of the White Yajurveda (and Ṛg- and Sāmaveda, as we saw

above) and the alternative tradition (see below). The *Gautamadharmasūtra* adds to the confusion when it declares that the student should sit at the right side of the teacher, but may face either east or north; in the former case, he sits parallel to the teacher: *prāṅmukho dakṣiṇataḥ śiṣya udaṅmukho vā* ... (GauDhS 1, in *Dharma-Śāstra or the Hindus Law Codes*, ed. Manmatha Natha Dutt (Delhi: Eastern Book Linkers, 1988), vol. 1.

18 BhGS 1.3: *apareṇāgnim udagagraṃ kūrcaṃ nidhāya tasmin prāṅmukha upaviśati / yajñopavītaṃ kṛtvāpa ācamya dakṣiṇataḥ kumāra upaviśyānvārabhate // 3 //.* Cf. HirGS 1.2.5-6.

19 BhGS 1.7: *apareṇāgniṃ dvayān darbhān pūrvāparān udagagrān stṛṇāti / teṣu pūrvāparāv upatiṣṭhete / prāṅmukhaḥ pratyaṅmukhasya hastaṃ gṛhṇīyād ity ekam / pratyaṅmukhaḥ prāṅmukhasyety aparam / athainayoḥ praiṣakṛd añjalī udakena pūrayati / athāsyāñjalināñjalāv udakam ānayati /.*

20 BhGS 1.8: *pradakṣiṇam agniṃ parikramya dakṣiṇata udagāvṛtyopaviśyopasaṃ gṛhya pṛcchati // 8 // sāvitrīṃ bho anubrūhīti /.* Cf. HirGS 1.6.10 (n. 21).

21 HirGS 1.6.9-10: *apareṇāgnim udagagraṃ kūrcaṃ nidhāya tasmin prāṅmukha upaviśati / rāṣṭrabhṛd asy ācāryāsandī mā tvad yoṣam // iti / 9 / ādityāyāñjaliṃ kṛtvācāryāyopasamgṛhya dakṣiṇataḥ kumāra upaviśya / adhīhi bho / ity uktvāthāha / sāvitrīṃ bho anubrūhi // iti / 10 /.*

22 ŚāṅGS 6.1.1: *athāto brahmāṇaṃ brahmarṣiṃ, brahmayonim indram ... sarvān eva pūrvācāryān namasya svādhyāyāraṇyakasya niyamān udāhariṣyāmaḥ /.*

23 ŚāṅGS 6.2.3-10: *prāgjyotiṣam aparājitāyāṃ diśi puṇyam upagamya deśam / ... maṇḍalam tu prāgdvāram udagdvāram vā ... bahirmaṇḍalasthābhir ācamya / prādhīyīran kṛtaśāntayaḥ /.*

24 Cf. *Āpastambadharmasūtra* 1.(2).6.24: *ekādhyāyī dakṣiṇam bāhum pratyupasīdet // 24 // yathāvakāśam bahavaḥ // 25 //*, which is translated in *Dharmasūtras – The Law Codes of Āpastamba, Gautama, Baudhāyana, and Vasiṣṭha*, ed. and trans. Patrick Olivelle, Oxford World's Classics (Oxford: Oxford University Press, 1999), 14: "A single student should sit on his teacher's right, while a group may sit as space permits."

25 MBh 7.57.14-16: *śokasthānaṃ tu tac chrutvā pārthasya dvijaketanaḥ / saṃspṛśyāmbhas tataḥ kṛṣṇaḥ prāṅmukhaḥ samavasthitaḥ // 14 // idaṃ vākyaṃ mahātejā babhāṣe puṣkarekṣaṇaḥ / hitārthaṃ pāṇḍuputrasya saindhavasya vadhe vṛtaḥ // 15 // pārtha pāśupataṃ nāma paramāstraṃ sanātanam / yena sarvān mṛdhe daityāñ jaghne devo maheśvaraḥ // 16 //.* Cf. MBh 12.333.15-16: *prokṣyāpavargaṃ deveśaḥ prāṅmukhaḥ kṛtavān svayam // 15 // maryādāsthāpanārthaṃ ca tato vacanam uktavān / ahaṃ hi pitaraḥ sraṣṭum udyato lokakṛt svayam // 16 //.*

26 Jan Gonda, *Change and Continuity in Indian Religion*, Disputationes Rheno-Trajectinae (London: Mouton, 1965), 317.

27 Ibid., 385.

28 Kauṇḍinya *ad* PS 1.1 (p. 8): *syā ity eṣye kāle / yāvad ayam ācāryo gṛhasthādibhyo 'bhyāgataṃ pūrvam ataḥśabdāt parīkṣitaṃ brāhmaṇaṃ vratopavāsādyaṃ mahādevasya dakṣiṇasyāṃ mūrtau sadyojātādisaṃskṛtena bhasmanā saṃskaroti utpattiliṅgavyāvṛttiṃ kṛtvā mantraśrāvaṇaṃ ca karoti tāvad eṣyaḥ kālaḥ kriyate /.* I consider the interpretation that takes the locative *mūrtau* as depending on °*saṃskṛtena*, rather than on *saṃskaroti,* possible, though less likely in the present context for reasons given below (cf., however, the Ṭīkā quoted in n. 43).

29 *Gaṇakārikā* 5cd: *dravyaṃ kālaḥ kriyā mūrtir guruś caiveha pañcamaḥ.*

30 Bhāsarvajña (?) *ad Gaṇakārikā* 5c (p. 9): *mūrtiśabdena yad upahārasūtre mahādevejyāsthānam ūrdhvaliṅgādilakṣaṇam vyākhyātaṃ tatsamīpadakṣiṇabhūpradeśaḥ kuṭ(ḍ)yādyavyavahito 'trābhipretaḥ.* As H. Isaacson has suggested to me, *kuṭyādya°* is probably a corruption of *kuḍyādya°.* I cannot subscribe to the translation of Gerhard Oberhammer, *Wahrheit und Transzendenz: Ein Beitrag zur Spiritualität des Nyāya,* p. viii, which makes *mūrtiśabdena* the logical subject of *vyākhyātaṃ* ("Mit dem Wort *mūrtiḥ,* das im Verehrungssūtram [vorkommt], wird der große Gott als [sichtbares] Object der Verehrung *[mahādevejyāsthānam]* genannt, das [ikonographisch] durch das aufgerichtete Glied gekennzeichnet ist *[ūrdhvaliṅgādilakṣaṇam]"*). The commentator's wording seems to me, on the other hand, a sign that he tried to avoid saying that the *mūrti* meant here is a *sculpture* that has the actual iconographic characteristics of *ūrdhvaliṅgādi.*

31 To interpret the *mūrtau* here (n. 28) in conformity with the commentary on the *Gaṇakārikā* was first suggested to me by Gérard Colas.

32 This interpretation deviates from Bakker, "Dakṣiṇāmūrti," in which I held the opinion that the initiation involves an image.

33 Bhāsarvajña (?) *ad Gaṇakārikā* 5c (p. 9): *gurur ācāryaḥ sa dvividhaḥ parāparabhedāt / tatrāparaḥ pañcārthajñānamaryādānvītaḥ / ... tasyādhiṣṭhātā bhagavān maheśvaraḥ paro guruḥ.*

34 SvT 3.129-131ab: *kṛtakṛtyaḥ prahṛṣṭātmā prahṛṣṭanayanaṃ śiśum / utthāpya hastāt saṃgṛhya dakṣiṇāṃ mūrtim ānayet //* 129 *// tatra maṇḍalakam kṛtvā puṣpeṇa praṇavāsanam / tasyopari śiśuṃ nyasya ūrdhvakāyam udaṅmukham //* 130 *// guruḥ pārvānanaḥ sthitvā prokṣaṇādīni kārayet /.* Kṣemarāja *ad* SvT 3.129d (I, 212): *dakṣiṇāṃ anukūlāṃ śivātmikām eva, na tu pāśavīṃ dehamayīm //* ("*'dakṣiṇām,'* i.e., favourable, purely of Śiva's auspicious nature, but not a *paśu*-type, corporeal *[mūrti]"*). See also SvT 4.496 (*sādhakābhiṣeka*) and SvT 4.468-9 (*ācāryābhiṣeka*). Cf. MṛĀ Kr. 7.61-62, 8.198-202ab.

35 Bhāsarvajña (?) *ad Gaṇakārikā* 7 (p. 18): *śanair garbhagṛhaṃ praviśet / tad anu mūrtidakṣiṇe bhūpradeśe jānunī pātayitvā hṛdi cāñjaliṃ baddhvā*

*mūrtistham sākṣād iva śiva<m> paśyan ... saṃyatātmanottarābhimukhena
pratyāhāraviśeṣārtham japtavyam japtvā tu śivadhyānāsakta evāṭṭahāsam
punaḥ punaḥ kuryāt /.* The commentator rejects the view of some *(ity eke)*
who say that he may burst into boisterous laughter as soon as he gets to
the temple, if his detachment has not ceased *(yady anivṛttapratyāhāras
tadā gatamātra eva hasitaṃ kuryād ity eke).*

36 MBh 14, app. I, no. 4, ll. 1454-58: *niveśayati manmūrtyā<m> ātmānaṃ
 madgataḥ śuciḥ / rudradakṣiṇamūrtyāṃ vā caturdaśyāṃ viśeṣataḥ // siddhair
 brahmarṣibhiś caiva devalokaiś ca pūjitaḥ / gandharvair bhūtasaṃghaiś ca
 gīyamāno mahātapāḥ / praviśet sa mahātejā māṃ vā śaṃkaram eva ca //.* Cf.
 ibid., ll. 3067f. *dakṣiṇamūrti* here instead of *dakṣiṇamūrti* for metrical reasons.
 I am grateful to Phyllis Granoff, who pointed out these passages to me.

37 Kauṇḍinya *ad* PS 1.9 (p. 15): *devasya iti ṣaṣṭhī / svasvāmibhāvaḥ sambandhaḥ
 / parigrahārtham evādhikurute / atra dakṣiṇeti dikprativibhāge bhavati / ādityo
 diśo vibhajati / diśaś ca mūrtiṃ vibhajanti / mūrtir nāma yad etad devasya
 dakṣiṇe pārśve sthitenodaṅmukhenopānte yad rūpam upalabhyate
 vṛṣadhvajaśūlapāṇinandimahākālordhvaliṅgādilakṣaṇam yad vā laukikāḥ
 pratipadyante mahādevasyāyatanam iti tatropastheyam /.*

38 The adverbial *dakṣiṇena* is equivalent to *dakṣiṇā,* which is the OIA
 instrumental in *ā* preserved in some adverbs (Jacob Wackernagel,
 Altindische Grammatik. III. Band: Nominalflexion – Zahlwort – Pronomen
 [Göttingen: Vandenhoeck und Ruprecht, 1930], §41b). Manfred
 Mayrhofer, *Etymologisches Wörterbüch des Altindoarischen* (EWA)
 (Heidelberg: Carl Winter, 1986) s.v. *dakṣiṇā:* "*dákṣiṇā* zur rechten Seite."
 The phrase *dakṣiṇamūrtigrahaṇāt* in his commentary *ad* PS 1.9 shows that
 Kauṇḍinya takes *dakṣiṇamūrteḥ* as a compound, although he does not
 explain it. However, his speaking of "eastern," "northern," and
 "western" *mūrtis* (see n. 39) implies that he takes the compound as a
 Karmadhāraya. In the gloss quoted (n. 37) he makes clear that
 "southern" is to be understood as "at the right side of" *(dakṣiṇe pārśve).*
 This is his explanation of the adverbial *dakṣiṇā* (cf. n. 44).

39 In this way, the *dakṣiṇamūrti* continues the Ṛgvedic idea that the
 supreme deity manifests only one fourth of himself. ṚV 10.90.3-4: *etāvān
 asya mahimá áto jyáyāṃś ca púruṣaḥ / pādo 'sya víśvā bhūtáni tripád
 asyāmṛtam diví // 3 // tripád ūrdhvá úd ait púruṣaḥ pādo 'syehábhavat púnaḥ /
 táto víṣvàṅ vyakrāmat sāśanānaśane, abhí // 4 //.* This seems to be the purport
 of Kauṇḍinya's remark (p. 15): *dakṣiṇamūrtigrahaṇāt pūrvottarapaścimānāṃ
 mūrtīnāṃ pratiṣedhaḥ /.*

40 R.C. Zaehner's translation in *Hindu Scriptures,* 197: *ajāta ity evaṃ kaścid
 bhīruḥ prapadyate / rudra yat te dakṣiṇam mukham tena mām pāhi nityam //
 21 //.*

41 This position conforms best with the view of images maintained in the Nyāya school, which is generally believed to have had close links with the Pāśupata. Elsewhere in this volume (p. 163), Gérard Colas describes Udayana's point of view as follows: "The rite does not specifically invest the image with a divine presence or power through a mechanical process, but occasions the conscious reflection, by deities, of themselves as being present in the image." In other words, Śiva's presence in the Dakṣiṇāmūrti is an act of grace *(parigraha)*.

42 *hasitagītanṛttaḍumḍumkāranamaskārajapyopahāreṇopatiṣṭhet mahādevasya dakṣiṇāmūrteḥ // 8-9 //*. I take *dakṣiṇāmūrteḥ* here as *genitivus pro dativo* depending on *upahāreṇa* (see J.S. Speijer, *Sanskrit Syntax* [Leiden: Brill, 1886], §132).

43 *śivadakṣiṇamūrtau*. Cf. Kauṇḍinya *ad* PS 1.1 (above p. 126).

44 SP 27.31 (= SPBh 27.31): *dakṣiṇāyāṃ tu yo mūrtau pāyasaṃ saghṛtaṃ śubhe / nivedayed varṣam ekaṃ sa ca nandisamo bhavet // 31 //*. Cf. SP 167.15: *tasminn āyatane rudraṃ tṛṇāṅgaḥ sa mahān ṛṣiḥ / dakṣiṇāṃ mūrtim āsthāya stauti nityaṃ kapardinam //*. Edition by P. Bisschop. When the compound *dakṣiṇāmūrti* is dissolved, *dakṣiṇa* is taken as an adjective – sometimes inflected nominally (above), sometimes pronominally (e.g., Kauṇḍinya *ad* PS 1.1, quoted in n. 28) – which shows again that we should read *dakṣiṇāmūrti* as a Karmadhāraya compound. However, when dissolved, the original use of the adverb *dakṣiṇā* (= *dakṣiṇena*) is ignored (cf. n. 38).

45 T.M.P. Mahadevan, ed., *The Hymns of Śaṅkara* (Delhi: Motilal Banarsidass, 1980), 2ff. Śaṃkara's authorship of this hymn is doubtful; see Karl H. Potter, ed., *Encyclopedia of Indian Philosophies: Advaita Vedānta up to Śaṃkara and His Pupils* (Delhi-Varanasi-Patna: Motilal Banarsidass, 1981), 317.

46 T.A. Gopinatha Rao, *Elements of Hindu Iconography*, 2 vols., 4 pts. (1914; reprint, New York: Paragon Book Reprint Corp., 1968), vol. 2.2, app. B, 140: *dakṣeṇa mudrāṃ pratipādayantaṃ sitākṣasūtraṃ ca tathordhvabhāge / vāme ca pustam akhilāgamādyāṃ bibhrāṇam ūrdhvena sudhādharaṃ ca // sitāmbujasthaṃ sitavarṇam īśaṃ sitāmbarālepanam indumaulim / jñānaṃ munibhyaḥ pratipādayantaṃ taṃ dakṣiṇāmūrtim udāharanti //*. Cf. *Mayamata* 36.98-101.

47 Gopinatha Rao, *Elements of Hindu Iconography*, vol. 2.1, 273 (boldface mine).

48 I could not find this "account" in the texts at issue presented in Gopinatha Rao's app. B (vol. 2.2, 137-46).

49 Ibid., vol. 2.1, 273.

50 Bruce J. Long, "Śiva as Promulgator of Traditional Learning and Patron Deity of the Fine Arts," *Annals of the Bhandarkar Oriental Institute* 52 (1971): 69; ibid., n. 1.

51 J.C. Harle, *The Art and Architecture of the Indian Subcontinent* (Harmonds-worth, UK: Penguin Books, 1986), 301: "All the principal images of the Brahmanical pantheon are represented in South India during the Coḷa period. There is a particular predilection for Bhikṣāṭana, Śiva as the naked young ascetic, and for Śiva as Dakṣiṇāmūrti, the expounder of yoga, music and the śāstras, who is always, where possible, facing south (*dakṣiṇa* means 'south,' and although there is no very convincing explanation of the name, it may account in part for the popularity of this image in South India)."

52 *Mayamata* 19.39-40 (trans. Bruno Dagens): *tale tale vimānānāṃ dikṣu devān nyaset kramāt | pūrvāyāṃ dvārapālau tu nandikālau ca vinyaset || 39 || dakṣiṇe dakṣiṇāmūrtiṃ paścime 'cyutam eva hi | athavā liṅgasambhūtam uttare tu pitāmaham || 40 ||*. For a survey of later texts see, in addition to Gopinatha Rao, *Elements of Hindu Iconography*, vol. 2.2, app. B, the *Pratimā-kosha* III, s.v., 73-80.

53 Adalbert, Gail. *The Enlightened Buddha and the Preaching* Śiva – *More Light on the Dakṣiṇāmūrti Icon* (forthcoming); cf. Raju Kalidos, "Buddhist Parallels in Hindu Iconography: A Case Study of Dakṣiṇāmūrti," in *The Art of Ajanta: New Perspectives*, ed. R. Parimoo et al., 2 vols. (New Delhi: Books and Books, 1991).

54 SP 62.19-20: *vāribhārālasāmbhodarucimadbhīmanisvanam | karāladaśanodbhāsi dīptaraktāntalocanam || 19 || atyādityaṃ tatas tejo mukhān niḥsṛtya dakṣiṇāt | dṛśyamānaṃ suraiḥ sarvair viveśa pramadottamām || 20 ||*. Edition by Y. Yokochi. Cf. MBh 13.128.6; here this southern face is said to be ... *raudraṃ saṃharati prajāḥ*, and is not (yet) conflated with the face of the teacher.

55 Jacques Dumarçay and Françoise l'Hernault. *Temples, Pallava Construits: Étude architecturale par J. Dumarçay. Étude iconographique par F. l'Hernault* (Paris: Publication d'École Française d'Extrême-Orient, 1975), photo 54. Cf. *Encyclopaedia of Indian Temple Architecture* I, pl. 77. For the few images classified as Dakṣiṇāmūrti found in Uttar Pradesh, see Sheo Bahadur Singh, "Dakṣiṇāmūrti Sculptures in Uttar Pradesh," *Vishveshvaranand Indological Journal* 14 (1976): 107-11. For an attempt to identify some images in Ellora and Elephanta as Dakṣiṇāmūrti, see K. Mankodi, "Śaiva Panels of Ellora and Elephanta: Yogīśvara or Dakṣiṇāmūrti?" in *Ellora Caves: Sculptures and Architecture*, ed. R. Parimoo et al. (New Delhi: Books and Books, 1988).

56 The end of the story may be supplied as it is told in the *Mahābhārata*. After Mahādeva has revealed himself, Arjuna falls to his knees – MBh 3.40.56 (*tato devaṃ mahādevaṃ giriśaṃ śūlapāṇinam | dadarśa phalgunas tatra saha devyā mahādyutim || 55 || sa jānubhyāṃ mahīṃ gatvā śirasā praṇipatya ca | prasādayāmāsa haraṃ pārthaḥ parapuraṃjayaḥ || 56 ||*).

Arjuna asks for forgiveness and receives a boon. Arjuna asks for the terrible Pāśupata weapon, also called "Brahmaśiras" (MBh 3.41) (*bhagavan dadāsi cen mahyaṃ kāmaṃ prītyā vṛṣadhvaja / kāmaye divyam astraṃ tad ghoraṃ pāśupataṃ prabho // 7 // yat tad brahmaśiro nāma raudraṃ bhīmaparākraman / yugānte dāruṇe prāpte kṛtsnaṃ saṃharate jagat // 8 //*). This is granted. Then Arjuna, purified, embraces the feet of the Lord and the latter says: "learn" (*tac chrutvā tvaritaḥ pārthaḥ śucir bhūtvā samāhitaḥ /* **upasaṃgṛhya viśveśam adhīṣveti ca so 'bravīt** // 17 //). Although the text omits it, we have to assume, after the above and in view of the other side of the lintel (see above), that Arjuna takes his seat at the right side of the Lord. Then Śiva explains the secrets of the weapon (*tatas tv adhyāpayāmāsa sarahasyanivartanam / tad astraṃ pāṇḍavaśreṣṭham mūrtimantan ivāntakam // 18 //*).

57 J.G. Williams, *The Art of Gupta India: Empire and Province* (Princeton: Princeton University Press, 1982), 141.

58 MBh 12, app. 1, no. 28, ll. 395-406:
athainam abravīd vākyaṃ trailokyādhipatir bhavaḥ /
āśvāsanakaraṃ vākyaṃ vākyavid vākyasaṃmitam //
dakṣa dakṣa na kartavyo manyur vighnam imaṃ prati /
ahaṃ yajñaharas tubhyaṃ dṛṣṭam etat purātanam //
bhūyaś ca te varaṃ dadmi taṃ tvaṃ gṛhṇīṣva suvrata /
prasannavadano bhūtvā tad ihaikamanāḥ śṛṇu //
vedāt ṣaḍaṅgād uddhṛtya sāṃkhyayogāc ca yuktitaḥ /
tapaḥ sutaptaṃ vipulaṃ duścaraṃ devadānavaiḥ //
apūrvaṃ sarvatobhadraṃ viśvatomukham avyayam /
abdair daśāhasaṃyuktaṃ (?) gūḍham aprājñaninditam //
varṇāśramakṛtair dharmair viparītaṃ kvacit samam /
gatāntair adhyavasitam atyāśramam idaṃ vratam //.

59 *tasya* refers to the above-mentioned *vratam*. The gender of *yogam* is neuter here (cf. MBh 13.17.18). *Yoga* in the Pāśupata system does not signify practice but rather its result (see Kauṇḍinya *ad* PS 1.1: *ucyate yogam / atra ātmeśvarasaṃyogo yogaḥ /*). My interpretation differs from that of Annemarie Mertens, *Der Dakṣamythus in der episch-purāṇischen Literatur: Beobachtungen zur religionsgeschichtlichen Entwicklung des Gottes Rudra-Śiva im Hinduismus*, Beiträge zur Indologie Band 29, (Wiesbaden: Harrassowitz, 1998), 76ff., who assumes a conflation of concepts: "Im selben Satz wird das *pāśupatavrata* als *yoga* bezeichnet (407); die beiden Begriffe *tapas* und *yoga* werden hier also synonym verwendet. Für bestimmte Schichten des Mahābhārata ist die Vermischung beider Begriffe üblich." However, no examples from the MBh are adduced to corroborate this contention.

60 Cf. MBh 1.410: *evam uktvā mahādevaḥ sapatnīko vṛṣabhadvajaḥ.*

144 Hans Bakker

Bibliography

Primary Sources

Āpastambadharmasūtra (ĀpDhS). *Āpastamba's Aphorisms on the Sacred Law of the Hindus*. Edited in the original Sanskrit, with critical notes, variant reading from Hiraṇyakeśi-dharmasūtras, an alphabetical index of sūtras, and word-index, together with extracts from Haradatta's commentary, the *Ujjvalā*, by George Bühler. 3rd ed. Bombay Sanskrit Series Nos. 44 and 50. Poona: Bhandarkar O.R. Institute, 1932.

Āpastambagṛhyasūtra (ĀpGS). *The Āpastambîya Gṛihyasûtra with Extracts from the Commentaries of Haradatta and Sudarśanārya*. Edited by M. Winternitz. Vienna: Alfred Hölder, 1887.

Āśvalāyanagṛhyasūtra (ĀśvGS). *Gṛhyasūtrāṇi*. Indische Hausregeln. Sanskrit und Deutsch herausgeben von Adolf Friedrich Stenzler. I. Âçvalâyana. Abhandlungen der Deutschen Morgenländischen Gesellschaft III. Band No. 4, IV. Band No. 1. Leipzig: Brockhaus, 1864-65.

–. *Āśvalāyana Gṛhyasūtram*. With Sanskrit commentary of Nārāyaṇa, English translation, introduction and index by Narendra Nath Sharma. Delhi: Eastern Book Linkers, 1976.

Baudhāyanagṛhyasūtra (BauGS). *The Bodhâyana Gṛihyasūtra*. Edited by R. Shama Sastri. Oriental Library Publications, Sanskrit Series 32/55. Mysore: University of Mysore, 1920.

Bhāradvājagṛhyasūtra (BhGS). *Het Hindoesche Huisritueel volgens de School van Bhāradvāja*. Edited by Henriette Johanna Wilhelmina Salomons. PhD thesis. Leiden: Brill, 1913.

Dharma-Śāstra or the Hindus Law Codes. Text. Yājñavalkya, Hārīta, Uśanas, Aṅgiras, Yama, Atri, Saṁvarta, Kātyāyana, Bṛhaspati, Dakṣa, Śātātapa, Likhita, Śaṁkhya, Gautama, Āpastamba, Vaśiṣṭha. Edited by Manmatha Natha Dutt. vol. 1. Delhi: Eastern Book Linkers, 1988.

Dharmasūtras. The Law Codes of Āpastamba, Gautama, Baudhāyana, and Vasiṣṭa. Translated from the original Sanskrit and edited by Patrick Olivelle. Oxford World's Classics. Oxford: Oxford University Press, 1999.

Gaṇakārikā. Gaṇakārikā of Ācārya Bhāsarvajña. (With four appendices including the Kāravaṇa-Māhātmya.) Edited by Ch. D. Dalal. Gaekwad's Oriental Series no. 15. Baroda: Oriental Institute Baroda, 1920; reprint, 1966.

Gobhilagṛhyasūtra (GoGS). *Gobhilagṛhyasūtram with Bhaṭṭanārāyaṇa's Commentary*. Crit. edit. from the original manuscripts with notes and indices by Chintamani Bhattacharya; with an introduction by V. Vedantatirtha. Calcutta Sanskrit Series no. 17. Calcutta: Metropolitan Printing and Publishing House, 1936.

Grihya-Sûtras. Rules of Vedic Domestic Ceremonies. Translated by Hermann
Oldenburg. Part I, Sânkhâyana-grihya-sûtra, Âsvalâyana-grihya-sûtra,
Pâraskara-grihya-sûtra, Khâdira-grihya-sûtra. Part II, Gobhila,
Hiranyakesin, Âpastamba. Âpastamba, Yagña-paribhâshâ-sûtras. Translated
by F. Max Müller. The Sacred Books of the East 29, 30. Oxford: Clarendon
Press, 1886-92.

Hindu Scriptures. Edited with new translations by Dominic Goodall. Based on
an anthology by R.C. Zaehner. London: J.M. Dent, 1996.

Hiraṇyakeśigṛhyasūtra (HirGS). *The Gṛhyasūtra of Hiraṇyakeśin with Extracts from
the Commentary of Mātṛidatta.* Edited by J. Kirste. Vienna: Alfred Hölder, 1889.

Hymns of Śaṅkara. Edited by T.M.P. Mahadevan. Delhi: Motilal Banarsidass,
1980.

Mahābhārata (MBh). *The Mahābhārata.* For the first time critically edited by V.S.
Suktankar and others. 19 vols. Poona: Bhandarkar O.R. Institute, 1927-59.

Mayamata. Traité Sanskrit d'Architecture. Première Partie Ch. 1 à 25. Deuxième
Partie Ch. 26-36 et Index-Glossaire général. Publications de l'Institut
Français d'Indologie no. 40.1-2. Édition Critique, Traduction et Notes par
Bruno Dagens. Pondichéry: Institut Français d'Indologie, 1970-76.

Mṛgendrāgama, Kriyāpāda (MṛÂ Kr). Kriyāpāda et Caryāpāda avec le
commentaire de Bhaṭṭa-Nārāyaṇakaṇṭha. Publications de l'Institut Français
d'Indologie no. 23. Edition critique par N.R. Bhatt. Pondichéry: Institut
Français d'Indologie, 1962.

Pāraskaragṛhyasūtra (PārGS). *Gṛhyasūtrāṇi.* Indische Hausregeln. Sanskrit und
Deutsch herausgegeben von Adolf Friedrich Stenzler. II. Pâraskara.
Abhandlung der Deutschen Morgenländischen Gesellschaft VI. Band No. 4.
Leipzig: 1878.

Pāśupatasūtra (PS). With the *Pañcārthabhāṣya* of Kauṇḍinya. Edited by R.
Ananthakrishna Sastri. TSS 143. Trivandrum: The Oriental Manuscripts
Library of the University of Travancore, 1940.

Ṛgveda (ṚV). *Hymns of the Rig-Veda in the Samhita and Pada Texts.* Reprinted
from the *Editio Princeps* by F. Max Müller. 2 vols. Varanasi: Chowkhamba,
1965.

Śāṅkhāyanagṛhyasūtra (ŚāṅGS). "Das Çâṅkhâyanagṛihyam." [Edited by] H.
Oldenberg. *Indische Studien 15,* 1-166. Albrecht Weber (Hrsg.). Hildesheim:
Olms, 1973 (reprint).

Śatapathabrāhmaṇa (ŚB). *The* Catapatha-Brāhmaṇa *in the*
Mādhyandina-Cākhā *with Extracts from the Commentaries of Sāyaṇa,
Harisvāmin and Dvivedaganga.* Edited by Albrecht Weber. Varanasi:
Chowkhamba, 1964 (reprint).

Skandapurāṇa (SP). *The Skandapurāṇa, Volume 1. Adhyāyas 1-25.* Critically edited
with prolegomena and English synopsis by R. Adriaensen, H.T. Bakker, and

H. Isaacson. Supplement to Groningen Oriental Studies. Groningen: Egbert Forsten, 1998.

– (SPBh). *Skandapurāṇasya Ambikākāṇḍaḥ*. Edited by Kṛṣṇa Prasāda Bhaṭṭarāī. Mahendra Ratnagrantha Series 2. Kathmandu: Mahendrasaṃskṛtaviśvavidyālaya, 1988.

Svacchandatantra (SvT). *The Swacchanda-Tantra with Commentary [Udyota] by Kṣemarāja*. Edited with notes by Madhusudan Kaul Shāstrī. Kashmir Series of Texts and Studies nos. 31, 38, 44, 48, 51/53, 56. 6 vols. Bombay: Nirnaya-sagar Press, 1921-35.

Śvetāśvatara Upaniṣad (Śvet. Up.). In *Eighteen Principal Upaniṣads. Vol. 1: Upaniṣadic Text with Parallels from Extant Vedic Literature, Exegetical and Grammatical Notes*. Edited by V.P. Limaye and R.D. Vadekar. Gandhi Memorial Edition. Poona: Vaidika Saṃśodhana Maṇḍala, 1958.

Secondary Sources

Bakker, Hans. "Dakṣiṇāmūrti." Pp. 41-53 in *Vidyārṇavavandanam: Essays in Honour of Asko Parpola*, edited by K. Karttunen and P. Koskikallio. Helsinki: Finnish Oriental Society, 2001.

Bodewitz, Henk W. "Classifications and Yonder World in the Veda." *Wiener Zeitschrift für die Kunde Südasiens* 44 (2000): 19-59.

Dagens, Bruno. *Entre Alampur et Śrīśailam: Recherches archéologiques en Andhra Pradesh*. Tôme I Texte. Tôme II Illustrations. Publications de l'École Française d'Indologie 67.1-2. Pondichéry: Institut Français d'Indologie, 1984.

Dumarçay, Jacques, and Françoise l'Hernault. *Temples Pallava Construits: Étude architecturale par J. Dumarçay. Étude iconographique par F. l'Hernault*. Publications de l'École Française d'Extrême-Orient. Mémoirs Archéologiques 9. Paris: École Française d'Extrême-Orient, 1975.

Encyclopedia of Indian Temple Architecture (EITA). South India. Lower Drāviḍadēśa 200 BC – AD 1324. Vol. 1, pt. 1: Text and Plates. Edited by Michael W. Meister, coordinated by M.A. Dhaky. 2 vols. New Delhi: American Institute of Indian Studies, 1983.

Gail, Adalbert. *The Enlightened Buddha and the Preaching Śiva: More Light on the Dakṣiṇāmūrti Icon*. Forthcoming.

Gonda, Jan. *Change and Continuity in Indian Religion*. Disputationes Rheno-Trajectinae. London: Mouton, 1965.

–. "The Ritual Sūtras." *A History of Indian Literature*, vol. 1, fasc. 2. Wiesbaden: Harrassowitz, 1977.

–. "Vedic Ritual: The Non-Solemn Rites." *Handbuch der Orientalistik* II. Abt., 4. Band 1. Abschnitt. Leiden-Köln: Brill, 1980.

–. "Prajāpati and the Year." *Verhandelingen der Koninklijke Nederlandse Akademie van Wetenschappen*, Afd. Lett., N.R., Deel 123. Amsterdam: North-Holland Publishing Company, 1984.

Gopal, Ram. *India of Vedic Kalpasūtras*. Thesis. Delhi: National Publishing House, 1959.

Gopinatha Rao, T.A. *Elements of Hindu Iconography*, 2 vols., 4 pts. 1914. Reprint. New York: Paragon Book Reprint Corp., 1968.

Harle, J.C. *The Art and Architecture of the Indian Subcontinent*. The Pelican History of Art. Harmondsworth, UK: Penguin Books, 1986.

Kalidos, Raju. "Buddhist Parallels in Hindu Iconography: A Case Study of Dakṣiṇamūrti." In *The Art of Ajanta: New Perspectives*, edited by R. Parimoo et al., 2 vols. New Delhi: Books and Books, 1991.

Kreisel, Gerd. *Die Śiva-Bildwerke der Mathurā-Kunst: Ein Beitrag zur frühhinduistischen Ikonographie*. Monographien zur indischen Archäologie, Kunst und Philologie. Vol. 5. Stuttgart: Franz Steiner Verlag, 1986.

Long, Bruce J. "Śiva as Promulgator of Traditional Learning and Patron Deity of the Fine Arts." *Annals of the Bhandarkar Oriental Institute* 52 (1971): 67-80.

Mankodi, K. "Śaiva Panels of Ellora and Elephanta: Yogīśvara or Dakṣiṇāmūrti?" Pp. 278-84 in *Ellora Caves: Sculptures and Architecture*, edited by R. Parimoo et al. New Delhi: Books and Books, 1988.

Mayrhofer, Manfred. *Etymologisches Wörterbüch des Altindoarischen* (EWA). Indogermanische Bibliothek II. Reihe: Wörterbücher. Heidelberg: Carl Winter, 1986.

Mertens, Annemarie. *Der Dakṣamythus in der episch-purāṇischen Literatur: Beobachtungen zur religionsgeschichtlichen Entwicklung des Gottes Rudra-Śiva im Hinduismus*. Beiträge zur Indologie Band 29. Wiesbaden: Harrassowitz, 1998.

Michell, George. *Monuments of India. Vol. 1: Buddhist, Jain, Hindu*. The Penguin Guide to the Monuments of India. Harmondsworth, UK: Penguin Books, 1990.

Oberhammer, Gerhard. *Wahrheit und Transzendenz: Ein Beitrag zur Spiritualität des Nyāya*. Österreichische Ak. d. Wiss. Phil.-hist. Kl. Veröffentlichungen der Kommission für Sprachen und Kulturen Südasiens, Heft 18. Wien: Verlag der Österreichischen Akademie der Wissenschaften, 1984.

Potter, Karl H., ed. *Encyclopedia of Indian Philosophies. Advaita Vedānta up to Śaṃkara and His Pupils*. Delhi-Varanasi-Patna: Motilal Banarsidass, 1981.

Pratima-kosha. Encyclopaedia of Indian Iconography, Vol. 3, by S.K. Ramachandra Rao. Kalpatharu Research Academy Publication. Bangalore: Kalpatharu Research Academy, 1990.

Singh, Sheo Bahadur. "Dakṣiṇāmūrti Sculptures in Uttar Pradesh." *Vishveshvaranand Indological Journal* 14 (1976): 107-11.

Speijer, J.S. *Sanskrit Syntax*. Leiden: Brill, 1886.

Wackernagel, Jacob. *Altindische Grammatik. III. Band: Nominalflexion – Zahlwort – Pronomen,* von Albert Debrunner und Jacob Wackernagel. Göttingen: Vandenhoeck und Ruprecht, 1930.

Williams, Joanna Gottfried. *The Art of Gupta India: Empire and Province.* Princeton: Princeton University Press, 1982.

5

The Competing Hermeneutics of Image Worship in Hinduism (Fifth to Eleventh Century AD)

GÉRARD COLAS

This chapter examines the significance of image worship as it was understood by several authors in classical India. This inquiry involves the following main questions: Does the worshipper consider the image as a thought stimulator in a process of presenting material offerings to a basically invisible being? Or does the worshipper consider the image as a living being or embodied god and, consequently, as the real recipient of the offerings?

To address these questions, I will examine several concepts of the image at a period roughly situated between the fifth and eleventh centuries AD. As this is a preliminary investigation, I shall, of course, examine only some of the available views. Since I wish to focus on rationally articulated views from Sanskrit texts, I shall refrain from exploring the works of devotees themselves. I shall also not study the position of Viśiṣṭādvaita, a doctrinal system that such authors as Nāthamuni (late ninth century to tenth century) and Yāmuna (tenth century)[1] built and whose main positions were fixed by Rāmānuja in the eleventh to early twelfth century. This system was a strong advocate of image worship. To situate it within the scope of our investigation would have narrowed our examination of other views (several of them much earlier than Viśiṣṭādvaita). I shall also not consider authors like Abhinavagupta (late tenth to early eleventh century), who clearly approved of image worship as recommended by

Tantras.[2] I do not do so since that would have required a much longer essay; I also preferred to explore the views of philosophical systems that did not take a special interest in divine images: Mīmāṃsā, Advaita, and Nyāya.[3] I should emphasize that the well-known upholders of these systems whose views are studied here do not deal with image worship at any great length, a subject that remains for them secondary and incidental.

At the end of this chapter, I shall also consider the views of temple priests and contrast them with the philosophical approach. These views will be illustrated by the Vaikhānasa temple ritual corpus, which centres on public image worship. Many of these Vaikhānasa texts were elaborated between the ninth and (circa) thirteenth centuries[4] and several of them were probably completed before the end of the eleventh century. Although they do not offer a theory of image worship per se, we may deduce their point of view from their prescriptions.

The approach to image worship in the classical systems should be envisaged with correlated questions. Some of them need to be stressed at the outset. One is the question of the embodiment of deities in general (not necessarily in images), as we will see. In Vedic texts, "the physical appearance of the gods is anthropomorphic, though only in a shadowy manner."[5] The most substantial and individualized part of their bodies consists of Vedic formulas.[6] The epics also describe anthropomorphic gods as possessing physical characteristics not found in human beings: "they do not blink; they have no shadows,"[7] for instance. What do the philosophical passages mentioned here have to say on that subject?

Another correlated question is that of the connection between two notions that are ideally separated (especially in Mīmāṃsā): "sacrifice" (yāga or yajña, more or less synonyms) and "worship" (pūjā). The first notion refers to the "Vedic" sacrifice. Specialists of "Vedic sacrifice" themselves refer to yāga as consisting of three elements: substance offered (dravya), deity (devatā), and relinquishment of the substance (tyāga).[8] The Vedic texts called Brāhmaṇas developed a concept of the sacrifice as a cosmic being to which the gods are subordinated.[9] Mīmāṃsā gave this interpretation a more philosophical, non-theistic dimension and, as we will see, contrasted it with pūjā. Pūjā means "honouring," "worshipping" eminent beings, especially divine beings. Hereafter, we will use the term pūjā in its specialized sense only (unless otherwise specified), that is, as addressing divine beings (not human

ones). In this context, *pūjā* can be translated, like the term *arcana*, either as "worship" in general or more specifically as "image worship," depending on the specific context. Worship usually involves devotion *(bhakti)* from the follower.

However, to contrast "Vedic sacrifice" and worship is to a certain extent artificial. One reason is that there is no absolute model of "Vedic sacrifice." Among other factors, such brilliant works as Lévi's on "the doctrine of the sacrifice" involuntarily contributed to freezing the Brāhmaṇa concept of sacrifice as a sort of ahistorical invariant. In fact, the so-called Vedic rites evolved continuously. Furthermore, a tendency to commingle "Vedic rites" and worship of gods arose at some point in the history of Indian rites. Several archeologists and art historians do not hesitate to place this admixture as early as the second or first century BC without any convincing argument. In fact, textual testimonies show a deep theicization of "Vedic sacrifice" from around the first century of our era.

This is the case, for instance, for several texts related or belonging to the *Mahābhārata* epic: the *Bhagavadgītā* (first century AD?), the *Nārāyaṇīyaparvan* (third to fourth-fifth century AD), and the *Harivaṃśa* (usually dated third-fourth, sometimes first-third century AD). In these texts, the god Viṣṇu appears as the ultimate recipient of all rites, which are thus understood as acts of homage to him. This includes "Vedic sacrifices" and worship originally not addressed to Viṣṇu. Along with this process of theicization of "Vedic sacrifice," a vedicization of image worship occurred, in terms of both practice and conceptual presentation: fire rituals and "Vedic" types of rites were added to image worship, and image worship itself was referred to as "sacrifice" *(yāga)*, for instance, in such texts as the early Pāñcarātra *saṃhitās*, which modern scholarship tends to date to the sixth century. This mutual intermingling of "Vedic rites" and "worship" developed in the context of yet another correlated question, that of the efficiency of rituals, a debate that should perhaps be connected with the Buddhist criticism of the "Vedic sacrifice."

Mīmāṃsā: Deities as Bodiless

Some views of the Mīmāṃsā on the subject are formulated in Śabara's *Bhāṣya* on Chapter 9 of the *Mīmāṃsāsūtras*[10] (attributed to Jaimini) and in Kumārila Bhaṭṭa's subcommentary[11] on 1.3. Śabara lived perhaps in the second half of the fourth century or in the fifth century AD.[12]

Kumārila Bhaṭṭa flourished between 600 and 700.[13] Kumārila perpetuated Śabara's views, sometimes with original nuances. The passages that we will examine do not deal directly with the notion of divine images. Their main concern is with the notion of the embodiment of deities. They refer to the notion of *pūjā*, which in that context means worship of god, but not necessarily always worship of a concrete divine image.

Mīmāṃsakas attack the thesis according to which deities *(devatā)* would be *vigrahavatī*, that is, would possess a body (Śabara on 9.1.6). According to this thesis, sacrifice *(yāga)* consists in feeding the deity. It is an offering to the deity. The given substance and the act of offering are subordinated to the deity. Sacrifice is indeed the worship of the deity *(devatāpūjā)*. The defender of this thesis (hereafter "the opponent") claims that deities possess a human, or rather an anthropomorphic, body *(puruṣavigraha)* and have the capacity to consume food. He draws his proofs from the testimony of the Smṛti, customary usage *(upacāra)*, and statements that (apart from their obvious meaning) also have another meaning *(anyārthavacana)*.[14] The term *smṛti* here refers to "Vedic" ritual texts of the *kalpa* type (whose authorship is acknowledged as human and historical and which regulate solemn as well as domestic rites) and legendary texts and epics, in contrast with Śruti, which refers to the so-called four Vedas with their collections of hymns (Saṃhitās, Brāhmaṇas, Āraṇyakas, and Upaniṣads) and whose textual authority is higher than that of Smṛti. The opponent argues that deities are painted and honoured as having an anthropomorphic body. Here painting (the verb *ālikh*) probably refers to concrete painted representation of deities, which could point (though not necessarily) to the ritual use of divine representations.[15] To the objection that food offered to a deity does not diminish, the opponent replies that the deity consumes the essence of the food *(annarasa)* that has been offered. The opponent also maintains that a deity can own wealth and is pleased by offerings and that the person who honours a deity with a sacrifice *(ijyā)* necessarily expects from the deity a specific result.

Śabara and the Mīmāṃsakas reject this thesis. According to them, the deity is secondary to the sacrifice. Sacrificial action *(karman)* is performed to obtain a fruit. The causal relation between sacrifice and its fruit is explained through the intermediary of the concept of *apūrva*, a transcendent but non-theistic principle. Deities do not bring the fruits of the rites in the Mīmāṃsaka perspective of ritual causality.

They are mere names and are virtually non-existent. Hence the notion of "worship" is inapplicable to sacrifice. Śabara's commentary on Sūtras 9 and 10 refutes point by point the opponent's view. "The injunction of pleasing *(prītividhāna)* (the deity) is absent from the ritual act *(karman)*." The main factor of the sacrifice is the *apūrva*. Smṛti, which the opponent adduced to prove his thesis, does not have the value of a proof by itself, but only insofar as it is supported by Vedic mantras and Vedic eulogistic passages *(arthavāda*, that is, Brāhmaṇas). These in turn, when considered carefully, do not support the opponent's views. Customary usage, being itself based on Smṛti, cannot constitute a convincing argument. The *anyārthavacanas*, which the opponent has quoted, are examined one by one. They are considered to be either misunderstood by the opponent or eulogistic in character (being *arthavādas* and panegyrics [*stutis*]). Deities have neither a body nor an anthropomorphic form *(puruṣavidhatā)*. Since they have no body *(avigrahatvena)*, they cannot consume food. Furthermore, they are not seen as consuming the essence of offered food, unlike bees.

Another argumentation of Śabara (9.1.9) concerns the ownership attributed (wrongly according to Mīmāṃsakas) to deities. In contrast with the more general question of the embodiment of the gods, this passage might (though not with certainty) refer more precisely to image worship. Śabara explains that the expressions "village of God" *(devagrāma)* and "territory of God" *(devakṣetra)* should not be understood literally but only as a customary usage, that is, conventional statement,[16] since a deity cannot by itself make use of any village or territory. As a consequence, a deity is not eligible to make a gift. "Servants of the god" *(devaparicāraka)* obtain prosperity[17] from "what has been relinquished" *(yat tyaktam)* (by them), that is, the offerings, in reference to the deity *(devatām uddiśya)*. The *anyārthadarśanas*[18] that apparently attribute ownership to deities have to be understood as based on customary (hence conventional) usage and of eulogistic purport, since the employment of the so-called possessions of a deity is in fact in the hands of the "servants of the deity" *(devatāparicāraka)*.

The precise identification of these "servants of the god / deity" in this text from (perhaps) the fourth to fifth century can be discussed. Jha translates "worshippers of the Deity" and "Temple-priests" instead of our "servants of the god" and "servants of the deity," respectively.[19] One might object that the translation "temple-priest" is audacious and that the Sanskrit compound could simply mean "attendant of the

deity," "worshipper." One might also stress that even if the term *paricāraka* has a technical meaning in Śabara's commentary, temple ritual texts (at least those of the Vaikhānasas, dated ninth to thirteenth century) give it the technical meaning of ritual assistant, not priest.[20] In spite of these reservations, Jha's translation "temple-priest" remains convincing. The Sanskrit expressions involved *(deva-/devatā-paricāraka)* can hardly refer to a "Vedic" type of rite. They are more naturally suited to a context of image worship. The rest of the passage also strongly suggests image worship in public temples: the expression "territory of God" consistently refers to a temple compound in texts later than the *Śābarabhāṣya*, and the expression "village of God" could very well refer to a village donated to the god of a temple. This passage remains difficult to interpret exactly, however. It is not clear how far the strict distinction between the notions of temple priest and patron-devotee (on the model of the Vedic distinction between the Vedic priest and the *yajamāna*) is implicit in this context.[21] Besides, the "prosperity" that the "servants of the god" obtain may refer to an immediate concrete gain and not to the fruit that would result from the *apūrva*. These questions require further investigation.

When Śabara deals with rites, he usually confines his observations to sacrifices of a "Vedic" type. But the passage that we analyzed here seems (exceptionally) to refer to image worship. If the interpretation that we offer is correct, it implies that Śabara does not reject image worship or, more precisely, public image worship. He does place strong restrictions on it, however. Gods, virtually non-existent, do not possess a body or an anthropomorphic form, and the agent of the efficiency of rites is the *apūrva*. This has two major consequences. First, the assimilation of sacrifice *(yāga)* with the worship *(pūjā)* of gods is considered as unjustifiable. Second, the concept of *pūjā* itself as worship is based on a conventional usage only, and as such does not correspond to any theological or metaphysical reality. Śabara's position here is complicated: Śabara rejects the notion of the embodiment of gods, but accepts image "worship." At the same time, however, he empties it of the worshipping dimension and refuses to accept that "worship" is addressed to a god.

How can we explain this rather complex and apparently abstract position? Śabara retains an exclusively linguistic concept of gods, as we saw, and dissociates rites from gods that had long been denigrated by Buddhism and Jainism.[22] To that extent, his explanation of the performance of sacrifice and *pūjā* is immune from

their criticisms. Śabara does not condemn *pūjā*, although the performance of that rite itself naturally suggests that gods can possess a body. It is probable that many Brahmins and perhaps Mīmāṃsakas too were practising *pūjā* as well as "Vedic rites" in his time. Śabara also does not reject Smṛti and custom (which the opponent refers to in favour of the embodiment of gods), but a particular interpretation of them. In any case, according to Śabara, Smṛti is not uniformly acceptable. Smṛti texts have no authority by themselves, and those that contradict Śruti cannot be accepted.[23] The authority of Smṛti texts (many of them, like *purāṇas*, being used to justify image worship) is not denied, but relativized.

About two centuries later, Kumārila, another Mīmāṃsaka, stressed several of these points in his subcommentary on 1.3. While discussing the authority of the well educated (*śiṣṭa*) in supporting the validity of Smṛtis, he clearly mentions that the "dharmic character" (*dharmatva*) of the rites performed in the temples of deities[24] is, like several other practices, approved because those who perform them are the same as the performers of "Vedic sacrifices" (130). Kumārila again insists (132) that such actions as the worship (*pūjā*) of gods and Brāhmaṇas, etc., are approved as belonging to the behaviour of a well educated man (*śiṣṭa*) and are regarded as having a dharmic character even though people who are similar to Mlecchas practise them too. This shows the acceptance of public image worship by the Mīmāṃsā system in Kumārila's time, as well as its confinement to the sphere of Smṛti.

Advaita: Superimposing the Idea of a God on His Image

Unlike Mīmāṃsā, Advaita tends to assimilate the notions of sacrifice and worship and acknowledges the notion of the embodiment of gods, but it also clearly denies the importance of the image as such in worship. I will draw my observations from two sources: Śaṅkara's commentary on several *Brahmasūtras*[25] and the subcommentary (the *Bhāmatī*) by Vācaspati Miśra.[26] The commentator is usually dated from the eighth century AD and the subcommentator from the tenth century (ca. AD 960).

In the Advaitin system, all rituals are said to belong to the practical (*vyāvahārika*) level of existence, and not to the highest (*pāramārthika*) level, which is that of the Brahman, the supreme and non-dual self. The third level, that of illusion or error (*prātibhāsika*), needs no more than a brief mention here. The highest level is that of the "absolutely

real."[27] The practical or "practically existent" level is that of everyday life, which includes cosmology and the processes of retribution and the gods. It implies duality. With regard to this level of practical reality, the Advaitins (to put it very briefly) show a mixed attitude. While they distinguish it from the level of supreme knowledge, they follow Brahmanical values and practices recommended for everyday practical life. Thus ritual, while it is not a means of realizing the state of Brahman, is not rejected but is considered as helpful though secondary. In contrast with Mīmāṃsā, which exalts the notion of the rite per se disconnected from any association with gods (who are next to non-existent), Śaṅkara and Vācaspati Miśra connect rituals with embodied gods and accept the blurring of the distinction between Vedic sacrifice and image worship, a blurring that was probably already current in the Brahmanical milieu of the eighth century.

In his commentary on 3.2.38-41, Śaṅkara directly criticizes the stand of Mīmāṃsā whereby *apūrva* is an agent of efficiency of the rite. In a metaphysical context, the practical level is characterized by a dual relationship between the god as Lord and his subjects (3.2.38). The cause of the fruits of the rites is the god, and it cannot be the rite itself or the *apūrva* (3.2.41). To support his view, Śaṅkara quotes a passage from the *Kauśītaki-upaniṣad* (3.8), a text of the Śruti, and another from the *Bhagavadgītā* (7.21), which he explicitly presents as a text of the Smṛti *(smaryate)*. The passage from the *Bhagavadgītā* describes the worship (denoted by the verbal root *arc*, and by the word *ārādhana*) performed out of faith by a devotee *(bhakta)*, of a (divine) body *(tanu)*, a worship that brings expected results to that devotee. However, neither the quotation from the *Bhagavadgītā* nor Śaṅkara's commentary on 3.2.38-41 explicitly mentions divine images here.

Śaṅkara defends the concept that the gods possess a body *(vigraha)* in his commentary on 1.3.26-33 (a passage that deals with the competence of gods for the performance of rites). One argument is the authority of traditional stories *(itihāsa)*, legends *(purāṇa)*, sacred formulas *(mantra)*, and eulogistic texts *(arthavāda):* the texts of the Smṛti (traditional stories and legends) are taken as forming an authority on par with those of the Śruti (eulogistic texts, that is, here, Brāhmaṇas and probably mantras). Another argument is the common experience of the world *(loka)*.

Śaṅkara mentions three objections to the embodiment of the gods: the absence of their visible presence *(svarūpasaṃnidhāna)* during the rites (that is, rites of the Vedic type), the impossibility of their

ubiquitous presence in different sacrifices, and the contradiction between the possession of a mortal body (1.3.27) and the eternity of Veda, which mentions the gods (1.3.28). I shall not enter into the details of the lengthy refutation of the third objection, which does not concern us directly. The reply to the two other objections is that gods have the ability to possess simultaneously several bodies and remain invisible. Śaṅkara asserts this on the basis of Śruti *(Bṛhadāraṇyaka-upaniṣad)* and Smṛti texts that mention yogic powers (1.3.27). He gives yet another explanation: even if gods have a single body, nothing prohibits them from being offered rites in different places. Śaṅkara also stresses that meditation on the embodiments *(svarūpa)* of gods is necessary for the performance of the sacrifice. He quotes the authority of the Smṛti (traditional stories and legends) and of the Śruti (mantras and Brāhmaṇas) in this regard (1.3.33).

However, these passages mainly concern Vedic rites. Even the quotation from the *Bhagavadgītā*, though suffused with devotion to a divine body, does not necessarily refer to a concrete divine image. By contrast, several other passages in Śaṅkara's commentary explicitly mention concrete representations of gods, that is, material images, though only as instances and analogies to demonstrate other points. It is clear from these passages that Śaṅkara does not identify concrete divine images with gods and considers that the idea of god is merely superimposed on these images.[28]

Śaṅkara uses the analogy of divine images in his commentary on 3.3.9. The passage aims to refute the idea that the sacred syllable *Oṃ* and the *Udgītha* (a song of the *Sāmaveda* that begins with *Oṃ*) are in a relation of superimposition. Śaṅkara explains that in the case of superimposition, the idea *(buddhi)* of something on which the idea of something else has been superimposed still persists. "It is like the case when the idea of the Brahman being superimposed on a name (like *Oṃ*), the idea of this name persists; it does not cease because of the idea of the Brahman. Or again it is like the superimposition *(adhyāsa)* of the idea of Viṣṇu, etc. on the images *(pratimā)*, etc." (543). In the case of the divine image, this means that the comprehension of the god superimposed on the image does not negate the reality of the image. But the image is definitely different from the god.

The relationship between the god and his image is one of superimposition *(āropaṇa)*, that is, imposing an idea (or perception) (of god) on something else (the image). In the commentary on 4.1.5, this relation is mentioned to illustrate the superimposition of the vision

(dṛṣṭi) of the Brahman on the symbols *(pratīka)* used to meditate on it, like the sun and so on. The contrary (that is, symbol superimposed on the Brahman) is impossible. The reason is found in a mundane maxim *(laukiko nyāyaḥ):* "The vision of the superior *(utkṛṣṭadṛṣṭi)* must be superimposed *(adhyasitavya)* on the inferior *(nikṛṣṭa)."* Thus, the consideration of the king is applied to his charioteer and not the contrary (1048), and, in a similar way, gods are superimposed on images *(pratimā)* and so on (that is, concrete objects of worship) (1050). This evidences the inferior character of the image and the fundamental dissociation of the image from the god it represents, in Śaṅkara's point of view.

In another passage (on 4.1.3), Śaṅkara indirectly gives another technical clue to the nature of the relationship between the god and his concrete image, again to illustrate the main subject, a debate on the oneness of the individual self with the Brahman. The opponent, who does not admit this oneness, concedes, however, that "even while there is a difference [between the Brahman and the individual self], one must resort to the apprehension of [their] identity *(tādātmyadarśanaṃ ... kartavyam)* on the strength of the Śāstra, like an apprehension of Viṣṇu in [his] images *(pratimādiṣv iva viṣṇvādidarśanam),* etc. [that is, other concrete objects of worship]," but he denies that "the transmigrating individual self be the Lord in a primary sense *(mukhya)"* (1042). It should be noted that the relationship of identity *(tādātmya)* implies the existence of two objects and is therefore distinct from non-duality *(advaita),* which means absence of difference between two objects. The opponent accepts the apprehension of identity between the Brahman and the individual self, but only in a secondary sense. In this context, the analogy of the relationship of the god with his images does not seem here to bear upon the notion of identity itself, but rather to stress the non-literal character of this identity. In other words (here we confine ourselves to what concerns images of gods), the identity of Viṣṇu with his image should not be taken literally, according to the opponent.

A few sentences later, Śaṅkara refers to the opponent's opinion as not "an apprehension of identity," but describes it as "the apprehension of a symbol *(pratīkadarśana)* on the line of the maxim of the image of Viṣṇu *(viṣṇupratimānyāyena)"* (1043). The symbolic type of relationship implies recourse to a secondary or figurative meaning *(gauṇatva).* If one applies this observation to the instance of the divine image, it signifies that the divine image can be identified only figuratively as the god, an analogy with which Śaṅkara agrees as an illustration of the

symbolic relationship. But, of course, the Advaitin who sees no duality between the individual self and the Brahman does not accept that the relationship between the individual self and the Brahman is of the symbolic type, and consequently does not agree to apply the analogy of divine images to that relationship.

Finally, while Śaṅkara is eager to assert the notion of the embodiment of god, he clearly distinguishes concrete images from the gods they represent in passages where he mentions images. A divine image has no value by itself. It receives value only through a superimposition, a mental application of the idea of a god to it.

Vācaspati Miśra's subcommentary, the *Bhāmatī*, would require a long investigation, which is impossible here. We may, however, mention that this author insists on the equivalence between "Vedic sacrifice" and worship and on the theistic dimension of Vedic rites. Commenting on 3.2.41, he identifies "sacrifice" as "consisting in the worship of a god": *devapūjātmako yāgaḥ*. This statement is the exact contradiction of the Mīmāṃsaka standpoint. Sacrifice is an act of devotion and faith that aims at pleasing a deity. The fruits of the rite arise from the worship of the deity *(devatārādhana)*. To sustain his point and to show the invalidity of the Mīmāṃsaka view, Vācaspati Miśra strikingly insists on referring to observable practices. This seems to imply that during his time, "Vedic sacrifice" was practised as an act of worship. Vācaspati also "emphasizes the necessity of individual, conscious deities."[29] In order to produce results, sacrifices should please the god, in the same way as honouring *(pūjā)* should please the king to obtain a reward.

The Naiyāyika Udayana: Deities as Conceiving Themselves in Images

Udayana, the Naiyāyika author of the *Nyāyakusumāñjali* (eleventh century),[30] articulates his view on the priestly practice of the consecration of the image, thus showing a greater awareness of the ritual technicalities involved in image worship than the authors previously examined. He also concentrates on the role of gods as active, conscious beings with regard to images, a dimension that is absent from Śaṅkara's analysis, which is made from the point of view of the worshipper. The Nyāya ("Logic") system, which deals mainly with epistemology, that is, the study of knowledge and the means of obtaining right knowledge, rarely discusses rituals. In this regard,

Udayana's lengthy development on the causality of rituals in chapter (*stabaka*) 1 of his *Nyāyakusumāñjali* (with his own commentary) is a rather exceptional passage. This development includes only a short discussion of divine images. In order to understand Udayana's point of view on this subject, however, we need to explain in some detail the Naiyāyika metaphysical background and the main argumentation in the context of which the question of the image arises in the *Nyāyakusumāñjali*.

Like other Naiyāyika authors and in contrast to Mīmāṃsā, which does not believe in a creator, Udayana can be considered a monotheist. His supreme god is Īśvara, who created the Vedas as well as the universe. Other gods are secondary to him.[31] Although Īśvara can create, be an agent of action, and perceive and have the same generic qualities as the souls, he does not possess a body. I need not expatiate here on this aspect, which requires a complex demonstration from Udayana.[32] However, Udayana admits that Īśvara has to take a body in cases when a body is necessary to produce specific effects. This kind of body, called "instrumental body" (*upakaraṇaśarīra*) or "body of manifestation" (*nirmāṇaśarīra*), is in fact an illusory type of body that is not subjected to the senses and that does not experience pleasure or pain. The bodies of the authors of the different Vedic schools and that which Īśvara took to teach speech and several human crafts are instances of Īśvara's "instrumental bodies."[33] According to Chemparathy,[34] the Nyāya system adopted the notion of "instrumental body" not only as an acceptable reply to various rational objections but also under the pressure of "popular" belief in the periodic divine descents (*avatāra*) for the protection of the good and re-establishment of righteousness (*dharma*), as expressed in the *Bhagavadgītā* and the *purāṇas*. As we will see, this concept of Īśvara's embodiment does not in fact help us to understand Udayana's position about divine images, not because it is restrictive and cautious but because Udayana envisages the question of the image in relation to the functioning of ritual rather than in the context of a debate over the notion of the divine body. He considers the ritual sphere as a whole including both image worship and Vedic sacrifices, Īśvara controlling the effects of all rites.

Kārikā 8 in chapter 1 raises the question of how the performance of rites can be justified if they do not yield obviously connected results. The auto-commentary on this *kārikā* examines numerous objections against the utility of rituals, whether they are sacrifices (*iṣṭa*) or

religious foundations *(pūrta)*. Udayana answers these various possible criticisms at some length. For instance, he denies that financing a rite is simply based on a quest for social prestige. He also denies that religious gifts could serve to attract a personal clientele. He further answers the objection that ritual activity is in fact a deception, blindly transmitted and whose origin cannot be found; he refutes another objection that ritual activity is a deception motivated by self-interest (since such an organized form of deception would require too much effort from the deceivers). We cannot examine these points in detail here. As these instances may have shown, Udayana reports very practical questions and criticisms against rituals, which we may assume were probably current in his time and did not come specifically from śāstric scholastic discussions.

But the main objection that Udayana formulates is the absence of obvious connections between the ritual sequence and the mundane or supra-mundane effects that are expected. That is, how can the ritual be explained in terms of ordinary causality? Rites do not produce an immediate effect. They have long since been completed when the expected effect occurs. In answer, Udayana explains the effects of a rite by the intervention of the transcending factor *(apūrva, atiśaya,* also identified with *adṛṣṭa)*, which the rite has created. This transcending factor, also called *śakti,* "power," is discussed in *kārikās* 9 and 10 and Udayana's auto-commentary on them. Although Udayana's *apūrva* bears the same name as the transcendent principle of the Mīmāṃsā, it differs from it in two major respects. Firstly, Udayana's *apūrva* is not an independent principle but it is guided and controlled by the supreme god, Īśvara. This principle, like any mundane cause, is consciousness-less *(acetana)* and therefore needs the guidance and control of a conscious agent that is Īśvara.[35] The second difference from the Mīmāṃsaka concept is that, according to Udayana, rites do not create *apūrva* by themselves, but through the individual *dharma* of the ritual patron or performer. It is in this context that the question of the efficiency of image worship arises.

Udayana rejects the idea that any specific efficiency could come from an object like fire or rice that has undergone a particular ritual treatment. In the same way, rites do not transform deities *(devatā)*. Thus he says in his commentary on *kārikā* 11: "As offerings of oblations with mantras poured into the fire *(hutāśane haviḥ āhutayaḥ samantrāḥ)* in relation to *(uddeśena)* a particular deity [in fact] perfect *(abhisaṃskurvate)* the man [who sacrifices] [and] not the fire nor the deities, in the same

way an aspersion, etc. for rice, etc. perfects *(saṃskurute)* man only [and] not that [rice]." The only real transformation (effected by the rite) that Udayana accepts is a transformation in the promoter of the rite.

This position makes it difficult to legitimate the worship of individual images of gods or deities *(devatā)*, as Udayana himself then acknowledges among the possible objections to his thesis. One of these objections concerns the divine image: "Or how could merit *(dharma)* occur through worship *(pūjana)*, etc. if there is no specificity in an image *(pratimā)*, etc. made of earth and which has been perfected *(saṃskṛta)* by a consecration *(pratiṣṭhā)*, etc.? How could demerit *(adharma)* occur in case of transgression [that is, when a regular worship does not follow a consecration or when a Cāṇḍāla touches the image]? And how [to explain that] nothing occurs in case [the image] has not been consecrated?" That is, if one says that the image has not been previously perfected by the consecration itself, how could there be any merit in worshipping it, any demerit in not worshipping it, any absence of either merit or demerit in a case when no consecration was performed? In other words, what is the importance of an image being consecrated if this rite does not procure any specific quality for the image, if it does not differentiate this image from those that have not been consecrated? What is in fact at stake here is whether consecration *(pratiṣṭhā)* has any meaning if it is not accepted that it brings about a real transformation of the image itself. Practically, this also indirectly questions the basic activities of temple priesthood (which include the ceremonial consecration of divine images) and their logical legitimacy.

Kārikā 12 and its auto-commentary contain a refutation of that objection. *Kārikā* 12 runs: "Generation, disappearance, etc. [arise] from the conjunction with various causes. Deities [come near] through [their] presence *(saṃnidhāna)* [in their images] or even through the acknowledgment *(pratyabhijñānato'pi vā)* [of their worshipfulness in their images]." I shall skip the technical (logical) details of the demonstration of the auto-commentary, but translate literally the passage that is now important for us:

> Images differentiated as deities *(devatābhedāḥ)* which consider themselves *(abhimānin)* as Rudra, Upendra, Mahendra, etc. and whose presence has been gained *(saṃnidhāpita)* through the application of such and such ritual rules *(vidhi)*, obtain *(āsādayanti)* worshipfulness *(ārādhanīyatā)* here and there. [This is] like the body of a king, who has

fallen down in a faint because of the poisoned bite of a serpent and where consciousness has been obtained *(āpāditacaitanya)* through a process of extraction of the poison. And [divine] presence *(saṃnidhāna)* in these [images] consists in the ego and feeling of mine *(ahaṃkāramamakārau)* of these [deities in the images], as for the king who sees his semblance in a painted representation of himself. This is our point of view. According to others one must interpret [worshipfulness of the image] as a state of (being) an object of acknowledgement of what has been long worshipped *(pūrvapūrvapūjitapratyabhijñānaviṣaya)* and of [being] an object of acknow-ledgement of what has been consecrated *(pratiṣṭhitapratyabhijñānaviṣaya).* Water, sprouts, etc. which have been consecrated by mantras *(abhimantrita)* are [also] envisaged through this [type of explanation]

Let us analyze his passage, which deals with deities, not with the supreme creator Īśvara. According to Udayana, the consideration of deities as themselves being these images coincides with the performance of the ritual process. Thus, the rite does not specifically invest the image with a divine presence or power through a mechanical process, but occasions the conscious reflection, by deities, of themselves as being present in the image. It is interesting to note here that the "presence" is not so much explained as a real positioning of the deity in the image but as an act of consciousness on the part of the deity towards the image. The commentator Haridāsa, who flourished around 1530,[36] gives an exegesis of *kārikā* 12: "The deities through the ritual process of consecration, by [their] presence, [that is,] by [their] ego, feeling of mine, etc., obtain worshipfulness [in these images]. Through the ritual process of consecration, [there are] the ego and feeling of mine in the images of the deities and by the touch of Cāṇḍālas, etc. the absence of such a self-knowledge [takes place]" (50-51), a gloss that in fact does not add much to our understanding of the process.

The sentence "According to others ..." in Udayana's auto-commentary explaining the last expression in *kārikā* 12, "or through acknowledgment [of their worshipfulness in their images]" in fact consists of two explanations that are not Udayana's own. Both explanations could implicitly refer to the concept, especially found in priestly literature, that contrasts images that are recognized because of their antiquity or miraculous origin, on the one hand, and those more recently established by men, on the other hand.[37]

According to this concept, the worshipfulness of an image comes either from its antique origin (including self-manifestation of a god or consecration by other gods or *ṛṣis*) or from its proper consecration by contemporary men.

Nothing in Udayana's *kārikā* 12 and auto-commentary thereon shows that he rejects these two explanations of "others." The question is whether or not Udayana meant Mīmāṃsakas by "others." Haridāsa seems to adopt this identification. He glosses Udayana's text in the following way: "Even if one might contest that deities have consciousness *(devatācaitanyavivāde'pi)*, the valid cognition that [the image] has been worshipped *(yathārthapūjitatvadhī)* or the [valid] cognition that it has been consecrated *(pratiṣṭhitatvadhī)*, [either cognition being] specified by the absence of touch, etc. of Cāṇḍālas, etc., constitute the worshipfulness [of the image] *(pūjyatāniyāmikā)* and ritual consecration is proper *(upayoginī)* to that."[38] Thus, according to Haridāsa, the worshipfulness of the image is consistent even if consciousness is denied to deities, a position that probably refers to the Mīmāṃsaka disagreement with the notion of gods as being conscious beings. However, it is possible that Udayana, who specifically referred to the technical process of consecrating images, perhaps had the priestly concept (as mentioned earlier) in mind, rather than the Mīmāṃsaka point of view. By contrast, Haridāsa, who flourished some four centuries later, probably read this passage as a transparent reference to Mīmāṃsakas. This could show that Udayana had a closer approach to temple rituals than his commentator Haridāsa.

Thus, Udayana can hardly accept that images themselves contain a specific power. This would go against his stand whereby the rite perfects the worshipper, not the objects. The essential condition of worshipfulness of the image is the *dharma* of the worshipper. At the same time, however, Udayana shows a concern for legitimizing the ritual worshipfulness of images. While Advaita gives an important role to human consciousness in considering the divine image, Udayana stresses the role of the consciousness of deities in the worshipfulness of the divine images, although it cannot be said that the image is the deity itself in his point of view. It is remarkable that he does not evoke the relationship between the god and the image in a general way (as Śaṅkara did), but argues from the perspective of the temple rite of consecration.

Vaikhānasas: Gods as Present and Powerful in and through Their Images

Udayana's approach to the notion of divine presence in the image, however briefly formulated it may be, reflects in a way the ritual concern of the temple priests themselves. Still, his understanding of the relationship between gods and the worshipfulness of the divine image differs from the priestly understanding. In this connection, it may be interesting to summarize several priestly views (and related questions) on this subject.

As an illustration of such views, I will refer to the testimony of the Vaikhānasa Vaiṣṇava corpus of temple rituals, which for the main part can be assigned (at the present state of research) to a period between the ninth and (circa) thirteenth century. The Vaikhānasa textual corpus of temple rituals mainly deals not with images that are miraculous or antique but with images that have been recently produced and consecrated by man. In contrast to the devotional context, where the worshipfulness of an image arises through its interaction with its devotees, the question of how temple rites bestow worshipfulness and efficiency on the divine image is crucial in this corpus, not only at an abstract level of principles but also in practical terms, to legitimate temple rites.[39] In fact, the Vaikhānasa textual corpus does not present a theory of the divine image as such, but its prescriptions express directly or indirectly concepts of the divine image that run concurrently within the texts themselves, even while they may not always be clearly distinct. I shall summarize these concepts from observations made in previous publications.[40]

One concept consists in the image as an abode where the god resides as long as he is pleased and which he leaves in different cases, for instance, in the absence of regular worship, in the case of damage to the image, and so on.[41] This concept stresses the free will of the god, on the one hand, and the role of his personal feelings (pleasure or anger) with regard to the quality of ritual service, the material image, and so on, on the other hand. It relies, in fact, on the more general and prominent notion of the presence of the god in the image.

The notion of the presence of the god in the image contains two concepts that can be clearly distinguished: that of power and that of life in the image. The bringing of divine power (śakti) into the image is the main object of the consecration of an image (pratiṣṭhā). Without insisting on the details of this rite, one may say that a main phase in

this transmission of power is the meditation on a jar filled with water and divine symbols and its worship, which results in the introduction of the divine power in the water. At the end of the rite of consecration, the water is poured over the image, thus suffusing it with power. In case of damage or carrying off (by enemies or thieves) of the image of worship, and in several other cases, the power of the image can be transferred temporarily into other supports, like a jar of water, a diagram of the sun, a gem, a piece of gold, a bundle of *kūrca* herb, or even the heart of a priest. Therefore, it seems that the divine power is by itself rather shapeless and non-individualized and that it does not specifically need an image to be active from a determined place. However, several factors induce the divine power to operate towards a certain type of effect. The shape, attitude, and definition of the image are such factors: for instance, the style of the image may be adequate to either the search of *yoga* or well-being or heroism or black magic. This concept of divine power in the image is the best-articulated view on the significance of image worship in the Vaikhānasa corpus.

Another concept is that of life in the image. In this perspective, the image is considered as a living being endowed with sense perception. Significantly, for instance, the *Kriyādhikāra* distinguishes acts of homage into tangible, edible, audible, and visible. Although this aspect of image worship is well known elsewhere too, we may wonder what is the real import of this consideration of the image as a living being in the Vaikhānasa corpus. Does it correspond to a deeply rooted belief or to a sort of mental voluntary resolution, and is it essential for understanding the functioning of the rite? While the operations related to "power" are consistent and impregnated with a strong logic, the depiction and testimonies of life in the image are not so well articulated as the procedures related to "power," and they are also more incidental. The image is depicted as a living being long before it is endowed with power. It is treated as a respectable and divine being even before the "opening of the eyes" *(akṣyunmocana)*, one of the first ceremonies of the consecration. Again, this "opening of the eyes," which consists in the ritual identification of the different parts of the eyes with natural elements and with the Supreme self, indicates that life is established in the image long before "power."

The assertion of life in the image is renewed occasionally. For instance, this is done (again in the consecration rite, but before the final empowerment) in a rather hyperrealist way during the fabrication of the clay image. The seven successive steps in preparing a clay image

are: assembling the wooden frame, application of a gum made of eight ingredients, binding of strings, application of the clay, application of a coating of limestone paste, application of cloth, and application of colours. The seven material elements involved are identified, respectively, with skeleton, fat, occult veins *(nāḍī)*, flesh, blood, skin, and individual life *(jīva)* with the help of rites and mantras. Yet another coating of colour, this time mixed with gold, gives "power" *(śakti)*, a prescription that tends to intermingle the concept of power with that of life and adds a nuance to our ideally clear-cut initial distinction. However, the prominent idea here is a step-by-step life-giving process. This lengthy ritual chain of identifications forms a literal illustration of the concept of divine images functioning as human beings. Its complexity contrasts with the fact that clay is generally considered as far less valuable than other materials (like metal or stone) for making divine images.

At about the same time in history as Udayana, the Vaikhānasa priestly group articulated the concept of "power" in its prescriptions of image worship. The presence of power should be renewed by daily worship and controlled by ritual. By contrast, the elaboration of the concept of life in divine images, which would appear to be naturally associated with that of *pūjā*, because of the anthropomorphic character of this rite, could appear more problematic in the Vaikhānasa corpus and even (occasionally at least) dissociated from the notion of power. These two concepts of power and life do not necessarily contradict each other, but correspond more probably to two lines of understanding that run concurrently. These two lines of understanding perhaps reflect two different attitudes towards the image – the ritual and the devotional. The ritual perspective insists on the mechanical building of power and efficiency through the strict application of the prescriptions. However, although the Vaikhānasa corpus of temple rituals is basically a collection of technical prescriptions, it remains impregnated with common devotion, which tends to favour the more "spontaneous" belief that images of gods are alive like human beings, even while this belief precedes the moment when ritual itself is expected to give power and life to a previously inert image.

Conclusion

This brief introduction to various ways of envisaging divine images in several Hindu systems did not aim, of course, to exhaust the subject in the works of the authors or even the texts considered here. Nor do these authors or these texts represent or express all the views of their respective schools on the subject. To conclude, I would like to draw attention to several points.

All the systems that we explored more or less clearly accept the notion of worship of god in one way or another, although reluctantly in the case of Mīmāṃsā (which also does not explicitly refer to "image worship"). This system, although it does not agree that deities are those who bring results to the rite, accepts worship and probably image worship at the level of the Smṛti injunctions that are legitimated by the practices of the well educated. The implicit definition of worship (often *pūjā*, also for image worship, in Sanskrit) varies in the different systems.

In the priestly point of view, the image plays an essential role in worship. Understood as being full of life and power, it is an individual personification of the god, and as such it receives acts of homage. By contrast, the philosophical systems are reluctant to assimilate the images themselves to the gods they represent. Hence, we may assume that for them it is basically the gods, not the images, that are supposed to receive worship (although worship is only a conventional usage in Mīmāṃsā, for which gods have almost no existence), even in the case of "image worship." In the perspective of Mīmāṃsā and Advaita, a particular question is whether sacrifice (*yāga, yajña*), that is, "Vedic sacrifice," should be understood as worship (*pūjā*) addressed to deities. Mīmāṃsakas reply negatively, Advaitins positively. The Naiyāyika Udayana not only understands sacrifice as worship but also clearly considers image worship as a practice on par with Vedic rites. The priestly Vaikhānasa corpus of temple rituals largely integrates (and adapts) "Vedic" or rather "vedicizing" types of prescriptions into its rite, which is basically image-oriented (we did not discuss this aspect here).[42]

By contrast with the priestly Vaikhānasa exposition, the philosophers I mentioned deal only casually with the notion of a divine image, although image worship was certainly well developed in their historical surrounding. One might think that they did not consider divine images and their worship as scholastic subjects, an

attitude somewhat comparable to that of European scholastics up to the early eighteenth century, which did not accept certain subjects as topics suitable for discussion, like metempsychosis, for instance.[43] This explanation does not seem convincing, however. In many respects, Indian philosophical systems did not have such kinds of restrictions. On the other hand, as mentioned earlier in the introduction, several rationally constructed Indian systems clearly approved of image worship before and around the tenth century. Should we then understand that the philosophers mentioned in this chapter considered image worship as a secondary, or even inferior, religious activity? In fact, since they did not specially aim at justifying image worship, perhaps they preferred to refer generally to the "Vedic sacrifice" rather than to worship or image worship because they addressed milieux that praised Vedic scriptures and prescriptions rather than those related to image worship. In fact, image worship has a different import in each of the philosophical systems examined here. Mīmāṃsā marginalizes the notion of worship (pūjā) in general. The Advaitin Śaṅkara mentions divine images only as an example and stresses their exclusively instrumental character. The Naiyāyika Udayana at the same time offers a metaphysical explanation of image worship and does not accept that the image could by itself possess any power.

The concept of the image as the body of a god is problematic. In the approaches of Mīmāṃsā, Advaita, and Nyāya, the notion of the embodiment of gods is clearly differentiated from that of the divine image as a body. The three philosophical systems (we have to infer the Mīmāṃsā view in the passages we examined, however) reject the identification of the image as a divine body, but they diverge on whether gods/deities have a body. Mīmāṃsakas deny that a deity may possess a body. For them, such a notion can be understood only as a figurative and conventional concept. They rule out any sense of ownership in gods. Advaita at the same time defends the notion of embodiment of gods, even while these may remain invisible, and refuses to identify the image with the god, who is simply superimposed on the image. Divine images are only, so to speak, markers of gods. They are devoid of any divinity by themselves. The Naiyāyika Udayana only reluctantly accepts that the supreme creator may occasionally assume an illusory body. With regard to images, his opinion is that the deities (which are secondary to the main god, who is Īśvara, the creator) reflect on images as being themselves. The

divine presence in the image appears to be a sort of mental projection from the deities.

The Vaikhānasa texts, which do not claim to construct a strictly homogeneous theory of the image, present a more complex perspective. There the image is identified as a divine living being either in the immediacy of devotional imagination or through ritual technique, the second approach being the specifically priestly one. Both approaches appear complementary rather than exclusive of each other in these Vaikhānasa texts. The heavily material worship offered to a concrete image that is understood as possessing a human sensibility tends to stress that the image is the god embodied.[44] At the same time, however, the presence of life and of power in the concrete image is neither unconditionally attached to nor inherent in it. This rather volatile presence closely depends on maintaining the material integrity of the image and the regular performance of the rites. Thus, even in a priestly point of view, the notion of the divine image as being the god's body remains equivocal.

The points of view on the efficiency of images also differ depending on the school. The Advaitin passages that we read are silent on the subject. Images are not credited with any particular power although gods themselves are considered to exercise power on the practical level of existence. Mīmāṃsā attributes efficiency to the rite itself, with the transcendent and non-theistic principle of *apūrva* as a secondary agent. In this perspective, where no extra-linguistic concept of god is taken into account, the reader gathers that divine images can hardly have any power by themselves. Udayana seems anxious to justify the worship of consecrated images (deities reflecting themselves in images), but he does not specifically attribute any individualized power to them. In his view, rites bring about changes in the promoter of the rite, but they cannot alter ritual objects (including images for Udayana) to make them efficient by themselves. In the Vaikhānasa perspective, which deals mainly with ritually consecrated images, the presence of the divine power in the image remains fragile, as we have seen. Thus, skepticism about the inherent efficiency of the divine image appears in various degrees in all these attitudes, even in the priestly one to some extent.

The final point I would like to make concerns the historical ideologies that may have been at work behind some of these positions. Social and political powers encouraged the development of public image worship against the background of a decline in Vedic rituals (in

spite of its transitory revivals). The prosperity of temple priests grew with that development. The Vaikhānasa corpus of temple rituals illustrates, as a comparatively late example, the close relationship between public image worship and the economic interests of priestly groups. The prescriptions of this corpus deal almost exclusively with ritually consecrated images, whose historical character is acknowledged, and not with self-manifested or "antique" images.[45] At the same time, it relates the necessity of a regular worship to the need for maintaining the economic welfare of priestly families.[46]

On the other hand, the well-established and conventional acceptance of image worship did not necessarily silence more skeptical opinions that probably existed throughout centuries and continue to exist today. In fact, Sanskrit texts show a multiplicity of opinions on image worship, and not a uniform "Brahmanical" view. However, rather unanimously, the philosophers, while they are aware of different kinds of critiques of ritualism and more particularly image worship, still concur in abstaining from condemning these practices, thus adopting an ambivalent position. This is particularly obvious in the positions of the Mīmāṃsakas and Udayana, as reported here. Udayana raises against ritualism harsh questions that can be applied to image worship too. These realistic questions, far from being abstract, probably reflect a current anti-ritualistic tendency in Hindu society.[47] Again, Udayana's denial of power in the image perhaps illustrates an iconophobic attitude (even while it stems from a more general philosophical stand about power in material objects). At the same time, however, Udayana shows concern for legitimating the consecration of the image, although he does not follow the priestly explanation as exemplified by the Vaikhānasa texts. In a similar vein, but several centuries before Udayana and in the context of a critique of the concept of worship, not of sacrifice, the Mīmāṃsaka Śabara acknowledges the fact that donations to gods and temples are in reality made to temple priests, thus demystifying public (image) worship (according to the interpretation that I retain for the passage involved). In spite of this position, however, Śabara does not condemn image worship but confines it to Smṛti.

Śabara's ambivalent attitude could testify to a comparatively early tension between two traditional professional careers among Brahmins, either as scholars (including Vedic scholars and specialists of Vedic rites) or as temple priests (if that is the meaning of *deva-/devatā-paricāraka*). The gradual increase of donations to temples and the

consequent decrease of donations to the Brahmanical settlements (*agrahāra, brahmadeya*) probably corresponded to important changes in the social situation of Brahmins (who had to migrate or sometimes embrace the profession of temple priests), at least in certain areas.[48] Śabara's rejection of the concept of ownership of gods (except as convention) and his contestation of the metaphysical ability of gods (hence, as we may understand, of temple images) to receive and provide gifts were certainly points to draw in resisting this shift. Debates on the legal and individual personality of divine images are well documented in modern history,[49] but there is no reason to believe that they did not also occur in earlier times, in spite of the scarcity of information on this matter.

However, a good number of followers of the Mīmāṃsā were perhaps also devotees of a deity and even regular visitors to images in temples. It is also possible that the ambiguity of Śabara's attitude about temple priesthood enabled him to legitimize this way of earning for Brahmins while at the same time asserting the superiority of Vedic ritual performers and of the Mīmāṃsā ritualistic tradition over the temple priesthood.[50] It is not improbable that this form of the debate, with its hierarchization and its ultimate justification of temple priesthood by philosophers, was to remain internal, so to speak, to Brahmanical circles.

Acknowledgements

I would like to thank Phyllis Granoff and Koichi Shinohara for giving me the opportunity to present the paper on which this chapter is based at the conference on "Images in Asian Religions: Texts and Contexts," held in Hamilton and Toronto in May 2001, and Phyllis for her observations. I am grateful for their remarks to the other participants at the conference, particularly M. Kapstein. I also thank Catherine Clémentin-Ojha for her attentive reading of and observations about this chapter.

End Notes

1 For the dates of these authors, see V.K.S.N. Raghavan, *History of Viśiṣṭādvaita Literature* (Delhi: Ajanta Publications, 1979), 6-7. No work of Nāthamuni is now extant.

2 See the references given in Alexis Sanderson, "Maṇḍala and Āgamic Identity in the Trika of Kashmir," in *Mantras et Diagrammes Rituels dans l'Hindouisme*, ed. A. Padoux (Paris: Éditions du Centre National de la Recherche Scientifique, 1986), 170 n. 3.

3 For another account of the positions of Mīmāṃsā and Advaita, see Francis X. Clooney, "*Devatādhikaraṇa*: A Theological Debate in the Mīmāṃsā-Vedānta Tradition," *Journal of Indian Philosophy* 16 (1988): 277-98. See also Günther-Dietz Sontheimer, "Religious Endowments in India: The Juristic Personality of Hindu Deities," *Zeitschrift für Vergleichende Rechtswissenschaft* 87 (1964): 49-58; Richard H. Davis, *Lives of Indian Images* (Princeton: Princeton University Press, 1997), 44-49.

4 See Gérard Colas, *Viṣṇu, ses Images et ses Feux: Les Métamorphoses du Dieu chez les Vaikhānasa*, Monographies, no. 182 (Paris: Presses de l'École Française d'Extrême-Orient, 1996), 94-97.

5 A.A. Macdonell, *Vedic Mythology*, Gründniss der Indo-Arischen Philologie und Altertumskunde III, 1A (Strassburg: Trübner, 1897), 17.

6 Charles Malamoud, *Cuire le Monde* (Paris: Éditions de la Découverte, 1989), 271; on the question of the embodiment of gods in Vedic texts more generally, see ch. 13 ("Briques et mots"), 253-73.

7 E. Washburn Hopkins, *Epic Mythology*, Gründniss der Indo-Arischen Philologie und Altertumskunde III, 1B (Strassburg: Trübner, 1915), 57.

8 See, for instance, Louis Renou, *Vocabulaire du Rituel Védique*, Collection de Vocabulaires Techniques du Sanskrit (Paris: Librairie C. Klincksieck, 1954), 128, and Yajñikadeva's commentary on *Kātyāyanaśrautasūtra* 1.2.1, ed. A. Weber, The Chowkhamba Sanskrit Series no. 104 (Varanasi: Chowkhamba Sanskrit Series Office, 1972).

9 For a detailed exposition, see Sylvain Lévi, *La Doctrine du Sacrifice dans les Brāhmaṇas*, Bibliothèque de l'École des Hautes Études, Sciences Religieuses, vol. 11 (Paris: Ernest Leroux, 1898).

10 *Śābarabhāṣya on Jaimini's Mīmāṃsāsūtras*, ed. Maheśacandra Nyāyaratna, Bibliotheca Indica, 2 vols. (Calcutta: The Asiatic Society of Bengal, 1863-87).

11 *Tantravārttika*, ed. Gaṅgādhara Śāstrī, Benares Sanskrit Series (Benares: Braj B. Das and Co., 1882-1903).

12 See Jean-Marie Verpoorten, *Mīmāṃsā Literature*, A History of Indian Literature, vol. 6, fasc. 5 (Wiesbaden: Otto Harrassowitz, 1987), 8.

13 Ibid., 22.

14 That seems to be the significance of this term, which Jha translates as "indicative text": see vol. 3 of his translation (Adhyāyas 9-12), Gaekwad's Oriental Series 73 (Baroda: Oriental Institute, 1936), 1429-37, *passim*). Śabara also uses another compound, *anyārthadarśana*, which might have the slightly different meaning of "indication of another

meaning (apart from the obvious one)" (9.1.6, 7, 8, 9). *Anyārthavacanas* and *anyārthadarśanas* in the passages mentioned here are found in Vedic collections (mostly *Ṛgsaṃhitā*). The use of these two terms in Śabara's commentary needs a systematic study.

15 It might also refer to other uses of painted representations of gods, for instance, as illustrations in the recitation of divine legends.

16 Hence it should be understood metaphorically only. "Again the usage *(upacāra)* which consists in speaking of 'village of God,' 'territory of God' is nothing but a usage *(upacāramātra)*." For *upacāra* (= *lakṣaṇā*) in the sense of metaphor, see K. Kunjunni Raja, *Indian Theories of Meaning*, 2nd ed., The Adyar Library Series, vol. 91 (Madras: Adyar Library and Research Centre, 1969), 231, 233 (Nyāyasūtra 2.2.62 as referred to in n. 1), 235, and 247. According to some authors, the "sanction of established usage" is an essential condition for the validity of a metaphor (Kunjunni Raja, *Indian Theories of Meaning*, 231-32).

17 *Bhūti* in the edition (Bibliotheca Indica) that I used. Another reading (in other editions) is *bhṛti*, which can be understood as "salary" (Stefano Corno, "La Théorie des Divinités dans l'Exégèse Indienne [Mīmāṃsā]: le 'Chapitre des Divinités' [Devatādhikaraṇa] du Commentaire de Śabara [Śābarabhāṣya 9.1.sū. 6-10])," Mémoire, Diplôme d'Études Approfondies (Paris: École Pratique des Hautes Études, Section des Sciences Religieuses, 2001), 50 and 63, with a discussion in n. 86) or "revenue."

18 See n. 14 above.

19 He translates the term *paricāraka*, which appears (twice) later in the same passage, as "priest" and "attendant priest."

20 See Colas, *Viṣṇu, ses Images et ses Feux*, 213-15.

21 Compare with ibid., 120, 123, 132, 258, 260.

22 Clooney, "*Devatādhikaraṇa:* A Theological Debate," 283.

23 See his commentary on 1.3.4-12. According to Kumārila, a possible interpretation of 1.3.4 is that a certain number of Smṛtis cannot be accepted because they are opposed to Veda and have greed and other defects as their origin. Kumārila names the compilations of the Pāñcarātra and Pāśupata systems among these Smṛtis.

24 More precisely, "the erection of Śakra (= Indra)'s banner and festive processions (?) in the temples of deities" (*śakradhvajamahoyātrā devatāyataneṣu*, on 1.3.7, 130).

25 Śaṅkara, [*Brahmasūtrabhāṣya* with Ānandagiri's *Nyāyanirṇaya*], ed. N.S. Ekasaṃbekare, Ānandāśramasaṃskṛtagranthāvali 21, 2 vols. (Poona, 1890-91).

26 Ed. Bāla Śāstrin, Bibliotheca Indica (Benares: The Asiatic Society of Bengal, 1880).

27 Paul Hacker, *Philology and Confrontation: Paul Hacker on Traditional and Modern Vedānta*, ed. W. Halbfass (Albany: State University of New York Press, 1995).

28 Two passages in Śaṅkara's commentary (on 1.2.14 and 1.3.14) also mention the *śālagrāma* (a holy black stone with an ammonite fossil) in discussions where, to summarize, the philosopher relativizes the concept of the presence of Viṣṇu in that stone.

29 Clooney, "*Devatādhikaraṇa*: A Theological Debate," 288.

30 Ed. and trans. N.S. Dravid, vol. 1 (New Delhi: Indian Council of Philosophical Research, 1996).

31 George Chemparathy, *An Indian Rational Theology: Introduction to Udayana's Nyāyakusumāñjali*, Publications of the De Nobili Research Library, vol. 1 (Vienna, 1972), 180.

32 Ibid., 140-48.

33 Ibid., 152-54.

34 Ibid., 152-53.

35 Ibid., 83.

36 *Nyāyakusumāñjali* [with Haridāsabhaṭṭācārya's *Vṛtti*, the editor's Sanskrit *(Prabhā)* and Hindi commentaries], ed. Nārāyaṇamiśra (Varanasi, 1968). For the author's date, see Karl L. Potter, *Encyclopedia of Indian Philosophies: Bibliography*, 2nd rev. ed. (Delhi: Motilal Banarsidass, 1983), 353.

37 For the different classes of images and temples, such as self-manifested, established by gods, established by *ṛṣis*, antique, and established by men, see, for instance, Colas, *Viṣṇu, ses Images et ses Feux*, 189-91.

38 My translation mostly agrees with the convincing Sanskrit and Hindi commentaries of the modern editor Nārāyaṇamiśra. It parts on several points from Cowell's and Maheśa Candra Nyāyaratna's understanding in their English translation *(The Kusumāñjali, or Hindu Proof of the Existence of a Supreme Being by Udayana Āchārya with the Commentary of Hari Dāsa Bhaṭṭāchārya*, ed. and trans. A.B. Cowell assisted by Paṇḍita Maheśa Candra Nyāyaratna [Calcutta, 1864]). I understand that *yathārtha* refers to *dhī* in *yathārthapūjitatvadhī* (as opposed to Cowell's "the idea ... that the worship has been performed in due manner") and is implied in *pratiṣṭhitatvadhī*. The *ca* (literally "and") that connects both the cognitions expresses more an alternative than an addition (as confirmed by the singular form of *pūjyatāniyāmikā*) and I therefore translate it as "or."

39 Vaikhānasa rites integrate (and transform) many features of "Vedic" rites, an aspect which I cannot explore here.

40 See Colas, *Viṣṇu, ses Images et ses Feux*, and works quoted in it, especially Colas, "L'Instauration de la Puissance Divine dans l'Image du Temple en

Inde du Sud," *Revue de l'Histoire des Religions* 206 (1989): 146 (for the "opening of the eyes"); Colas, *Le Temple selon Marīci*, Publications de l'Institut Français d'Indologie no. 71 (Pondichéry: Institut Français d'Indologie, 1986), 180-90 (for the clay image).

41 See, for instance, Colas, *Le Temple selon Marīci*, 189.

42 For more details, see Colas, *Viṣṇu, ses Images et ses Feux*, especially 257-84.

43 R. Hedde, "Métempsychose," in *Dictionnaire de Théologie Catholique*, ed. A. Vacant, E. Mangenot, and E. Amann (Paris: Librairie Letouzet et Ané, 1929), vol. 10, pt. 2, col. 1592.

44 Colas, *Viṣṇu, ses Images et ses Feux*, 302-47; see also Colas, *Le Temple selon Marīci*, 71 (*bera*, "divine image" < *vera*, "body"?).

45 For more details on this subject, see Colas, "Êtres Supérieurs, Temps et Rite: Les Sources du Pouvoir du Temple Hindou," in *Religion et Pratiques de Puissance*, ed. A. de Surgy, Collection Anthropologie – Connaissance des hommes (Paris: Éditions L'Harmattan, 1997), 250.

46 I could not insist on this aspect in the present chapter. See Colas, *Viṣṇu, ses Images et ses Feux*, 121, 129-130.

47 See Phyllis Granoff, "Reading between the Lines: Colliding Attitudes towards Image Worship in Indian Religions," paper read at the École des Hautes Études en Science Sociales, June 2000.

48 See, for instance, for the Andhra area, B.S.L. Hanumantha Rao, *Social Mobility in Medieval Andhra* (Hyderabad: Telugu University, 1995), 18-32, 49 *sqq.*

49 See S.C. Bagchi, *Juristic Personality of Hindu Deities*, Asutosh Mookerjee Lectures, 1931 (Calcutta: University of Calcutta, 1933); Sontheimer, "Religious Endowments in India," *passim*; Davis, *Lives of Indian Images*, 248-52.

50 For some elements and bibliography on the related notion of *devalaka*, see Colas, *Viṣṇu, ses Images et ses Feux*, 133-40; see also Colas, "Êtres Supérieurs, Temps et Rite," 240.

Bibliography

Primary Sources

[*Kātyāyanaśrautasūtra*] = *The Śrautasūtra of Kātyāyana with Extracts from the Commentaries of Karka and Yajñikadeva*. Edited by A. Weber. The Chowkhamba Sanskrit Series no. 104. Varanasi: Chowkhamba Sanskrit Series Office, 1972.

Kumārila Bhaṭṭa. *Tantravārttika.* Edited by Gaṅgādhara Śāstrī. Benares Sanskrit Series. Benares: Braj B. Das and Co., 1882-1903.

–. *Tantravārttika.* Partly translated by Gaṅgānātha Jhā. Bibliotheca Indica. Calcutta: The Asiatic Society of Bengal, 1924.

Śabara. *Śābarabhāṣya on Jaimini's Mīmāṃsāsūtras.* Edited by Maheśacandra Nyāyaratna. Bibliotheca Indica. 2 vols. Calcutta: The Asiatic Society of Bengal, 1863-87.

–. *Śābarabhāṣya.* Translated by Gaṅgānātha Jhā. Vol. 3 (Adhyāyas 9-12). Gaekwad's Oriental Series 73. Baroda: Oriental Institute, 1936.

Śaṅkara. [*Brahmasūtrabhāṣya* with Ānandagiri's *Nyāyanirṇaya*] = *Śrīmaddvaipāyanapraṇītabrahmasūtrāṇi ānandagirikṛtaṭīkāsaṃvalitaśāṃkarabhāṣyasametāni.* Edited by N.S. Ekasaṃbekare. Ānandāśramasaṃskṛtagranthāvali 21. 2 vols. Poona, 1890-91.

Udayanācārya. [*Nyāyakusumāñjali.* Edition and translation of the kārikās and Haridāsabhaṭṭācārya's *Vṛtti*] = *The Kusumāñjali, or Hindu Proof of the Existence of a Supreme Being by Udayana Āchārya with the Commentary of Hari Dāsa Bhaṭṭāchārya.* Edited and translated by A.B. Cowell assisted by Paṇḍita Maheśa Candra Nyāyaratna. Calcutta, 1864.

–. *Nyāyakusumāñjali* [with Haridāsabhaṭṭācārya's *Vṛtti,* the editor's Sanskrit *(Prabhā)* and Hindi commentaries]. Edited by Nārāyaṇamiśra. Varanasi, 1968.

–. *Nyāyakusumāñjali.* Edited and translated by N.S. Dravid. Vol. 1. New Delhi: Indian Council of Philosophical Research, 1996.

Vācaspati Miśra. *Bhāmatī.* Edited by Bāla Śāstrin. Bibliotheca Indica. Benares: The Asiatic Society of Bengal, 1880.

Secondary Sources

Bagchi, S.C. *Juristic Personality of Hindu Deities.* Asutosh Mookerjee Lectures, 1931. Calcutta: University of Calcutta, 1933.

Chemparathy, George. *An Indian Rational Theology: Introduction to Udayana's Nyāyakusumāñjali.* Publications of the De Nobili Research Library, vol. 1. Vienna, 1972.

Clooney, Francis X. "*Devatādhikaraṇa:* A Theological Debate in the Mīmāṃsā-Vedānta Tradition." *Journal of Indian Philosophy* 16 (1988): 277-98.

Colas, Gérard. *Le Temple selon Marīci.* Publications de l'Institut Français d'Indologie no. 71. Pondichéry: Institut Français d'Indologie, 1986.

–. "L'Instauration de la Puissance Divine dans l'Image du Temple en Inde du Sud." *Revue de l'Histoire des Religions* 206 (1989): 129-50.

–. *Viṣṇu, ses Images et ses Feux: Les Métamorphoses du Dieu chez les Vaikhānasa.*

Monographies, no. 182. Paris: Presses de l'École Française d'Extrême-Orient, 1996.

–. "Êtres Supérieurs, Temps et Rite: Les Sources du Pouvoir du Temple Hindou." Pp. 239-52 in *Religion et Pratiques de Puissance,* edited by A. de Surgy. Collection Anthropologie – Connaissance des hommes. Paris: Éditions L'Harmattan, 1997.

Corno, Stefano. "La Théorie des Divinités dans l'Exégèse Indienne (Mīmāṃsā): le 'Chapitre des Divinités' (Devatādhikaraṇa) du Commentaire de Śabara (Śābarabhāṣya 9.1.sū. 6-10)." Mémoire, Diplôme d'Etudes Approfondies. Paris: École Pratique des Hautes Études, Section des Sciences Religieuses, 2001.

Davis, Richard H. *Lives of Indian Images.* Princeton: Princeton University Press, 1997.

Granoff, Phyllis. "Reading between the Lines: Colliding Attitudes towards Image Worship in Indian Religions," paper read at the École des Hautes Études en Science Sociales, June 2000.

Hacker, Paul. *Philology and Confrontation: Paul Hacker on Traditional and Modern Vedānta,* edited by W. Halbfass. Albany: State University of New York Press, 1995.

Hanumantha Rao, B.S.L. *Social Mobility in Medieval Andhra.* Hyderabad: Telugu University, 1995.

Hedde, R. "Métempsychose." Vol. 10, pt. 2, cols. 1574-95 in *Dictionnaire de Théologie Catholique,* edited by A. Vacant, E. Mangenot, and E. Amann. Paris: Librairie Letouzet et Ané, 1929.

Hopkins, E. Washburn. *Epic Mythology.* Gründniss der Indo-Arischen Philologie und Altertumskunde III, 1B. Strassburg: Trübner, 1915.

Kunjunni Raja, K. *Indian Theories of Meaning.* 2nd ed. The Adyar Library Series, vol. 91. Madras: Adyar Library and Research Centre, 1969.

Lévi, Sylvain. *La Doctrine du Sacrifice dans les Brāhmaṇas.* Bibliothèque de l'École des Hautes Études, Sciences Religieuses, vol. 11. Paris: Ernest Leroux, 1898.

Macdonell, A.A. *Vedic Mythology.* Gründniss der Indo-Arischen Philologie und Altertumskunde III, 1A. Strassburg: Trübner, 1897.

Malamoud, Charles. *Cuire le Monde.* Paris: Éditions de la Découverte, 1989.

Potter, Karl L. *Encyclopedia of Indian Philosophies: Bibliography.* 2nd rev. ed. Delhi: Motilal Banarsidass, 1983.

Raghavan, V.K.S.N. *History of Viśiṣṭādvaita Literature.* Delhi: Ajanta Publications, 1979.

Renou, Louis. *Vocabulaire du Rituel Védique.* Collection de Vocabulaires Techniques du Sanskrit. Paris: Librairie C. Klincksieck, 1954.

Sanderson, Alexis. "Maṇḍala and Āgamic Identity in the Trika of Kashmir."

Pp. 169-227 in *Mantras et Diagrammes Rituels dans l'Hindouisme*, edited by A. Padoux. Paris: Éditions du Centre National de la Recherche Scientifique, 1986.

Sontheimer, Günther-Dietz. "Religious Endowments in India: The Juristic Personality of Hindu Deities." *Zeitschrift für Vergleichende Rechtswissenschaft* 87 (1964): 45-100.

Verpoorten, Jean-Marie. *Mīmāṃsā Literature*. A History of Indian Literature, vol. 6, fasc. 5. Wiesbaden: Otto Harrassowitz, 1987.

6

Stories of Miraculous Images and Paying Respect to the Three Jewels: A Discourse on Image Worship in Seventh-Century China

KOICHI SHINOHARA

In this chapter, I examine how a distinctive discourse about image worship evolved in medieval Chinese Buddhism. This examination is guided by two large assumptions. The first is that image worship was introduced relatively late in Buddhism and that the tradition is often ambivalent about its status.[1] Images are seldom mentioned in the *vinayas*.[2] In this literature, monastic rules are said to have been established by Śākyamuni Buddha himself, although many of these rules must reflect later practices and are anachronistically projected back into the time of the Buddha. Typically, images are presented as substitutes for the absent Buddha, and the Buddha himself generally does not comment directly on them.

The second assumption, to be contrasted with the first, is that images in fact occupied a central place in Chinese Buddhism. Legends of the introduction of Buddhism in China centre on images. Stories about miraculous images appeared early and became popular quickly.[3] A large number of images are preserved.[4] Records of Indian Buddhism produced by Chinese monks who travelled in India, such as the account attributed to the fifth-century monk Faxian, frequently mention images, suggesting the importance of the image cult in India as well. The general thesis I present in this chapter is that the gap between these two assumptions, between the discursive vacuum and the centrality of the image cult, is reflected in the way in which

discussions of images appear in medieval Chinese Buddhism. The discourse about images evolved gradually and disconnectedly in different contexts.

I illustrate this situation by focusing on what appears to me to be a sustained effort to produce a coherent account of image worship. The record of this effort is found in the textual material brought together by the seventh-century Chinese *vinaya* specialist Daoxuan (596-667) and his colleague Daoshi (dates unknown). I begin by commenting briefly on the image miracle stories that they collected. In Daoshi's encyclopedic anthologies of scriptural passages and miracle stories, these stories are presented within the larger framework of the practice of paying respect *(zhijing)* to the Three Jewels – the Buddha, the Dharma, and the Saṃgha. Daoxuan's independent collection of Chinese Buddhist miracle stories is also organized around the same categories.

The second step in this exploration is to take a closer look at this organization around the Three Jewels.[5] I will try to shed light on the underlying logic of this formulation by turning to a specific historical context. Daoxuan played an important role in the 662 debate on the controversial monastic practice of monks and nuns refusing to pay respect to or bow in front of rulers and parents. A part of the material presented in Daoshi's discussion of paying respect to the Three Jewels was taken directly from the memorial Daoxuan presented on that occasion. The discussion of paying respect to the Three Jewels thus appears to have been formulated, at least initially, in response to the attack on the monastic practice of not paying respect to secular authorities. Intriguingly, in many of the scriptural passages collected within this framework, the direction of the practice is reversed, from that of the monks refusing to pay respect to the ruler and parents to rulers and parents paying respect to the Three Jewels. Nevertheless, this discourse on paying respect to the Three Jewels needs to be read against this defensive and apologetic background.

Here I will also try to clarify the relationship between the image miracle stories that occupy a prominent place in Daoshi's anthology of scriptural passages and the framework of paying respect to the Three Jewels. I will note that a striking contrast exists between the section on the scriptural passages, which highlight the practice of Buddha visualization, and the section on miracle stories, where the object to which one pays respect is not the Buddha but the Buddha image. Stories of miraculous images, identified carefully as specific material objects, appear to be somewhat artificially inserted into the framework

of paying respect to the Three Jewels more generally and to the Buddha in particular. And yet a closer examination suggests that the concern that guided the construction of the framework had more in common with image miracle stories than with the scriptural passages on visualization. From this point of view, it is these passages that appear artificially inserted into a larger context. We find here again an illustration of the diversity and indeterminacy of discourse about images in medieval China.

In the third step in my investigation, I will focus on the section entitled "Paying respect to monks and images" (sengxiang zhijing) in Daoxuan's vinaya commentary, Sifenlü shanfan bujue xingshi chao (T. 1804). In this earlier discussion, which lists only two of the Three Jewels as the object of this practice, the strategy of situating the discourse on image worship in the context of the monastic practice of paying respect is clearly discernible and the doctrinal issues it raises are more explicitly discussed.

In the concluding section, I support the central hypothesis, that the discourse on images developed slowly and in diverse contexts, by reviewing a practice involving images mentioned in one famous miracle story, namely bathing images. This brief review suggests that not only the discourse on images but also ritual practices involving images may have often been divergent and developed slowly.

Image Miracle Stories

The large collection of image miracle stories appended to the presentation of scriptural passages on "Paying respect to the Buddha" in Daoshi's encyclopedic anthology, The Jade Forest in the Dharma Garden (Fayuan zhulin, T. 2122), largely overlaps with the section on image miracle stories, also in the Buddha Jewel section, in Daoxuan's miracle story collection Collected Records of the Three Jewel Miracles in China (Ji shenzhou sanbao gantong lu, T. 2106).[6] Among the many well-known stories in both these collections, those about miraculous images believed to have been produced by King Aśoka in India occupy a prominent place. Typically, an Aśoka image story begins with an elaborate account of its discovery in China, suggesting that the image, originally produced in India, travelled to China of its own accord.

What looked like two people who came floating on the river near Wu Commandary rejected the reception by followers of other religions

and responded only when those who believed in the Buddha called for them. They also became miraculously light and were carried to the Tongxuansi monastery. The images were identified by inscriptions on the back of them as the past Buddhas Vipaśyin and Kāśyapa.

Gao Li, governor of Danyang, saw an unusual light near a bridge and found there a golden image. When the carriage carrying the image came to cross the road leading to the Changgansi monastery, the oxen would not move any further. The carriage was then directed to the Changgansi monastery and the image was placed there. Later, five Indian monks arrived and told Gao Li that they had obtained an Aśoka image in India but, encountering military disturbances on the way, had hidden the image at a riverbank. When the road became passable, they went back to recover the image but could not find it. Then the image appeared to them in a dream, informing them that it had been discovered by Gao Li and had been placed at the "Aśoka temple."

Tanyi, a disciple of the famous Buddhist leader Daoan (AD 312-85), was invited to supervise the establishment of a temple in Changsha. When the building was completed, he expressed the belief that Aśoka images appeared in response to sincere requests. Then an image appeared to the north of the city; a boat that suddenly became heavy after people heard someone coming on board at night arrived and then suddenly became light after people heard someone leaving the boat in the middle of the night. The image that appeared was heavy and no one could move it. When Tanyi prayed to it, it took only three of his disciples to move the image and bring it to his temple.

Tao Kan discovered an image by responding to a report that fishermen in Nanhai saw light on the beach every evening. Later, the image suddenly became very heavy and sank the boat that was used to transport it to Jingzhou. When Huiyuan prayed for it, the image could be moved to Mt. Lu without any difficulty.

The focus of these stories is clearly on specific images, and on them as physical objects. Not all Buddha images are endowed with miraculous powers. The images said to have been produced by King Aśoka appear to have been of particular interest to Daoxuan and Daoshi because they were typically endowed with these powers.[7] While Daoxuan and Daoshi collected these representative examples of Aśoka image stories from earlier sources, particularly Huijiao's *Biographies of Eminent Monks* (around 531) (*Gaoseng zhuan*, T. 2059), their versions of these stories are expanded with additional accounts of later miraculous demonstrations. For example, the rulers and

ministers of the five southern dynasties all worshipped ("paid respect to," *guijing*) the image discovered by Gao Li. At the time the Chen dynasty was conquered by the northern power Sui, the image predicted this development with a miraculous sign; during the night, the image took off the jewelled crown placed on its head. The image at the Changshasi monastery also repeatedly predicted dynastic fortunes.

The stories about Aśoka images and other miraculous images produced in China indicate that a long tradition of a distinctive discourse on images existed by the time Daoxuan and Daoshi produced their miracle story collections. As in other sections of *The Jade Forest in the Dharma Garden,* the setting of the scriptural passages collected in this section is India of the distant past, while the appended miracle stories describe events that occurred more recently in China. An apologetic agenda lies behind this interest in miracle stories; these stories prove the effectiveness and relevance of the Buddha's teaching in contemporary China. It may further be noted that in the section on paying respect to the Buddha, the subject of miracle stories is always images of the Buddha. In medieval China, while the teaching of the Buddha is demonstrated in miraculous events, paying respect to the Buddha appears to have been understood largely as a matter of paying respect to physical images.

"Paying Respect to the Three Jewels" in Daoshi's Anthologies
The Jade Forest in the Dharma Garden and *Essential Teachings of Scriptures*

Daoshi's collection of Buddha image miracle stories is appended to a collection of scriptural passages on paying respect to the Buddha, in his *Jade Forest in the Dharma Garden.*[8] Although worship of the Buddha image may be appropriately understood as a form of Buddha worship, or "paying respect to the Buddha," Buddha worship may also take other forms. Furthermore, Buddhist scriptures are typically presented as the instruction given by the Buddha or in the presence of the Buddha, and Buddha images are seldom mentioned in them. In the passages quoted from scriptures in this part of Daoshi's anthologies, the practice of paying respect to the Buddha is unlikely to be understood as image worship. The placement of Chinese image miracle stories in the "Paying respect to the Buddha" section thus leaves a conceptual gap, a gap that may partly be understood as one that separates the

worship of the Buddha in the form of Buddha images as they are known in China and the paying respect to the Buddha as he is presented in scriptures set in the distant past and in India.

In this anthology, and in Daoshi's shorter parallel anthology, *Essential Teachings of Scriptures,* the practice of paying respect is presented in connection with the scheme of the Three Jewels as its object.[9] The relationship between image worship and the practice of paying respect to the Buddha in the presentation by Daoshi (and Daoxuan) needs to be understood partly in this larger context. I will at this point briefly review the content of the scriptural passages presented in each of the three categories, of paying respect to the Buddha, paying respect to the Dharma, and paying respect to the Saṃgha, in the hope that such a review may shed some light on the underlying logic of this scheme. I will reverse the order of the three categories and begin my discussion with the scriptural passages collected in the section on paying respect to the Saṃgha and then proceed to the discussion of those in the section on paying respect to the Dharma. We will then be able to turn to the section on paying respect to the Buddha, the focus of our interest here, with the larger context of this overall presentation clearly in view. Since Daoshi compiled *Essential Teachings of Scriptures* exclusively as a collection of scriptural passages, without corresponding sections on Chinese miracle stories, in the discussion of scriptural passages I will first comment on this more compact collection and then turn to the earlier and more comprehensive *Jade Forest in the Dharma Garden.*

Scriptural Passages on Paying Respect to the Saṃgha

The entry in *Essential Teachings of Scriptures* is organized around three headings: an introductory essay on the meaning of the topic, the "benefits" of proper conduct, and "the harmful effects" of improper conduct. This organization appears to correspond to the basic message of this section; the theme that we should honour, or pay respect to, monks and the community of monks is first announced, and then the importance of this theme is illustrated by scriptural quotations describing the positive consequences of following this instruction and the negative consequences of failing to do so.

The introductory essay placed at the beginning of this section on paying respect to the Saṃgha contains an intriguing clarification of the concept of the Three Jewels. Following an unidentified scriptural

quotation to the effect that one should pay respect to and not make light of monks, whether they uphold the precepts or not, and whether they are old or young, the Three Jewels are discussed on the two levels of their true reality *(zhen)* and of their provisional expressions *(jia)*. Śākyamuni and other Buddhas are said to be the True Buddha Jewel; the teaching spoken by the Buddha is the True Dharma Jewel, and *śramaṇas* who have attained the fruits of the path are the True Saṃgha Jewel. But, the author tells us, because of the poor karmic conditions (being born in China at a much later time), he and his contemporaries have not been able to receive the Teaching from the Buddha himself, so they must rely on the traces that have been left behind. Sculpted and painted images represent the appearance of the Buddha *(shengrong,* "the appearance of the Holy One") and are called the Buddha Jewel. Scriptures written on paper, silk, and bamboo are called the Dharma Jewel, and those who have their head and beard shaved, wear the dyed robe, and hold a begging bowl are called the Saṃgha Jewel. These Three Jewels are "provisional" *(jia),* yet express the true realities *(zhenrong,* 54.16b13). By paying respect to them *(jing),* one can eternally extinguish the long flow of rebirths. By treating them with contempt, one invites painful rewards. I will return to the topic of this unexpected placement of a discussion of the Three Jewels in the section on paying respect to the Saṃgha, the third part in the serial treatment of the Three Jewels. This discussion is also of interest to us, since it attempts to clarify, among other things, the relationship between paying respect to the Buddha and paying respect to images. Paying respect to images is defined here as an inferior form of the practice of paying respect to the Buddha.[10]

The passage concludes by stating that it is a mistake to honour the Buddha and the Dharma and neglect monks and nuns. A statement from *The Analects* of Confucius is quoted: "It is Man who is capable of broadening the Way" (XV, 29). In the scriptural passage quoted and in insisting that one should pay respect not only to the Buddha and the Dharma but also to monks and nuns, this introductory paragraph appears to be arguing that one should pay respect to monks and nuns even if they happened to be flawed.

The entry on the "benefits" of proper conduct begins with quotations from the *Fanwangjing (Brahmājāla sūtra?,* 16b23-24; T.1484: 24.1008c4-6), *Daban neipan jing* or *Nirvāṇasūtra* (16b25; T.374: 12.399c12; T.375: 12.640a28-29), and *Sifenlü* or *Dharmaguptakavinaya* (16b24; T.

1428: 22.940a26-29), all emphasizing the rule that monks do not pay respect to secular authorities.[11] These quotations, along with the quotations from the *Fobenxing jing* (16b28-c2) and the *Sazheniqianzi jing* (T. 272: 9.336b4-5; *Bodhisattvagocaropāyaviṣayavikurvāṇanirdeasūtra?*) that follow them, are cited as crucial scriptural support in the "Memorial presented by Daoxuan of the Ximingsi monastery and others to instruct senior ministers on the history of Buddhist teaching," *Ximingsi seng Daoxuan deng xu fojiaolongtishi jian zhuzaifu zhuan,* that Daoxuan presented to the court in 662 (*Ji shamen buying baisu deng shi,* T. 2108: 52.457b4-15 and *Guang hongming ji,* T. 2103: 52.286a19-29).[12] These quotations appear to have been first introduced in the "Memorial" that Daoxuan and other leaders of the monastic community presented to the court in 662 and then later placed in the present version of the *Essential Teachings of Scriptures.*[13]

The debate over the refusal of monks and nuns to pay respect, or bow, in front of the ruler and parents had had a long history in China by Daoxuan's time. The controversy first erupted in AD 340 and then again in 402. Huiyuan (334-416) was consulted on the second occasion. The argument Huiyuan presented first in a letter to Huan Xuan (369-404), an anti-clerical ruler, was later elaborated further in his famous essay on this issue, "Monks do not pay respect to the king" (*Shamen bujing wangzhe lun,* found in T. 2108: 52.449a-451b). Huiyuan insisted on the fundamental distinction between the secular realm and the realm of those who have left the householder's life. Those who belong to the latter are not subject to secular authorities.[14]

In the early Tang dynasty, Emperor Taizong (r. AD 626-49) and then his successor Gaozong attempted to put an end to Buddhist monks' refusal to bow in front of secular authorities. Taizong's edict requiring monks and nuns to "pay respect" (or "pay homage," *zhijing*) to parents and the ruler was issued in 631, although it was quickly withdrawn in 633, presumably due to strong resistance from the monastic community and its supporters.[15] In 662, Gaozong issued an order to have the matter of requiring monks and nuns do reverence (*zhibai*) to the emperor, the empress, the crown prince, and parents be publicly debated (T. 2108: 52.455ab; T. 2103: 52.284a).[16]

These debates regarding the relationship between the Buddhist monastic order and the ritual order of the state need to be examined in the larger context of the evolution of the Tang system of rites.[17] The first such system, called *Zhenguanli,* or the "Rites of the Zhenguan Era," was presented and put into practice in 633, under

Taizong; under Gaozong another version, called *Xianqingli*, or the "Rites of the Xianqing Era," was completed in 658.[18] If the initiatives to reform the age-old practice of monks and nuns not paying respect to the ruler were part of the larger context of the gradual consolidation of the Tang system of public ceremonies, it is not difficult to see that Buddhists might well have responded to this new situation by developing a new systematic defence of the practice. In the preface to *Essential Teachings of Scriptures*, Daoshi notes that he reviewed the entire canon during the Xianqing period (656-61). I suspect that this project, which eventually resulted in the two massive anthologies of scriptural passages attributed to Daoshi and other related works, must have at least partly been intended as a part of this response. Ximingsi monastery was established in the capital city in 658; Daoxuan was appointed as the head monk *(shangzuo)* and Daoshi is said to have joined him in the newly established monastery.[19]

In 661, Daoxuan composed an essay on the practice of paying respect (*Shimen guijing yi*, or the "Buddhist practice of taking refuge and paying respect," T. 1896) at the Ximingsi monastery. Material closely affiliated with the corresponding part of Daoshi's anthology *Jade Forest in the Dharma Garden* (with a preface dated 668) forms an important part of this essay. This suggests that relevant material in this anthology may have existed in more or less final form by 661.

The response of the monastic community to Gaozong's edict calling for a public debate of the practice was based in the Ximingsi monastery, and Daoxuan as the head monk played a prominent role in organizing it. The 662 "Memorial" needs to be read against this larger background. The shared set of scriptural passages, from *Fanwangjing, Nirvāṇasūtra, Dharmaguptakavinaya, Fobenxing jing,* and *Sazheniqianzi jing*, first appeared in public in Daoxuan's "Memorial." The same set of passages also appears both in *Essential Teachings* and in *Jade Forest*. The latter was first completed sometime before 668; *Essential Teachings* was produced subsequently, based largely on the first anthology. This shared set of passages thus appears to have been copied first from the "Memorial" into *Jade Forest*, and then from there into *Essential Teachings*. The wording is identical in the 662 "Memorial" and in the corresponding sections of the two anthologies. The more natural context for the scriptural passages in the "Memorial" further supports this conclusion.

In fact, we may note that these scriptural passages sit somewhat

awkwardly in the context of the discussion of paying respect to the Saṃgha. With only one exception, the topic of scriptural passages common to the "Memorial" and this part of *Essential Teachings* is the conduct of the monks. Scriptures are shown to have forbidden them to pay respect to secular authorities. In one passage, from the *Fobenxing jing / Fobenxingji jing*, the focus is the conduct of secular authorities, and the example is given of King Śuddhodana, the Buddha's father, and his entourage, who paid respect to the Buddha and his disciples. These disciples are explicitly said to be monks and it is only here that the title "Paying respect to the Saṃgha, or monks *(seng)*" appears to be appropriate. The focus of this discussion is the ruler's conduct, and other passages that appear only in *Essential Teachings* share this focus. Thus, a majority of the scriptural passages, perhaps originally collected by Daoshi during the Xianqing period and incorporated first into Daoxuan's "Memorial" and then into the paying respect to the Saṃgha section of *Essential Teachings* appear to have been more appropriate to the context of the "Memorial" than that of the section on paying respect to the Saṃgha.[20]

In the entry on the "harmful effects" of improper conduct, a passage from the *Scripture of Humane Kings* (*Renwang jing*, T. 245; 54.18a29-b5; 8.833b19) speaks of the improper conduct of kings and princes. Not permitting image making is mentioned here (18b1-2; 8.833b21). In three of the subsequent quotations, from *Daji jing* (*The Scripture of Great Gathering*, T. 397: 13.354c16-359c7), *Dabei jing* (*The Scripture of Great Compassion*, T. 380: 12.958a24-b5), and *Shilun jing* (*The Scripture of Ten Wheels*, T. 410: 13.693c20-694b25), the Buddha teaches that even evil monks who have violated precepts must not be subjected to a variety of punishments by secular authorities. In these passages on paying respect to monks, the emphasis again seems to be clearly on demanding special treatment of monks by secular authorities, rather than on defending the refusal of monks to pay respect to secular authorities. Secular rulers should pay respect to monks and not harm them, even in cases where the monks have violated the precepts and thus compromised their status.

In *Jade Forest*, a larger collection that appears to have been compiled earlier and to have served as the source for the more compact *Essential Teachings*, the introductory essay in the section on paying respect to the Saṃgha Jewel is largely identical to the corresponding essay in *Essential Teachings*. The discussion of the true and provisional Three Jewels mentioned earlier also appears here. This introductory essay is

followed by an entry on the "scriptural evidence." The passages collected under "The benefits of proper conduct" in *Essential Teachings* appear as part of this larger collection of scriptural passages.

This long section of scriptural evidence is followed by an entry entitled "The benefits of paying respect." The passages that appear under the same heading in *Essential Teachings* have already appeared under a different heading ("Scriptural evidence") in this larger collection. Instead, under this heading in *Jade Forest* we find one long passage from the *Baoxing lun* (*Ratnagotravibhāgamahāyānottaratantraśāstra*, T. 1611: 31.826c) followed by another short quotation from the *Chengshi lun* (T. 1646: 32.247a12). The *Baoxing lun* passage lists the six meanings of the Three Jewels, noting that all these meanings explain why we need to pay respect to them. The topic of this quotation, then, is the practice of paying respect to the Three Jewels in general, and not specifically the more narrowly defined practice of paying respect to the monks or the monastic community.

In *Essential Teachings*, the identical *Baoxing lun* quotation appears at the very beginning of the subsection on paying respect to the Buddha. This subsection appears first in the section on the Three Jewels, and this section in turn is placed at the beginning of the entire work (1c). Since the section on the Three Jewels has no introduction of its own, this quotation should probably be read as a general comment on the practice of paying respect to the Three Jewels. Since *Essential Teachings* appears to have been produced after *Jade Forest*, we can conclude that in reworking the corresponding part of *Jade Forest* as a more developed discussion of the practice of paying respect to the Buddha, the Dharma, and the Saṃgha, Daoshi found it appropriate to move the *Baoxing lun* quotation to the very beginning of the entire discussion. Both in *Jade Forest* and *Essential Teachings*, the *Baoxing lun* quotation is accompanied by a brief quotation from the *Chengshi lun*, indicating that these two sets of quotations are directly related to each other.[21]

The passages that appear under "The harmful effects of improper conduct" in *Essential Teachings* are introduced under the same heading in *Jade Forest*. In this larger work, the section on paying respect to the Saṃgha concludes with a subsection on miracle stories. As I noted elsewhere, the entries in this subsection overlap with a part of the section on "supernatural monks" in Daoxuan's *Ji shenzhou sanbao gantonglu* (52.428-429).[22]

Scriptural Passages on Paying Respect to the Dharma

Scriptural citations in the section on paying respect to monks and images in Daoxuan's *vinaya* commentary are reproduced and expanded in the two corresponding sections in Daoshi's anthologies, in the sections on paying respect to the Saṃgha and on paying respect to the Buddha. The section on paying respect to the Dharma appears to have been introduced as the original discussion was reorganized and expanded in terms of the scheme of the Three Jewels.

The *Essential Teachings of Scriptures* entry on the Dharma Jewel is organized around eight headings: introductory comments on the meaning of the topic, preaching the Dharma, listening to the Dharma, gradual understanding of the Dharma, seeking of the Dharma, miraculous acquisition of merits, paying back one's debts to the teacher, and reviling of the Dharma. References to respecting *(jing)* the Dharma appear in several of the passages scattered among these categories. The practice of preaching, listening to, and seeking the Dharma presupposes respecting the Dharma, and when these practices are performed with the proper attitude, they lead to remarkable consequences.

In *Jade Forest in the Dharma Garden*, the scriptural passages presented in *Essential Teachings* under the heading of paying respect to the Dharma are presented in two separate sections, one in the section on paying respect to the Dharma (fascicle 18; 411c-416b) and the other in the section on preaching and listening, located outside the context of the discussion of the practice of paying respect (fascicles 23-24; 459c-465a). If *Essential Teachings* was compiled later, then Daoshi appears to have expanded this entry on the Dharma by incorporating another section of *Jade Forest* into its discussion of paying respect to the Dharma. This may be seen as a step in the larger process. The new category of paying respect to the Dharma was developed as the discussion of paying respect to monks and images in Daoxuan's *vinaya* commentary was reorganized around the scheme of the Three Jewels in Daoshi's encyclopedic anthologies. Thus, the scriptural passages in this newly introduced category were expanded in Daoshi's later anthology by incorporating further material classified differently in the earlier one.

This brief examination of the paying respect to the Saṃgha and paying respect to the Dharma sections in Daoshi's anthologies suggests that this discussion of paying respect to the Three Jewels may have been driven largely by the contemporary effort to defend the monastic practice of monks and nuns not paying respect to, or bowing

in front of, the ruler and parents. The importance of this concern can be clearly detected in some of the scriptural passages that feature in the section on paying respect to the Saṃgha; these passages appear to have been copied from Daoxuan's 662 "Memorial," presenting the argument offered by the monastic community for the debate at the court. The treatment of a crucial passage on the Three Jewels in the *Baoxing lun* in the two anthologies further suggests that scriptural passages that appear in the section on paying respect to the Saṃgha in *Jade Forest* may have formed the original core that evolved gradually into the more fully developed presentation of the practice of paying respect to the Three Jewels. In the course of this development, the immediate concern over the autonomy of the Saṃgha appears to have been translated into a larger framework of the Three Jewels as objects of worship.

In this development, the focus of the discussion and the nature of the practice under examination appear to have shifted. In the discussion of paying respect to the Saṃgha, or monks, the focus shifts from the unusual instruction given to monks to the instruction intended for secular rulers concerning their treatment of monks ("paying respect to monks"), and ultimately to the issue of monks who have violated precepts, who nevertheless must be treated with respect by secular rulers. Similarly, the focus of the discussion broadens when passages on proper conditions for preaching and listening to the Dharma originally collected under the title "Preaching and listening" are included in the section on paying respect to the Dharma. The framework of the Three Jewels appears to have served to ground the discussion of a specific and controversial monastic practice, that of refusing to bow before secular authorities, within the larger context of the practice of paying respect in general. The focus of discussion broadened from monastic practice to the proper attitude towards Buddhism, particularly on the part of secular rulers. The original narrow concern of Daoxuan and Daoshi over a specific monastic practice is translated into a more general advocacy of the cause of Buddhism.

The conduct of secular rulers is often highlighted in the large collection of image miracle stories appended to the section on paying respect to the Buddha, in *Jade Forest*. It is thus somewhat surprising that an entirely different concern of soteriology, centred on the practice of Buddha visualization, is highlighted in the scriptural collection in this section. A rather different discourse on images dominates the scriptural passages presented in this section of Daoshi's anthologies.

Scriptural Passages on Paying Respect to the Buddha

The section on paying respect to the Buddha in *Essential Teachings of Scriptures* is organized around six headings: the meaning of paying respect in all directions, meditating on the Buddhas of the ten directions, meditating on Śākyamuni Buddha, meditating on Amitābha Buddha, meditating on Maitreya Buddha, and the Samādhi of Buddha meditation. As noted above, the introductory subsection presents a quotation from the *Baoxing lun* on the Three Jewels.

The second subsection, on meditating on the Buddhas of the ten directions, opens with two quotations from the *Guanfo sanmei[hai] jing* (*The Ocean-like Samādhi of Buddha Meditation*, T. 643: 15.688b, 688c-689a); another quotation from the same source appears later (689ab). The second subsection, on meditating on Śākyamuni Buddha, also begins with a long quotation from the same scripture (660b). The concluding subsection, on the Samādhi of Buddha meditation, consists mostly of a long quotation, abbreviated in places, from the *Guanfo sanmei[hai] jing*. The discussion of paying respect to the Buddha in this encyclopedic anthology thus appears to be framed by long quotations from this scripture.[23] The topic of these quotations is image worship and Buddha visualization, and images are mentioned explicitly in virtually all of them.

The first quotation in the subsection on the Buddhas of the ten directions tells the following story: A long time ago, when a Buddha called Baoweideshangwang appeared in the world, a monk and his nine disciples went to a *stūpa* of a Buddha and worshipped *(libai)* an image of this Buddha. As they saw the jewelled image, worshipped it, and uttered verses of praise, when they died they were all reborn by transformation, sitting in large lotus flowers in the Buddha land of Baoweideshangwang in the eastern direction. They then met this Buddha, studied under him, and achieved "the ocean-like *samādhi* of the Buddha meditation." They then received a prediction from the Buddha that they would achieve Buddhahood in the future, and eventually achieved Buddhahood, becoming themselves the Buddhas in the ten directions. These Buddhas are said to have achieved Buddhahood because in the past they had worshipped a *stūpa*, contemplated a Buddha image, and praised it (1c-2a).

In the *Guanfo sanmei[hai] jing* stories quoted here and elsewhere, paying respect to the Buddha is presented as Buddha visualization that begins by going to a *stūpa* and seeing an image. The merit of this

practice results in rebirth in a Buddha land and achieving the *samādhi* of Buddha meditation. In this meditation, the Buddha appears and predicts the future attainment of Buddhahood. The practice is described in further detail in the long quotation from the *Guanfo sanmei[hai] jing* (7a-8c). This quotation appears in the subsection entitled "The Samādhi of Buddha meditation," which appears as the last subsection in the section on paying respect to the Buddha (54.77a-8c).

Bodhisattva Maitreya asks the Buddha how in the future world, when the Buddha is no longer present, sentient beings who have committed evil deeds are to get their sins removed. The idea here appears to be that at the time when the Buddha is present, sentient beings may have their sins removed by the Buddha. The Buddha tells Maitreya that after the Buddha has entered *nirvāṇa*, because they do not see the Buddha, many sentient beings will commit evil deeds. He then says that sentient beings should therefore contemplate an image of the Buddha. There is no difference between the image that they contemplate and the Buddha's body. The Buddha then explains the practice of viewing the image as a way of removing sins.

In viewing the Buddha image, the practitioner first goes inside a Buddha *stūpa* and purifies the ground with fragrant clay and clean earth. He burns as much incense as he can, and scatters as many flowers as he can as offerings to the Buddha image. Having confessed his sins, the practitioner worships the image and repents. After seven days of conquering the mind in this way, the practitioner goes to the monastery. There he sweeps the ground and cleans it of any refuse. Then, facing the monks, he repents. He then worships the feet of the monks. After another seven days of this practice, keeping the mind from becoming wearied, the practitioner, if he is a monk, recites the *vinaya* rules so that he will become very well versed in them; if he is a layman, he performs filial piety towards his parents and honours his teachers and superiors. In this way, the practitioner controls the mind so that it becomes responsive ("soft"). If the mind is still not responsive, he should forcefully conquer it.

With a well-controlled and obedient mind, the practitioner stays in a quiet place, burns a variety of superior incense, and worships Śākyamuni Buddha, saying the following, "Praise to the Great Virtue My Great Teacher, Arhat and Perfectly Enlightened One, the Greatly Compassionate World Honoured One, with your kindness and sanctity, please protect [this] disciple." Having said this, the practitioner throws himself down and cries in front of the image.

Rising again from the ground and straightening his clothing, the practitioner sits with legs crossed and concentrates his mind in one place. He concentrates the mind on the tip of his nose, then on other spots, from his forehead above to his toes below. He concentrates his mind on each of these spots and keeps it from becoming scattered or moving. If the mind moves, the practitioner places his tongue behind the back of his teeth. With mouth closed and eyes opened, hands held together, the practitioner sits straight. For seven days he sits to quiet the body. After the body is quieted, the practitioner visualizes the image *(xiangxiang)*. A detailed instruction is presented, explaining how the practitioner "contemplates" the image from the toe upward to the crown ("contemplation in the reverse order"), and from the crown to the leg ("contemplation in the proper order"). He goes back and forth fourteen times.

Having finished contemplating one image, the practitioner sees the image constantly standing in front of him, whether or not he is in the meditative state. The practitioner then visualizes the second image, and so on until he has visualized ten images. The practitioner then visualizes a chamber filled with Buddha images, leaving no vacant space. He continues his practice, burning incense and scattering flowers, cleaning the *stūpa* and painting the ground, bathing monks, and offering assistance and food to the monks and his parents.

The practitioner is then to make the following vow: "I now have viewed the Buddhas. With this merit I do not seek rebirths as a human being, or a god, or a hearer, or a *pratyekabuddha*. I only seek the Buddha's enlightenment and that alone." Having made this vow, the practitioner seeks the Greater Vehicle *(mahāyāna)*, and practises repentance, petitioning the Buddhas, taking delight in good deeds, and directing the fruits of good deeds to all sentient beings. Sitting straight and concentrating his mind on the space in front of him, the practitioner contemplates the realm of the Buddha. He lets the Buddha grow gradually in size, filling the monastic chamber with the image, to the height of one *zhang* and six *chi*, with a lotus flower pedestal and haloes, and accompanied by transformation Buddhas and attendants. The practitioner visualizes the size of the chamber growing from one *qing* to 100 *qing*. As far as 100 *yojana*, he sees the space filled with Buddha images. Having formed this vision of images, the practitioner visualizes the entire Jambudvīpa filled with Buddha images; the three other continents are similarly filled.

Body and mind filled with joy, the practitioner intensifies his

practice. Holding the twelve divisions of scriptures respectfully above his head, in front of the Perfection of Wisdom (Scripture), the practitioner throws himself on the ground and sincerely repents. Having accomplished this vision, the practitioner sits straight with eyes closed and hands held together, and visualizes even further into space, seeing all worlds in the ten directions filled with Buddha images. Their bodies are of pure golden colour, and light shines from all the hair follicles all over their bodies. Each ray of light is of the colour of 10 billion jewels, each colour formed of innumerable shades. This subtle realm appears spontaneously. This visualization is called "contemplating a standing image." If the practitioner performs this visualization, he removes the sins of six billion *kalpa*s. The practitioner also sees the Buddhas; in future rebirths, he encounters the one thousand Buddhas of World Age of the Wise *(bhadrakalpa)*. With them as teachers, the practitioner renounces the householder's life, hears the Buddha's sermons, and, in the subsequent World Age of Stars under the Guangming Buddha, receives the prediction to achieve Buddhahood. The sermon of the Buddha continues, describing the visualization of the sitting and walking images.

The practice of paying respect to the Buddha is presented here as a form of Buddha visualization. The concern is exclusively soteriological.

In *The Jade Forest in the Dharma Garden,* the section on paying respect to the Buddha occupies over four fascicles (fascicles 13-16 and part of 17), organized into seven subsections: introduction, Buddha meditation, Buddha contemplation (fascicle 13), Amitābha (fascicle 15), Maitreya (fascicle 16), Samantabhadra, and Avalokiteśvara (fascicle 17). A large part of each section is devoted to miracle stories. Most of the passages on visualization that appear in *Essential Teachings* occur in the second subsection on Buddha meditation, although with the notable exception of the long quotation on the Samādhi of Buddha meditation summarized above. This passage does not appear in *Jade Forest*. In preparing the section on paying respect to the Buddha in *Essential Teaching*, Daoshi appears to have taken this second subsection of the corresponding section in *Jade Forest* and expanded it further by adding the long and elaborate *Guanfo sanmei[hai] jing* passage on the Samādhi of Buddha meditation.

Other sets of scriptural passages are cited in subsections on Amitābha and Maitreya, while the sections on Samantabhadra and Avalokiteśvara present only stories of miracles involving those bodhisattvas that are said to have occurred in China. Thus, in *Jade*

Forest, the section on paying respect to the Buddha is dominated by miracle stories. Stories of image miracles typically consist of either (a) accounts of their miraculous discovery or production in China, or (b) stories of miracles performed by these images after they have been installed in monasteries or at court. As noted earlier, in some narratives of miracles involving Aśoka images, this second type of miracle story often centres on predicting dynastic fortunes. The image in these accounts is presented as the object to which the rulers pay respect.

In the "Memorial" that Daoxuan composed on behalf of the monastic community in 662, he mentions that supernatural beings such as gods and dragons honour and bow before monks who have received the precepts and are dressed in the proper Buddhist fashion, stating that this is the reason for the frequent occurrence of mysterious and auspicious events (in China) (52.286a9-11/457a24-26). In the introductory paragraph that appears in the first entry on miracle stories in *Jade Forest,* Daoshi speaks of the subtle differences between good and evil deeds resulting in dramatically varied karmic consequences, and lists several familiar instances of karmic retribution known in China (fascicle 5, 303a). He then observes that such stories of miraculous karmic retribution are found in a variety of Chinese miracle story collections and historical records. Both Daoxuan and Daoshi appear to have read Chinese miracle stories as evidence of the effectiveness of the Buddhist teaching, as stories in which Buddhist gods and other supernatural beings demonstrated their power in China, or as stories illustrating the working of karma. References to Buddhist miracles in China in Daoxuan's 662 "Memorial" carried an apologetic message. This is also the case with the extensive miracle stories in Daoshi's *Jade Forest* and Daoxuan's own miracle story collection. In fact, as we noted earlier, Daoxuan's miracle story collection is organized around the Three Jewels and is virtually identical in content to the corresponding parts of *Jade Forest.*

Thus we can easily see the connection between the miracle stories in the paying respect to the Buddha section of *Jade Forest* and the general apologetic concern that guided Daoshi's construction of the sections on paying respect to the Three Jewels in his scriptural anthologies. By contrast, the connection between the distinctly soteriological emphasis in passages describing the Buddha visualization in *Essential Teachings* and *Jade Forest* and this general apologetic concern is more difficult to explain. In these scriptural

passages, paying respect to the Buddha is understood as a visualization practice that removes one's sins and leads to rebirth in the lands of the Buddhas. This entails the prediction of achieving Buddhahood. In these passages, images are repeatedly mentioned, but only as aids to visualization. The specific identity of the image as a material object is disregarded; one views an image but it does not seem to be important what that image is. In image miracle stories, on the other hand, the object to which one pays respect is clearly presented as a specific, concrete, physical image found or created in China. Its miracles, as miracles of a specific and presumably well-known instance of the Buddha image, affirm the effectiveness of Buddhist teaching in China. It is these concrete images to which everyone, including powerful secular rulers, pay respect.[24]

In this examination of Daoshi's two encyclopedic anthologies, I attempted to throw some light on the larger framework within which Daoshi presented his collection of miracle stories. Daoxuan and Daoshi were trying to defend the controversial practice of monks and nuns refusing to pay respect to, and bow in front of, the ruler and parents against repeated attacks from the newly established Tang dynasty. This distinct agenda was translated into the more general demand that both members of the monastic community and secular rulers pay respect to the Three Jewels. The disproportionate weight given to image miracle stories presented within this larger framework suggests that the paradigmatic model for this practice of paying respect to the Three Jewels was image worship. The contrast between the soteriological emphasis in the scriptural passages and the apologetic agenda behind image miracle stories collected in the section on paying respect to the Buddha further highlights the diversity and indeterminacy of the discourse about images in medieval Chinese Buddhism. Even in a concerted effort to present image miracle stories as a part of a distinctly apologetic argument, a rather different kind of discourse on images, more soteriological in emphasis, could not be ignored. In fact, in the later version of this presentation in *Essential Teachings*, the practice of paying respect to the Buddha is described almost exclusively as a matter of Buddha visualization. However, if image miracle stories occupied an important place in the original construction of this framework, as I suggested earlier, this reformulation may have left the internal coherence of the framework somewhat obscure.

Daoxuan's *Vinaya* Commentary

In the foregoing discussion of the sections on paying respect to the Three Jewels in Daoshi's anthologies, I saw the internal logic of this elaborate presentation in the combination between a specific apologetic agenda and the popularity of image miracle stories. The apologetic agenda originally centred on the controversy over the ritual of "paying respect." The weight given to image miracle stories suggests that Daoshi and others saw images, or miraculous images, as a typical example of the Three Jewels.

As indicated earlier, Daoshi's discussion of paying respect to the Three Jewels was based on an earlier discussion. In his *vinaya* commentary *Sifenlü shanfan bujue xingshi chao* (T. 1804), first drafted between 627 and 630 and then revised in 636, Daoxuan had introduced a separate chapter on "paying respect to monks and images" (*sengxiang zhijing*, 40.131b-135a). Here images are explicitly mentioned as the object of paying respect. The strategy to introduce the issue of paying respect into the discourse about image worship thus appears to have originated with Daoxuan, with whom Daoshi collaborated closely at the Ximingsi monastery. I shall now turn to a brief examination of Daoxuan's discussion in this chapter in the *vinaya* commentary.[25]

Daoxuan begins his discussion with an explanation of the practice of *jing*, or paying respect to others. Several scriptural passages are quoted, and the choice of these passages reveals the outline of Daoxuan's nuanced argument. Daoxuan first accepts that the worship of the external form of the Buddha is inferior to the internal quest for wisdom through meditation, and then argues for its relative merit by insisting on the importance of the hierarchical order in the monastic community. Here image worship, as the worship of the Buddha, is understood in connection with the monastic practice of "paying respect" to superior monks.

Daoxuan begins with the story about the nun Utpalavarṇā, taken from the *Treatise on the Great Perfection of Wisdom* (*Dazhidu lun*, T. 1509: 25.137a); when the Buddha returned from the Heavens of Thirty-three Gods, where he had spent the summer retreat, a large crowd gathered to welcome him. Subhūti, who was practising the *Samādhi* of emptiness, wondered whether he should go to the Buddha, but remembered the Buddha's teaching, to the effect that the highest way of seeing the Buddha is to see the Buddha's Dharma body with the eye of wisdom. The nun Utpalavarṇā, in contrast, transformed herself into a Universal

Monarch, accompanied by a thousand sons decorated with seven jewels. Others gave way and she reached him first. When she greeted him in her original form, the Buddha told her that she was not the first to greet him. Subhūti was the first to greet him, because the true worship *(gongyang)* is not to pay respect *(zhijing)* to the living body *(shengshen)* but to see the Buddha's Dharma body *(fashen)*. It is striking that Daoxuan begins his discussion with a quotation that relativizes the importance of *jing*, or paying respect, and highlights its limits. If paying respect to the "living body" of the Buddha is problematical, then worship of Buddha images would be at least equally problematical.

Having quoted this passage, Daoxuan then notes, "The reason why we pay respect to others *(xiangjing)* is to remove arrogance *(manfa)*" (131c11-12). Here he appears to be making a case for the validity of paying respect to the physical body or bodies. A long quotation from the "Residence chapter *(fangshe jiandu)*" of the *Dharmaguptakavinaya* follows, in which the Buddha is said to have established the hierarchical order in his community. This order is described as a matter of "paying respect to others" *(xiang gongjing,* 131c12-21; T. 1428: 22.939c-940a). Before this order was established, monks were "arrogant." The Buddha heard that his senior disciples Śāriputra and Maudgalyāyana, having arrived late at the place where monks were staying, could not find rooms to sleep in and had to sleep outside. Having further determined that there was no consensus on the hierarchical standing of members in the community, the Buddha told the story of an elephant, a monkey, and a bird, who in an age long past lived together in the same fig tree. Having agreed on a hierarchy based on age, they travelled from village to village, with the bird, who was the oldest, perched on the shoulder of the monkey, and the monkey sitting on the head of the elephant, who was the youngest. The bird preached that those who respected *(jing)* elders live in accord with the teaching; they will achieve fame in this world and produce good deeds in the future. People followed this instruction. The Buddha told the monks that they should follow a similar principle, and established the hierarchy based on the number of years spent in the monastic community.[26]

Daoxuan here appears to be arguing as follows: although paying respect is only a relative value, as exemplified by the story of the nun Utpalavarṇā, this practice is nevertheless necessary for the monastic community. We should also note that in citing these two passages side by side, Daoxuan appears to be linking the issue of paying respect to

the Buddha with that of establishing and maintaining the monastic hierarchy; we are to pay respect to the Buddha in the same way junior monks pay respect to senior monks. In the context of the present discussion, of paying respect to monks and images, furthermore, the Buddha is also equated with images; the reason we pay respect to images, even though this is not the highest form of "seeing the Buddha," is because we must follow the hierarchical principle that is necessary for the working of the monastic community. This, then, may be the reason why, in speaking of paying respect, Daoxuan first mentions monks and then images, indirectly suggesting that the more familiar object of respect is the monks, and that we should treat paying respect to images as something similar to this familiar practice.

In the second subsection in this chapter in his *vinaya* commentary, Daoxuan discusses the circumstances under which to pay or not to pay respect (*duiyuan shifei*, 132a5; cf. *duijingliyuan hebu liangxiang*, 131c7); the practice is situated in the monastic context. Daoxuan is particularly concerned about the circumstances under which one is not to pay respect. Returning to the *Dharmaguptakavinaya* passage cited earlier, he lists the circumstances under which monks are not supposed to pay respect: they are not to honour lay people or women; those who received the precepts earlier are not to honour those who received them later; and those who have been expelled from the Saṃgha because of the thirteen negative conditions (*shisan nan*, 40.132a7; 22.940b2-4; cf. 22.814c), such as having committed one of the four grave *pārājika* offences, should be kept outside (and not honoured), along with all those who preach untrue teachings (22.940ab). A quotation from another scripture lists the eight negative consequences for monks who violate precepts and yet accept the respect paid by those who uphold the precepts (T. 310: 11.639c28-640a5).

Although Daoxuan's presentation does not explicitly mention its contemporary relevance, the emphasis on the circumstances under which monks are not permitted to pay respect, naming first lay people in this context, suggests that this discussion may also have been obliquely directed to the contemporary debate over the practice of monks and nuns paying respect to parents and rulers. Daoxuan may have dwelt on a scriptural passage that explained the origin of the monastic hierarchy because it enabled him to argue first that monks also practised *jing*, but furthermore, and more importantly, that they were not permitted to pay respect to lay people, even those who happened to be their rulers or their parents.

In the chapter on paying respect to monks and images, the topic of images is introduced awkwardly and obliquely in connection with the practice of *jing*. Monks worship images as a way of worshipping the Buddha. In the essay on making images that is appended, the focus shifts unmistakably from the Buddha worshipped in images to images as specific physical objects.[27] This emphasis on image making suggests that image worship may well have been the real focus of Daoxuan's discussion. Although the discussion of the monastic practice of paying respect to superior monks occupies an important place here, particularly in connection with the prohibition on monks paying respect to lay people, Daoxuan may have been particularly eager to present images as distinctly monastic objects of worship.

The two concerns that we detected behind Daoshi's discussion of paying respect to the Three Jewels appear, then, as Daoxuan's primary concerns as well. It must have been Daoxuan who first attempted to offer a new discourse on image worship by connecting it to the contemporary debate on the practice of paying respect.

Daoxuan's *vinaya* commentary was first drafted between 627 and 630 and then revised in 636. The colophon attached to the end of this work mentions the date of the sixth month of Wude 9 (627) (T. 1804: 40.156c). Around this time, Daoxuan withdrew to Mt. Zhongnan in response to the anti-Buddhist policies adopted by the new Tang Emperor Gaozu.[28] Daoxuan appears to have begun to work on this commentary at that time. In 630 he left the capital city on an extended journey in order to consult authorities on the *vinaya*.[29] A new revised version of the commentary was then produced.[30] We do not know when Daoxuan compiled the entry on image worship in the existing version of the *vinaya* commentary. As noted earlier, Taizong's edict requiring monks and nuns to pay homage, or "extend respect" (*zhijing*), to parents and the ruler was issued in 631 and withdrawn in 633. The chapter may have been introduced as a part of Daoxuan's revision in response to this new threat. Daoshi, perhaps in collaboration with Daoxuan, developed this discussion further, both by producing a large collection of image miracle stories and by placing it within the framework of the idea of paying respect to the Three Jewels.

My general hypothesis, then, is that the discourse on image worship developed gradually and in a variety of separate and disconnected directions over a long period in Buddhism. That this was also the case in India itself is suggested by the lack of a consistent account in the scriptural passages translated into Chinese. In China, where we can

trace the evolution of distinct traditions about image worship, we see that they resist easy integration into a single dominant discourse.

In concluding this very hypothetical discussion, I will try to illustrate this situation further by briefly reviewing a few passages on one particular practice in which images figure. This is the practice of bathing the Buddha images on the eighth day of the fourth month, known as the Buddha's birthday. This is a ritual that focuses on the physical object of an image; the image is further connected with a distinct episode in the life of the Buddha.

Bathing of the Buddha Images

The following remarkable story is an account of the establishment of Buddhism in the southern part of China, and appears early in the image miracle story collection compiled by Daoxuan and Daoshi (53.383b/52.413c). A golden image was discovered in the flat ground behind the capital city of Jianye of the Wu dynasty (AD 222-80). The author of the story suggests that the image must been produced by King Aśoka very early in history, since the Buddhist teaching, reintroduced to China later, had not been brought to the south at the time of its discovery. The ruler of the southern state, Sun Hao (r. 264-80) obtained it, but he did not believe in the Buddha and placed it near the toilet. On the eighth day of the fourth month, Sun Hao said jokingly, "This is the eighth day when they bathe the Buddha." He then urinated on the head of the image. Shortly thereafter he was covered with boils and suffered extreme pain in the genital area. He screamed from unbearable pain. Having performed divination, the court historian reported that the king had offended a great deity, who was causing this suffering. Immediately offerings were made to all divinities, but to no avail. A palace woman who believed in the Buddha said, "The Buddha is a great deity and you defiled him earlier. You should immediately ask for forgiveness." Sun Hao believed her and, taking refuge in the Buddha, begged for forgiveness earnestly. After a while he recovered.

Elsewhere in *The Jade Forest in the Dharma Garden*, a quotation from a scripture called *The Scripture of Great Chatou* or *The Scripture on Bathing the Buddha Image* describes the practice of bathing the Buddha image on the eighth day of the fourth month (T. 2122: 53.543a22-b10).[31] In the quoted passage, the Buddha first tells all people under heaven that all the Buddhas of the ten directions are born on the eighth day of

the fourth month, renounce the world on the eighth day of the fourth month, achieve enlightenment on the eighth day of the fourth month, and enter *Nirvāṇa* on the eighth day of the fourth month. This is because at the point when spring turns to summer, all harmful influences have been exhausted, all beings are reborn, and poisonous forces have not yet come into effect; it is neither cold nor hot and the weather is mild. The Buddha then declares that it is the day of the birth of the Buddha and that therefore all people should think of the Buddha's merits and bathe the Buddha image. An instruction on the ritual of bathing the Buddha image follows. In the original scripture, this quoted passage is preceded by a paragraph describing the birth of the Buddha, in which it is said that after numerous previous rebirths, the Buddha was born at the time when the morning star appeared on the eighth day of the fourth month; as soon as he was born, he took seven steps and, raising his right arm, said, "Above and below the heavens I am to be the teacher for people." The earth shook, and gods from heavens came down, bringing with them fragrant water and various flowers for the purpose of bathing the body of the newborn prince (16.796c8-12). In this scripture, then, the practice of bathing the Buddha image is closely tied to the story of the birth of the Buddha on the eighth day of the fourth month, and the ritual is to be performed on that day.

It is somewhat surprising, therefore, that the earlier version of Sun Hao's story that appears in Huijiao's *Biographies of Eminent Monks*, compiled around 531, does not mention any specific date (T. 2059: 50.326a1-17). Sun Hao's offence is described without any reference to a specific ritual. The palace woman identified the deity Sun Hao offended as the Buddha. She is then said to have brought the image into the palace, bathed it many times with fragrant water, burned incense, and performed a repentance ritual. Sun Hao worshipped the image and confessed his sins. This story thus may have served to explain the origin of the ritual of bathing the image at the palace.

The author of the later version I cited here from the miracle story collections by Daoxuan and Daoshi read this story of defilement in Huijiao's version of the anecdote by connecting it explicitly with the ritual, familiar to him, of bathing images on the eighth day of the fourth month.[32] But the ritual assumed here, of bathing the image, may not have been connected with a specific date or with the birth of the Buddha. Some sources describe the ritual of bathing of the Buddha image without connecting it to the Buddha's birthday. In the *Scripture*

on the Merits of Bathing the Buddha (*Yufo gongde jing*, T. 698) translated by Yijing (635-713) and also preserved in another translation attributed to Manicintana, bodhisattva Pure Wisdom asks the Buddha "how, after the Buddha enters *nirvāṇa*, should sentient beings make offerings and cultivate merits so that they can quickly achieve the unsurpassed wisdom" (16.799c18-19).[33] The Buddha's answer leads ultimately to a detailed instruction on the ritual of image bathing. Bodhisattva Pure Wisdom concludes by stating that he will now encourage kings, ministers, and all the faithful to bathe the image "daily" and obtain great merits (800c13).[34]

In his essay on Buddhist practices in India and Southeast Asia (*Nanhai jigui neifa zhuan*, T. 2125), Yijing also comments in some detail on the practice of bathing images (54.226bc; cf. 221b). Every day at noon the monastic officer (*karmadāna*) hits the hammer (*ghaṇṭā*). A canopy is set up in the courtyard of the monastery and jars of incense are lined up against the building. An image, or images, of gold, silver, bronze, or stone are placed on a plate of bronze, wood, or stone. Female musicians perform music inside the monastery building. The image is painted with ground incense, and fragrant water is poured over it. It is then wiped with a white cloth and placed inside the temple. Flowers are scattered everywhere. Yijing notes that this is the ritual for the monastery as a whole. In addition, images are bathed every day in many monastic cells. Bronze images of all sizes are polished and, as pure water is poured over them, they shine like mirrors. One takes a pinch of the water used for bathing and puts it on one's head. This water is called "auspicious water."[35]

The practice of bathing images is known in other Indian traditions. In one striking passage in the *Bodhisattvabhmi* of Asaṅga (ca. 310-90), we see an explicit prohibition of the practice of painting images with yellow orpiment and bathing them in ghee (*Pusa dichi jing*, T. 1581: 30.926a23; *Pusa shanjie jing*, T. 1582: 991c24; Wogihara 234.21). Here Asaṅga may be referring to contemporary Hindu practice and trying to clearly distinguish the Buddhist practice involving images from it. I wonder whether bathing was thus a typical and widely shared form of image ritual, and that at some point this practice, already well established in Buddhist communities, was connected to the story of the birth of the Buddha and to the date of the eighth day of the fourth month.

There appears to have been a separate ritual involving images that was also connected with this same date. Some passages describe the ritual of parading images on the eighth day of the fourth month,

without any reference to bathing. Faxian, who left for India in 399 and travelled through Central Asia, speaks repeatedly of this practice (51.857b; 862b). Bathing of images does not appear in his account. Parading of images is also mentioned in early Chinese sources.[36]

In one passage of the *Mūlasarvāstivādavinaya* a "Jambu shade image" is said to have been brought into the city of Śrāvastī and ample offerings were made to it (T. 1452: 24.446ab). The image was to be surrounded by monks, nuns, *sikṣamāṇa*, *rāmaṇera*, and *rāmaṇer*, and music was performed. Monks were instructed to announce seven or eight days beforehand that a special festival ("dharma gathering," *fahui*) was to be held. In another similar passage (434b-435b), the Buddha is said to have given permission to Elder Anāthapiṇḍata to hold a great festival (*dahui*) on his birthday ("in the month of Bishequ, or Vaiākha [a spring month?] when the sun and the moon are round," 435a). The emphasis in this long passage in Yijing's Chinese translation is on a variety of ways in which the image was decorated and offerings were made to it. In contrast, the corresponding passage in the Tibetan translation (Derge, Pa 137b4-140a7) tells a story of taking the image around the region on a palanquin and on a wagon as well as one of the offerings made to the image.[37]

Conclusion

What we see here is a group of rituals centring on images that appear to be distinct from each other but nonetheless have much in common. I wonder if it is appropriate here to see a gradual evolution, from ritual practices closely tied to the character of images as physical objects, such as bathing or parading them, to a more precise understanding of these practices as having their origin in the story of the Buddha's birth on a specific day. Life-of-the-Buddha stories typically speak of the bathing and walking (the seven steps) of the newborn Buddha. These developments must go back to Buddhism in India and Central Asia. A study of the development of rituals of bathing images in other Indian religions, some of which are ultimately connected with stories of the birth of the deity, such as Kṛṣṇa, Rāma, or the Jain Tīrthankaras, may prove helpful in understanding the development of this familiar Buddhist ritual.

This brief glimpse of the ritual of bathing images suggests that practices involving images and the discourse about them have evolved gradually.[38] The new discourse that Daoxuan and Daoshi developed in

seventh-century China, where image worship, or paying respect to images, is highlighted as a crucial element in a defence of the autonomy of the Saṃgha, might then be understood as yet another and rather striking initiative in this long process of evolution. This new discourse seems to have disappeared rather quickly, being replaced by a more general discussion of the Three Jewels. The large body of image miracle stories collected in connection with this apologetic effort was conceived of as a part of the newly formulated discourse of paying respect to the Three Jewels. In Daoshi's second anthology, where only scriptural passages are presented, image worship is conceived of simply as a preliminary step in the practice of Buddha visualization, and the linkage between image worship and the defence of the Saṃgha is no longer visible.

Nevertheless, the central place given to images in Daoxuan's original defence of the ceremonial autonomy of the Saṃgha also testifies to the power of images in medieval Chinese Buddhism. It was perhaps the popularity of images as material objects that stimulated the evolution of divergent and often disconnected discourse on images in textual sources.

End Notes

1 Gregory Schopen discussed an aspect of the introduction of the image cult in "On Monks, Nuns, and 'Vulgar' Practices: The Introduction of the Image Cult into Indian Buddhism," *Bones, Stones, and Buddhist Monks: Collected Papers on the Archaeology, Epigraphy, and Texts of Monastic Buddhism in India* (Honolulu: University of Hawai'i Press, 1997), 238-57. One example of the ambivalent attitude towards images is seen in the *Dazhidulun* passage about the nun Utpalavarṇā discussed later.
I presented an earlier version of this paper at the China Seminar, University of Michigan in February 2001. See also Hirakawa Akira, "Daijō no buddhakan to butsuzō no shutsugen," in *Katsumata Shunkyō hakushi kokikinen ronshū: Daijōbukkyō kara kikkyō e,* ed. Katsumata Shunkyō hakushi kokikinen ronshū kankōkai. (Tokyo: Shunjūsha, 1981), 25-49.

2 For a review of these passages, see Takada Osamu, *Butsuzō no kigen* (Tokyo: Iwanami Shoten, 1967), 19-23. *Vinaya* passages are also reviewed in the entry on "butsuzō" in *Hōbogirin,* 210-15. Shimoda Masahiro notes that Buddha images drawn at the *stūpa* are mentioned only in the *Mūlasarvāstivāda vinaya* and not in the *vinaya* of other schools (*Nehangyō*

no kenkyū, 109). In this literature, monastic rules are said to have been established by Śākyamuni Buddha himself, although many of these rules must reflect later practices and are anachronistically projected back into the time of the Buddha. The *vinaya* passages that mention images may be read as examples of such anachronistic projection. The stories about the origin of the image are generally set against the background of the absence of the Buddha, as this point is explicitly recognized in the concluding part of the chapter in Daoxuan's *vinaya* commentary, on the construction of the Buddha images, *stūpas*, and temples (T.1804:40.233b29).

3 See E. Zürcher, *The Buddhist Conquest of China* (Leiden: Brill, 1972), 21-22, 28. Robert Sharf, basing himself on Wu Hung's 1986 article, offers particularly thoughtful comments on the early references to Buddha images in *Coming to Terms with Chinese Buddhism: A Reading of the Treasure Store Treatise*, 21-23.

4 See Matsubara Saburō, *Chūgoku bukkyō chōkokushi ron*, 4 vols. (Tokyo: Yoshikawa kōbunkan, 1995), and Marylin Martin Rhie, *Early Buddhist Art of China and Central Asia. Vol. 1: Later Han, Three Kingdoms and Western Chin in China and Bactria to Shan-shan in Central Asia* (Leiden: Brill, 1999).

5 This monastic privilege was eventually taken away in the Five Dynasties period (907-60): Tairyo Makita, *Chūgoku Bukkyōshi kenkyū*, vol. 2 (Tokyo: Daitō shuppansha, 1984), 117.

6 A collection of Buddhist stories of miraculous events that occurred in China appears to have been produced at the Ximingsi monastery, where both Daoxuan and Daoshi were based. The term Three Jewels *(sanbao)* appears in the title of Daoxuan's collection, and this collection is loosely organized accordingly, with the collection of relic miracle stories (fascicle 1) and the collection of image miracle stories (fascicle 2) representing the Buddha Jewel, the collection of miraculous scripture stories (in fascicle 3) representing the Dharma Jewel, and the collection of stories of miraculous temples and supernatural monks (also in fascicle 3) representing the Saṃgha Jewel. Thus, the same scheme of the Three Jewels appears both in the sections on paying respect to the Buddha, paying respect to the Dharma, and paying respect to the Saṃgha of the *Fayuan zhulin* and in Daoxuan's miracle story collection. We may note, however, that in Daoxuan's collection the miracle stories about relics and *stūpas* are presented first and are followed by those about images, both presumably as representation of the Buddha Jewel miracles. In contrast, in Daoshi's *The Jade Forest in the Dharma Garden*, the corresponding collection of *stūpa* miracle stories is found under a

separate heading of "Paying respect to the *stūpa*" (fascicle 38, 53: 584c-591a). In the *Essential Teachings of Scriptures*, passages on paying respect to the *stūpa* are similarly treated separately from the category of the Three Jewels (fascicle 2, 54: 19c-25c).

7 Some images produced in China possessed similar powers; their stories frequently mention the names of those under whose direction the image was produced, such as the famous monk Daoan (384bc) or Emperor Wu of the Liang dynasty (389ab). For a discussion of Daoxuan's collection of image miracle stories, see "Changing Roles for Miraculous Images in Medieval Chinese Buddhism: A Study of the Miraculous Images section of Daoxuan's 'Collected Records'."

8 In addition to *The Jade Forest in the Dharma Garden*, another similar collection, *Essential Teachings of Scriptures* (*Zhujing yaoji*, T. 2123), is attributed to Daoshi. The relationship between these two encyclopedic collections is not entirely clear. As noted by Stephen F. Teiser, a passage in *Essential Teachings* (24a7-8) mentions a specific section in *Jade Forest*, suggesting that by the time this passage was composed, a version of *Jade Forest* in 100 fascicles, organized around a set of topics similar to the 100 topics in the version preserved today, already existed (Teiser, 120-21 n. 10). In the preface to *Essential Teachings*, in twenty fascicles and organized around thirty topics, Daoshi notes that he reviewed the Chinese Buddhist canon during the Xianqing period (656-61) (54.1a19). The project may well have been started at the Ximingsi monastery shortly after Daoxuan was appointed as its first abbot in 658. Since the scriptural passages collected in *Essential Teachings* are also found in paralleling sets in *Jade Forest*, these passages collected during this period appear to have been presented later in two different forms, first as a more comprehensive work in 100 fascicles and then in a shorter version in 20 fascicles. The sections on Chinese miracle stories are not found in *Essential Teachings*.

9 *Essential Teachings* begins with a section on the Three Jewels, which in turn is divided into subsections on paying respect to the Buddha, paying respect to the Dharma, and paying respect to the Saṃgha. This section is immediately followed by one on paying respect to the *stūpa*. *Jade Forest* does not use the Three Jewels as a heading; each of the subsections in *Essential Teachings* is listed as a separate section. We thus have sections on "Paying respect to the Buddha" (sec. 6, fasc. 13-16), "Paying respect to the Dharma" (sec. 7, fasc. 17-18), and "Paying respect to the Saṃgha" (sec. 8, fasc. 19). These sections are then followed by one on the practice of paying respect itself (sec. 9, fasc. 20). A section entitled "Paying respect to the *stūpa*" (fasc. 36-37) appears separately several fascicles later. Each of these sections in *Jade Forest* concludes with a subsection on

miracle stories. These miracle stories also appear in Daoxuan's miracle story collection, in which they are organized around the categories of the Three Jewels.

10 It is also noteworthy that this discussion of the Three Jewels appears at the beginning of the section on the Saṃgha Jewel, following extensive discussions of the Buddha and Dharma Jewels. As I will discuss in greater detail later, at an earlier stage in the long, complex evolution of Daoshi's anthology, this treatment of the Saṃgha Jewel appears to have served as the first item in the treatment of the Three Jewels.

11 We will see later that the quotation from the *Dharmaguptakavinaya* presented here also appears in Daoxuan's *vinaya* commentary, compiled earlier (16bc; 40.132a5-6).

12 A work with the title *Fobenxing jing*, a biography of the life of the Buddha in verse, is preserved in the Taisho collection (T. 193). However, here in the section of *Essential Teachings* on paying respect to the Saṃgha, the passage appears to have been taken from another work with a very similar title (cf. *Fobenxingji jing*, T. 190, 3.900c9-26). In fact, *Jade Forest* generally gives the title for T. 190 as *Fobenxing jing*, as seen in repeated citations in the One Thousand Buddha sections, fasc. 9-11.

13 The same set of quotations also appears in *Jade Forest* (53.423a28-b10). Since *Jade Forest* appears to have been produced first and then abbreviated into *Essential Teachings*, the passage from the "Memorial" would first have been copied into *Jade Forest* and then into *Essential Teachings*. The *Sazheniqianzi jing* quotation both in *Jade Forest* / *Essential Teachings* and the "Memorial" is accompanied by an interlinear note commenting on the debate on monks being forced to bow and kneel in front of secular people that is said to be taking place at the time the text was being written ("now," 53.423b9-10/54.16c5 and 52.286a28-29/457b15). Another quotation from the same scripture appears separately in the subsequent entry on the "harmful effects" of *Jade Forest* and *Essential Teachings* (53.426c15-22/54.18a21-28; T. 272: 9.336b1-23); these two *Sazheniqianzi jing* quotations in Daoshi's two anthologies are in fact taken from the same passage in the original scripture, and appear as one long quotation in the "Memorial." The presence of the identical interlinear note and the fact that the one passage in the original scripture, which was reproduced as one passage in the "Memorial," is broken up into two in *Jade Forest* and *Essential Teachings* suggest that this quotation was first introduced in the 662 "Memorial."

14 See, Zürcher, *The Buddhist Conquest of China*, 106-8, 231-39, and 254-85, as well as Leon Hurvitz, "'Render unto Caesar' in Early Chinese Buddhism," 80-114.

15 Stanley Weinstein, *Buddhism under the T'ang* (Cambridge: Cambridge University Press), 15.

16 Ibid., 32.

17 An entry on this topic is found in the Tongdian, fasc. 68: 4.1892-1983.

18 Howard J. Wechsler, *Offerings of Jade and Silk: Ritual and Symbol in the Legitimation of the T'ang Dynasty* (New Haven: Yale University Press, 1985), 42-44; David McMullen, "Bureaucrats and Cosmology: The Ritual Code of T'ang China," 189.

19 See the entry on Daoshi in the "Song Biographies of Eminent Monks," T. 2061: 50.726c15-16.

20 The *Fobenxing jing / Fobengxingji jing* passage is also mentioned in the "Memorial," 457b10-13. The passage is here said to be in fasc. 53 of the *Fobenxing jing*. A passage that corresponds closely to the quoted passage appears in fasc. 53 of the *Fobenxingji jing*, T. 190 in the Taisho collection. The *Fobenxing jing*, T. 193 in the Taisho collection, is a work of seven fascicles. This suggests that the title may first have been copied incorrectly but with the correct fascicle number in the "Memorial" and that the passage in *Essential Teachings* copied this incorrect title while abbreviating the fascicle reference.

21 The puzzling placement of this *Baoxing lun* quotation in the section on paying respect to the Saṃgha in *Jade Forest* may shed some light on the history of the composition of Daoshi's anthologies. As I indicated earlier, the present section on paying respect to the Saṃgha as a whole appears to contain a variety of scriptural quotations that at an early stage in the compilation were intended as the core of the entire discussion of paying respect to the Three Jewels. These included the quotations from the *Fanwangjing, Nirvāṇa sūtra, Dharmaguptakavinaya*, and the *Fobenxingji jing* as well as the *Baoxing lun*. At some later stage, this material must have been incorporated specifically into the section on paying respect to the Saṃgha. The discussion of the Three Jewels in the introductory essay for the section on paying respect to the Saṃgha in both anthologies must originally have served as the introduction for the earlier core collection. It remains unclear why Daoshi, in reorganizing this material in terms of the scheme of Three Jewels and eventually moving the *Baoxing lun* and the *Chengshi lun* quotations, chose not to move this introduction as well to the very beginning of the section on paying respect to the Three Jewels.

As I will discuss in greater detail later, Daoxuan had framed his discussion in the *vinaya* commentary, first drafted in 627-30 and revised in 636, as a discussion of "paying respect to monks and images"; the broad context of this discussion was the debate on the relationship of monks to secular authorities, and it may be significant that here

"monks" or the Saṃgha is named first as the object to which one pays respect. At some later point, this discussion was reframed in terms of the idea of the Three Jewels. In 656-61 Daoxuan and Daoshi at the Ximingsi monastery appear to have collected scriptural passages instructing monks and nuns not to pay respect to secular authorities, and introduced the discourse of the Three Jewels. Daoxuan's 661 essay on the practice of paying respect (T. 1896) takes the Three Jewels as the proper object of this practice, and a large part of this essay appears to have been based on material prepared for *Jade Forest;* the existing version of this anthology is accompanied by a preface that bears a much later date of 668. Daoxuan's 662 "Memorial" describes the introduction of Buddhism as the transmission of the Buddha Jewel and the Dharma Jewel to China and the establishment of the Saṃgha Jewel in China (52.285b11-15/456b20-24). We may note, however, that the newly collected scriptural passages prohibiting monks and nuns from paying respect to the ruler and the parents are not mentioned in the 661 essay, and in the 662 "Memorial" they are presented separately from the references to the Three Jewels. They are not framed as a part of the practice of paying respect to the Three Jewels or, more specifically, to the Saṃgha, as in Daoshi's two anthologies.

At one point, the key scriptural passages taken from the *Baoxing lun* and the *Chengshi lun* that spoke of paying respect to the Three Jewels were combined with the collected scriptural passages on the refusal to pay respect to secular rulers. This original grouping of scriptural passages, perhaps with an introductory essay on the Three Jewels specifically composed for it, remained intact in the first fully developed discussion of paying respect to the Three Jewels in *Jade Forest.* Since the majority of these passages focus on the conduct of monks and nuns, however, in this discussion of the Three Jewels these passages were placed in the section on paying respect to the Saṃgha, that followed the sections of the other two Jewels. In this way, in *Jade Forest,* the *Baoxing lun* passage on the Three Jewels, the appropriate place for which would have been at the beginning of the discussion on paying respect to the Three Jewels, was placed towards the end of the entire section, grouped with the other passages closely affiliated with the practice of paying respect to the Saṃgha. While in the second anthology, *Essential Teachings,* this *Baoxing lun* quotation was taken out of this context and placed at the very beginning of the discussion of paying respect to the Three Jewels, for some reason the introductory essay Daoshi appears to have composed was left in the section on paying respect to the Saṃgha.

22 See Koichi Shinohara, "Daoxuan's Collection of Miracle Stories about

'Supernatural Monks' (*Shenseng gantong lu*): An Analysis of its Sources,"
Chung-hwa Buddhist Journal 3 (1990): 354-56.

23 For a discussion of Buddha visualization in the *Guanfo sanmei[hai] jing*,
see Nobuyoshi Yamabe, "The Sūtra on the Ocean-Like Samādhi of the
Visualization of the Buddha: The Interfusion of the Chinese and Indian
Cultures in Central Asia as Reflected in a Fifth Century Apocryphal
Sūtra," PhD dissertation, Yale University, 1999, 125-84.

24 In *Jade Forest*, the sections on paying respect to the Buddha, the Dharma,
and the Saṃgha (fasc. 12-19) are immediately followed by a section
entitled "Paying respect" (*zhijing*, fasc. 20). In this section, the emphasis
shifts from the Three Jewels as objects of respect *(jing)* to the practice of
jing, or "paying respect" itself. As noted earlier, the preceding three
sections are clearly related to Daoxuan's earlier discussion in the *vinaya*
commentary, as can be seen in the paralleling sets of scriptural
quotations. The section on paying respect, on the other hand, appears to
be related to Daoxuan's essay *Shimen guijing yi*, or the "Buddhist
practice of taking refuge and paying respect," which was composed in
the Ximingsi monastery in 661.

This order of presentation in *Jade Forest* strikes me as somewhat
irregular. Rather than moving from the general topic of paying respect
as a form of practice to specific expressions of this practice in relation to
each of the Three Jewels, the practice of paying respect is first presented
in reference to each of the Three Jewels and only then discussed in more
general terms as a form of practice. This irregularity may be partly
explained as a consequence of the complex history of the composition of
this anthology. I suspect that the section on paying respect, showing
close affinity to Daoxuan's "Buddhist practice of taking refuge and
paying respect," dated 661, was composed separately and later
appended to the discussion of paying respect to the Three Jewels. A
comparable discussion of paying respect by itself as a general form of
practice does not appear in Daoshi's later, revised and abbreviated
anthology, *Essential Teachings of Scriptures*. Daoshi may have made this
choice mindful of the separate origins of these two treatments of the
idea of paying respect.

As I noted above in n. 21, in the 662 "Memorial" the reference to the
Buddha Jewel, the Dharma Jewel, and the Saṃgha Jewel appears
separately from the scriptural passages on the prohibition on monks and
nuns paying respect to secular authorities. At this stage, these scriptural
passages may have been collected separately from the discussion of the
Three Jewels. The "Buddhist practice of taking refuge and paying
respect" discusses the Three Jewels as the proper object of paying

respect, but does not mention the scriptural passages in question. If the reference to the Three Jewels in the 662 "Memorial" was based on the discussion of this topic in the 661 essay, the scriptural passages that the "Memorial" presents separately must have been taken from a different source. As I observed in n. 13, there are good reasons to believe that Daoshi appears to have simply copied this section of the "Memorial" into the corresponding sections of his anthologies, *Jade Forest* and *Essential Teachings*.

I suspect that the 661 essay on "taking refuge and paying respect" was composed in two stages: at the point when he produced the existing version of the essay, Daoxuan combined a body of material he had drafted separately with available material prepared that may have been intended for *Jade Forest*. A part of the separately drafted body of material is devoted to the abstract and doctrinal discussion of the Three Jewels as the proper object of the practice of paying respect (sec. 2). A fairly well developed draft of *Jade Forest* may have existed by 661, based on the systematic reading of the entire canon at the Ximingsi monastery in 656-61. Daoxuan may have drawn from it on two occasions, first in drafting the 661 essay and then again in composing the 662 "Memorial." The set of scriptural passages prohibiting monks and nuns from paying respect to secular authorities could have been prepared on the second occasion, and then eventually incorporated into Daoshi's two anthologies. When Daoxuan composed the 661 essay, this set of scriptural passages may not have been brought together. It may have been Gaozong's order to have the practice of monks and nuns not paying respect to the ruler and the parents debated at court that focused the issue sharply, and by the time Daoshi's anthologies were produced, the defence of the autonomy of the Saṃgha had taken shape around the formula of paying respect to the Three Jewels. An earlier formulation, of the kind attempted in Daoxuan's 661 essay, had by then been superseded. Nevertheless, the body of material used by Daoxuan in that essay was gathered as a separate section in *Jade Forest* and appended to the by then more familiar discussion of the Three Jewels.

25 The subsection on paying respect to the Buddha Śākyamuni in *Essential Teachings* concludes with a segment that presents a group of scriptural passages commenting on the often miraculous effects of the practice of paying respect to the Buddha. These passages are taken from the *Dabeijing* (T. 380: 12.960a27-c10), *Zengyi ahanjing* (*Ekottarāgama*, T. 125: 2.659c20-22), and *Sifenlü* (or *Dharmaguptakavinaya*, T. 1428: 22.940a22-24; cf. 885a4-5) (3abc). A more or less identical set appears in the Maitreya subsection of the section on paying respect to the Buddha in *Jade Forest*

(403abc). It is significant for our discussion here that these passages parallel scriptural quotations in the opening segment of *Sengxiang zhijing* in Daoxuan's *vinaya* commentary (T. 1804: 40.131c). Thus the quotations appear to have been copied from Daoxuan's *vinaya* commentary into Daoshi's anthologies.

Also, as noted earlier, the section on paying respect to the Saṃgha in *Jade Forest* and the corresponding subsection in *Essential Teachings* present a set of quotations from the *Fanwangjing*, *Nirvāṇa sūtra*, and *Dharmaguptakavinaya*. These quotations all state that monks should not pay respect to secular authorities (423ab; 16b). The *Dharmaguptakavinaya* quotation here is virtually identical to the opening quotation in the subsection on the proper object of the practice of paying respect (132a5-6) in Daoxuan's *vinaya* commentary. Here an important quotation from the *Dharmaguptakavinaya* in Daoxuan's *vinaya* commentary appears to have been augmented by similar quotations from other sources in Daoshi's anthologies.

26 See E. Reinders, "Ritual Topography: Embodiment and Vertical Space in Buddhist Monastic Practice," *History of Religions* 36 (1997): 244ff.

27 Given the general character of Daoxuan's commentary, which bases itself on the *Dharmaguptakavinaya* and supplements it with a wide range of scriptural quotations, this discussion of image making is strikingly unusual. Instead of collecting passages on image making from a wide range of scriptural sources, Daoxuan focused the entire section on the instruction the Buddha is said to have given after returning from heaven, given without a scriptural reference, and devoted the remaining part to the admonition that people should follow the ancient practice in making images. I remarked briefly on this part of Daoxuan's commentary in my article "Image Makers in Xuanzang's Record of the Western Regions and Daoxuan's Miracle Story Collection," in *Jainism and Early Buddhism: Essays in Honour of Padmanakh S. Jaini*, edited by Olle Qvarnstrom (Berkeley: Asian Humanities Press, 2003), 609-620.

28 Fujiyoshi Masumi, *Dōsenden no kenkyū* (Kyoto: Kyōto daigaku gakujutsu shuppankai, 2002), 115; Weinstein, *Buddhism under the T'ang*, 7-11.

29 Fujiyoshi Masumi, *Dōsenden no kenkyū*, 106.

30 Ibid., 116.

31 The short scripture from which this passage is quoted exists in two versions, one giving Faju (T. 695) and the other giving Shengjian as the translator (T. 696). A pair of scriptures called *Huanjing* ("Bathing scripture") and *Mohechatou jing* are found in Sengyou's "Record of the translation of the tripiṭaka scriptures" in the section on scriptures for which the names of the translators have been lost (T. 2145: 55.28a10;

29a19). The latter is said to be virtually identical with the former, with minor differences. See Lessing, "Structure and Meaning," 160-62.

32 A reference to bathing of the Buddha on the eighth day of the fourth month appears in one of the biographies included in the *Biographies of Eminent Monks* collection (50.384b25-26). The practice is attributed here to Shi Le (r. AD 319-33) of the Later Zhao dynasty. In a passage describing the prohibition against monks touching gold and silver, the Mahāsaṃghika *vinaya* comments on the treatment of *stūpas* and bodhisattva images of gold and silver; the offerings to be made to images on the eighth day of the fourth month and at other large gatherings are mentioned here, and it is noted that monks should not bathe the bodhisattva images of gold and silver themselves but rather let "pure people" *(jingren)* do so (T. 1425: 22.312b15-24).

33 Yijing's version is translated into English with an introduction by Daniel Boucher, "Sūtra on the Merit of Bathing the Buddha," in *Buddhism in Practice*, ed. Donald Lopez (Princeton: Princeton University Press, 1995), 59-68. For a discussion of Manicintana, see Antonino Forte, "The Activities in China of the Tantric Master Manicintana (Pao-ssu-wei: AD ?-721) from Kashmir and of His Northern Indian Collaborators," *East and West* 34 (1984): 301-45.

34 An Esoteric Buddhist ritual manual on bathing of images (*Xinji yuxiang yigui*, T. 1322: 21.488-489, translated by Huilin) speaks of monks in India bathing images every day, burning incense, and offering flowers (488b23-24). Verses identical to those in the scripture translated by Yijing (T. 698) appear in this manual (16.799a and 21.488c).

35 Yijing concludes this description with a comment in which he notes that he has seen on the eighth day of the fourth month monks and lay people bring images to the roadside and bathe them. The images are not wiped and are exposed to wind and sun. He considers this inappropriate. Elsewhere, under a different heading in the same essay, Yijing speaks of bringing images to the roadside and exposing them to dusts to secure material gains. This and other dishonest practices are then said to be entirely absent in "western kingdoms" (228a26-29). Here, as in the comment appended to his discussion of the bathing of images, Yijing may be criticizing practices in China. In yet another passage in the same essay, Yijing speaks of bathing images every morning (221b13).

36 See Shinkō Mochizuki, *Bukkyō daijiten*, expanded ed. (Tokyo: Sekai seiten kankōkai, 1951), 1.601; *The Jade Forest in the Dharma Garden*, 53.406b18; *Weishu*: 8.3032; *Fozu tongji*, T. 2035: 49.355b; *Loyang qielanji*, T. 2092: 51.1010b (Yi-t'ung Wang, *A Record of Buddhist Monasteries in Lo-yang*, 126; Iriya Yoshitaka, *Rakuyō garanki*, Tōyō bunko 517, 132).

37 I would like to thank Gregory Schopen for making his translation of the two Tibetan passages available to me.
38 What we have seen here is a very small part of a large, complex, and not necessarily coherent process of evolution. Images played important roles in other contexts in medieval Chinese Buddhist practices. Elsewhere in his *vinaya* commentary, Daoxuan describes the use of an image in a deathbed ritual, citing a passage from a Chinese tradition on the Jetavana monastery (T. 1804: 40.144a). The same passage is also cited, with some differences, by Daoshi in the section on illness in *Jade Forest* (T. 2122: 53.987a). We also need to keep in mind the extensive use of images in Esoteric Buddhism.

Bibliography

Collections and Dictionaries

Dimiéville, Paul, ed. *Hōbōgirin: Dictionaire encyclopédique du bouddhisme d'après les sources chinoises et japonaises*. Fascicle 3. Paris: Adrien Maisonneuve, 1974.
Mochizuki, Shinkō. *Bukkyō daijiten*. Expanded ed. Tokyo: Sekai seiten kankōkai, 1951.
Nakano, Tatsue. *Dainihon zokuzōkyō*, 150 vols. Kyoto: Zōkyō shoin, 1905-12. Reprint. Taibei: Xinwenfeng, 1968-70. Abbreviation: ZZ.
Takakusu, Jun'ichirō et al. *Taishō shinshū daizōkyō*, 100 vols. Tokyo: Taishō Issaikyō Kankōkai, 1924-1932. Abbreviation: T.

Primary Sources

BUDDHIST SCRIPTURES
Chengshi lun (Tattvasiddhiāstra / Satyasiddhiāstra?). T. 1646; 32.239-373.
Daban niepan jing (Mahāparinirāṇasūtra). T. 374: 12.365-603; T. 375: 12.605-852.
Dabei jing (Mahākaruṇṇāpundarīkasūtraṇ). T. 380: 12.945-973.
Dafang guang shilun jing (Shilun jing, Daāacakrakṣitigarbha). T. 410: 13.681-720.
Dafangdeng daji jing (Daji jing, Mahāvaipulyamahāsaṃnipātasūtra). T. 397: 13.1-408.
*Dasazhenniqianzisoshuo jing (Sazhenniqianzi jing,
 Bodhisattvagocaropaāyaviṣayavikurvāṇnanirdeśa,
 Mahāsatyanirganthaputravyākaṇasūtra?)*. T. 272: 9.317-365.
Dazhidu lun (Mahāprajñāpāramitopadeśa, Mahāprajñāpāramitśāstra). T. 1509: 25.57-756.
Fanwang jing (Brahmājālasūtra?). T. 1484: 24.997-1010.
Fobenxing jing (Fobenxing jing, Abhiniṣkramaṇasūtra?). T. 190: 3.655-932.

Foshuo guanfo sanmeihai jing (Guanfo sanmei jing,
 Buddhānusmṛtisamādhisāgarasūtra). T. 643: 15.645-697.
Foshuo huanxi foxingxiang jing. T. 695: 16.796-797.
Foshuo mohechatou jing. T. 696: 16.797-798.
Foshuo renwang banruoboluomi jing (Renwang jing). T. 245: 8.825-834.
Genben shuoyiqieyoubu nituono mudejia (Mūlasarvāstivādanidānamātṛika). T.
 1452: 415-455.
Jiujing yisheng baoxing lun (Baoxing lun, Mahāyānottaratantrśāstra,
 Ratnagotravibhāgamahāyānottaratantraśstra; Ratnagotravibhāgaśastra,
 Ratnagotravibhāgamahāyanottaratantrasśāstra). T. 1611: 31.813-848.
Pusa dichi jing (Bodhisattvabhyūmi). T. 1581: 30.888-959.
Pusa shanjig jing (Bodhisattvacaryanirdeśa). T. 1582: 30.960-1013.
Sifen lü (Dharmaguptakavinaya?). T. 1428: 22.567-114.
Wogihara, Unrai. *Bodhisattvabhūmi: A Statement of Whole course of the*
 Bodhisattva (Being Fifteenth Section of Yogācārabhūmi). Tokyo: Sankibo
 Buddhist Book Store, 1971 (first published in 1926).
Yufo gongde jing. T. 698: 16.799-800.
Zenyi ahan jingi (Ekottarāgama). T. 125: 2.549-830.

CHINESE BUDDHIST COMPILATIONS
Daoshi. *Fayuan zhulin* ("The Jade Forest in the Dharma Garden"). T. 2122:
 53.269-1030.
–. *Zhujing yaoji* ("Essential Teachings of Scriptures"). T. 2123: 54.1-194.
Daoxuan. *Guang hongming ji.* T. 2103: 52.97-361.
–. *Ji shenzhou sanbao gantong lu* ("Collected Records of the Three Jewel
 Miracles in China"). T. 2106: 52.404-435.
–. *Shimen guijing yi* ("Buddhist Practice of Taking Refuge and Paying
 Respect"). T. 1896: 45.854-868.
–. *Sifenlü shanfan bujue xingshichao* ("Summarized Account of Monastic
 Conduct, Based on the Four-part [dharmagupta] Vinaya, Unnecessary
 Details Removed and Gaps Filled from Other Sources"). T. 1804: 40.1-156.
–. *Ximingsi seng Daoxuan deng xu fojiaolongtishi jian zhuzaifu zhuan* ("Memorial
 Presented by Daoxuan of the Ximingsi Monastery and Others to Instruct Senior
 Ministers on the History of Buddhist Teaching"). T. 2108: 52.457/ T. 2103: 52.286.
Huijiao. *Gaoseng zhuan* ("Biographies of Eminent Monks"). T. 2059: 50.322-423.
Huilin. *Xinji yuxiang yigui* ("Newly Collected Rituals for Bathing the
 Image"). T. 1322: 21.488-489.
Huiyuan. *Shamen bujing wangzhe lun* ("Monks Do Not Pay Respect to the
 King"). T. 2108: 52.449-451.
Yanzong. *Ji shamen buying baisu deng shi* ("Collected Sources on the Issue of
 Monks Not Paying Respect to Secular Authorities"). T. 2108: 52.443-474.

Yijing. *Nanhai jigui neifa zhuan* ("Record of the Inner Law Sent Home from the South Seas"). T. 2125: 54.204-234.

Zhipan. *Fozu tongji* ("Comprehensive Record of the Buddhas and Patriarchs"). T. 2035: 49.129-475.

NON-BUDDHIST SOURCES

Du You. *Tongdian*, 5 vols. Punctuated edition prepared by Wang Wenjing et al. Beijing: Zhonghua shuju, 1988.

Wang Pu. *Tang huiyao*, 3 vols. Shijie shuju edition. Taibei: Shijie shuju, 1984.

Wei Shou. *Weishu*, 8 vols. Punctuated edition. Beijing: Zhonghua shuju, 1974.

Xu Zhen. *Shuowen jiezi*. Hong Kong Taiping shuju edition. Hong Kong: Taiping shuju, 1969.

TRANSLATIONS OF PRIMARY SOURCES

Iriya, Yoshitaka. *Rakuyō garanki*. Tōyō bunko 517. Tokyo: Heibonsha, 1990.

Lau, D.C. *Confucius, The Analects*. Harmondsworth: Penguin Books, 1979.

Wang, Yi-t'ung. *A Record of Buddhist Monasteries in Lo-yang*. Princeton: Princeton University Press, 1984.

Secondary Sources

Fujiyoshi Masumi. *Dōsenden no kenkyū*. Kyoto: Kyōto daigaku gakujutsu shuppankai, 2002.

Boucher, Daniel. "Sūtra on the Merit of Bathing the Buddha." Pp. 59-68 in *Buddhism in Practice*, edited by Donald Lopez. Princeton: Princeton University Press, 1995.

Forte, Antonino. "The Activities in China of the Tantric Master Manicintana (Pao-ssu-wei: ?-721 A.D.) from Kashmir and of His Northern Indian Collaborators." *East and West* 34 (1984): 301-45.

Hirakawa, Akira. "Daijō no buddhakan to butsuzō no shutsugen." Pp. 25-49 in *Katsumata shunkyō hakushi kokikinen ronshū: Daijōbukkyō kara mikkyō e*, edited by Katsumata Shunkyō hakushi kokikinen ronshū kankōkai. Tokyo: Shunjūsha, 1981.

Hurvitz, Leon. "'Render unto Caesar' in Early Chinese Buddhism." Pp. 96-114 in *Sino-Indian Studies*, Vol. 5. Libenthoal Festschrift. Santiniketan. 1957.

Lessing, Ferdinand. "Structure and Meaning of the Rite Called the Bath of the Buddha According to Tibetan and Chinese Sources." Pp. 159-171 in *Studia Serica Bernhard Karlgren Dedicata: Sinological Studies Dedicated to Bernhard Karlgren on his Seventieth Birthday, October Fifth, 1959*, edited by Soren Egrod and Else Glahn. Copenhagen: Ejnar Munksgaard, 1959.

McMullen, David. "Bureaucrats and Cosmology: The Ritual Code of T'ang China." Pp. 181-236 in *Rituals of Royalty: Power and Ceremonial in Traditional Societies*, edited by David Cannadine and Simon Price. Cambridge and New York: Cambridge University Press, 1987.

Makita, Tairyo. *Chūgoku Bukkyōshi kenkyū*, vol. 2. Tokyo: Daitō shuppansha, 1984.

Matsubara, Saburo. *Chūgokubukkyō chōkokushi*, 4 vols. Tokyo: Yoshikawa kōbunkan, 1995.

Reinders, E. "Ritual Topography: Embodiment and Vertical Space in Buddhist Monastic Practice." *History of Religions* 36 (1997): 244ff.

Rhie, Marylin Martin. *Early Buddhist Art of China and Central Asia. Volume 1. Later Han, Three Kingdoms and Western Chin in China and Bactria to Shan-shan in Central Asia*. Leiden: Brill, 1999.

Schopen, Gregory. *Bones, Stones, and Buddhist Monks: Collected Papers on the Archaeology, Epigraphy, and Texts of Monastic Buddhism in India*. Honolulu: University of Hawai'i Press, 1997.

Shimoda, Masahiro. *Nehangyō no kenkyū: Daijōkyōten no kenkyūhōhō shiron*. Tokyo: Shunjūsha, 1997.

Shinohara, Koichi. "Daoxuan's Collection of Miracle Stories about 'Supernatural Monks' *(Shenseng gantong lu)*: An Analysis of Its Sources." *Chung-hwa Buddhist Journal* 3 (1990): 319-80.

–. "Changing Roles for Miraculous Images in Medieval Chinese Buddhism: A Study of the Miracle Image Section in Daoxuan's 'Collected Records.'" Pp. 141-88 in *Images, Miracles, and Authority in Asian Religious Traditions*, edited by Richard Davis. Boulder, CO: Westview Press, 1998.

–. "Image Makers in Xuyanzang's Record of the Western Regions and Daoxuan's Miracle Story Collection." Pp. 609-620 in *Jainism and Early Buddhism: Essays in Honor of Padmanabh S. Jaini*, edited by Olle Qvanström. Berkeley, CA: Asian Humanities Press, 2003.

Takada, Osamu. *Butsuzō no kigen*. Tokyo: Iwanami Shoten, 1967.

Teiser, Stephen F. "T'ang Buddhist Encyclopedias: A Bibliographical Introduction to Fa-yüan chulin and Chu-ching yao-chi." *T'ang Studies*, no. 3 (Winter 1985): 109-28.

Wechsler, Howard J. *Offerings of Jade and Silk: Ritual and Symbol in the Legitimation of the T'ang Dynasty*. New Haven: Yale University Press, 1985.

Weinstein, Stanley. *Buddhism under the T'ang*. Cambridge: Cambridge University Press, 1987.

Yamabe, Nobuyoshi. "The *Sūtra on the Ocean-Like Samādhi of the Visualization of the Buddha*: The Interfusion of the Chinese and Indian Cultures in Central Asia as Reflected in a Fifth Century Apocryphal Sūtra." PhD dissertation, Yale University, 1999.

Zürcher, E. *The Buddhist Conquest of China*. Leiden: Brill, 1972 (first published in 1959).

Glossary of Characters

Baoxing lun 寶性論
Changgan 長干
Changsha 長沙
Chengshi lun 成實論
chi 尺
Dabei jing 大悲經
Daji jing 大集經
Danyang 丹陽
Daoan 道安
Daoshi 道世
Daoxuan 道宣
Dazhi dulun 大智度論
Duijingliyuan hebu liang xiang
　　　對敬立緣合不兩相
Duiyuan shifei 對緣是非
fangshe jiandu 房舍犍度
Fanwang jing 梵網經
fashen 法身
Faxian 法顯
Fayuan zhulin 法苑珠林
Fobenxing jing 佛本行經
Fujiyoshi, Masumi 藤善真澄
Gao Li 高悝
Gaoseng zhuan 高僧傳
Gaozong 高宗
gongyang 供養
Guanfo sanmei[hai] jing
　　　觀佛三昧海經
Guanming 光明
Huan Xuan 桓玄
Huijiao 慧皎
Huiyuan 慧遠
Ji shezhou sanbao gantong lu
　　　集神州三寶感通錄
jia 假
jing 敬
Jingzhou 荊州

li 禮
li/lü 履
libai 禮拜
lijing 禮敬
Lu 盧
manfa 慢法
Nanhai jigui neifa zhuan
　　　南海寄歸內法傳
Pini taoyao 毗尼討要
qing 頃
Renwang jing 仁王經
Sazheniqianzi jing 薩遮尼乾子經
seng 僧
sengxiang zhijing 僧像致敬
Shamen bujing wangzhe lun
　　　沙門不敬王者論
Shangzuo 上座
shengrong 聖容
shengshen 生身
Shilun jing 十輪經
Shimen guijing yi 釋門歸敬儀
shisan nan 十三難
Shuowen jiezi 說文解字
Sifenlü shan fan bujue xingshi chao
　　　四分律刪繁補闕行事鈔
Sun Hao 孫皓
Taizong 太宗
Tang huiyao 唐會要
Tanyi 曇翼
Tao Kan 陶侃
Tongdian 通典
Tongxuan 通玄
Wu 吳
xiang gongjing 相恭敬
xiangjing 相敬
Xianqing 顯慶
Ximingsi 西明寺
Ximingsi seng Daoxuan deng xu
fojiaolongtishi jian zhuzaifu zhuan
　　　西明寺僧道宣等序佛教隆

替事簡諸宰輔
Yijing 義淨
Yüfo gongde jing 浴佛功德經
Zengyi ahan jing 增一阿含經
zhang 丈
zhen 真
Zhenguan 貞觀
zhenrong 真容
zhi 致
zhi 智
zhibai 致拜
zhijing 致敬

Part 3

Re-creating the Context of Image
Worship: Four Case Studies

7

Icon and Incantation: The Goddess Zhunti and the Role of Images in the Occult Buddhism of China

ROBERT M. GIMELLO

Around the turn of the eighth century, a new Buddhist deity, a goddess, arrived unheralded in China. She was one of many relatively recent additions to a Buddhist pantheon greatly expanded by the contemporary emergence in Mahāyāna of an occult mode of Buddhism known variously as Mantrayāna, Esoterism (Mijiao 密教), Tantra, or Vajrayāna.[1] The manner of her introduction was curious. On the one hand, Chinese Buddhists were told a great deal about her from the start. They were given her name (Zhunti 准提, Sanskrit: Cundī) and several of her epithets, a precise description of her appearance, careful instructions on how to paint her image, and detailed guidance on how to invoke her presence in recitations, gestures, and ritual/ contemplative performances. Of course, all this information came adorned with lavish praise for her extraordinary powers, both mundane and supramundane. On the other hand, much that one might have wanted to know about her was not revealed; in this sense, her introduction was unforthcoming and she remained quite a mysterious figure. In the beginning, for example, no stories were told about her; no accounts were given of her history; no specific geographical or cosmographical domains were assigned to her; she was placed in no particular "family" or array of buddhas and bodhisattvas; she was accorded no particular doctrinal significance; nor was she associated with any particular system of Buddhist

thought. Part of her mystery, surely, lay in her singularity. She was at first what the occult traditions would come to call a *biezun* (別尊), an object of special or discrete veneration, the central focus of her own self-contained and self-sufficient cult. Only later would she be incorporated, as a subordinate or emanant figure, into larger constellations of deities.[2]

Of special interest in the several brief scriptural texts in which Zhunti was first conveyed to China[3] is her mutually constitutive relation to a particular mystical incantation – *dhāraṇī* (*tuoluoni* 陀羅尼, *zhou* 咒), *mahāvidyā* (*daming* 大明), or mantra (*zhenyan* 真言) – and to a certain manual gesture (*yin, mudrā*), both of which bear her name.[4] The spell, reputed to guarantee both ultimate transcendence and manifold control of the world, is said to be uttered by the goddess herself but is also held to be continuously recited by a myriad of buddhas. For any mere worldlings who recite it, even if they be the most abject sinners, its efficacy is said to be infinite. In fact, the early Zhunti *dhāraṇī*-scriptures consist largely in enumeration of the wonderful benefits effected by the spell, especially when it is uttered and/or visualized in concert with performance of the *mudrā* and practice of ritual/contemplative communion with the image of the deity.

The Goddess Depicted and Invoked

Understanding of a deity about whom we know so much and yet so little, whose person and rites are meticulously described for us but scarcely interpreted, requires procedures of study that are as attentive to images and figurations as they are to discourse and predications. Let us begin, then, with a passage from the Amoghavajra version of the *Cundī dhāraṇī sūtra,* in which the image of the goddess is described specifically for the sake of those who would reproduce it.[5]

> Next we tell the method for painting an image of the goddess[6] Cundī.
> Taking a length of whole fine white cotton cloth rid of all hair and stretching it against a clean wall, first preparing a plaster altar and making such offerings of precious (*argha*) food and drink as are within his means, the painter should keep the eight abstentions so as to paint the image in purity. His pigments should be free of animal glue; his colors should be mixed in a new vessel.
>
> So should he paint the image of Cundī: Her body is golden, seated in full cross-legged posture atop a lotus, swathed in shimmering chiffon,

dressed in the vestments of a bodhisattva of the ten-perfections, white from top to bottom. She also wears goddess robes, bangles, torques, and a crown; her arms are encircled with conch-shaped bangles; and on her little fingers are jeweled rings. The image has a face with three eyes and her arms number eighteen. Her two topmost hands make the preaching gesture (*dharmacakra-pravartana-mudrā*). On the right, the second hand makes the fear quelling gesture (*abhaya-mudrā*), the third holds a sword (*khadga*), the fourth a jeweled banner (*dhvajā*), the fifth a citron fruit (*mātulunga*), the sixth an axe (*parau*), the seventh a goad (*ankuśa*), the eighth a thunderbolt wand (*vajra*), and the ninth a rosary (*akṣamālā*). On the left, the second hand holds a wish-fulfilling gem pennant (*cintāmaṇi-dhvajā*), the third a red lotus (*padma*) blossom in full bloom, the fourth an aspergillum (*kuṇḍikā*), the fifth a cord (*pāśa*), the sixth a wheel (*cakra*), the seventh a conch (*śankha*), the eighth an auspicious vase (*kalaśa*), and the ninth a *Prajñā[pāramitā]* volume. Beneath the lotus is painted a pool of water in which the dragon kings, Nanda and Upananda, hold up the lotus seat.[7] Off to the left is shown a priest [literally, "a reciter"] holding a thurible in his hand and gazing up reverently at the holy one. As the Buddha mother, Cundī has compassion for the priest so she gazes back down on him. Above are painted two ethereal deities, both called *śuddhāvāsika devaputra*.[8] Holding garlands (*mālikā*) in their hands, they come upon the sky to make offerings to the holy one.

When the painting is finished then a monk may, according to his means, invite seven other monks to [join him in] making offerings and intoning the spells, vows, and doxologies of the eye-opening ceremony.[9] Under the image one should inscribe the *"Dharmakāya* Dependent Origination" *gāthā*.[10] Then, taking the image to a special chamber for secret worship, one should cover it with a cloth. When it is time for recitation one removes the cloth, but when veneration, worship, and recitation are finished one puts the covering back on, taking care not to let others see it. Why is this? If the *sādhana* for painting the image, which has been conferred by one's teacher, should be divulged to others it would be susceptible to diabolical (Māra) use, and so it must be kept secret.

These instructions had their intended effect. They have been very conscientiously followed for the past twelve centuries and have informed the vast majority of sculpted and painted images of Zhunti in East Asia. In South, Southeast, and Central Asia, and in the Tibetan cultural realm, Cundī/Cundā has taken multiple forms. There are images of her with only two arms, others with four, six, eight, twelve,

sixteen, and twenty-four as well as eighteen arms. Some hold sets of accoutrements and regalia different from that listed by Amoghavajra; in some cases, for example, the begging bowl *(pātra)* is a key distinguishing feature. There is also a greater variety of *mudrā* and body postures. Certain later representations show her with three faces rather than only one.[11] In East Asia, however, with the exception of Tibetan images found in China, she almost always has eighteen arms and holds the very same regalia, is attended by the same retinue, and displays the very same *mudrā* that Amoghavajra's text prescribed (see Figures 7.1 and 7.2.).

Also standard and relatively invariant is the *dhāraṇī* with which the goddess is identified. This formula is, in its own way, as "mute" as the anthropomorphic image of the deity, and therefore equally in need of interpretation sensitive to more than only the discursive dimension of Buddhism. The core of the Cundī *dhāraṇī* are the following nine syllables:

> *oṃ cale cule cunde svāhā*[12]

Cunde, of course, is the vocative form of the goddess's name; the literal significance of the other syllables, if any, is obscure. The fuller version of the *dhāraṇī* reads:

> *namaḥ saptānāṃ samyaksambuddha koṭīṇāṃ tadyathā:*
> *oṃ cale cule cunde svāhā*

This can be translated, at least partly, as "Hail to the 70 million perfectly awakened ones; thus, *oṃ cale cule cunde svāhā*." In some later texts, the longer version is routinely framed by certain preliminary and concluding *dhāraṇī* uttered for purificatory and protective purposes. Thus:

> *om raṃ om jrīṃ oṃ maṇī padme huṃ*[13]
> *namaḥ saptānāṃ samyaksambuddha koṭīṇāṃ tadyathā:*
> *oṃ cale cule cunde svāhā*
> *vrāṃ*

Although in their origin *dhāraṇī* are quintessentially oral phenomena, they are also written and the use of their written forms is as crucial to occult Buddhist practice as their recitation. In this sense, the Cundī

Figure 7.1. Line drawing of Zhunti (Juntei), after a thirteenth-century Japanese painting belonging to the Kōryūji (廣隆寺) in Kyoto.

Figure 7.2. Line drawing of Zhunti (Juntei) after the *Genzu* (現圖) version of the *Mahākaruṇāgarbhadhātu* (Taizōkai 胎藏界, or "Womb") *maṇḍala*.

dhāraṇī belongs to the same field of visual experience that paintings or sculptures of the goddess inhabit. It was meant to be seen as well as heard and uttered. By preference, the *dhāraṇī* was inscribed and visualized in Sanskrit – in the Siddham script during the Tang and Song dynasties in China and throughout Japanese history, in Rañjā or Rañjana (Tibetan: Lan tsa) script in China since Yuan times.[14] (See Figures 7.3 and 7.4.) However, it could also be, and often was, transliterated in Chinese script. There was much variation in the choice of Chinese logographs for this purpose, but the transliterated version found in modern editions of Amoghavajra's translation of the Cundī *dhāraṇī* is: 娜莫颯哆南三藐三沒馱俱胝南恆你也他　唵者禮主禮准泥娑嚩賀部林

Figure 7.3. The core Zhunti *dhāraṇī* in *Siddham* script.

It is a defining feature of Zhunti practice, beginning with the Tang translation of the *Cundī dhāraṇī* scriptures, that devotees are encouraged to use a mirror – "as an altar" (*wei tan* 為壇), some of the texts say – to facilitate visualization. Gazing into a mirror while reciting the *dhāraṇī*, one is to visualize both the image of the deity and the mystic letters that embody her. In time, the small disc-shaped bronze mirrors used for this purpose came to be commonly imprinted, on the back, with the deity's iconic form, according to the canonical description, and, on the front and/or the back, with the inscribed *dhāraṇī*. It was not unusual to have the Sanskrit version of the spell embossed on the outer edge of the front or reflecting side of the disc, and to have the transliterated Chinese version embossed on the circumference of the back. The effect is of an image of the goddess encircled by "garlands" of sacred syllables, as though to reinforce the claim that the goddess and the incantation were inseparable, perhaps even mutually constitutive. And, of course, as the instrument in question is a mirror, the fusion of goddess and spell is further fused with the practitioner's own reflection. Sometimes, to emphasize the theme of communion between devotee and deity, the goddess's image is imprinted on the back of the mirror, facing backwards, so that someone viewing the rear

॥ ꣡꣡꣡꣡
꣡꣡꣡꣡꣡꣡
꣡꣡꣡꣡꣡꣡꣡꣡꣡
꣡꣡꣡꣡꣡꣡
꣡꣡꣡꣡꣡꣡꣡꣡
꣡꣡ ॥

oṃ raṃ oṃ jrīṃ
oṃ maṇi padme huṃ
namo saptanāṃ samyak sambuddhā
koṭināṃ tadyathā
oṃ cale cule cuṇde svāhā
oṃ vrāṃ

Figure 7.4. The Zhunti *dhāraṇī* in *rañjana* script with transliteration, as set forth in Daozhen, framed by Ṣadakṣarī and other subsidiary *dhāraṇī*. (The *rañjana* computer font used here was designed by Miroj Shakya of the Nāgārjuna Institute, Lalitpur, Nepal.)

of the mirror would see the back of the goddess and could therefore easily imagine, when gazing at his or her own image in the front of the mirror, that it was the goddess herself, in the guise of one's own visage, who is gazing back. (See Figures 7.5 and 7.6.)

Reflecting common occult practice, visualization of the icon and visualization *cum* recitation of the *dhāraṇī* are accompanied by the formation of the *mudrā* proper to this deity. Thus are engaged all three of the "three mysteries" (*trīṇi guhyāni, sanmi* 三密) that comprise the occult dimension of Buddhism: the mystery of body (*kāya-guhya, shenmi* 身密) as well as the mystery of speech (*vāg-guhya, koumi* 口密 or *yumi* 語密), and the mystery of mind (*mano-guhya, yimi* 意密). The Cundī *mudrā*, a particularly elegant interlacing of fingers, is better shown than verbally described (see Figure 7.7). It, too, like the inscribed *dhāraṇī*, is inextricable from the icon of the goddess.

The Goddess in Liao Times

Apart from the prescriptions set forth in the translations of the fundamental scriptures, we know little about the actual practice of the

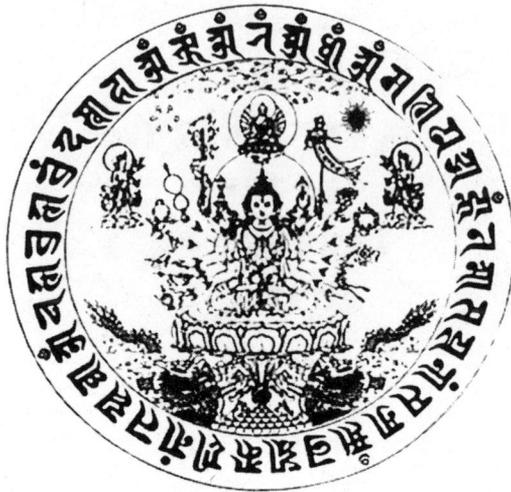

Figure 7.5. Image of Zhunti and her *dhāraṇī* as embossed on the back of a modern Zhunti mirror.

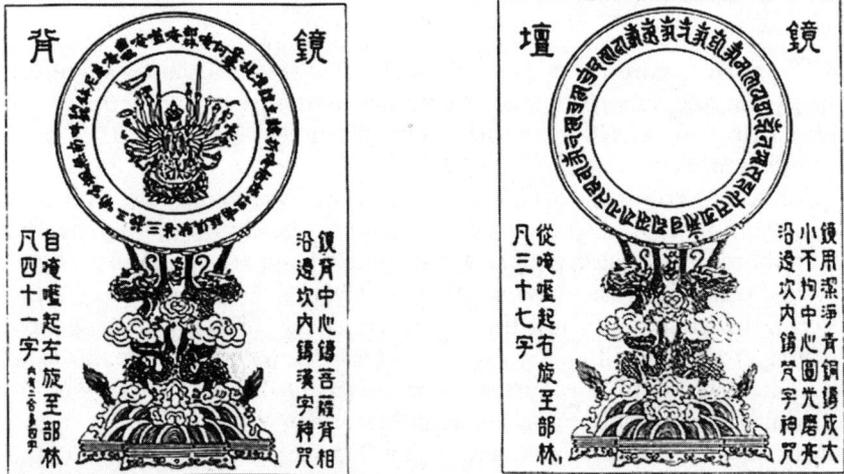

Figure 7.6. Block-print image of a Ming or Qing dynasty bronze Zhunti mirror and dragon stand, *recto* and *verso*, from the *Jinshisuo* (金石索), the 1821 catalogue of the collection of bronze and stone artifacts assembled by the early nineteenth-century collectors and connoisseurs, the brothers Feng Yunpeng (馮雲鵬) and Feng Yunyuan (馮雲驤).

Figure 7.7. Visual instructions for the Zhunti *mudrā*, from a modern pamphlet promulgating Zhunti practice.

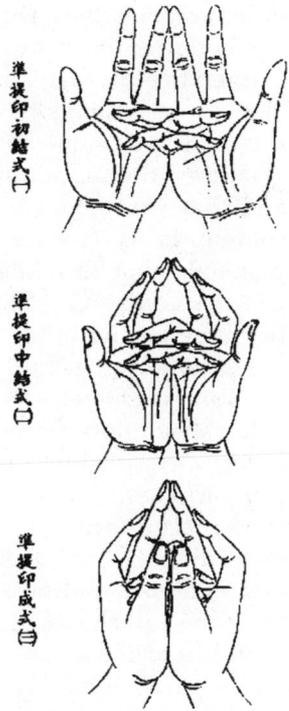

準提印初結式㈠

準提印中結式㈡

準提印成式㈢

Zhunti cult in the first several centuries of its history in China. Zanning (贊寧, 919-1001), in his *Song gaoseng zhuan* (宋高僧傳), does tell a tale about Vajrabodhi and the painting of "an image of the bodhisattva of the seventy-million" (*qi jiudi pusa xiang* 七俱胝普薩像).[15] One of Zhunti's principal epithets is "Goddess of the Seventy Million" (七俱胝佛母) – or, as the tradition would come to understand it, "Mother of the Seventy Million Buddhas." It is therefore not impossible that Zanning was referring to Zhunti. The story goes that Vajrabodhi once accompanied the Tang emperor Xuanzong (玄宗, r. 712-36) from the principal capital of Chang'an to the subsidiary capital of Luoyang to escape some of the effects of a five-month drought. Having been ordered by the emperor to perform an occult ritual to end the drought, the Indian priest set up, in a hall of one of the city's major temples, a large ritual platform or altar on which to perform (we presume) the Zhunti liturgy. He then set about painting an image of the goddess, announcing that on the day he would complete the image and bring it to life by painting in its eyes, the rains would come.

On the predicted day, the emperor sent the courtier monk Yixing (一行, 673-727) to observe the proceedings. Yixing reported that on the morning in question the sky was clear and the weather hot and dry, but later on, as Vajrabodhi began to paint the goddess's brows and eyes, wind and clouds suddenly arose and the skies burst open with rain so heavy that it broke through the roof above the altar. The general opinion at the time was that by painting the deity's image and preparing the *sādhana*, Vajrabodhi had gained control of a dragon

(dragons being the custodians of rain in Chinese belief), and that it was the flailing of the captured dragon that had destroyed the roof. Bearing in mind the fact that Vajrabodhi's translation of the *Cundī dhāraṇī sūtra*, like Amoghavajra's, contains directions for painting the goddess's image, that dragons (*long* 龍) and *nāga* were assumed to be the same creatures, that *nāga* kings are a standard feature of the Cundī icon, and that Cundī is said to come to the aid of Xuanzong's Indian contemporary Gopāla by helping him slay a *nāga*, it seems quite plausible that this tale offers a glimpse into late Tang belief and practice concerning Zhunti. If so, however, then it is a rare glimpse, for there are no other references to Zhunti in the Tang, or even in the early Song (except for her appearance in the 983 translation of the *Kāraṇḍavyūha*).

It was not until the eleventh century, and then in the north of China in territory ruled by the Liao (遼, 916-1125) dynasty, the realm of the proto-Mongol Khitan (Qidan 契丹) peoples, that we find Zhunti given special prominence as a major cult figure. The Liao rulers, especially the eighth of them, Daozong (道宗, r. 1055-1101), were pious Buddhists and generous patrons of the faith. With their support, Buddhism flourished in the north of China throughout the tenth and eleventh centuries, as we can see in the many magnificent Liao Buddhist antiquities that have survived in northern China. It is to be noted that the Liao seemed especially to favour forms of Buddhism that had enjoyed particular prestige in the Tang but that were in decline under the Song in southern China. Huayan (華嚴) Buddhist thought and occult (Mijiao) practice enjoyed pride of place in this regard, and the Liao period in Buddhist history is particularly rich in teachings that sought systematically to combine the two.

One of the most eminent Liao monks, a high-ranking ecclesiastical official under Daozong whose life was spent mostly in major temples in the Liao eastern capital of Yanjing (燕京, i.e., Beijing) or in retreat in mountains southwest of the city known as Little Wutaishan (Xiao wutai 小五台), is a case in point. His name was Daozhen (道㲀), also known as Fachuang Dashi (法幢大師). Only one of his writings survives, but it is a work of great significance and lasting influence,[16] not least because it proved to be the font of an expanded and enduring devotion to the goddess Zhunti. The text in question is the *Xianmi yuantong chengfo xinyao ji* (顯密圓通成佛心要集, T. 1955), the *Collection of Essentials for Realization of Buddhahood in the Perfect Penetration of the Exoteric and the Occult Teachings*. This work, according to its prefaces

composed probably sometime in the 1080s, is a concerted effort to synthesize the doctrines of Huayan Buddhism, which its author characterizes as the acme of the Buddha's exoteric or manifest teachings (*xianjiao* 顯教), and the practices and assumptions of the occult Buddhist traditions (*mijiao*, i.e., tantrism, esoterism, etc.). By the late eleventh century, there had long been a clear pattern of interdependence between these two traditions but (with the exception, perhaps, of Kūkai's efforts in Japan) that interdependence had been largely tacit, random, and unself-conscious. Until Daozhen and certain of his Liao contemporaries,[17] no one in China had yet explicitly advocated their systematic synthesis. Just this, however, was Daozhen's chief intent. His work is in three parts.

Part 1 summarizes the fundamentals of Huayan Buddhist thought and is written on the premise that Huayan is the most perfect expression of the explicit or manifest theoretical teachings of the Buddha. It is shown to culminate in a contemplation of the mutual inherence of all things, a profound interdependence that one might describe in language borrowed from Christian Trinitarian theology as perichôrêsis or circumincession (of which the Chinese Buddhist terms *wu'ai* 無礙 [non-obstruction] or *yuanrong* 圓融 [complete interfusion] could serve as fairly literal translations). This co-inherence of all things is compared to "Indra's Net," a famous metaphor for unity-in-diversity according to which the universe is like a vast cosmic net at each knot of which is fixed a gem that reflects all other gems in the net and the net as a whole, without losing its own distinct particularity, each and every particular thing or event in the universe being said to be like such a gem. Unlike many of the classical expositions of Huayan, however, Daozhen's text turns its attention quickly from Huayan scholasticism (the fivefold *panjiao* 判教 system, etc.) and the profundities of what it calls "awakening to the realm of Vairocana" (悟毗盧 法界) to more practical matters, addressed under the rubric of "cultivating the ocean of Samantabhadra's practices" (修普賢行海). This path of practice comprises a broad array of disciplines, including contemplation of the impurities of the body, counting breaths, meditations on emptiness as instanced in the composite character of the body, prostration, offerings, rituals of confession and contrition, the pledging of vows, recitation of the names of buddhas and bodhisattvas, and so on – as well as the more typically cerebral Huayan exercises of contemplating the interpenetration of things and so forth.

Part 2 introduces occult Buddhism by way of a fascinating and pregnant simile. The exoteric teachings, Daozhen argues, are like recipes for medicines (*haoyao fang* 好藥方) that one must concoct oneself, measuring out the ingredients in the proper proportions and combining them correctly. They are effective, but they require technical expertise and careful effort. Occult Buddhism, by contrast – that is, the religion of *dhāraṇī, dhāraṇī*-deities, *mudrā,* and *maṇḍala* – is like patent medicine (*hecheng miaoyao* 合成妙藥) – wonder drugs! – not only especially potent but also already mixed and thus not requiring the "pharmacist's" skill or the "chemist's" special knowledge. Then, drawing upon the *Cundī dhāraṇī* texts translated into Chinese in the eighth century, the scriptures we discussed earlier, he proceeds to expound a series of tantric contemplative/liturgical performances (*sādhana, chengjiu yigui* 成就儀軌) consisting precisely in the recitation of the Zhunti spell. This is performed as one sits in cross-legged meditation posture, sometimes in front of a mirror, while performing the Zhunti *mudrā* and while rehearsing before the mind's eye a series of visualizations either of the goddess herself and/or the mystic Sanskrit syllables of her spell that are understood to be the runic emblems or embodiment.

First, one employs the single-syllable mantra *"raṃ."* While seated in the lotus posture, hands forming the *samādhi mudrā* (三昧印; left hand placed in the lap with palm facing upward, right hand with palm up placed on left palm, thumbs touching), one visualizes the Sanskrit grapheme for *raṃ* hovering brightly above one's head. Then, with the left hand clenched in the *vajra*-fist *mudrā* (金剛拳印; fingers closed over the thumb), one utters twenty-one times the syllables *"oṃ raṃ."* This ensures purification and either accompanies or substitutes for bathing and donning clean clothes. Next comes the mantra *"jrīṃ."* Its recitation – again, twenty-one times – ensures protection from evil influences, nightmares, illnesses, demons, and so on. This is followed by the famous and powerful *"oṃ maṇi padme hūṃ"* mantra, which Daozhen professes to have learned from the *Kāraṇḍavyūha.* Daily recitation of this incantation – called the "six-letter *mahāvidyā mantra*" (六字大明真言) and declaimed to be "the very heart of the bodhisattva Avalokiteśvara" – conjures up the presence of buddhas, bodhisattvas, and deities, endows one with boundless *samādhi*, guarantees liberation for oneself and members of one's whole clan for seven generations, turns even the parasites in one's stomach into bodhisattvas, counteracts all poisons, and – most important – summons the

immediate appearance or vision (*xianqian* 現前) of millions of buddhas who are themselves all chanting in unison the Cundī *dhāraṇī*.

The efficacy of the Cundī *dhāraṇī* itself is then described (see above) and celebrated. For laity as well as monastics, and even for those who drink wine, eat meat, have wives and children, and are otherwise defiled, its blessings are manifold and difficult to exaggerate. Daozhen makes it clear that the *dhāraṇī* is best employed in the ritual use of a bronze "mirror-altar" (鏡壇). Before a Buddha image, on the night of a full moon, the practitioner sits facing east and sets the mirror before him. After burning incense, preferably expensive incense like the *gugula* (i.e., Parthian) variety, but only to the extent that one's means allow, and after sprinkling pure water, one performs the Cundī *mudrā* while simultaneously reciting the Cundī *dhāraṇī* and visualizing it in graphic form on the mirror's surface. This should be done 108 times, if possible. Thereafter, the mirror should be placed in a cloth purse and kept on one's person so as to be conveniently available whenever one wants to perform the ritual again. Daozhen further specifies that the *dhāraṇī* may be employed (*chi* 持, literally "grasped" or "wielded") in one of five different ways:

- by way of *yoga* (*yuqie* 瑜伽), that is, by visualizing one's own mind as a bright moon disc on which the Sanskrit letters of the core Cundī *dhāraṇī* are inscribed, the syllable *oṃ* in the centre, the other eight around its perimeter
- by way of breathing (*churuxi* 出入息), that is, by visualizing the string of letters of the *dhāraṇī*, like a string of brightly coloured gems, flowing continuously in and out of one's body and the body of the goddess in a remarkable process of shared breathing
- by way of "adamantine" (*jin'gang* 金剛) practice, that is, by actually speaking the *dhāraṇī* but with barely perceptible movement of lips and tongue ("under one's breath," as it were)
- in a soft voice (*weisheng* 微聲) audible only to oneself
- in a loud voice (*gaosheng* 高聲) audible to others.

The last of these can be performed either with or without counting the repetitions. Ancillary exercises are also described using other syllables such as *a, aṃ, huṃ, sa,* and *ra,* as are a series of variations in practice, each consecrated to a different purpose – for quelling of calamities (*xizai* 息災), for increase of blessings (*zengyi* 增益), to elicit the esteem and love (*jing'ai* 敬愛) of others, for subjugation (*jiangfu*

降伏) of malevolent beings, and for transcendence (*chushijian* 出世間). The last mentioned – practised in isolated and silent retreat for a period of four months and four days – entails an especially elaborate visualization process, not only of the letters of the *dhāraṇī* (consumed by flames, encircled by wind, and engulfed in water) but also the multiplied figure of the goddess Cundī, with all her holy insignia, emerging from the petals of a great lotus, her body encircled by the letters of the *dhāraṇī*.

In outlining such performances, the text guides the practitioner in the simultaneous exercise of the "three mysteries" of body, speech, and mind upon the understanding that these three dimensions of human experience are the loci of the "empowerment" or "sacramental grace" (*adhiṣṭhāna, jiachi* 加持) that propels one rapidly to liberation in this very lifetime while also generating a multitude of worldly blessings. Much is made in this and other occult texts of the mutual complementarity of body, speech, and mind (i.e., of the physical, the vocal, and the mental dimensions of reality and the experience thereof).

Part 3 of Daozhen's work propounds the systematic integration of exoteric doctrine and occult practice, arguing that each is incomplete without the other, whether they are practised in sequence or in tandem. He then enumerates the ten virtues inherent in mystical incantations:

(1) The *dhāraṇī* guarantee national security (including protection of the nation from foreign enemies, from astrological and other kinds of uncanny disasters, from wind and fire, from family dissension, from evil spirits, from untimely deaths, from crop failure, from drought, and from ferocious animals).
(2) They purge sin and exorcize ghosts.
(3) They cure illnesses and increase blessings.
(4) They guarantee the miraculous achievement of things sought.
(5) They ensure rebirth in paradise.
(6) They are the font of all teachings and practices, the mother of all buddhas.
(7) They enable the easy practice of adamantine protection for all four classes of believer.
(8) They confirm the equality of ordinary beings with buddhas.
(9) They effect awakening by both own power and other power.
(10) They are of such value that even buddhas still cherish them.

Finally Daozhen asserts that although different *dhāraṇī* have

particular advantages, varying according to the doctrinal principles they connote (i.e., depending upon their respective positions in relation to the Huayan *panjiao* system), ultimately they are all of equal efficacy insofar as they all comprise the mystical mind-seal of Vairocana.

The Issue of Iconology:
Some Theoretical and Comparative Reflections

Before addressing the larger issue of what the Zhunti cult – its icons, visualizations, liturgies, and incantations – can tell us about the role of images in Buddhism, some theoretical considerations are in order. Let us begin at some distance from the world of Chinese Buddhism but at a point that is, for better or worse, nearer to home for Western scholars who study such matters. Martin Luther is said to have told his congregation that if they wished to "see God" they would have to "take their eyes and put them in their ears." This injunction, and the principle of *fides ex auditu* to which it gave characteristically sharp vernacular expression, had powerful and persistent resonance well beyond anything Luther could have imagined. I doubt, for example, that he would have anticipated (though he might well have welcomed) the proliferation of burlap banners in place of statues in so many post–Vatican II Catholic churches, even though this strange phenomenon is arguably a consequence of the very sort of privileging of ears over eyes that he advocated. I am, however, quite certain that the great Christian reformer could not even have guessed that his exclusive devotion to the Word would shape nineteenth- and twentieth-century attitudes towards "pagan" religions like Buddhism. But this too can be, and has recently been, quite plausibly argued. It has in fact become something of a new truism – nonetheless true for all that – that modern attitudes towards Buddhism have long been profoundly "protestant" in their unself-conscious preference for text over image, for the disembodied over the corporeal, for "spirit" over "flesh," for the intelligible over the sensible, for the inward over the outward, for subject over object, for thought over behaviour, for theory over practice, and so forth – always on the tacit assumption that the former member of each rendition of the age-old dichotomy is somehow more real, or more revealing of the truth, than the latter.

Thus, until recently most academic study of Buddhism, not only in the West but also in Asia, has been study of texts, and texts, in turn, have been understood chiefly as vehicles for the construction,

conveyance, and analysis of doctrine. Far more often than not, the *dharma* was presented as a series of subtle variations on the truth of, say, "dependent origination" *(pratītyasamutpāda)* or "emptiness" *(śūnyatā)* or "representation-only" *(vijñaptimātratā)*. That the sūtras in which such doctrines were enunciated were seldom read as we now read them (silently, in private, at one sitting, and with the chief intent of extracting from them their doctrinal messages); that they were instead chanted, sometimes intoned over the course of months by persons who made a full prostration with the utterance of each syllable; written out in gold or silver ink, or in blood; placed on altars; perfumed with incense; wrapped in rarest silk or deposited in bejewelled cases; exquisitely illuminated with multi-coloured images; hidden inside bronze, wooden, or clay statues as though they were textual viscera; placed inside *stūpa*s and otherwise treated as relics – all this was either overlooked or treated as an array of curiosities merely incidental to the message of the text.

The relatively few scholars who ventured beyond the bounds of philology and philosophy into the study of Buddhism's institutional, political, or economic history saw little in their subjects that was particularly pertinent to Buddhism as a religion and, in any case, they tended to see themselves more as historians than as Buddhist scholars. Likewise, with a few notable exceptions, art historians who studied Buddhist art were concerned largely with the formal properties of their subject, hardly at all with its iconography, and still less with any role it may have played in the economy of Buddhist salvation.

Indeed, Buddhism as a religion "of the book" and "of the word" was made to seem an eminently modernist enterprise. It was celebrated for its inherently critical character, its deliberate and relentless alienation from tradition, its reflexively disenchanting *(entzauberte)* disposition. Modern interpreters of Buddhism, for example, loved to cite passages from the canon in which the Buddha urged his followers to be "lamps unto themselves"; to rely on reason and immediate experience rather than authority; to practise the *dharma* by transcending the *dharma;* to dispense with myth and magic; in the rhetoric of Zen, to "kill" any Buddha whom one might meet. The more conventional forms of Buddhist piety – merit making, ritual worship, prayer, rigorist asceticism, vatic spirituality, occultism, and so on – although amply present even in the texts themselves, were simply ignored, or they were ingeniously explained away. Especially fascinating is the way in which the modernist academic study of Buddhism actually helped

conjure up in the present the very kind of "rational religion" it claimed to have discovered in the past. For example, the "Buddhist modernism" or "protestant Buddhism" of Walpola Rahula's enormously influential book *What the Buddha Taught* was created in an accommodating response to Western expectations, and in nearly diametric opposition to Buddhism as it had actually been practised in traditional Theravāda. Likewise, the denatured Zen of Suzuki Daisetsu, Hisamatsu Shin'ichi, and Abe Masao; the Buddhist humanism (*renjian fojiao* 人間佛教) of the contemporary Chinese scholar-monk Yinshun Daoshi 印順導師; and the "Critical Buddhism" (*hihan bukkyō* 批判佛教) movement in contemporary Japan are all deeply indebted to modern, largely Western notions of what Buddhism ought to be.

However, all of that has now – more or less suddenly and somewhat mysteriously – changed. Although one is hard-pressed to find among younger scholars of Buddhism working today more than a few who profess interest in Buddhist doctrine, universities here and abroad are teeming with scholars engaged in the study of Buddhist material culture, Buddhist ritual, Buddhist notions and practices of the body, Buddhist sexualities, and so on. Instead of dissertations being written on the theory of "emptiness" or the doctrine of "consciousness-only," as was quite common ten to twenty or more years ago, we see people now qualifying for their doctorates with treatises on topics like self-immolation, bowing and prostration, mortuary practices, the history of monastic robes, pilgrimage, and so on. There is an almost alarming number of dissertations being written now, for example, on Buddhist practices of mummification and relic worship. And those who nowadays do take up the study of Buddhist texts are likely to be more interested in the means of their production and distribution, the process of their commodification, their use as currency in the purchase of power, and so on, than in anything they may actually say. More important for our immediate purpose, the eyes, as it were, are being reinstated as the most privileged sense organs in Buddhist Studies, insofar as a great deal of attention is now being paid to Buddhist imagery. And art historians (who, of course, have always favoured the eyes) are now likely to be more interested in iconography or patterns of patronage than in stylistics and aesthetics.

There is, to be sure, much that is salutary and liberating in these new developments. Even those like me who persist in an interest in texts and doctrine find exhilarating and edifying all of the many reminders we are now given of the fact that Buddhist thought is not, and never

really has been, merely a thesaurus of disembodied ideas and arguments. It is good to be reminded also that Buddhism is not, so to speak, "free for the taking," not something to be selectively "mined" or "raided" for just those particular notions that we may find to be congenial with, or of service to, our current intellectual enthusiasms. When we realize, for example, that the doctrine of emptiness was somehow connected with the practice of fasting and celibacy; when we notice that the teaching that all things are "mind-only" was of a piece with rituals of meditative visualization in which images of buddhas are consecrated and thus transubstantiated, so as to allow psychosomatic union of deity and devotee; when we ponder the fact that belief in the inherent buddhahood of all sentient beings was held by persons who thought that such a belief somehow entailed the especially strict attention to the way napkins are to be precisely folded around rice bowls after meals in the monastery – then it becomes harder to think of Nāgārjuna as a Wittgenstein or a Derrida born out of his time, of Vasubandhu as a kind of proleptic Husserl, or of Dōgen as a prefiguration of Heidegger.

Then too – and this ought not to be underrated – there is the sheer sensory pleasure of seeing Buddhism rendered in line, colour, shading, volume, and texture rather than only in arid discourse and often tedious dialectic.

Of course, it must also be noted that many contemporary scholars who have chosen to focus on the material, visual, and practical dimensions of Buddhism, rather than on doctrinal discourse alone, cite as a major reason for their choice the assumption that texts and doctrine, being essentially prescriptive in function, reveal only an imagined or idealized Buddhism rather than "the real thing." This assumption is often allied with the conviction that reflective written discourse has always been the exclusive domain of a very small, quite unrepresentative elite within the Buddhist community, whereas the practical and material productions of Buddhism are much more likely to give us access to the actual lives and values of the Buddhist masses. Some scholars, in fact, confess that this choice to study Buddhism in the concrete rather than in the abstract was ethically and/or politically motivated; they wish to give voice to those whom history had deprived of a voice, to effect a kind of postmortem liberation of the oppressed by refusing to use as instruments of study only the property of the oppressors. I am generally dubious of such assumptions and convictions – not only because the elite status of the Buddhist

intelligentsia has often been exaggerated (the Saṃgha was usually, at most, only a very marginal sort of elite whose interests were quite distinct from, at times even in conflict with, the interests of the economic and political elites), but also because drawing such sharp class distinctions often betrays a failure to understand the extent to which popular piety and doctrinal reflection have nourished each other. It was not only the unlettered masses who burnt incense in front of images of the buddhas and the bodhisattvas; intellectuals did such things too, and found meaning in the doing. Also, there were media by which the reflections of the intellectuals proved indirectly but powerfully consequential for the religion of the larger populace. Nevertheless, it is clear that assumptions about the inherent elitism and "immateriality" of texts and doctrine are at work in much of the latest scholarship on Buddhism. Mistaken or arbitrary though these assumptions may be, they have led to the recovery of much in Buddhism that had been forgotten, or overlooked, or illegitimately discounted – and for this we should be grateful.

Having said that, however, I must now proceed to say also that there is a troubling irony in this new trend of emphasis on Buddhism as a material thing, as something to be seen, and perhaps virtually touched and smelled, rather than merely heard or read. At the very moment we are being urged to turn our attention away from legible Buddhism to visible or tangible Buddhism, we are also being advised – often by the same people – that such a move will require abandonment, or at least radical retrenchment, of our interpretative ambitions, our hermeneutical or exegetical aspirations. Apropos of images, which are our principal focus here, we are being told, for example, that an image is not a sign or a symbol pointing to some other or transcendent reality that it also somehow (sacramentally?) embodies; it is rather a simulacrum, a phantasm rather than an icon. We are said, in other words, to have recently lost what Baudrillard calls Western civilization's "wager on representation" – the bet, placed first perhaps by Plato, that "a sign could refer to a depth of meaning."

Nor are we permitted at this late stage to hedge that bet. Literary theorists have been telling us for decades now that there is nothing "outside the text," that all discourse is ultimately self-referential and devoid of "presence." If there were any who were persuaded by such a claim about texts but thought that perhaps images were in this regard different, who assumed that in their more vivid immediacy images offered at least a modicum of purchase on something beyond

themselves, they have now been firmly told, not so. Magritte painted an image of a pipe on which he inscribed the famous locution "this is not a pipe," and since then it is, in certain widening circles, simply forbidden, or derided as naive, ever to try to look "through" paintings so as to see what they only pretend to represent. Thus, for some who urge the study of images and material religion, such study is recommended as part of a project to dissuade from the effort at interpretation (I have actually heard some of my colleagues say that they have been drawn away from the study of texts and doctrine to the study of practice and of *realia* like images because they have "grown weary of interpretation").

The result is that the images and artifacts that are more and more frequently adduced these days as the proper objects of Religious or Buddhist Studies are also rendered opaque. They are said to be, in other words, all surface, without depth or interior. Sometimes their opacity is alleged to be so "perfect" as to actually repel or reflect light, in the manner of mirrors. All images are to be treated, then, as "idols" rather than "icons" (according to the distinction drawn by Jean-Luc Marion in his brilliant *God without Being*).

You will all have noticed the currency of the term "gaze" in much of contemporary theory. "Gaze," it would appear, is that particularly blank, objectifying sort of regard that is appropriate to opaque things, or to things that are taken to be (perhaps thereby made to be) opaque. Consider what Marion has to say about idols and the gaze:

> That which characterizes the idol stems from the gaze. It dazzles with visibility only inasmuch as the gaze looks on it with consideration. It draws the gaze only inasmuch as the gaze has drawn it whole into the gazeable and there exposes and exhausts it. The gaze alone makes the idol, as the ultimate function of the gazeable ... When the idol appears, the gaze has just stopped; the idol concretizes that stop.[18]

What kinds of meaning can idols in this sense convey, or the gaze in this sense discern? Surely no meanings intrinsic to the things themselves, nor any that lie vertically beyond the realm of things, in some suprasensory realm to which iconic things might be thought to point. The only sort of meaning that "idols" or opacities can convey to the idolatry of "the gaze" is the meaning that lies between and among things, at the level of things. This, I would suggest (and I have time here to do no more than suggest), is why so much contemporary study

of images and other religious realia proceeds by way of leaving their surfaces unbreached and tracing only their outward, horizontal connections. I recently read a very learned and informative book entitled *Jewel in the Ashes*, by Brian Ruppert, a study of Buddha relics in early medieval Japan.[19] Relics, it should be borne in mind, belong to the same basic category of sacred signs that also includes images. Throughout this work, the "meanings" credited to relics are invariably extrinsic to the relics themselves, tacit rather than articulated, and merely assigned or ascribed. These precious things – commonly ensconced, by the way, in reliquaries that are among the masterpieces of the Japanese plastic arts – have meaning in Ruppert's book only in the sense that, and insofar as, they were incorporated into the structures of power and desire that comprised medieval Japanese society, or only in their roles as "mediators of power relations" therein. The book deals expertly with such matters as (to cite the titles of some of its chapters) "Buddha relics, exchange, and the value of death," "Buddha relics as imperial treasures," "the genealogy of relic theft," "samurai society and the powers of relics," "Buddha relics and the ritual economy of early medieval Japan," "Buddha relics and gender," and so on. All of these topics are, to be sure, worthy of the kind of expert consideration Ruppert gives them, from which we learn much about medieval Japan. But what, I would ask, do we learn of the relics themselves? And is it really required, as Ruppert seems to suggest, that we observe only their mute surfaces and external valences? What about their power to generate rather than only to receive meaning? Is there any sense in which they may be said to be icons rather than idols? An icon – as, again, Jean-Luc Marion puts it – is an image that never thwarts or obstructs the gaze, that therefore never allows the vision to rest or settle, that is inherently elusive rather than determinate, translucent rather than opaque.

In fact, I think there is a sense in which the relics and images of Buddhism may be seen as true icons, and I would argue that even after one has treated exhaustively of their implication, for example, in networks of social and political power, there is still much remaining to be learned about them – not least what it is about them that prompted their use as instruments of power and exchange to begin with. I do not believe, in other words, that a sacred image or relic is simply a simulacrum, or merely the sum of its extrinsic sociopolitical implications. However, I do believe that if we are to see what more than that they are, then it is necessary to marry them once again to the

discourses, the words and texts, from which modern theory has divorced them – this so as to still the pendulum that has lately swung in Buddhist Studies from the visually impaired fixation on texts to the opposite extreme of insistence that images and realia are merely mute placeholders for assigned interests.

And of course it is not only images and the visual dimension of the religion that may be indemnified in this way. Language and discourse are also thereby endowed with certain kinds of security against their inherent deficiencies. Buddhism bids fair, for example, to be labelled the apophatic tradition *par excellence;* its discourse on emptiness and the like is routinely a discourse of negation or denial, which is held to be necessary but also dangerous, and which one might think is naturally inimical to the use of imagery. But Buddhism is also a religion abounding in images, so much so that the Chinese, for example, were wont to call it the "teaching of images" (*xiang-jiao* 像教). The natural and unspoken cataphasis bodied forth in the image is regarded in Buddhism as an entailed counterbalance to the potential nihilism of the tradition's relentless naysaying. It is no accident that traditions that counterpose to apophasis or the *via negationis* a countervailing respect for the affirmative capacities of language (the *via affirmativa* or *via eminentiae*) also celebrate the value of images. Consider the following remarkably subtle observation from the West's apostle of apophasis, Pseudo-Dionysius. Speaking of negation he says (emphasis mine):

> For this is to see and to know truly, and to praise in a transcendent way Him who is beyond being through negation of all things, *just as those who make statues with their hands cut away everything which obscures the clear beholding of the hidden form, and thus make manifest its hidden beauty solely by the process of cutting away.*[20]

It is not only the case that negative discourse needs to be offset by the affirmation of the image; negation actually consists in a kind of image making. The naysayer, Pseudo-Dionysius tells us, is also a sculptor! The abundance of images in Buddhism, and the reverence accorded to them, is to be understood analogously, I think. And if so, then images are not (*pace* David Eckel[21]) merely tokens of "the presence of an absence"; they are rather presentiments of presence itself (as I will show soon by way of example).

Conclusion

Let me return finally to the matter of Zhunti/Cundī, to the exposition of her practice and her significance provided by Daozhen, and to my suggestion that the study of images ought to be not only added to the repertoire of Buddhist scholars but also combined with their more standard protocols of textual study.

Daozhen's central thesis in the work is that the "body" of Huayan doctrine and the envisaged image of Cundī are somehow co-inherent, and that by invoking the presence of the goddess we somehow confirm the truth of the doctrines and render them practically efficacious. In other words, Daozhen holds that if one recites Cundī's *dhāraṇī*, and/or visualizes the *dhāraṇī* in its graphic form as an array of Sanskrit letters or Chinese characters, and then imagines the goddess's anthropomorphic bodily image emerging from the intoned and envisioned syllables of the spell, all the while performing the corresponding manual gestures *(mudrā)*, one will thereby both quicken and verify the truth of the doctrines, and one will do this not merely allegorically but also, if I may say so, sacramentally.

There is, of course, an allegorical element to the iconography of tantric deities like Cundī. The texts are replete with explanations according to which, for example, the four arms of the four-armed Cundī symbolize the "four immeasurable contemplations of Buddhist meditation – benevolence *(maitrī)*, compassion *(karuṇā)*, sympathetic joy *(muditā)*, and equanimity *(upekṣā)* – and the eighteen arms of the eighteen-armed Cundī symbolize the eighteen *āveṇikadharmas* (不共法), characteristics exclusive to Buddhas as distinct from other beings); each syllable of the *dhāraṇī* conveys an aspect of the truth that all things are "unarisen" *(anutpāda* 無生, i.e., empty); and so forth. It is essential to bear in mind, however, that the image is not simply an instructional device or a conveyance of allegorical meaning; it also embodies its purport. Let us note, in this connection, that doctrines in their role as locutions (the *abhidhāna* 能詮 = *significant*) – as distinct from what they convey (the *abhidheya* 所詮 = *signifié*) – are what comprise the "manifest" *(xian* 顯) or "exoteric" teaching, whereas the images, gestures, and emblems comprise the "secret" *(mi* 密) or "occult" teachings.

This might seem counterintuitive at first. After all, are not images somehow more "patent" or "evident" than words? Not so, it would seem. Daozhen follows the general occult tradition in holding that

words (at least conventional words), in their role as conveyors of meaning – that is, as devices for rendering meanings explicit – are inherently more "forthcoming" than images. Images are repositories of tacit or silent meanings and as such are inherently more "mysterious" (*mi* 密), their meanings somehow "deeper." The implication, which Daozhen makes explicit several times, is that the deeper levels of truth are not accessible through words alone, that discourse requires imagery for its fulfillment or perfection. And yet images detached from discourse are mute and inert. This Daozhen also makes clear because his principal point, which my remarks are intended in a way only to echo, is that discursive and visionary Buddhism must be (re)united.

Indeed, Daozhen's work, and other elements of the Cundī cult (both its other texts and its icons) display a constant fluidity of movement from word to image and from image to word. Consider once again – but now all together – several of the instances of such fluidity and instability that we have already noted in passing:

• Cundī is a form, an embodied person and a painted and sculpted image. However, she is also a *dhāraṇī*, a sacred utterance.
• As *dhāraṇī*, Cundī is "spoken" (she embodies what the tradition calls "the mystery of speech"), but she is also written, because the *dhāraṇī* is not only an utterance but also a hieroglyph – something that can be written on a page, in not one but several scripts.
• Likewise, the inscribed *dhāraṇī* is seen also to be unstable in its identity as an array of graphemes, for Daozhen urges the devotee to envision the *dhāraṇī* and then to envision its transformation into a goddess.
• Daozhen and later devotees of Zhunti go even further to hold that when he envisions the goddess, the devotee or mediator should, in his mind's eye, exchange breaths with her – that is, imagine breath emanating from her mouth, entering his own mouth, circulating through his body, exiting through his mouth, entering again the mouth of the goddess, circulating in her body, and so on in a repeating cycle. And what is especially pertinent to our concern is that the "breath" thus exchanged is, in fact, the spoken *dhāraṇī* and one is to imagine it visually as the stream of Chinese or Sanskrit letters being exhaled and inhaled.
• Moreover, as a goddess Cundī holds in one of her many hands a book, the *Perfection of Wisdom*, which is itself (like the Sophia or Chochma of biblical tradition) a kind of *prosopon* or hypostasis.
• We are also reminded in this connection that in the Huayan tradition,

which Daozhen intends to conflate with occult Buddhism or tantra, meditation practice is often said to lead to mystical transports in which the practitioner is conveyed to the Buddha Vairocana's paradise, an Elysium wherein the principal joy is that of ceaselessly hearing the *buddhavacana* (the Buddha's word).

I could go on, but I think the point may already be made. Daozhen urges upon his readers a kind of religious synesthesia in which hearing or reading doctrine, as distilled in *dhāraṇī*, and seeing a deity – the apprehension of the word and the apprehension of the image – entail and merge with each other.

I would suggest that we scholars of Buddhism, as we now add images to the array of things we study and as we liberate ourselves from bondage to texts, should pay special attention to the ways in which Buddhist thinkers and visionaries like Daozhen used both kinds of resource together – just as we might well note the ways in which the "theology" of icons, and not only their sociology and the like, might usefully inform even the academic study of Buddhism and other religions.

End Notes

1 The career of this deity outside of East Asia is a subject for separate study. Suffice it to say here that she seems to have emerged into history, perhaps as a divinized ogress *(yakṣiṇī)*, not long before she travelled to China; that she flourished first in Bengal and Orissa under the grateful patronage of the Pāla dynasty (ca. 750 to ca. 1200), whose founder, Gopāla, was believed to have owed his reign to her protection; that her cult spread from Northeastern India to the rest of the subcontinent, to Sri Lanka, to Southeast Asia, and north to the Tibetan cultural regions with the gradual spread of Pāla culture; and that museums and archeological sites throughout South and Southeast India abound in scores if not hundreds of her sculptured images, some of them very similar to her standard East Asian representation. The often repeated claim that she is the Buddhist form of the Śaivite deity Durgā invites suspicion, except insofar as both goddesses are examples of the general growth of devotion to female and maternal deities so rife throughout medieval India. Although East Asian Buddhists came to know her, by way of transliteration, chiefly as "Cundī" (a name connoting low-caste female status, perhaps that of a prostitute or procuress), the more

common form of her name in South and Southeast Asia, especially in later times, was Cundā. For both "Cundī" and "Cundā" there are many variant spellings, not to mention many creative etymologies (*nirukti,* e.g., *śundhi* = "pure," *sunda* = "bright," and *cuṇḍī* = "tiny"), and one or more of these is likely the source of the dubious identification with Durgā, who is also called Caṇḍī or Caṇḍra. Cundī is not often mentioned in extant Indic literature of the Pāla or earlier periods, although Śāntideva (ca. 695-743) does refer to her spell in his *Śikṣāsamuccaya* (ch. 8) and she appears in the *Mañjuśrīmūlatantra,* the *Guhyasamājatantra,* and the *Kāraṇḍavyūha.* The *Kāraṇḍavyūha,* which is probably the source of the tradition according to which Cundī is a form of Avalokiteśvara, relates an occasion on which seventy-seven krore of tathāgatas recited the Cundī *dhāraṇī,* thereby causing a pore in Avalokiteśvara's body to open and reveal in brilliant illumination a vast multitude of world-systems (T. 1050: 20.63a). Cundī is also well represented in later Indian liturgical / iconographical encyclopedias such as the *Sādhanamāla,* in which three *sādhana* are consecrated to her (nos. 129-31), and Abhayākaragupta's *Niṣpannayogāvalī,* which places her as a minor figure in the *Dharmadhātuvāgīśvara, Mañjuvajra,* and *Kalacakra maṇḍala.* There is a fairly extensive body of scholarship on Cundī/Cundā in South and Southeast Asia, most of it by art historians. I mention here only a few of the more noteworthy contributions: Alfred Foucher, *Étude sur l'iconographie bouddhique de l'Inde d'après du documents nouveaux,* vol. 1 (Paris: E. Leroux, 1900); J.E. van Lohuizen-De Leeuw, "The Paṭṭikera Chundā and Variations of Her Image," in *Nalini Kanta Bhattasali Commemoration Volume: Essays on Archaeology, Art, History, Literature and Philosophy of the Orient, Dedicated to the Memory of Dr. Nalini Kanta Bhattasali [1888-1947 AD],* ed. A.B.M. Habibullah (Dacca: Dacca Museum, 1966), 119-43; Puspa Niyogi, "Cundā – A Popular Buddhist Goddess," *East and West* 27, nos. 1-4 (1977): 299-310; Marie-Thérèse de Mallmann, *Introduction á l'iconographie du tântrisme bouddhique* (Paris: Librairie d'Amérique et d'Orient /Maisonneuve, 1986); Sudarshan Devī Singhal, "Iconography of Cundā," in *The Art and Culture of South-East Asia,* ed. Lokesh Chandra (New Delhi: International Academy of Indian Culture and Aditya Prakashan, 1991), 384-410; Lokesh Chandra, "Cundā, Cundī," in *Dictionary of Buddhist Iconography,* vol. 3 (New Delhi: International Academy of Indian Culture and Aditya Prakashan, 2001), 849-66.

2 Most notably in the East Asian context, she was assigned a place in the mature version of the *Mahākaruṇāgarbhadhātu* (Chinese: Taizangjie 胎藏界, "womb realm") *maṇḍala.* In the standard Japanese renditions of this diagram, beginning with the Genzu (現圖) version derived from a

copy brought back from China by Kūkai (空海, 774-835) in the early ninth century, she was located in the far left (i.e., the north) of the "Chamber of Pervasive Knowledge" (*Bianzhi Yuan* 遍知院), which compartment is situated just above (i.e., east) of the central lotus chamber. Her presence here is somewhat puzzling, however. She is not to be found in most earlier versions of the Womb *maṇḍala,* nor is she even mentioned in the tantric scripture on which the *maṇḍala* is based, the *Mahāvairocana-abhisaṃbodhi vikurvita-adhiṣṭhāna sūtra* (*Dabiluzhena chengfo shenbian jiachi jing* 大毘盧遮那成佛神變加持經, also known as *Dari jing* 大日經; T. 848). The earliest reference to Zhunti's presence in the Womb *maṇḍala,* under the name Qi judi fomu (七俱胝佛母), seems to be a ritual text composed by the ninth-century monk Faquan (法全), T. 852.

3 The texts in question, the earliest Cundī sources we have in any language, are three versions of a *Cundī dhāraṇī* scripture: *Foshuo qijudi fomuxin da zhunti tuoluoni jing* 佛說七俱胝佛母心大准提陀羅尼經 (T. 1077), translated by Divākara (Dipoheluo 地婆訶羅, 613-88; arriv. China 680); *Foshuo qijudi fomu zhunti daming tuoluoni jing* 佛說七俱胝佛母准提大明陀羅尼 (T. 1075), translated by Vajrabodhi (Jin'gangzhi 金剛智, 671-741; arriv. China 719); and *Qijudi fomu suoshuo zhunti tuoluoni jing* 七俱胝佛母所說准提陀羅尼經 (T. 1076), translated by Amoghavajra (Bukongjin'gang 不空金剛, 705-74; arriv. China 715). The Amoghavajra version is appreciably longer than the others. Two other texts, both attributed to Śubhākarasiṃha (Shanwuwei 善無畏, 637-735; arriv. China 716) – not translations of the *dhāraṇī* but outlines of rituals pertaining thereto – were known until modern times only in Japan and are of questionable authenticity. They are *Qijudi fomuxin da zhunti tuoluoni fa* 七俱胝佛母心大准提陀羅尼法 (T. 1077) and *Qijudi dubu fa* 七俱胝獨部法 (T. 1079). All of these texts are usefully studied together with the relevant sections of several medieval Japanese liturgical and iconographical encyclopedias. These serve after a fashion as commentaries on the Tang scriptures, but it must be borne in mind that they may also reflect some post-Tang and distinctly Japanese developments in occult practice. There are five that warrant particular attention. Representing Tendai (天台, Taimitsu 台密) conventions are the *Gyōrinshō* (行林抄) by Jōnen (静然, fl. 1154), T. 2409: 76.99c-103b and the *Asabashō* (阿娑縛抄) by Shōchō (承澄, 1205-81), T. 3195: 95.99a-101b. Representing Shingon (真言, Tōmitsu 東密) perspectives are the *Bessonzakki* (別尊雜記) by Shinkaku (心覺, 1117-80), T. 3007: 88.200a-261c; the *Kakuzenshō* (覺禪鈔) by Kakuzen (覺禪, 1143 to ca. 1218), T. 3022: 89.905a-913b; and the *Usuzōshikuketsu* (薄草子口決) by Raiyu (賴瑜, 1226-1304), T. 2535: 79.221a-225b.

4 Cundī/Cundā is, in fact, one of a group of deities, eventually twelve in number and all of them female, who are said to actually be embodiments of their *dhāraṇī*. Other such, especially important in East Asia, are Uṣṇīṣavijayā (Fodingzunsheng 佛頂尊勝) and Mārīcī (Molizhi 摩利支).

5 T. 1007: 20.184c7-185a2.

6 The Chinese term is *fomu* (佛母), literally, "buddha-mother." Although it is true that this term was interpreted literally in the later tradition to mean "mother of buddhas," there is good reason to believe that originally it was simply a conventional rendering of the Sanskrit *bhagavatī* or *devī*. Thus "goddess" seems to be the preferred English translation for these early texts. It would appear that retro-constructions from *fomu* of the Sanskrit *buddhamātṛkā* or *buddhamātṛī* are speculative.

7 Perhaps these *nāgarāja* are an echo of Cundī's archaic identity as a subduer of serpents. This is the role she played in the myth of Gopāla's founding of the Pāla dynasty, enabling him to slay the malicious serpent demon that had until then been devouring all candidates for the throne. See the story told by Tāranātha in his account of Gopāla – *Tāranātha's History of Buddhism in India*, trans. Lama Chimpa and Alaka Chattopadhyaya (Delhi: Motilal Banarsidass, 1970), 257-64.

8 The Chinese term is *sutuo* (素陀). I thank Phyllis Granoff for identifying the corresponding Sanskrit as *śuddhāvāsika*. The *śuddhāvāsika* deities (those of pure abode) are the gods who dwell in the five highest of the seventeen heavens of the realm of form *(rūpadhātu)*, including the highest of them all, Akaniṣṭha. The more common Chinese term for these deities is *shoutuo* (首陀).

9 This is the precise moment in the consecration ritual when the pupils of the deity's eyes are painted in. It is just then that the image becomes, as it were, a living embodiment of the deity, an icon rather than a mere representation.

10 This may well be the famous epigram, best known by its Pāli designation as the *ye dhamma*, commonly found inscribed on Buddhist images throughout South and Southeast Asia: "*ye dharmā hetuprabhavā hetuṃ teṣaṃ tathāgato hy avadat / teṣāṃ ca yo nirodho evaṃvādī mahāśramaṇaḥ //*" ("Of those things that arise from a cause, the Tathāgata has told the cause, and also their cessation – this is the doctrine of the Great Ascetic").

11 In some cases, identification of such images as Cundī/Cundā is difficult owing to a general resemblance to several other female deities such as Prajñapāramitā, Mahāpratisarā, Vasudhāra, Bhṛkuṭī, Tārā, and so on. Scholars often disagree over which is which.

12 There are occasional, minor variations – e.g., Cuṇḍe rather than Cunde – related no doubt to the variant spelling of the goddess's name mentioned above. In Japan there has been preserved two very

interesting abbreviated Sanskrit (Siddham) versions of the Cundī *dhāraṇī* said to derive from manuscripts brought back from China by Kūkai. These have been carefully studied and compared with the Sanskrit versions preserved in the *Sādhanamālā*, with the Tibetan versions, and with Amoghavajra's Chinese – see Sakai Shirō 酒井紫朗, "Juntei butsumo (Cundī) ni tsuite 准提佛母 (Cundī) について," in *Itō Shinjō, Tanaka Junshō ryōkyōju shōtoku ki'nen bukkyōgaku ronbunshū* 伊藤真城 ●田中順照両教授頌德記念仏教額論文集, ed. Kōyasan Daigaku Bukkyōgaku Kenkyūshitsu 高野山大学仏教額研究室 (Ōsaka: Tōhō Shuppan 東方出版, 1979), 221-72. Sakai was working from Hase Hōshū's 長谷宝秀 1938 transcriptions of ancient manuscripts. See Hase Hōshū 長谷宝秀, "Kōbō daishi goshōrai bonji shingon shū (jō)" 弘法大師御請來梵字信言集(上), in *Hase Hōshū zenshū* 長谷宝秀全集, vol. 5 (Kyoto: Hōzōkan 法蔵館, 1997).

13 The incorporation of this even more famous mantric formula is a consequence of the appearance of Cundī, as noted above, in the *Kāraṇḍavyūha*, which is both the *locus classicus* of the "six-syllable" mantra and the earliest surviving text to establish a link between Cundī and Avalokiteśvara. This link led to the widespread East Asian assumption that Cundī is simply one of the many forms of Guanyin. We can note that the story of King Gopāla (q.v.) also suggests a connection with Avalokiteśvara, in this case as Khasarpaṇa. It is not implausible that Avalokiteśvara's connection with the goddess Cundī could have provided a warrant for the female transformation of Guanyin that would unfold in the Song. The *Kāraṇḍavyūha* was translated into Chinese in 983 by *Devaśānti (Tianxizai 天息災), also known as Dharmabhadra (Faxian 法賢) – see *Dasheng zhuangyan baowang jing* 大乘莊嚴寶王經 (T. 1050). Later Chinese devotees of Zhunti were quite familiar with this translation and tended to see the Cundī *dhāraṇī* and the Ṣadakṣarī *mahāvidyā* as a pair; they do so even today.

14 Variations in orthographic competence often led to scribal errors. For example, in T. 1071 (186b), one finds *"cāddhe"* rather than *"cunde."*

15 T. 2061: 50.711b-c. See also Zhou Yiliang (Chou I-liang), "Tantrism in China," *Harvard Journal of Asiatic Studies* 8 (1945): 276.

16 Daozhen's work, still popular even today, had wide and long-lasting influence throughout East Asian Buddhism. Very soon after it was written, it found its way to Korea, where the famous royal monk and bibliographer Ŭich'ŏn (義天, 1055-1101) included it in his famous supplement to the Buddhist canon. The Korean printing blocks for the text were carved in 1095; sometime shortly thereafter, a copy printed from those blocks was taken to Japan and was acquired by the Japanese

monk Myōe Shōnin (明惠, also known as Kōben 高辨, 1087-1185), who
included it in his library at Kōzanji (高山寺). Daozhen's work may well
have influenced Myōe in the construction of the latter's own amalgam of
Huayan (Kegon) and Mijiao (Mikkyō), his so-called *gonmitsu* (嚴密)
synthesis. Copies were also to be found in other medieval Japanese
archives, such as the library of Shōmyōji (稱名寺, later the Kanazawa
Bunko 金澤文庫). In China, the work was first "entered into the canon"
(*ruzang* 入藏) in the late thirteenth or early fourteenth century, with the
addition to the Qisha (磧沙) canon of a number of Mijiao texts. It has
been included in every subsequent Chinese edition of the canon. Over
the centuries, there have been countless separate editions. A number of
works based on Daozhen's texts were printed during the Yuan dynasty,
none of which survives, but from the late Ming and early Qing we have
no fewer than six substantial works on Zhunti practice that are all
heavily indebted to Daozhen. For a brief survey of the Zhunti cult in
these later periods, see Lu Jianfu 呂建福, *Zhongguo mijiao shi*
中國密教史 (Beijing: Zhongguo Shehuikexue chubanshe, 1995), 514-63.
Daozhen's work is also favoured by a number of contemporary popular
Chinese and Japanese teachers, such as Nan Huaijin (南懷瑾) and
Kiriyama Seiyū (桐山靖雄), but this is a subject for separate study.

17 For example, Jueyuan 覺苑, the author of the *Darijing yishi yanmi chao*
大日經義釋演密鈔 (*Shinsan zokuzōkyō* 新纂續藏經, vol. 23, no. 439,
522-659), a subcommentary on Yixing's commentary on the
Mahāvairocana abhisaṃbodhi that reads the earlier occult tradition
associated with those Tang texts through a Huayan lens. Note the
homage Jueyuan paid to the fourth Huayan patriarch, Chengguan
(澄觀, 738-839), in his choice of a title. "*Yanmi chao*" is clearly a play on
the "*Yanyi chao*" (演義鈔) of the title of Chengguan's famous
subcommentary on the *Huayan jing,* and Jueyuan regularly draws upon
Chengguan in his work.

18 Jean-Luc Marion, *God without Being,* trans. Thomas A. Carlson (Chicago:
University of Chicago Press, 1991), 10-11.

19 Brian D. Ruppert, *Jewel in the Ashes: Buddha Relics and Power in Early
Medieval Japan* (Cambridge: Harvard University Press, 2000).

20 Andrew Louth, *The Origins of the Christian Mystical Tradition: From Plato
to Denys* (Oxford: Oxford University Press, 1981), 174.

21 Malcolm David Eckel, *To See the Buddha: A Philosopher's Quest for the
Meaning of Emptiness* (Princeton: Princeton University Press, 1992).

Bibliography

Conventions

SSZZ = *Shinsan dainihon zokuzōkyō* 新纂大日本續藏經 (The Newly Compiled Japanese Supplement to the Buddhist Canon), 90 vols., edited by Ōcho Enichi 黃超慧日 et al. Tokyo: Kokusho Kankōkai 國書刊行會, 1973-89.

T = *Taishō shinshō daizōkyō* 大正新修大藏經 (The Buddhist Canon Newly Compiled during the Taishō Era [1912-1925]), 100 vols., edited by Takakusu Junjirō 高楠順次郎, Watanabe Kaigyoku 渡部海旭, and Ono Gemmyō 小野玄妙. Tokyo: Taishō Issaikyō Kankōkai 大正一切經刊行會, 1924-35.

Primary (Canonical) Sources

Asabashō 阿娑縛抄, compiled by Shōchō 承澄 – T 3190.

Bessonzakki 別尊雜記, compiled by Shinkaku 心覺 – T 3007.

Dapiluzhena chengfo shenbian jiachi jing 大毘盧遮那成佛神變加持經 (*Mahāvairocana-abhisaṃbodhi-vikurvita-adhiṣṭhāna sūtra*), translated by Śubhākarasiṃha – T 848.

Darijing yishi yanmi chao 大日經義釋演密鈔 by Jueyuan 覺苑 – SSZZ 439.

Dasheng zhuangyan baowang jing 大乘莊嚴寶王經 (*Kāraṇḍavyūha*), translated by Tianxizai 天息災 (*Devaśanti), a.k.a. Faxian 法賢 (*Dharmabhadra) – T 1050.

Foshuo qijudi fomu zhunti daming tuoluoni jing 佛說七俱胝佛母准提大明陀羅尼, translated by Vajrabodhi – T 1075.

Foshuo qijudi fomuxin da zhunti tuoluoni jing 佛說七俱胝佛母心大准提陀羅尼經, translation attributed to Divākara – T 1077.

Foshuo zhimingzang yuqie dajiao zunna pusa daming chengjiù yiguijing 佛說持明藏瑜伽大教尊那菩薩大明成就儀軌經, translated by Faxian 法賢 (*Dharmabhadra), a.k.a. Tianxizai 天息災 (*Devaśanti) – T 1169.

Gyōrinshō 行林抄, compiled by Jōnen 靜然 – T 2409.

Kakuzenshō 覺禪鈔, compiled by Kakuzen 覺禪 – T 3022.

Qijudi dubu fa 七俱胝獨部法, translation attributed to Śubhākarasiṃha – T 1079.

Qijudi fomu suoshuo zhunti tuoluoni jing 七俱胝佛母所說准提陀羅尼經, translated by Amoghavajra – T 1076.

Qijudi fomuxin da zhunti tuoluoni fa 七俱胝佛母心大准提陀羅尼法, translation attributed to Śubhākarasiṃha – T 1077.

Usuzōshikuketsu 薄草子口決, compiled by Raiyu 賴瑜 – T 2533.

Xianmi yuantong chengfo xinyao ji 顯密圓通成佛心要集, by Daozhen 道殿 – T 1995.

Secondary Sources

Chandra, Lokesh. "Cundā, Cundī." Pp. 849-66 in *Dictionary of Buddhist Iconography,* vol 3. New Delhi: International Academy of Indian Culture and Aditya Prakashan, 2001.

Chattopadhyaya, Alaka, and Lama Chimpa, trans. *Tāranātha's History of Buddhism in India.* Delhi: Motilal Banarsidass, 1970.

Chou I-liang. "Tantrism in China." *Harvard Journal of Asiatic Studies* 8, nos. 3-4 (1945): 241-332.

de Mallmann, Marie-Thérèse. *Introduction à l'iconographie du tântrisme bouddhique.* Paris: Librairie d'Amérique et d'Orient/Maisonneuve, 1986.

Eckel, Malcom David. *To See the Buddha: A Philosopher's Quest for the Meaning of Emptiness.* Princeton: Princeton University Press, 1992.

Foucher, Alfred. *Étude sur l'iconographie bouddhique de l'Inde d'apres du documents nouveaux,* vol. 1. Paris: E. Leroux, 1900.

Hase Hōshū 長谷宝秀. "Kōbō daishi goshōrai bonji shingon shū (jō)" 弘法大師御請來梵字信 言集（上）. In *Hase Hōshū zenshū* 長谷宝秀全集, Vol. 5. Kyoto: Hōzōkan 法蔵館, 1997.

Louth, Andrew. *The Origins of the Christian Mystical Tradition: From Plato to Denys.* Oxford: Oxford University Press, 1981.

Lu Jianfu 呂建福. *Zhongguo mijiao shi zhi* 中國密教史. Beijing: Zhongguo Shehuikexue Chubanshe 中國社會科學出版社, 1995.

Marion, Jean-Luc. *God without Being,* trans. by Thomas A. Carlson. Chicago: University of Chicago Press, 1991.

Niyogi, Puspa. "Cundā – A Popular Buddhist Goddess." *East and West* 27, nos. 1-4 (1977): 299-310.

Ruppert, Brian D. *Jewel in the Ashes: Buddha Relics and Power in Early Medieval Japan.* Cambridge: Harvard University Press, 2000.

Sakai Shirō 酒井紫朗. "Juntei butsumo (Cundī) ni tsuite" 准提佛母 (Cundī) について. Pp. 221-72 in *Itō Shinjō, Tanaka Junshō ryōkyōju shōtoku ki'nen Bukkyōgaku ronbunshū* 伊藤真城・田中順照両 教授頌徳記念仏教学論文集, edited by Kōyasan Daigaku Bukkyōgaku Kenkyūshitsu 高野山大学仏教学研究室. Ōsaka 大坂: Tōhō Shuppan 東方出版, 1979.

Singhal, Sudarshan Devi. "Iconography of Cundā." Pp. 384-410 in *Art and Culture of South-East Asia,* edited by Lokesh Chandra. New Delhi: International Academy of Indian Culture and Aditya Prakashan, 2001.

van Lohuizen-De Leeuw, J.E. "The Paṭṭikera Chundā and Variations of Her Image." Pp. 119-43 in *Nalini Kanta Bhattasali Commemoration Volume: Essays on Archaeology, Art, History, Literature and Philosophy of the Orient, Dedicated to the Memory of Dr. Nalini Kanta Bhattasalai [1888-1947 AD],* edited by A.B.M. Habibullah, Dacca: Dacca Museum, 1966.

8

The Tenjukoku Shūchō Mandara: Reconstruction of the Iconography and Ritual Context

CHARI PRADEL

One of the most puzzling Japanese National Treasures is the Tenjukoku Shūchō Mandara. It consists of fragments of embroidered textile randomly mounted on a support fabric that measures 88.8 by 82.8 centimetres (Figure 8.1). The fragments belong to the Buddhist nunnery of Chūgūji in Nara Prefecture, but they are now housed in the Nara National Museum, for preservation purposes. It is possible to trace the history of the fragments because of the vast corpus of textual material associated with them. For example, it is known that "a pair of embroidered curtains" *(shūchō nicho)* with the representation of Tenjukoku[1] were made sometime in the seventh century, after the death of Prince Shōtoku (Shōtoku Taishi, AD 574-622), and his mother, Empress Anahobe no Hashihito (d. 621), upon request of one of the prince's consorts, Princess Tachibana (Tachibana no Oiratsume, dates unknown). The history of the fragments is not limited to that period of time. Documents indicate that the embroidered artifact was discovered in 1274, and a replica was made the following year. In these texts, both the original artifact and its replica are called *mandara*, which is the Japanese term for the Sanskrit *maṇḍala*.

Among the fragments, the turtles with four characters embroidered on their shells are particularly important. Four turtles are pasted on the support fabric, one more turtle is in the collection of Chūgūji, and in addition there are five small pieces with characters in Shōsōin

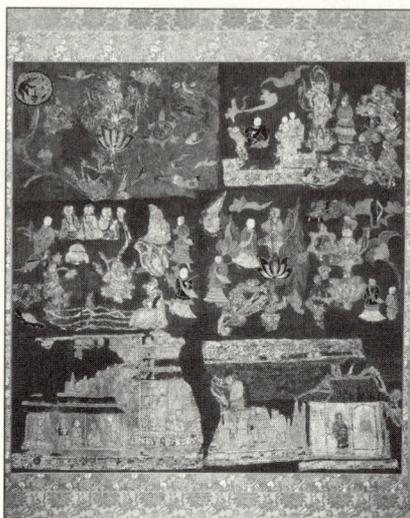

Figure 8.1. Tenjukoku Shūchō Mandara, Chūgūji temple, Nara Prefecture. Embroidered silk. Seventh and thirteenth centuries AD. (Photo: Nara National Museum)

(Tōdaiji, Nara Prefecture), making a total of twenty-five extant characters. These correspond to a text recorded in a Heian period (794-1185) document, *Jōgū Shōtoku hōō teisetsu* ("Imperial Record of Shōtoku, Dharma King of the Upper Palace," hereafter *Hōō teisetsu*).[2] This document is a biography of Prince Shōtoku, who is a controversial figure in Japanese historiography of the Asuka period (552-645). The earliest accounts of the life of the prince are narrated in *Nihon shoki* ("Chronicles of Japan"), which was completed in 720, and in the so-called Hōryūji documents, which include the previously mentioned *Hōō teisetsu* and the inscriptions on the mandorla of the Shaka or Śākyamuni triad, the halo of the Yakushi or Bhaiṣajyaguru image (both in the Golden Hall or Kondō of Hōryūji, dated to 623 and 607, respectively),[3] and the text of the Tenjukoku Shūchō, dated also to the seventh century. According to these, Prince Shōtoku was the son of Emperor Yōmei (r. 585-87), and Empress Anahobe no Hashihito. It is asserted that he could speak at birth, and that he was a wise, holy person. When he was nineteen years old, he became the regent for his aunt, Empress Suiko (r. 592-628). As regent, he is believed to have played a major role in the establishment of the Japanese state and the

emergence of Imperial rule. The Seventeen Article Constitution and a cap-rank system are attributed to the prince. In addition, he is considered to be not only a believer who had a deep understanding of Buddhist doctrine but also the "father of Japanese Buddhism." It is said that he lectured on sūtras and that he wrote commentaries on the *Lotus sūtra*, the *Vimalakīrti-nirdeśa-sūtra*, and the *Śrīmālā-devī-siṃhanāda-sūtra*.[4] A cult of the prince began in the eighth century, and along with it developed a vast corpus of textual and visual material asserting his saintly nature.[5] The cult of Prince Shōtoku has greatly influenced the way in which the historiography of the prince has been re-created by modern scholars. Most of them followed a very strict, orthodox methodology and reconstruct a history of the prince that is essentially hagiographic. Recent studies use a more critical approach, and some conclude that the figure of Prince Shōtoku as a Buddhist saint is a construction of the compilers of *Nihon shoki*.[6]

Studies of the Tenjukoku Shūchō Mandara show a strong influence of the orthodox historiography.[7] Accordingly, the text – originally embroidered on the turtles – is regarded as important evidence of Buddhist beliefs of the prince. Moreover, as documents narrating the thirteenth-century events refer to a *mandara*, it is assumed that the original artifact was a representation of a Pure Land named Tenjukoku.[8] As a *mandara*, it is presumed that it was hung on a wall, and that it was worshipped as a Buddhist image.[9] The Tenjukoku Shūchō Mandara is therefore usually discussed as one of the rare examples of Buddhist pictorial art of the Asuka period.[10] The most common approach is to frame the fragments, and the text, in a Buddhist context and to interpret Tenjukoku as the Buddhist paradise where Prince Shōtoku was reborn. The problem with this interpretation is that the term *Tenjukoku* apparently does not appear in the Buddhist sūtras.

This chapter focuses on the original embroidered curtains and attempts to re-create the meaning of the text and the images on the extant fragments in the context of the seventh century. It analyzes the text without the established assumptions regarding the Buddhist beliefs of Prince Shōtoku, and then concentrates on some of the motifs represented in the fragments in an attempt to partially reconstruct the subject matter of the embroidered curtains. By considering text and image without the established Buddhist interpretative framework, we might partially visualize Tenjukoku as Princess Tachibana did, and be able to reconstruct the circumstances of the manufacture of the

embroidered curtains and their function to understand the meaning of Tenjukoku in the seventh century.

The Text

As mentioned previously, the text of the Tenjukoku Shūchō was transcribed in the *Hōō teisetsu*, with a total of 398 characters. Records indicate that there were 100 turtles, so there must have been 400 characters embroidered on the artifact. The same text (hereafter Shūchō text) is recorded in "Tenjukoku shin mandara uragaki" ("Certificate of authenticity of the new Tenjukoku Mandara"), in *Shōyoshō* ("Summary by Shōyo," 1547), and *Hōryūji tōin engi* ("Legend of Horyuji's East Compound," 1736). By comparing these documents, scholars have fully reconstructed the Shūchō text.[11]

The Shūchō text can be divided in two parts. The first part is a genealogy of Prince Toyotomimi (which is another name for Prince Shōtoku), and one of his four wives, Princess Tachibana. The second part of the inscription states that Empress Anahobe (Prince Shōtoku's mother) died on the twenty-first day of the twelfth month of Suiko 29 (621), and that the prince died on the twenty-second day of the second month of Suiko 30 (622). Princess Tachibana was devastated by the loss of two beloved people in such a short period of time. She went to see her grandmother, Empress Suiko, and told the empress that the prince used to say, "This world is empty, the only truth is the Buddha," and so he must be in Tenjukoku. Since the princess could not visualize that land, she expressed her wish to depict him in that "afterlife world" (*ōjō no yōsu*) to cherish his memory. The empress was deeply moved, and ordered the ladies of the court (*uneme*) to make a pair of embroidered curtains, which were designed by Yamato Aya no Maken, Koma no Kasei, and Aya no Nukakori, and the manufacture was supervised by Kurahitobe no Hata no Kuma.[12] A postscript, probably written when the text was copied, states that the pair of curtains were in Hōryūji and that characters were embroidered on turtles.

The text clearly states that the embroidered curtains were made after the death of Prince Shōtoku and his mother, at the request of the grieving Princess Tachibana; thus, it can be argued that they were conceived as a memorial for the deceased prince and empress. Importantly, it appears to reveal the ideas and beliefs of Prince Shōtoku, since Princess Tachibana brought up a phrase allegedly expressed by the prince. She assumed that he was in Tenjukoku and

wanted to have a visual representation of the prince in that afterlife world. Here I would like to point out that the term in Japanese that I have translated as afterlife world is *ōjō no yōsu*. If taken in the Buddhist context, *ōjō* refers to the faith in being transported to a Pure Land of a Buddha or Bodhisattva after death, or rebirth in a Buddhist paradise. Then, the translation would be "the princess believed that the prince was in Tenjukoku but she could not visualize his rebirth in a Buddhist paradise." Yet *ōjō* also means the process of dying, and *ōjō no yōsu* can be translated as "aspects or circumstances of death," hence my translation of "afterlife world." Since the phrase clearly mentions the Buddha, it is logical to assume that Tenjukoku is a Buddhist paradise, particularly because the Asuka period is considered to be the time of the Buddhist transformation of Japan, as attested by the extant temples and icons as well as historical records. The question to be asked, however, is whether the afterlife beliefs were indeed Buddhist in the seventh century. If the beliefs were Buddhist, then *ōjō no yōsu* could be referring to the belief in being transported to a Buddhist Pure Land or paradise, but, as we will see later, the archeological evidence suggests that in the seventh century the afterlife belief might not yet have been influenced by the imported religion. By proposing "afterlife world," I would like to consider other postmortem alternatives besides those of Buddhism.

As mentioned earlier, in addition to the Shūchō text, the corpus of textual material associated with the fragments includes a group of documents that refer to the discovery of a Tenjukoku Mandara in a repository of Hōryūji in 1274, and the subsequent manufacture of a replica the following year. According to the documents, a nun named Shinnyo wanted to re-establish Chūgūji, but she did not know the date of the death anniversary of the temple patron, Empress Anahobe no Hashihito. The nun had a dream in which she saw a monk from Hōryūji bringing out a *mandara* that had an inscription with the information she was looking for. After many requests, the nun was allowed into the repository, and after searching for a long time, she found the *mandara* she had seen in her dream. This *mandara*, named Tenjukoku Mandara, had not only the date of the death of the empress but also her portrait, and the information she was looking for was embroidered on 100 turtles. According to *Shōyoshō*, since the *mandara* was in bad condition, the nun decided to make a replica, which was dedicated in 1275.[13]

The corpus of textual material strongly suggests that two

embroidered artifacts were made at different periods of time. The Shūchō text refers to the circumstances of manufacture of the original artifact in the seventh century, which will be called Tenjukoku Shūchō, or embroidered curtains representing Tenjukoku. On the other hand, the later documents allude to the rediscovery of the embroidered curtains in 1274, and the manufacture of a replica. Although in these texts both the original and the replica are called *mandara,* for the sake of clarity, the name "Tenjukoku Mandara" will refer to the thirteenth-century replica. Textile historians corroborate the information provided by the texts; based on analysis of fabric structures, embroidery threads, and stitches, specialists indicate that the fragments on the support fabric can indeed be divided in two groups. The fragments with bright and well-preserved threads are the remains of the original artifact, and the ones with faded threads are those of the Tenjukoku Mandara.[14] Therefore, the present artifact – Tenjukoku Shūchō Mandara – is a composite constructed of the fragments from artifacts made almost six centuries apart. As the fragments were pasted together on a support fabric, so was the textual evidence. Texts explaining the circumstances of manufacture of the Tenjukoku Mandara in the thirteenth century were used to interpret the meaning of the Tenjukoku Shūchō in the seventh century.[15]

As with most of the early historical texts in Japanese history, there are many controversies and issues related to the Shūchō text that are the focus of an ongoing discussion among scholars. Although these are crucial for the dating of the text and the artifact, they will not be discussed here.[16] Since orthodox historians and Buddhologists consider the Shūchō text as evidence for the Buddhist beliefs of the prince, and in spite of the fact that the term "Tenjukoku" does not appear in the Buddhist sūtras, the fragments are nevertheless usually considered to be one of the earliest representations of a Buddhist Pure Land, although only one motif – the being emerging from the lotus flower – can be associated with Buddhist iconography. As there are many Pure Lands in Buddhism, a great deal of ink has been spilled in attempting to establish which is Tenjukoku. It has been suggested that Tenjukoku is the Pure Land of either Amida, Miroku (Sanskrit: Maitreya), Shaka, or Ashuku (Sanskrit: Akṣobhya), or also strange and exotic lands such as India, or places associated with Chinese beliefs.[17] Since the number of studies that address the meaning of Tenjukoku is vast, in the following paragraphs only a few examples will be considered.

One accepted interpretation is that Tenjukoku refers to Tosotsuten (Sanskrit: Tuṣita Heaven), the Pure Land of Miroku. This theory was proposed for the first time by Tsuji Zennosuke in 1901, when he indicated that since a postscript in the Shūchō text states that "Tenjukoku is heaven," then it must be Tuṣita Heaven.[18] Later, Matsumoto Bunzaburō, in his study of Miroku belief, indicated that Tenjukoku must be Tosotsuten because the cult of Miroku was popular in the seventh century, as indicated by the number of extant Miroku icons and the entries in the *Nihon shoki*.[19] A different approach was proposed by Shigematsu Akihisa to demonstrate that Tenjukoku was associated with Miroku. In examining the Miroku sūtras, he found the word *tenju* (heavenly life), and took this as proof that Tenjukoku was indeed the Pure Land of Miroku.[20]

The most widely accepted theory is that Tenjukoku is the Pure Land of Amida. When the embroidered curtains were discovered in 1274, Tenjukoku was identified as Muryōjukoku (Land of Utmost Bliss, which is the Western Pure Land), as stated in *Taishi Mandara kōshiki* ("Hymn for the Prince's *Mandara*," hereafter *Kōshiki*) and *Shōtoku Taishi denki* ("Biography of Prince Shōtoku," hereafter *Denki*). As previously mentioned, scholars such as Kosugi Sugimura used these documents as evidence that Tenjukoku is a Pure Land.[21] In the same way, other scholars have argued that Prince Shōtoku had faith in rebirth in the Pure Land, and the statement "This world is empty, the only truth is the Buddha" in the Shūchō text is taken as evidence of that belief. Pure Land priests explain that the phrase indicates that Prince Shōtoku had knowledge of the principle of impermanence that is one aspect of Pure Land belief.[22] A crucial piece of evidence to support the theory that Tenjukoku was Amida's Pure Land was presented by Tokiwa Daijō, who found the term "Tenjukoku" in a postscript in a *Kegongyō* (Sanskrit: Avataṃsaka-sūtra; English: Garland Sūtra) that belongs in the Mitsui family collection. The sutra has a Northern Wei inscription equivalent to AD 513, and the postscript indicates that in the year corresponding to 583, vows were made for the life of the deceased parents in Saihō Tenjukoku (Western Tenjukoku). Tokiwa concluded that because the phrase indicates that Tenjukoku is in the west, it must be the Western Pure Land.[23]

Although this text discovered by Tokiwa seems to be the solution to the puzzle, the question remains of when the belief in Amida became popular. The *Nihon shoki* entry of the fifth month of Jōmei 12 (640) that records the lecture on *Muryōjukyō* (Sanskrit: Sukhāvatī-vyūha; English:

Buddha of Infinite Life Sūtra) by the monk Eon is considered to be the beginnings of the cult.[24] In any event, although it is not clear whether the belief in Amida was popular by the time the embroidered curtains were made, the idea that Tenjukoku could be the Western paradise or Pure Land of Amida has been accepted. In addition to the textual evidence, the motif of the being emerging from the lotus supports the hypothesis that Tenjukoku is the Pure Land of Amida since this is a motif seen in the paintings of his Pure Land.[25]

Prince Shōtoku lived during one of the most important times of the history of Japan, the Asuka period, when Buddhism was introduced along with continental culture and technology. Because of the deep roots that Buddhism took in Japan, when discussing the Asuka period historians tend to focus on the role played by the religion. Archeological remains as well as textual evidence, however, suggest that in the early seventh century, when the embroidered curtains were made, beliefs in the Japanese islands were far from completely transformed to Buddhism and many pre-Buddhist practices and beliefs were still popular. I strongly believe, therefore, that in order to understand the Shūchō text and the remaining fragments, we should not limit our framework to Buddhism.

The Fragments and the Images

One of the problems in reconstructing the subject matter is the fragmentary condition of the artifact, and also the scarcity of pictorial representations contemporaneous with these fragments. Until recently, the only known pictorial examples of the seventh century were the paintings on the panels of the Tamamushi shrine.[26] Although excavations, such as the Takamatsuzuka tomb discovered in 1972, have brought to light some material crucial to the understanding of the Japanese islands in the late seventh century, early visual material is still scarce. In order to reconstruct the iconography of the Tenjukoku Shūchō, I will consider pictorial material from China and the Korean peninsula for the sake of comparison. This consideration is based on archeological and documentary evidence that shows these three geographical areas sharing many common cultural traits, particularly between the third and the seventh centuries, due to constant commercial and cultural interchange.[27] As we will see, most of the motifs on the fragments are also found in funerary monuments in China and on the Korean peninsula and, in a few cases, on Buddhist

monuments.[28] Particularly important as visual evidence for comparison are the mural paintings of the funerary chambers of tombs of Koguryo in northern Korea (fifth to seventh centuries). The fact that the supervisor and the designers of the Tenjukoku Shūchō are connected to the Korean peninsula further supports the pan–East Asian approach for this study. In sum, I suggest that we see the fragments of the Tenjukoku Shūchō as a pictorial manifestation that reflects the many East Asian cultural waves that shaped the visual culture of the Japanese islands in the seventh century.

Representations of men and women on the fragments are convincing proof of the strong relationship between the Korean peninsula and the Japanese islands. Among the seventh-century fragments, there is a representation of a standing man on the top right section (section A).[29] The man wears a long red jacket tied at the waist by a cord, a pleated garment (known as *hirami*), long pants, and pointed shoes. His hands are together and covered by the sleeves. Women, as seen in sections C and D, wear a long jacket without a cord over a *hirami*, long skirts, and a baglike garment across the chest (called *tasuki*). Three of the women have skirts with vertical stripes that suggest pleats or a striped pattern, and two have horizontal lines, indicating various levels of ruffles. The type of attire previously described is also worn by men and women depicted in the murals of the Koguryo tombs, particularly in the tomb of Susanni, dated to the fifth century, in the South Pyongyang province. The most obvious common features are the long jackets with tubular sleeves and the long skirts worn by women (Figures 8.2 and 8.3). In the murals of the tombs, standing men and women are usually aligned as participating in a procession, or perhaps some other ritual activity. Women wearing the same type of clothing are represented in the previously mentioned tomb of Takamatsuzuka in the Asuka region, dated to the late seventh and early eighth centuries. The Tang style of representation of fully fleshed and elegant women supports the dating of these mural paintings.[30]

When analyzing the representation of people on the fragments, Ōhashi noticed two of the women holding stalk-like elements, and since the kneeling figure in section D and the one riding a horse in section A both hold flowers, he suggested that those are flower stems. As some are walking to the right and one towards the left, he thought that they must be participating in a procession. Moreover, among the motifs there are some men and women kneeling with their hands

Figure 8.2. Representation of women. Detail from left side of the north wall painting of the Susanni tomb, Taean city, South Pyongyang province. Fifth century AD. (Photo: The Chosonsinbo)

Figure 8.3. Representation of men. Detail from the right side of the north wall painting of the Susanni tomb, Taean city, South Pyongyang province. Fifth century AD. (Photo: The Chosonsinbo)

together or holding flowers, so he suggests that they are a group of people participating in a memorial service or perhaps worshipping. Ōhashi suggests, however, that the people must be the reborn souls in paradise, since he thinks that the embroidered curtains had a representation of a Buddhist Pure Land.[31] I think his conclusion shows the influence of the Shōtoku myth, which limits the frame of interpretation to a Buddhist context. In the same way, Ishida Mosaku's suggestion that the man with the red jacket is Prince Shōtoku as a regent is another example of this tendency.[32]

Although I agree with Ōhashi that the people in the composition seem to be participating in a procession or a ritual activity, I believe that they are not reborn souls but representations of members of the ruling elite, or people associated with them. The argument is based on the iconographical program of the Koguryo tombs, which usually includes on the walls portraits of the deceased; genre scenes, such as hunting; ritual scenes, such as processions; and a representation of the sky or heaven on the corbeled ceilings.[33] Since the extant images and Shūchō text do not provide enough information, it seems highly implausible to identify figures, such as the man in the red jacket, as Prince Shōtoku, since the fragments do not have cartouches with identification labels as in some Chinese pictorial representations. We can, however, establish their social status on the basis of their garments. Entries in *Nihon shoki* include regulations on the garments to be worn by the ruling elite, and in the seventh month of Suiko 13 (605), an entry indicates that princes and ministers have to wear *hirami*, also known as *hiraobi*, which was part of the formal attire, worn over pants for men and over skirts for women.[34] Thus, it can be argued that the man in the red jacket was a prince or a minister, as he wears that garment. Seventy-seven years later, as an entry for the third month of Tenmu II (682) records, the sumptuary laws were changed, and now everyone from princes to public functionaries was forbidden to wear caps of rank, aprons, *hirami*, and *habaki* pants. The same entry forbids *kashiwade* (stewards) and *uneme* (court ladies) to wear *tasuki* and *hire*.[35] *Tasuki* is an oblong piece of fabric that hangs from one shoulder and goes across the chest to the hip on the opposite side, and *hire* is an elongated scarf that is worn on the neck with the ends falling to both sides. As indicated previously, the women in the fragments wear the *tasuki*. Given this, we can argue that they are court ladies, still dressed in the garment that has not yet been prescribed.[36]

The extant images of people on the fragments demonstrate the

strong connection between the Korean peninsula and the Japanese islands. The images are important evidence for the history of clothing in the Japanese islands. It can also be argued that, in the seventh century, the types of clothes worn in those two geographical areas were very similar. Moreover, these images also provide clues for the dating of the fragments. The fact that the man wears a *hirami* and the women wear *tasuki* suggests that the embroidered curtains must have been made sometime after the death of Prince Shōtoku in 622, and before 682, when the new regulations regarding the garments to be worn by *kashiwade* and *uneme* were established. Therefore, the clothing worn by the people allows us not only to establish their social status but also to corroborate the information provided by the Shūchō text. Furthermore, if we reconstruct a scene represented on the embroidered curtains with people involved in ritual processions, they might have been required to wear the official attire.

Taking the Koguryo tombs as a pictorial model, besides the procession scene it is highly likely that the embroidered curtains included a representation of the sky. This is based on the short description in *Denki* and *Kōshiki* that mention that there were the sun and the moon.

Figure 8.4. Crow in the Sun. Brick relief rubbing, tomb at Jinjiacun, Danyang county, Jiangsu province. Late fifth century AD. (From Yao Qian and Gu Bing, *Liuchao yishu* [Beijing: Wenwu Press, 1982])

Among the extant motifs, on the upper left corner of section B there is a circle with a rabbit, a medicine jar, and a cassia tree, which is a symbolic representation of the moon. Unfortunately, the symbolic form of the sun is no longer extant, but we can trace the motif in other East Asian pictorial representations. The earliest extant symbolic representation of the sun and the moon is found in China, on the famous painted silk banner found in Mawangdui Tomb No. 1 in Changsha (Hunan province), dated to 168 BC, and also on the one from Jinqueshan Tomb No. 9 in Linyi (Shandong province), dated to the first to second centuries.[37] In both banners, the sun circle has a crow and the moon circle has a toad. The same symbolic representations of the sun and the moon are found in Western Han tombs.[38] These celestial bodies continued to be an important part of funerary iconography, as seen in a lacquered coffin dated to the Northern Wei (AD 386-534), where the sun and the moon, the River of Heaven (Milky Way), and two palaces with the King Father of the East and the Queen Mother of the West are represented on the lid. Luo Feng indicates that this painting is a representation of heaven, and that it embodies the Daoist concept of immortality and the Daoist ideal of

Figure 8.5. Hare in the Moon. Brick relief rubbing, tomb at Jinjiacun, Danyang county, Jiangsu province. Late fifth century AD. (From Yao Qian and Gu Bing, *Liuchao yishu* [Beijing: Wenwu Press, 1982])

ascending to heaven.[39] The symbolic representations of the sun and the moon are also found in the Southern Qi (AD 479-502) brick tombs at Danyang county, Jiangsu province.[40] The pictorial bricks in the tomb at Jinjiacon represent both sun and moon: the former displays a three-legged bird with wings outspread, and the latter features a hare standing on its two hind feet under a cassia tree, its front paws pounding a pestle on a mortar, just as in the Tenjukoku Shūchō[41] (Figures 8.4 and 8.5). Although the images of the sun and the moon are not extant in the other tombs, inscriptions indicate that they were located on the ceiling between the corridor entrance and the first stone door, and that the sun was on the east wall while the moon was on the west.[42]

The sun and the moon, as well as constellations, fantastic animals, auspicious clouds, and immortals, are represented in the corbeled ceilings of the Koguryo tombs. The sun and moon are represented in symbolic form following the Chinese model, with a three-legged crow in the sun and a toad in the moon, as seen in Tokhungri (fifth century). Interestingly, in Tokhwari No. 1 and No. 2 (late fifth to early sixth century), both a hare and a toad are inside the moon disc, and in Jinpari No. 1 (sixth century), a hare and a cassia tree are also inside the moon disc, as in the Tenjukoku Shūchō.[43] In most cases, the sun is on the eastern side of the dome and the moon on the western side. From the Chinese and Korean examples presented, we can argue that the symbolic representations of the sun and the moon began in China and became key elements in funerary iconography. The sun was always represented with either a crow or a three-legged crow, but the moon's iconography changed around the fifth to sixth centuries. The image of the toad was replaced with the representation of the hare pounding the elixir of immortality next to a cassia tree. This hare is one of the hybrid creatures believed to inhabit Kunlun (Japanese: Konron) the immortal world of the Queen Mother of the West.[44]

Another motif further supports the theory that the embroidered curtains had an iconographical program similar to those of the Koguryo tombs, as well as with some Chinese tombs. The right side of section B is a particularly important fragment because it is the only large piece and it offers clues as to the relationship between the motifs (Figure 8.6). In the fragment, there is a red bird with a green palmetto motif in the beak, a black and red cloud, a budlike motif, a turtle with four characters, flowing red scarves, and a green plantlike motif. This fragment provides important information regarding the placement of the 100 turtles in the original composition, and from this fragment it

can be argued that the turtles mingled with other motifs on the embroidered curtains rather than being placed on the borders, as suggested by some scholars.[45] Moreover, all the motifs on this fragment support the idea that the embroidered curtains' iconographical program was similar to those in the Koguryo tombs, and also some South Chinese tombs.[46]

Figure 8.6. Tenjukoku Shūchō Mandara. Detail of section B.

In this chapter, I will concentrate on the red bird, since the significance of the 100 turtles and the budlike motif is a very complex issue that will be discussed in a forthcoming publication. The Red Bird in East Asia is one of the four directional animals (Japanese: Shijin), and is found in China as early as the Warring States period (ca. 450-221 BC), Qin (221-207 BC), and Han (206 BC to AD 220) periods. According to Sun, their role was to chase away evil spirits and accompany people in the ascent to heaven.[47] The Red Bird (Japanese: Shujaku) is associated with the south; the Great Warrior (Japanese: Genbu), a combination of a turtle and a snake, with the north; the White Tiger (Japanese: Byakko) with the west; and the Blue Dragon (Japanese: Seiryō) with the east. In China, the four directional animals are found in various contexts, but they are particularly popular as motifs on the backs of

bronze mirrors as early as the Han dynasty,[48] and they were also stamped on roof tiles to decorate official buildings in the same period.[49] The four directional animals became an important subject in Koguryo tombs, especially in the sixth to seventh centuries, when they occupied the whole surface of the wall of their respective directions.

In the Japanese islands, until the tomb of Takamatsuzuka was discovered, the only known early representations of these four animals were on a pedestal of the image of Yakushi in Yakushiji, dated to the eighth century.[50] The walls of the small chamber of the Takamatsuzuka tomb are decorated with the Blue Dragon and White Tiger flanked by a group of men and a group women, on the east and west, respectively; the Great Warrior is on the northern wall. Unfortunately, the southern wall was destroyed, and the Red Bird is no longer extant. In terms of style, the directional animals are similar to those represented in the seventh-century Koguryo tombs of Kangso, the Middle-sized Tomb, and the Large Tomb.[51] Another tomb with a similar iconography is the tomb of Kitora, located one kilometre south of Takamatsuzuka, which is being examined using the latest available technology. In 1983, a fibrescope was introduced into the tomb, and archeologists discovered a representation of the Great Warrior on the north wall. In 1998, a small video camera was used, and it was possible to see the Blue Dragon of the east and the White Tiger of the west, in addition to the constellations on the ceiling. In 2001 a digital camera was introduced, and the Red Bird of the southern wall was photographed. This is the first Red Bird found in a tomb in Japan.[52] The presence of the four directional animals in the tombs of Takamatsuzuka and Kitora further supports the connection between the Korean peninsula and the Japanese islands and, moreover, strongly suggests that there was a common visual vocabulary associated with funerary iconography in both geographical areas.

From the evidence presented, it can be argued that the four directional animals were part of the iconography of Tenjukoku. Yet the Red Bird on the fragment is surrounded by other motifs, such as a black-and-red cloud, turtle, and budlike motif, thus suggesting that it was not conceived as one of the directional animals. Red birds were not exclusively used in the iconography of the four directional animals, as they have been found painted on the corbeled ceilings of the Koguryo tombs, such as Tokhungri and the Tomb of the Dancers, dated to the fifth century, and in the Kangso Middle-sized Tomb and the Kangso Large Tomb, dated to the seventh century[53] (Figure 8.7). On

the ceilings, the red bird mingles with other fantastic animals, the sun and moon, constellations, clouds, and immortals or celestial beings. In this case, the red bird is identified as *hōō*, which together with the *kirin*, the dragon, and the turtle were believed to be omen figures that appeared in the sky.[54]

Figure 8.7. Paintings on the south side of the ceiling, Kangso Large Tomb, Taean city, South Pyongyang province. Seventh century AD. (Photo: The Chosonsinbo)

From the motifs discussed, we can argue that the embroidered curtains representing Tenjukoku had a procession of men and women, and perhaps other genre scenes, beneath the representation of the heavenly realm. As in the Koguryo tombs, this was represented with the symbolic images of the sun and the moon, auspicious clouds, and animals believed to inhabit that realm and manifest themselves as omens, such as the red bird. The motifs discussed clearly demonstrate that these are not associated with Buddhist iconography; instead, they correspond to a visual vocabulary used in funerary monuments in East Asia, one that was transmitted to the Japanese islands as seen in the tombs of Takamatsuzuka and Kitora and in the fragments on the embroidered curtains.

Context

In 1978, Ōhashi Katsuaki was the first to suggest that the Tenjukoku Shūchō was not used as a wall hanging to be an object of worship. He indicated since the Shūchō text states that the embroidered artifact was manufactured as "a pair of curtains," they must have functioned as such. He investigated the use of curtains in East Asia and specified that curtains were used around beds, which in ancient East Asia were four-sided raised structures with pillars at each of the corners. Moreover, he noted that curtains were placed in shrines containing Buddhist images. He concluded that the panels were placed around the favourite bed of Prince Shōtoku, and in that way Princess Tachibana had a chance to see the prince represented in Tenjukoku and cherish his memory.[55] As the Shūchō text implies that the curtains were made as a memorial, and, moreover, the images discussed previously are associated with funerary iconography, I think it is important to investigate whether curtains were used in the funerary context in ancient East Asia, especially in Japan.

Among the Chinese monuments, curtains are found in some Chinese tombs of the Han dynasty. In the previously mentioned Tomb No. 1 of Mawangdui, dated to 168 BC, silk curtains were found in a compartment of the grave pit.[56] According to Wu Hung's interpretation, the tomb was conceived as an underground home surrounding the coffin. In Mawangdui Tomb No. 1, there is a central compartment for the coffin and around it there are four additional compartments. The northern compartment, which imitates the inner chamber (Chinese: *qin*) in a real household, is the one that has the silk curtains. These hang on the four walls and a bamboo mat covers the floor. Vessels and a low table were displayed in the middle, and bedroom articles, furniture, and figurines of dancers, musicians, and personal attendants of Lady Dai are also seen. The figures are identified as personal attendants because they are different from those in the eastern and southern compartments of the burial pit, which are known to be household servants. The domestic utensils and food were piled up in these three sections as in the storage rooms, simulating a household and its material possessions.

There is another tomb, that of Liu Sheng (Tomb No. 1) at Mancheng in Hebei province, dated to 113 BC, that, like most of the Han tombs, also re-creates a house. Among the funerary paraphernalia, two sets of bronze supports and accessories for wooden structures were found in

the central chamber.[57] Since the bronze pieces are inscribed, they were reassembled, and two wooden frames for gable-roofed structures were reconstructed. Each structure measured approximately two and a half metres in length, one and a half metres in width, and two metres in height. Importantly, these wooden structures were originally covered with silk curtains, and they might have looked like the one represented in the mural painting of Tomb No. 2 at Dahuting in Mixian county in Henan province, dated to the Eastern Han dynasty (AD 25-220).[58] The whole scene, which is painted on the northern wall of the central chamber, measures over seven metres in length and seventy centimetres in height, and appears to be a formal gathering. At the left end of the scene, a man and a woman are seated behind a table, which is placed in front of a gable-roofed structure, represented as an isometric projection, and covered with curtains and a canopy.[59] Unfortunately, the mural is damaged in the centre of the structure, and so it is impossible to know what is represented inside. Since a person, standing upright, is represented at the side of the structure, we might conclude that the structure was tall enough for a person to stand in. There are musicians, dancers, and acrobatic performances, as well as servants standing on both sides of the host and hostess. About fifty guests seated in two rows participate in the gathering.

Representations of curtains are also found in the mural paintings of the Koguryo tombs. In these paintings, people are seated inside a structure with a canopy and curtains. In the tomb of Anak No. 3, there are two of this type of representation, one of a male figure and the other of a woman; and in the northern wall of Maesanri, one man and three women are also seated in a curtained structure, as are the the man and the woman in the Two Columns Tomb.[60] These scenes are identified as the portraits of the deceased and his wife (or wives). In later tombs, there are also structures with curtains, but in this case the structures are bigger and include various persons, who seem to greet each other, as seen in the Tomb of the Wrestlers and in the Tomb of the Dancers.

In the same way, textual material suggests that curtains were important elements in funerary practices. The Chinese text *Beishi* ("History of the North") states: "The corpse of the dead [is] in a place with curtains."[61] Interestingly, in the Buddhist cave temple of South Xiangtangshan (dated to the sixth century), there is a representation of the Nirvana of the Buddha, where the Buddha lies on a raised platform surrounded by his disciples. They are all inside a structure with

curtains (Figure 8.8). If that was common practice in China, then the curtained structure represented in the Dahuting mural, as well as the reconstructed structures found in the Mancheng tombs, might have been used for that purpose. It can therefore be argued that curtains were part of the paraphernalia for funerary rituals in East Asia. This is clearly stated in *Nihon shoki* in the entry of Kōgyoku 2 (646) on the regulations of the Taika Reform regarding tomb building and funerary rituals. The regulations include the number of coffins to be used according to rank, as well as the size of tombs and the number of workers to be employed for the building. It also indicates that "at the time of the interment white silk shall be used for the curtains."[62] White silk curtains are suggested for ministers and functionaries, according to their rank, while coarse fabric should be used for common people.

Figure 8.8. Nirvana of the Buddha. Relief at Cave 8, South Xiangtangshan cave temple. Sixth century AD. (From Cheng Mingda and Ding Mingyi, *Gongxian, Tianlongshan, Xiangtang shan, Anyang she ku diao ke* [Beijing: Wenwu Press, 1989])

The fact that the new regulations state that "white silk" should be used for the curtains might indicate that colourful curtains, perhaps with pictorial decoration, were used for the entombment ritual. Importantly, although these regulations were promulgated at the time

of the supposed Buddhist transformation of the Japanese islands, there is not a single reference to Buddhism, possibly because the newly imported religion was not yet involved in the affairs of death. Prince Shōtoku himself is buried in a funerary mound located in Shinaga in modern Osaka.[63] Thus, it can be argued that if he was buried according to the pre-Buddhist funerary practices, then the afterlife beliefs in the early seventh century were not yet associated with Buddhism. It is plausible that the embroidered curtains representing Tenjukoku were part of the paraphernalia used in the funerary rituals of Prince Shōtoku.[64]

Conclusion

Previous scholarship on the Shūchō text and the fragments was based on assumptions regarding the Buddhist beliefs of Prince Shōtoku. As one of the few extant texts that can be dated to the seventh century, the Shūchō text has been the focus of studies by historians and philologists. One of the most controversial issues in the text is the meaning of Tenjukoku, a term that has been interpreted as the Buddhist paradise where the prince was reborn, since in orthodox historiography Prince Shōtoku is seen as a devout Buddhist. These studies did not take the visual evidence into account, however. Instead, art-historical studies, due to the influence of interpretations by historians and philologists, focus on the motifs that might support the idea that the subject matter of the embroidered curtains representing Tenjukoku was a Buddhist Pure Land or in some cases try to find Prince Shōtoku among the extant images, in both cases disregarding the motifs that do not support these theories.

As mentioned previously, the few motifs discussed in this chapter show that China, the Korean peninsula, and the Japanese islands shared a common funerary iconography and, moreover, that funerary practices such as the construction of elaborate tombs and the use of curtains in the funerary rituals are also comparable. The analysis of the Shūchō text and some of the images on the fragments enables us to place them in their original seventh-century context, which was not Buddhist but rather associated with other funerary practices that might also reflect the afterlife beliefs of the time. The Shūchō text suggests that in the seventh century, people believed that Tenjukoku, or the Land of Heavenly Life, was a postmortem alternative. Since it is not Buddhist, some scholars have suggested that it is Daoist.[65] It is true

that some elements could be associated with Daoist ideas, but at this point, the evidence does not associate Tenjukoku with a specific belief system or religion. On the basis of the continental models and the extant images, it can be argued that Tenjukoku was not presided over by any particular Buddha, but was visualized as an ideal realm equivalent to the sky or heaven, where the sun and the moon shone at the same time and auspicious clouds accumulated, and which was inhabited by fantastic animals and immortal or celestial beings. In addition, it seems that the subject of the embroidered curtains was not limited to the representation of the heavenly realm but also included scenes, perhaps associated with funerary rituals, such as a procession, or, as seen in sections E and F, men, women, and Buddhist monks inside structures, or a monk striking a bell. The presence of the monks corroborates the importance of Buddhism in the seventh century, but cannot force the embroidered curtains to be a Buddhist icon.

Acknowledgements

Research for this study was supported by the Getty Postdoctoral Grant in 2000-2001. I would like to thank the temple of Chūgūji and the Nara National Museum for allowing me to study the Tenjukoku Shūchō Mandara. My gratitude also goes to Professors Donald McCallum and Sherry Fowler for their comments and suggestions on previous drafts; to Dr. Audrey Spiro for providing the photographs of the tomb at Jinjiacun; and to Mr. Yutaka Yoshii for contacting Mr. Hyeonmin Li from Chosonsinbo, who kindly allowed me to reproduce the photographs of the Koguryo tombs.

End Notes

1 *Tenjukoku* can be translated as the Land of Heavenly Life (or Longevity).
2 The author and exact date of *Jōgū Shōtoku hōō teisetsu* are not known. It is believed that it was compiled by the mid-Heian period using documents from the late seventh century. The earliest extant copy is the one at Chiō-in, Kyoto, dated to the mid-eleventh century. See Ogino Minahiko, "*Hōō Teisetsu* shosha nendai ni kansuru shin shiryō," in *Nihon kodai bunshogaku to chūsei bunka shi* (Tokyo: Yoshikawa Kōbunkan, 1995), 412-16; first published in *Gasetsu* 47 (1940). Also Ienaga Saburō, *Jōgū Shōtoku hōō teisetsu no kenkyū* (Tokyo: Sanseidō, 1972).

3 The dates of the inscriptions are controversial. Scholars agree that the Yakushi image and its inscription are later than 607.

4 The bibliography on Shōtoku Taishi in Japanese is extensive. For a short English reference, see William E. Deal, "Hagiography and History: The Image of Prince Shōtoku," in *Religions of Japan in Practice*, ed. George H. Tanabe Jr. (Princeton: Princeton University Press, 1999), 316-33.

5 For the cult of Prince Shōtoku, see Hayashi Mikiya, *Taishi shinkō: sono hassei to hatten* (Tokyo: Hyōronsha, 1972); and Tanaka Tsuguhito, *Shōtoku Taishi shinkō no seiritsu* (Tokyo: Yoshikawa Kōbunkan, 1983).

6 Ōyama Seiichi's book entitled *"Shōtoku Taishi" no tanjō* ("The Birth of 'Prince Shōtoku'") has caused a major reaction in the circle of historians. Ōyama's main argument is that Prince Shōtoku as a saintly figure portrayed in the sources did not exist, and that he is a "construction" of the compilers of *Nihon shoki*. He also argues that the documents associated with the prince, including the previously mentioned "Hōryūji documents" were made after 720, after the image of Prince Shōtoku as a saint was created. See Ōyama Seiichi, *"Shōtoku Taishi" no tanjō* (Tokyo: Yoshikawa Kōbunkan, 1999). Responses to Ōyama's book have been published in the journal *Higashi Ajia no kodai bunka* 102 and 104 (2000).

7 The most comprehensive study of the Tenjukoku Shūchō Mandara is that of Ōhashi Katsuaki, *Tenjukoku Shūchō no kenkyū* (Tokyo: Yoshikawa Kōbunkan, 1995), which is a compilation of a series of papers on the subject that he had previously published.

8 For instance, Okazaki includes the Tenjukoku Shūchō Mandara as one of the earliest representations of Pure Land paintings. See Joji Okazaki, *Pure Land Buddhist Painting*, trans. Elizabeth ten Grotenhuis (Tokyo and New York, and San Francisco: Kodansha International and Shibundo, 1977), 30-31.

9 Ishida Mosaku, "Nihon bukkyō to shūbutsu," in *Shūbutsu*, ed. Nara Kokuritsu Hakubutsukan (Tokyo: Kadokawa Shoten, 1964), 2-4.

10 See Joan Stanley-Baker, *Japanese Art* (London: Thames and Hudson, 1986), 35; Robert Paine and Alexander Soper, *The Art and Architecture of Japan* (1981; reprint, Harmondsworth, UK: Penguin Books, 1987), 35; Peter C. Swann, *A Concise History of Japanese Art* (Tokyo, New York, and San Francisco: Kodansha International, 1983), 56; and Seiichi Mizuno, *Asuka Buddhist Art: Horyuji*, trans. Richard L. Gage (New York and Tokyo: Weatherhill/Heibonsha, 1974), 52.

11 For the reconstruction of the Shūchō text, see Iida Mizuho, "Tenjukoku Shūchō mei o meggutte," *Kobijutsu* 11 (1965): 43-47. An English translation and discussion is available in J.H. Kamstra, *Encounter or Syncretism: The Initial Growth of Japanese Buddhism* (Leiden: E.J. Brill,

1967), 379-81. There are some serious mistakes in his translation, particularly with the dates. *Shōyoshō* and *Hōryūji tōin engi* in *Dai Nihon Bukkyō zensho,* vols. 72 and 85, respectively (Tokyo: Suzuki Gakujutsu Zaidan, 1972).

12 The names of the supervisor and designers are of continental origin. Koma and Hata are from the Korean peninsula, and there are discrepancies regarding Aya. Some argue that they are of Chinese origin, while others suggest Korean lineage. See Wontack Hong, *Paekche of Korea and the Origin of Yamato Japan* (Seoul: Kudara International, 1994), 136-45. Also William Carter, "Aya family" and "Hata family," in *Kodansha Encyclopedia of Japan* (Tokyo and New York: Kodansha, 1983), 1: 125 and 3: 111.

13 For the Kamakura period events, see Ōhashi, *Tenjukoku Shūchō,* 63-84. I have reconstructed and summarized this account on the basis of the information provided by *Chūgūji engi* ("Legendary history of Chūgūji"), *Shōtoku taishi denki* ("Biography of Prince Shōtoku"), *Taishi mandara kōshiki* ("Hymn to the prince's mandara"). The information provided by the sources has some small differences. The three documents are published in *Yamato koji taikan* (Tokyo: Iwanami Shoten, 1977), 1: 87-88.

14 The most recent study of the fragments is by Sawada Mutsuyo, "Tenjukoku Shūchō no genjō," *Museum* 495 (1992): 4-25. The motifs on the fragments also indicate that the replica was an exact copy of the original Tenjukoku Shūchō since motifs such as the turtle and the being emerging from a flower are not only of the same form but also the same size.

15 See Kosugi Sugimura, "Suiko mikado jidai no bijutsu kōgeihin Tenjukoku no mandara to iu mono," *Shigaku zasshi* 12, no. 1 (1901): 69-74.

16 One of the most frequently discussed points in the inscription concerns the appearance of the term *tennō* (emperor), and also the discrepancies of dates recorded in *Nihon shoki* and in the previously mentioned "Hōryūji documents."

17 For a summary of the interpretations, see Shigematsu Akihisa, *Nihon jōdokyō seiritsu katei no kenkyū* (Kyoto: Heirakuji Shoten, 1964); Iida Mizuho, "Tenjukoku Shūchō no mei o megutte," *Kobijutsu* (1965): 47-49; Ōno Tatsunosuke, *Jōdai no jōdokyō* (Tokyo: Yoshikawa Kōbunkan, 1972), 63-79; Ōhashi, *Tenjukoku Shūchō,* 125-40; and Ōno Tatsunosuke, *Shōtoku Taishi no kenkyū – sono Bukkyō to seiji shisō* (1970; reprint, Tokyo: Yoshikawa Kōbunkan, 1996).

18 Tsuji Zennosuke, "Wakayama ken oyobi Kyōto fu e kenkyū ryōko hō (shōzen)," *Shigaku zasshi* 12, no. 2 (1901): 100-1.

19 Matsumoto Bunzaburō, *Miroku jōdo ron* (Tokyo: Heigo Shuppansha, 1911), 12.

20 Shigematsu, *Nihon jōdokyō*, 66.
21 A study of the historical context reveals that Tenjukoku was identified as Muryōjukoku because of a facet of the cult of Prince Shōtoku. This will be discussed in detail in a forthcoming publication.
22 Tanaka, *Shōtoku Taishi*, 275-84.
23 Tokiwa Daijō, "Tenjukoku ni tsuite," in *Shina bukkyō no kenkyū*, vol. 1 (Tokyo: Shunjūsha, 1939). It might be important to point out that in Chinese thought, the west was associated with the immortal world of the Queen Mother. On the Queen Mother of the West, see Suzanne Cahill, *Transcendence and Divine Passion: The Queen Mother of the West in Medieval China* (Stanford: Stanford University Press, 1993), 11-65. Also Wu Hung, *The Wu Liang Shrine* (Stanford: Stanford University Press, 1989), 108-41.
24 *Nihon shoki* 2, vol. 68 of *Nihon koten bungaku taikei* (Tokyo: Iwanami Shoten, 1965), 234-35, hereafter *Nihon shoki*; and W.G. Aston, *Nihongi: Chronicles of Japan from the Earliest Times to AD 697* (Rutland, VT, and Tokyo: Charles E. Tuttle, 1988), 169-70.
25 In the standard iconography of Amida's Pure Land, there is a representation of *kuhon ōjō zu* (the nine grades of aspirants to Amida's Pure Land), where in a lotus pond nine lotus seats are offered to the aspirants at their death to be taken to the Pure Land, as explained in *The Meditation on the Buddha of Infinite Life Sutra*. For the earliest Chinese representation of the subject, see Katsuki Genichirō, "Shōnankai sekkutsu chūkutsu no sanbutsu zōzō to kuhon ōjōzu ukibori ni kansuru ikkosatsu," *Bijutsushi* 45, no. 1 (1996): 68-86.
26 For the Tamamushi shrine, see Uehara Kazu, *Tamamushi zushi no kenkyū* (Tokyo: Yoshikawa Kōbunkan, 1991).
27 Kawakami Kunihiko, "Sōron," and Machida Akira, "Taigai kōryū to kōeki," chs. 1 and 4, respectively, in *Higashi ajia no naka no kofun bunka*, vol. 13 of *Kofun jidai no kenkyū*, ed. Ishino Hironobu et al. (Tokyo: Yūzankaku, 1993). Also Gina L. Barnes, *China, Korea and Japan: The Rise of Civilization in East Asia* (London: Thames and Hudson, 1993).
28 For instance, both the motif of a being emerging from a lotus flower and the budlike motif are found in the Buddhist cave temples of Gongxian and Longmen of the Northern Wei period (AD 386-534). For Gongxian, see Yoshimura Rei, "Kyōken sekkutsu ni okeru keshō no zuzō ni tsuite," *Waseda daigaku daigakuin bungaku kenkyūka kiyō* 21 (1976): 115-26; for Longmen, see photographs in Ryūmon Bunbutsu Hokansho and Pekin Daigaku Kōkokei, eds., *Ryūmon sekkutsu*, vol. 1 (Tokyo: Heibonsha, 1987-88), pls. 55 and 77. The same motifs are also represented in the South Chinese brick tomb of Dengxian. See Anette Juliano, *Teng-hsien: An*

Important Six Dynasties Tomb (*Artibus Asiae Supplementum* 37, 1980).

29 For the sake of clarity, the top right section will be referred to as section A; top left, section B; middle right, section C; middle left, section D; bottom right, section E; and bottom left, section F.

30 For the Takamatsuzuka tomb, see Takamatsuzuka Kofun Sōgō Gakujutsu Chōsakai, *Takamatsuzuka kofun hekiga chōsa hōkokusho* (Tokyo: Benridō, 1974). Also Edward Kidder, "The Newly Discovered Takamatsuzuka Tomb," *Monumenta Nipponica* 27 (1972): 245-51, and *Takamatsuzuka kofun tokushū*, in *Bukkyō geijutsu* 87 (1972).

31 Ōhashi, *Tenjukoku Shūchō*, 114.

32 Ishida Mosaku, "Kokuhō Tenjukoku Mandara Shuchō," in *Chūgūji ōkagami* (Tokyo: Ōtsuka Kogeisha, 1940), 9.

33 For excellent photographs of the Koguryo tombs, see *Kokuri kofun hekiga* (Tokyo: Chōsen Gahōsha, 1985).

34 In *Nihon shoki*, 186, and Aston, *Nihongi*, 134. For a definition of *hirami*, see *Kojien*, 3rd ed., s.v. "Hiraobi."

35 *Nihon shoki*, 451, and Aston, *Nihongi*, 354-55.

36 The *uneme* were women from powerful clans presented as tribute, who served as ladies-in-waiting. For the political and religious function of *uneme*, see Isogai Masayoshi, "Uneme to miko," in *Kodai ōchō no josei*, vol. 3 of *Nihon josei no rekishi*, ed. Tsubota Itsuo (Tokyo: Akatsuki kyōiku tosho, 1982).

37 For the Mawangdui banner, see A.G. Bulling, "The Guide of the Souls Picture in the Western Han Tomb in Ma-Wang-tui near Ch'ang-sha," *Oriental Art* 20, no. 2 (1974): 158-73. Also Wu Hung, "Art in Ritual Context: Rethinking Mawangdui," *Early China* 17 (1992): 111-44.

38 For Western Han tombs with the representation of the heavenly realm, see Sun Zuoyun, "An Analysis of the Western Han Murals in the Luoyang Tomb of Bo Qianqiu," trans. Suzanne Cahill, *Chinese Studies in Archaeology* 1, no. 2 (1979): 44-78; Jonathan Chaves, "A Painted Tomb at Loyang," *Artibus Asiae* 30, no. 1 (1968): 5-27. For Han tomb decoration, see Robert L. Thorpe, "The Mortuary Art and Architecture of Early Imperial China," PhD dissertation, University of Kansas, 1980, 228-39.

39 Luo Feng, "Lacquer Painting on a Northern Wei Coffin," *Orientations* 21, no. 7 (1990): 20.

40 For South Chinese tombs, see Nanjing Museum, "Two Tombs of the Southern Dynasties at Huqiao and Jianshan in Danyang County, Jiangsu Province," trans. Barry Till and Paula Swart, *Chinese Studies in Archaeology* 1, no. 3 (1979-80): 74-124; and Nanjing Museum, "A Large Tomb of the Southern Dynasties Period with Decorated Bricks at Huqiao, Danyang, Jiangsu," in *Chinese Archaeological Abstracts 4, Post*

Han, ed. Albert E. Dien, Jeffrey K. Riegel, and Nancy T. Price (Los Angeles: Institute of Archaeology, UCLA, 1985), 1486-93.

41 For a description of the iconographical program and meaning of the tomb, see Audrey Spiro, *Contemplating the Ancients: Aesthetics and Social Issues in Early Chinese Portraiture* (Berkeley, Los Angeles, and Oxford: University of California Press, 1990), 138-52.

42 See n. 38.

43 See *Kokuri hekiga,* pls. 64, 138 and 147-48, and 176, respectively.

44 Wu Hung, *The Wu Liang Shrine,* 108-41.

45 See Ōhashi, *Tenjukoku Shūchō,* 92-95 and 109-10.

46 A similar motif is found in the Chinese tomb of Dengxian in the southwest of Henan, on the border between the northern and southern territories. On the basis of stylistic analysis, Juliano determined that the pictorial tiles can be dated to the late fifth or early sixth century: Juliano, *Teng-hsien.*

47 See Sun Zuoyun, "Analysis of the Western Han Murals."

48 Examples of Han mirrors with the four directional animals are reproduced in Stephen Little et al., eds., *Taoism and the Arts of China* (Chicago: Art Institute of Chicago, 2000), 140-41.

49 Ibid., 129.

50 Reproduced in *Yakushiji,* vol. 6 of *Nara rokudaiji taikan* (Tokyo: Iwanami Shoten, 1970), pls. 59-63 and 104-8.

51 See reproduction in *Kokuri kofun:* for Kangso Middle-sized Tomb, pls. 177-78; for Kangso Large Tomb, pls. 189-90.

52 Asuka Kokyō Kenshōkai, *Kitora kofun to hekiga* (Nara: Asukamura Kyōiku Iinkai, 2001).

53 For Tokhungri and the tombs at Kangso, see *Kokuri hekiga,* pls. 62-67, 177-78, and 189-90, respectively. For the Tomb of the Dancers, see Mizuno Yū, *Kokuri hekiga kofun to kikajin* (Tokyo: Chūō Kōron Bijutsu Shuppansha, 1973), 108-14.

54 See Matsumoto Eiichi, "Tonkō hon zuiō zukan," *Bijutsu kenkyū* 184 (1956): 241-58. Matsumoto presents a scroll found in the Dunhuang caves, probably a Tang copy of a Six Dynasties scroll, that is a compilation of omen figures.

55 Ōhashi, *Tenjukoku Shūchō,* 95-101, originally published in "Tenjukoku Shūchō no genkei," *Bukkyō geijutsu* 117 (1978): 49-79.

56 For Mawangdui, Hunan Provincial Museum and Institute of Archaeology, *The Han Tombs at Mawangtui, Changsha* (in Chinese with an English abstract) (Beijing: Wenwu Press, 1973). Also Wu Hung, "Art in a Ritual Context," 111-44.

57 For the reconstruction of the wooden structures, see Institute of

Archaeology, CASS (Institute of Archaeology of the Chinese Academy of Social Sciences), and the Hopei CPAM (Hopei Provincial Bureau of Cultural Properties and Antiquities Management), *Excavation of the Han Tombs at Man-ch'eng* (in Chinese with an English abstract) (Beijing: Cultural Relics Publishing House, 1980), 160-78. Also Wu Hung, *Monumentality in Early Chinese Art and Architecture* (Stanford: Stanford University Press, 1995), 132-33.

58 For Dahuting mural paintings, see Henan Provincial Institute of Archaeology, *Han Dynasty Tombs at Dahuting Village in Mixiang County* (in Chinese with an English abstract) (Beijing: Cultural Relics Publishing House, 1993), pls. 38-44.

59 Ōhashi argues that the structure in the painting is a big bed: *Tenjukoku Shūchō*, 98.

60 For reproductions, see Kim Won-yong, Han Byong-sam, and Chin Hong-sup, *Painting*, vol. 2 of *The Arts of Korea* (Seoul: Dong Hwa Publishing, 1979): Anak, pl. 2; Maesanri, pl. 11; and Two Columns, pl. 17.

61 As cited by Saitō Tadashi, *Higashi Ajia sō, bosei no kenkyū* (Tokyo: Daiichi Shobō, 1987), 477-78. The *Beishi (Pei shih)* was written in the seventh century and is the history of North China covering the years 386-617. I would like to thank Dr. Audrey Spiro for the information on this document.

62 In *Nihon shoki*, 293. Aston translates *katabira kakishiro* or *ichō* (curtains) as hangings: *Nihongi*, 218.

63 For the tomb of Prince Shōtoku, see Umehara Sueji, "Shōtoku Taishi Shinaga no gobyō," in *Shōtoku Taishi ronsan* (Tokyo: Heian Kōkokai, 1921), 344-70.

64 The use of textiles in funerary rituals in early seventh-century Japan is an interesting topic; however, extant textiles dated to that time are scarce and the only textual reference to fabrics in funerary practices is the one mentioned previously.

65 Japanese scholars argue that Tenjukoku is associated with Han immortality beliefs *(shinsen shisō)*, particularly because of the turtle motif. See Mochizuki Shinjō, "Tenjukoku Shūchō no saikō," in *Nihon jōdai bunka no kenkyū*, ed. Yoshida Kakuin (Nara: Hossōshū Kangakuin Dōsōkai, 1941), 400-1. In a recent publication, Edward Kidder argues that the motifs are Daoist. See Edward J. Kidder, *The Lucky Seventh: Early Horyu-ji and Its Time* (Tokyo: International Christian University and Hachiro Yuasa Memorial Museum, 1999), 261-62. His argument does not present any convincing evidence, however. In addition, the field of Daoist art in China is still in its early stages. See Wu Hung, "Mapping Early Taoist Art: The Visual Culture of Wudoumi Dao," in Little et al., *Taoism and the Arts of China*, 77-93.

Bibliography

Aston, W.G., trans. *Nihongi: Chronicles of Japan from the Earliest Times to AD 697*. Rutland, VT, and Tokyo: Charles E. Tuttle, 1988.

Asuka Kokyō Kenshōkai 飛鳥古京顕彰会. *Kitora kofun to hekiga*『キトラ古墳と壁画』. Nara: Asukamura Kyōiku Iinkai 明日香村教育委員会, 2001.

Barnes, Gina. *China, Korea and Japan: The Rise of Civilization in East Asia*. London: Thames and Hudson, 1993.

Bulling, A.G. "The Guide of the Souls Picture in the Western Han Tomb in Ma-Wang-tui near Ch'ang Sha." *Oriental Art* 20, no. 2 (1974): 158-73.

Carter, William. "Aya family." P. 125 in *Kodansha Encyclopedia of Japan*, vol. 1. Tokyo and New York: Kodansha, 1983.

–. "Hata family." P. 111 in *Kodansha Encyclopedia of Japan*, vol. 3. Tokyo and New York: Kodansha, 1983.

Chaves, Jonathan. "A Han Painted Tomb at Loyang." *Artibus Asiae* 30, no. 1 (1968): 5-27.

Deal, William E. "Hagiography and History: The Image of Prince Shotoku." Pp. 316-33 in *Religions of Japan in Practice*, edited by George Tanabe Jr. Princeton: Princeton University Press, 1999.

Hayashi Mikiya 林幹彌. *Taishi shinkō: sono hassei to hatten*『太子信仰 その発生と発展』. Tokyo: Hyōronsha 評論社, 1972.

Henan Provincial Institute of Archaeology. *Han Dynasty Tombs at Dahuting Village in Mixiang County* (in Chinese with an English abstract). Beijing: Cultural Relics Publishing House, 1993.

Hong, Wontack. *Paekche of Korea and the Origin of Yamato Japan*. Seoul: Kudara International, 1994.

Hunan Provincial Museum and Institute of Archaeology. *The Han Tombs at Mawangtui, Changsha* (in Chinese with an English abstract). Beijing: Wenwu Press, 1973.

Ienaga Saburō 家永三郎. *Jōgū Shōtoku Hōō teisetsu no kenkyū*『上宮聖徳法王帝説の研究』. Tokyo: Sanseidō 三省堂, 1972.

Iida Mizuho 飯田瑞穂. "Tenjukoku Shūchō mei o megutte"「天寿国繍帳銘をめぐって」. *Kobijutsu*『古美術』(1965): 39-49.

–. "Tenjukoku Shūchō mei no fukugen ni tsuite"「天寿国繍帳銘の復原について」. *Chūō daigaku bungakubu kiyō shigakuka*『中央大学文学部紀要史学科』11 (1966): 23-43.

Institute of Archaeology, CASS, and the Hopei CPAM. *Excavation of the Han Tombs at Man-ch'eng* (in Chinese with an English abstract). Beijing: Cultural Relics Publishing House, 1980.

Ishida Mosaku 石田茂作. "Kokuhō Tenjukoku Mandara Shūchō"
「国宝天寿国曼荼羅繡帳」. Pp. 6-10 in *Chūgūji ōkagami*『中宮寺大鏡 』. Tokyo:
Ōtsuka Kōgeisha 大塚巧芸社, 1940.

Ishino Hironobu 石野博信 et al. *Higashi ajia no naka no kofun bunka*
『東アジアの中の古墳 文化』. Vol. 13 of *Kofun jidai no kenkyū*『古墳時代の研究』.
Tokyo: Yūzankaku 雄山閣, 1993.

Juliano, Anette. *Teng-hsien: An Important Six Dynasties Tomb. Artibus Asiae*
Supplementum 37, 1980.

Kamstra, J.H. *Encounter or Syncretism: The Initial Growth of Japanese Buddhism.*
Leiden: E.J. Brill, 1967.

Katsuki Genichirō 勝木言一郎. "Shōnankai sekkutsu chūkutsu no sanbutsu
zōzō to kuhon ōjōzu ukibori ni kansuru ikkosatsu"
「小南海石窟中窟の三仏造像と九品往生図浮彫に　関する一考察 」. *Bijutsushi*
『美術史』45, no. 1 (1996): 68-86.

Kidder, Edward J. "The Newly Discovered Takamatsuzuka Tomb."
Monumenta Nipponica 27 (1972): 245-51.

–. *The Lucky Seventh: Early Horyu-ji and Its Time.* Tokyo: International
Christian University and Hachiro Yuasa Memorial Museum, 1999.

Kim, Won-Yong. "Wall Paintings of Koguryo Tombs." In *Art and Archaeology*
of Ancient Korea. Seoul: Taekwang Publishing, 1986.

Kokuri kofun hekiga『高句麗古墳壁画』. Tokyo: Chōsen Gahōsha 朝鮮画報社,
1985.

Kosugi Sugimura 小杉榲邨. "Suiko mikado jidai no bijutsu kōgeihin
Tenjukoku no mandara to iu mono"
「推古帝時代の美術工芸品天寿国の曼荼羅といふもの 」. *Shigaku zasshi*
『史学雑誌 』12, no. 1 (1901): 69-74.

Little, Stephen, et al., eds. *Taoism and the Arts of China.* Chicago: Art Institute
of Chicago, 2000.

Loewe, Michael. *Ways to Paradise: The Chinese Quest for Immortality.* London:
George Allen and Unwin, 1979.

Luo Feng. "Lacquer Painting on a Northern Wei Coffin." *Orientations* 21, no.
7 (1990): 18-29.

Maeda Eun 前田慧雲. "Tosotsu ōjō shisō hassei jidai kō"
「兜率往生思想発生時代考」. *Shigaku zasshi*『史学雑誌』13, no. 1 (1902): 21-26.

Matsumoto Bunzaburō 松本文三郎. *Miroku jōdo ron*『 彌 勒 浄土論』. Tokyo:
Heigo Shuppansha 丙午出版社, 1911.

Matsumoto Eiichi 松本栄一. "Tonkō hon zuiō zukan"「燉煌本瑞応図巻」.
Bijutsu kenkyū『美術研究』184 (1956): 241-58.

Mizuno Yū 水野祐. *Kokuri hekiga kofun to kikajin*『高句麗壁画古墳と帰化人』.
Tokyo: Chūō Kōron Bijutsu Shuppansha 中央公論美術出版社, 1973.

Mochizuki Shinjō 望月信成. "Tenjukoku Shūchō no saikō"
「天寿国繍帳の再考. In *Nihon jōdai bunka no kenkyū*『日本上代文化の研究』,
edited by Yoshida Kakuin 吉田覚胤. Nara: Hossōshū Kangakuin Dōsōkai
法相宗勧学院同窓会, 1941.

Nanjing Museum. "Two Tombs of the Southern Dynasties at Huqiao and
Jianshan in Danyang County, Jiansu Province," translated by Barry Till and
Paula Swart. *Chinese Studies in Archaeology* 1, no. 3 (1979-80): 74-124.
Originally published in *Wenwu* 2 (1980): 1-17.

–. "A Large Tomb of the Southern Dynasties Period with Decorated Bricks at
Huqiao, Danyang, Jiangsu." Pp. 1484-93 in *Chinese Archaeological Abstracts 4,
Post Han,* edited by Albert E. Dien, Jeffrey K. Riegel, and Nancy T. Price.
Los Angeles: Institute of Archaeology, UCLA, 1985.

Nara National Museum. *Shūbutsu*『繍仏』. Tokyo: Kadokawa Shoten
角川書店, 1964.

Nihon shoki『日本書紀』. Vol. 68 of *Nihon koten bungaku taikei*
『日本古典文学大系』. Tokyo: Iwanami Shoten 岩波書店, 1965.

Ogino Minahiko 荻野三七彦. "*Hōō Teisetsu* shosha nendai ni kansuru shin
shiryō"「法王帝説書写年代に関する史料」. Pp. 412-16 in *Nihon kodai
bunshogaku to chūsei bunka shi*『日本古代文書学と中世文化史』. Tokyo:
Yoshikawa Kōbunkan 吉川弘文館, 1995. First published in *Gasetsu*『画説』
47 (1940).

Ōhashi Katsuaki 大橋一章. *Tenjukoku Shūchō no kenkyū*『天寿国繍帳の研究』.
Tokyo: Yoshikawa Kōbunkan 吉川弘文館, 1995.

Okazaki, Joji. *Pure Land Buddhist Painting,* translated by Elizabeth ten
Grotenhuis. Tokyo and New York: Kodansha International, 1977.

Ōno Tatsunosuke. *Jōdai no jōdokyō*『上代の浄土教』. Tokyo: Yoshikawa
Kōbunkan 吉川弘文館, 1972.

–. *Shōtoku Taishi no kenkyū – sono Bukkyō to seiji shisō*『聖徳太子の研究 −
その仏教と政治思想』. 1970. Reprint. Tokyo: Yoshikawa Kōbunkan
吉川弘文館, 1996.

Ōyama Seiichi 大山誠一. "*Shōtoku Taishi*" no tanjō『〈聖徳太子〉の誕生』.
Tokyo: Yoshikawa Kōbunkan 吉川弘文館, 1999.

Saitō Tadashi 斉藤忠. *Higashi Ajia sō, bosei no kenkyū*
『東アジア葬、墓制の研究』. Tokyo: Daiichi Shobō 第一書房, 1987.

Sawada Mutsuyo 沢田むつ代. "Tenjukoku Shūchō no genjō"
「天寿国繍帳の現状」. *Museum* 495 (1992): 4-25.

Shigematsu Akihisa 重松明久. *Nihon jōdokyō seiritsu katei no kenkyū*
『日本浄土教成立過程の研究』. Kyoto: Heirakuji Shoten 平楽寺書店, 1964.

Spiro, Audrey. *Contemplating the Ancients: Aesthetic and Social Issues in Early
Chinese Portraiture.* Berkeley, Los Angeles, and Oxford: University of
California Press, 1990.

Sun Zuoyun. "An Analysis of the Western Han Murals in the Luoyang Tomb of Bo Qianqiu," translated by Suzanne Cahill. *Chinese Studies in Archaeology* 1, no. 2 (1979): 44-78. Originally published in *Wenwu* 6 (1977): 17-22.

Takamatsuzuka Kofun Sōgō Gakujutsu Chōsakai 高松塚古墳総合学術調査会. *Takamatsuzuka kofun hekiga chōsa hōkokusho*『高松塚古墳壁画調査報告書』. Tokyo: Benridō 便利堂, 1974.

Takamatsuzuka hekiga kofun tokushū『高松塚壁画古墳特集』. *Bukkyō geijutsu*『仏教芸術』87 (1972).

Tanaka Tsuguhito 田中嗣人. *Shōtoku Taishi shinkō no seiritsu*『聖徳太子信仰の成立』. Tokyo: Yoshikawa Kōbunkan 吉川弘文館, 1983.

Thorpe, Robert L. "The Mortuary Art and Architecture of Early Imperial China." PhD dissertation, University of Kansas, 1980.

Tokiwa Daijō 常盤大定. "Tenjukoku ni tsuite"「天寿国について」. In *Shina no bukkyō kenkyū*『支那の仏教研究』. Tokyo: Shunjūsha 春秋社, 1939.

Tsubota Itsuo 坪田五雄. *Kodai ōchō no josei*『古代王朝の女性』. Vol. 3 of *Nihon josei no rekishi*『日本女性の歴史』. Tokyo: Akatsuki kyōiku tosho 暁教育図書, 1982.

Tsuji Zennosuke 辻善之助. "Wakayama ken oyobi Kyōto fu e kenkyū ryokō hō (shōzen)" 和歌山県及京都府へ研究旅行報（承前）」. *Shigaku zasshi*『史学雑誌』12, no. 2 (1901): 98-116.

Umehara Sueji 梅原末治. "Shōtoku Taishi Shinaga no gobyō"「聖徳太子磯長の御廟」. Pp. 344-70 in *Shōtoku Taishi ronsan*『聖徳太子論纂』. Tokyo: Heian Kōkokai 平安考古会, 1921.

Umehara, Suyeji [sic]. "The Newly Discovered Tombs with Wall Paintings of the Kao-kou-li Dynasty." *Archives of the Chinese Society of America* 6 (1952): 5-17.

Wu Hung. *The Wu Liang Shrine.* Stanford: Stanford University Press, 1989.

–. "Art in a Ritual Context: Rethinking Mawangdui." *Early China* 17 (1992): 111-44.

–. *Monumentality in Early Chinese Art and Architecture.* Stanford: Stanford University Press, 1995.

–. "Mapping Early Taoist Art: The Visual Culture of Wudoumi Dao." In *Taoism and the Arts of China,* edited by Stephen Little et al. Chicago: Art Institute of Chicago, 2000.

Yamato koji taikan『大和古寺大観』. Vol. 1. Tokyo: Iwanami Shoten 岩波書店, 1977.

Yoshimura Rei 吉村怜. "Kyōken sekkutsu ni okeru keshō no zuzō ni tsuite"「鞏県石窟における化生の図像について」. *Waseda daigaku daigakuin bungaku kenkyūka kiyō*『早稲田大学大学院文学研究科紀要』21 (1976): 115-26.

Glossary

Amida 阿弥陀
Anahobe no Hashihito 孔部間人
Asuka 飛鳥
Aya no Nukakori 漢奴加巳利
Beishi (Japanese: Hokushi) 北史
Byakko 白虎
Chūgūji 中宮寺
Eon 恵隠
Genbu 玄武
hirami 褶
hōō 鳳凰
Hōryūji tōin engi 法隆寺東院縁起
Jōgū Shōtoku hōō teisetsu
　　　　上宮聖德法王帝説
kashiwade 膳
Kegongyō 華厳経
kirin 麒麟
Koma no Kasei 高麗加溢
Kunlun (Japanese: Konron) 崑崙
Kurahitobe no Hata no Kuma
　　　　椋部秦久麻
Miroku 弥勒
Muryōjukyō 無量寿経
Nihon shoki 日本書紀
ōjō no yōsu 往生之状
Saihō 西方天寿国
Seiryō 清竜
Shaka 釈迦

shijin 四神
Shinnyo 信如
shinsen shisō 神仙思想
Shōtoku Taishi 聖德太子
Shōtoku Taishi denki 聖德太子伝記
Shōsōin 正倉院
Shōyoshō 聖誉抄
Shūchō nichō 繍帳二張
Shujaku 朱雀
Suiko 推古
Tachibana no Oiratsume
　　　　橘大女郎
Taishi Mandara kōshiki
　　　　太子曼荼羅講式
Tamamushi 玉虫
tasuki 襷
tenju 天寿
Tenjukoku shin mandara uragaki
　　　　天寿国新曼陀羅裏書
Tenjukoku Shūchō Mandara
　　　　天寿国繍帳曼荼羅
Tosotsuten 兜率天
Toyotomimi 豊聡耳
Yakushi 薬師
Yakushiji 薬師寺
Yamato Aya no Maken 東漢末賢
Yōmei 用明

9

Ōbaku Zen Portrait Painting and Its Sino-Japanese Heritage

ELIZABETH HORTON SHARF

Ōbaku is the name of the last and smallest of three major lineages of Chan (Japanese: Zen) Buddhism transmitted from China to Japan, the other two being the better-known Rinzai and Sōtō schools.[1] Unlike the Rinzai and Sōtō lineages, which were imported in medieval times, the Ōbaku line was transmitted hundreds of years later, following the emigration to Japan in 1654 of the south Chinese prelate Yinyuan Longqi (1592-1673; better known by the Japanese transliteration of his name, Ingen). Yinyuan claimed to occupy the thirty-second generation in a strict line of transmission going back to the ninth-century monk Linji (known in Japanese as Rinzai, the venerable founder of Rinzai Zen). In Japan, however, Yinyuan achieved fame as the leader of a monastic community easily distinguished from Japan's contemporary Rinzai lineages by virtue of its striking Chineseness.[2] While this Chineseness was most evident at the time in the general ambience of Ōbaku monasteries, where Chinese monks and their Japanese disciples re-created the ritual sights and sounds of Ming dynasty monastic life, today it is perhaps best preserved in the numerous portraits of Ōbaku abbots made in the first fifty years of the community in Japan – images that, at first glance, look strikingly foreign.

Political and economic turbulence attending the demise of the Ming dynasty in the mid- to late seventeenth century fostered the emigration

of monks, men of letters, artisans, and professionals from southern China to Nagasaki. The considerable knowledge and diverse skills of these accomplished immigrants generated renewed nationwide interest in Chinese traditions. The Tokugawa shogunate cultivated orthodox Confucian philosophy as a state ideology, and thus encouraged the naturalization in Japan of these emissaries of Chinese learning and elite culture. Yinyuan and his immediate disciples, the most prominent newcomers, in due course won ample government patronage, and the monasteries they founded formed the nucleus of a new school of Zen, later known as Ōbaku. Yinyuan and his entourage first served the needs of Chinese merchants and their families living in Nagasaki, but with the construction of a head temple in the environs of Kyoto, the lineage spread rapidly throughout Japan and acquired national stature. Numerous portrait paintings of prominent Ōbaku-lineage monks were produced for a burgeoning monastic community.

The Ōbaku monks were men of learning whose careers began, and in some cases flourished, in China in the last decades of the Ming dynasty. They were well-versed in the Chinese classics, and in the literary arts of calligraphy, poetry, seal carving, and painting, in addition to Buddhist scriptures and monastic regulations. They enjoyed immediate prestige in Japan, and were treated as exemplary representatives of late Ming society. They received considerable material and moral support from the Japanese military government and the imperial family, and were permitted to establish new monasteries, or convert existing monasteries, in Nagasaki and in many other areas of the country. According to a survey conducted in the year 1745, the monks had founded over a thousand monasteries and temples.[3] Chief among these was the head temple, Manpukuji, founded in 1661.

This influx of Chan monks to Japan greatly stimulated established Japanese Buddhist schools, and led to the growth of the arts and sciences. Ōbaku monks made significant contributions to Buddhist thought, institutional organization, and religious practice; they introduced advances in medicine and engineering, stimulated monastery building, and revitalized the art of Buddhist sculpture. Ōbaku monks and craftsmen succeeded in duplicating the Buddhist cloisters of late imperial China on Japanese soil. They constructed and renovated monastic halls, then filled them with ritual objects they either imported or re-created. Names of buildings and short Buddhist maxims brushed in ink by monks were carved on wooden panels and profusely displayed on temple exteriors.

Numerous paintings in contemporary late Ming styles were created for the newly built or newly converted Ōbaku monasteries. Portraits of contemporary priests and venerable patriarchs in the Ōbaku lineage were in particular demand. Of the portraits extant from the mid-seventeenth to the early eighteenth century, numbering over 250, most depict the leading Ōbaku abbots and their spiritual ancestors. Less venerable members of the overseas Chinese community were also depicted: a merchant, a political figure, an abbot's mother, a monk esteemed as a scholar and physician, and others. Artists also produced images of Buddhist deities – Buddhas, bodhisattvas, arhats, and eccentric figures – traditionally associated with Zen in Japan. These Ming-style portraits and paintings were displayed during rites and ceremonies of the calendar year, and took their place among numerous other categories of monastic cultural property: ritual paraphernalia, regalia and furnishings, musical instruments, library collections, memorials in stone, sculptures, works of calligraphy, gardens, halls, and *stupas*. Many were formal compositions executed in bright colours on silk or paper; others were brushed quickly in ink. Yet whether formal or informal, they were so unlike paintings previously produced in Japan that they clearly stood out as exotic and greatly stimulated later painters of Buddhist subjects in Japan.[4]

The pervasive influence of the Chinese monks in matters of religious doctrine, institutional practice, and early modern Buddhist culture did not, however, lead to the immediate acceptance of the Chinese monastic community in Japan. The Chinese monks arrived at a time when monks of the Rinzai and Sōtō schools also enjoyed patronage at the highest levels of Japanese society. The Chinese monks were associated with the prominent Rinzai lineage on the mainland, but had no close affiliation with either the Rinzai or Sōtō lines in Japan, nor were they entirely welcomed by the Japanese clergy. Some Japanese Rinzai monks were ecumenical in their attitude and embraced the émigré monks as Dharma brothers; indeed, their support was critical to the initial integration of the Chinese monastic community as a legitimate Zen lineage in Japan. However, their efforts to gain recognition for the émigré monks provoked an indignant and jealous response from other Rinzai monks, who were contemptuous of the claim by the Chinese to represent the authentic Rinzai lineage. The charge that the Chinese school was syncretic (and therefore impure), having succumbed to Pure Land Buddhist influences, was typical of the polemical attacks.[5] Early prejudice against Ming Chinese religious

practices extended to monastic culture and the arts. Vestiges of this prejudice survive into modern times. The investigation of such vestiges reveals a history of ambivalence towards the considerable accomplishments of the Ōbaku monastic community.[6]

The primary manifestation of this ambivalence is the relative neglect of the Ōbaku tradition by scholars of Zen in both Japan and the West. Western scholars of Chan and Zen tend to follow the lead of their Japanese mentors, and the research of Japanese scholars is in turn shaped in many ways by their sectarian affiliations. As the majority of Japanese Zen scholars emerge from either the Sōtō or Rinzai fold, the neglect and/or disparagement of Ōbaku is not surprising. Indeed, the comparatively fewer writings on Ōbaku come from historians within the Ōbaku school, whose own defensive attitudes and sectarian agendas have somewhat compromised their work. Only recently have scholars in Japan and the West begun to redress this situation and present us with a more balanced rendering of the history of the school and its contribution to Japanese Buddhism. It will no doubt take many years, however, to overcome the inertia of long-held attitudes.

This marked indifference and open antipathy has engendered the erroneous impression that the monks in Yinyuan's lineage made no significant contribution in the area of religious doctrine. Modern art historians interested in Ōbaku culture inadvertently reiterate this notion when making the claim that the real contribution of the émigré monks lay in the realm of the arts and sciences. Such scholars generally come to the study of Ōbaku art from an interest in the growth of the Chinese arts of poetry, painting, and calligraphy in Edo Japan. Literati culture is an Edo-period phenomenon with innumerable links to the Ōbaku monks and monasteries that flourished in Japan, particularly in the eighteenth century. The impact of the émigré monks on Japanese literati traditions has received more attention than any other aspect of Ōbaku culture.[7]

Unlike the literary arts of poetry, calligraphy, and painting, portrait painting is fundamentally a professional art and therefore attracts far less attention from art historians interested in elite facets of Ōbaku culture. Indeed, not unlike the school of Zen of which it forms a part, the school of portrait painting associated with the émigré Chinese monks has been marginalized by historians of art, its historical impact obscured or ignored.

In the art-historical scholarship on Ōbaku portraits, there is very little of significance predating 1983, with the exception of a single

definitive monograph by Nishimura Tei.[8] In fact, until the 1980s, interest in Ōbaku portraits was limited to art historians doing research on regional artistic traditions in southern Japan. Most of these scholars accorded Ōbaku portraiture mention, along with Ōbaku-school painting generally, as one category of Nagasaki painting, taking, in my view, a somewhat unreflective approach to the material.[9] Contributions of style or pictorial convention were ascribed to the influence of largely Flemish-style European pictures introduced by Jesuit missionaries. Kita Genki (fl. ca. 1664-1709) was the only artist accorded serious attention, and scholars focused on but a handful of his many portraits. In short, Ōbaku portraits were regarded as the product of a minor school of "Westernized" painting in Japan.

Then, in the 1980s, historians working on the periphery of the academy began to move Ōbaku art and culture into the mainstream. Four deserve special mention.

Ōtsuki Mikio's biographical dictionary of Ōbaku culture, edited with Katō Shōshun and Hayashi Yukimitsu, presents the lives of not only Ōbaku monks of all ranks but also literati painters, professional artists, lay patrons, government officials, other clerics, and figures from Ōbaku's prehistory in China.[10] The dictionary is the most comprehensive single resource on the Ōbaku monastic community.

In 1983, Nishigori Ryōsuke began to publish a series of groundbreaking articles on Ōbaku portraiture in major academic journals.[11] His interest, sparked by the general neglect of this material, led him to introduce relatively unknown portraitists associated with the school and to re-evaluate the paintings and sort out the identities of the more familiar portraitists. He has also published accounts of seventeenth-century artists who supplied the Ōbaku community with orthodox Buddhist paintings. His research has established a foundation for the modern study of Ōbaku portrait painting, and I am singularly indebted to it here.

Nishigami Minoru, following on the heels of Nishigori, and with the help of Ōtsuki and others, has integrated his own considerable expertise in later Chinese painting into his study of Ōbaku artists. He was the chief curator involved in the major 1993 Kyoto National Museum fall exhibition devoted to Ōbaku art and culture.[12] His work in particular has furthered our knowledge of the prehistory of Ōbaku-style painting in China.

Helen Baroni, an American scholar of Japanese Buddhism, has written a comprehensive English-language overview of Ōbaku Zen. Her

dissertation (1993) on Ōbaku Zen and the monk Tetsugen Dōkō (1630-82) and her book (2000) on Ōbaku Zen are rare instances of an outsider's measured appraisal of the evolution and stature of the school in Japan.[13]

Despite such recent contributions, however, modern scholars allocate Ōbaku portrait paintings no more than a minor role in the history of East Asian painting, excluding them from the mainstream because of their exotic style. A preoccupation with questions of stylistic heritage continues, as does a considerable ambivalence about placing Ōbaku portraits in the tradition of Chan/Zen painting, where, in my opinion, they squarely belong. That is, although scholars have no choice but to refer to Ōbaku portrait paintings by the Japanese term *chinzō*, a medieval term construed in modern times to signify formal portraits of Chan/Zen abbots, they nonetheless remain reluctant to accept them as full-fledged members of that venerable tradition. In their preoccupation with questions of style, they ignore or gloss over questions of meaning and function. In this chapter, I attempt first to portray and then to redress this situation.

A Portrait of Yinyuan Longqi at Eighty

Kita Genki's best-known painting hangs against the plain plank walls of the Bunkaden, Manpukuji's treasure hall.[14] It is a life-size, half-length image depicting the Chinese priest Yinyuan Longqi in Buddhist ceremonial robes against a blank ground (Figures 9.1 and 9.2). The portrait subject, a distinguished and somewhat elderly gentleman, has long, well-groomed fingernails and neatly combed hair. Under a dark burgundy silk gown, he wears two robes: below, a brilliant white; above, a deep blue. Over the burgundy gown, a surplice of solid red silk lined in yellow is fastened by a jade ring and a shiny gilt metal clasp. In one hand, Yinyuan grasps a long wooden staff, gnarled and knotty; in the other, he holds the lacquered handle of an ornamental whisk such that a cascade of white animal hair trails over a sleeve.

The broad-shouldered figure squarely faces the viewer, gazing steadily ahead and surveying impassively all before him. Distinctive features – a high forehead yet relatively small eyes, a large nose and prominent cheekbones, a shapely mouth, and a strong jaw – define a handsome face no longer young. Dark hairs are found among the snowy white; large freckles and faint pockmarks appear here and there on the jowls and nose. After prolonged viewing, one finds that the

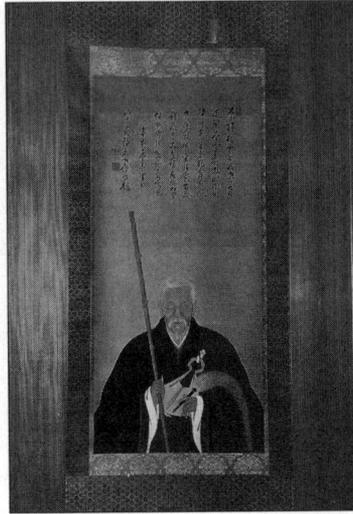

Figure 9.1. Kita Genki (active ca. 1664-1709), *Portrait of Yinyuan Longqi at Eighty.* Self-eulogy dated 1671 (first month, fifteenth day). Artist's seal: "Genki." Hanging scroll, ink and colours on paper, 138.4 x 60.2 cm. Shōindō, Manpukuji, Kyoto Prefecture. (Photo: E. Sharf)

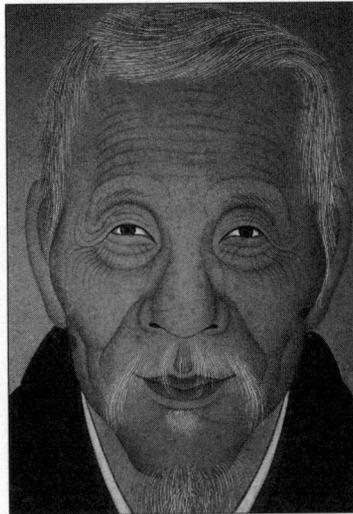

Figure 9.2. Detail of Figure 9.1. (Photo: E. Sharf)

sheen of the skin asserts itself: wrinkles queue up on the forehead and encircle the eyes without marring the skin's outer fleshy layer. Soft hills and shaded valleys of smooth facial terrain – the eye socket, the cheek, the nostrils, the temples – dominate. The lips are slightly pursed, the eyes fully open – whites edged in red, pupils circled in black, the upper lid thick with lashes. The eyes, deep within their sockets, seem vaguely tense.

The portrait subject has inscribed a eulogy of his own composition above the image. In this we learn, among other things, that the portrait is to be preserved in the Shōindō (Pine Hall), Yinyuan's hermitage on the grounds of Manpukuji:

> With staff in hand I reached the land of the sacred Mulberry,[15]
> There gaining a head of hair white as frost and snow.
> Yet with eyes as perfectly clear and pure as the Dharma realm,
> My revealed half-figure all the more glowing,
> I expound the meaning of Sākyamuni's holding up the flower
> And awaken my descendants to the place of the great dream.
> May this hang forever in the Pine Hall together with plum and bamboo,
> And the teachings endure on earth as long as heaven reigns.
> – *Self-eulogy by the old monk Yinyuan, age eighty, on the fifteenth day of* *the new year, 1671*[16]

Kita Genki's Legacy

In the fourth month of 1673, slightly over two years after inscribing the portrait, Yinyuan Longqi fell ill and died, aged eighty-two.[17]

In 1671, the year he painted the portrait described above, Kita Genki was in the seventh year of a long career spanning almost five decades, yet this portrait would become in modern times his most published work. He survived Yinyuan by many years – so many, in fact, that his career and Yinyuan's overlap only slightly. Among Ōbaku portraitists, Genki belongs to the second, or even third, generation, yet, although little is known of Genki's life or his origins, the substantial body of work that he left behind has coloured the imagination of scholars who study the portraits of eminent monks in Yinyuan's line.

Genki's work has dominated the field with good reason: he was the most prolific and long-lived of all the artists thought to have produced portraits of the Chinese émigré monks and their disciples. Of all the Ōbaku portraitists, only Genki has acquired a reputation of any note.

His reputation was such that Nishimura Tei, in an early study, described an artist who preceded Genki as "before Genki already displaying splendidly the style and technique of Genki-style portraits."[18] This almost exclusive focus on the artist, and, specifically, on his characteristic style, has skewed perceptions of Ōbaku portraiture in its entirety, and has led most modern scholars since the early twentieth century to identify the "Ōbaku style" with Genki's own.

It is not difficult to list the dominant features of Genki's style: the uncompromising *en face* pose of the portrait subjects, brightly coloured monastic robes, faces and hands hardened by a pronounced modelling method, summarily executed high seats (Figures 9.3 and 9.4). The harmonious application of shading in strong linear patterns on smooth flesh surfaces combines with the flat, opaque colours of the robes and a dominant, stylized line to produce a clean, sanitary effect. In Genki's best-known paintings, the subtle portrayal of facial expression encourages the viewer to project his or her own consciousness into the portrait subject (Figures 9.1, 9.2, and 9.15 to 9.17); in many other

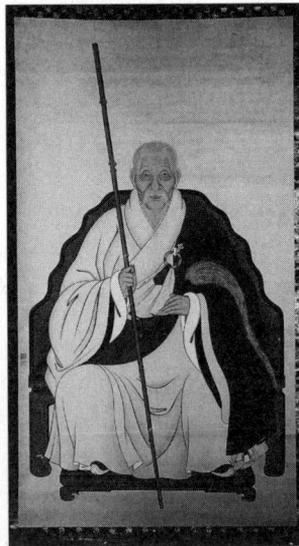

Figure 9.3. Kita Genki (active ca. 1664-1709), *Portrait of Yinyuan Longqi*. Artist's seals: "Kita shi" and "Genki." Executed after eighth month, 1674. Hanging scroll, ink and colours on paper, 144.5 x 77.4 cm. Shōindō, Manpukuji, Kyoto Prefecture. (Photo: E. Sharf)

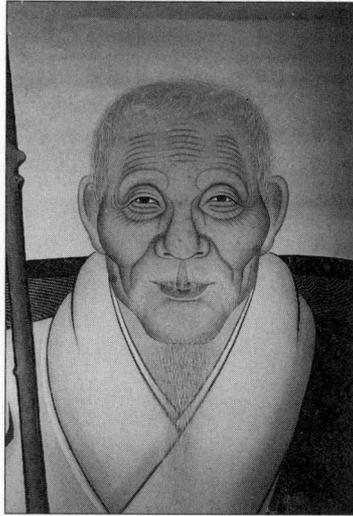

Figure 9.4. Detail of Figure 9.3. (Photo: E. Sharf)

paintings in the "Genki style," however, this sense of human relationship is noticeably absent (Figures 9.3, 9.4, and 9.19).

Genki's forceful style has had the effect of marginalizing Ōbaku portraiture within the venerable *chinzō* tradition in East Asia. Medieval portraitists usually employ the three-quarter view – a decorous compositional format that complements the muted colour schemes, subdued calligraphic brushwork, and naturalizing features, such as the avoidance of strict symmetry, that have made these portraits so accessible to viewers.[19] Ōbaku portraits fare poorly in comparison with the more widely published portraits in this group, most of which feature Rinzai patriarchs, thus echoing the relationship of Ōbaku to Rinzai as a whole. Rarely expressed in the literature, but widely held, is the view that Ōbaku portraiture is difficult to reconcile with Japanese aesthetic sensibilities, that it is in bad taste and lacks elegance,[20] a normative judgment not inconsistent with the claim of influence from the West.

On reviewing the Japanese literature on Ōbaku portraits, it is apparent that Genki's distinctive style led modern scholars to discover – above all else – "Western influence" in Ōbaku portraiture. Genki's oeuvre helped relegate Ōbaku portraiture to a minor role in the history

of Western-style painting in Japan, and took its place in the modern art-historical struggle to identify the routes of Europe's influence on seventeenth-century East Asian painting.

Japanese Studies of Ōbaku Portrait Painting[21]

In 1934, in the only definitive monograph on Ōbaku portrait painting, Nishimura Tei argued that Ōbaku portraits were infused with elements of Western painting. He called on the reader's mental repertoire of "old Western-style" paintings of the late sixteenth and early seventeenth century to account for the exotic appearance of Kita Genki's paintings (Figure 9.5). Advancing the theory that techniques of a school of painting called Nanban ("Southern Barbarian" or European)[22] somehow survived the persecution of Christianity in Nagasaki to influence artists associated with the Chinese émigré community, Nishimura postulated Genki's use of non-traditional pigments that produced a sheen on the painting's surface. Noting the use of walnut oil as a binder by the Christian artist Yamada Uemonsaku,[23] he speculated that Genki might also have used walnut oil, and therefore should be placed in the tradition of Nanban painting that survived underground in Nagasaki following the persecution of Christianity. He concluded by suggesting that Genki be regarded as belonging to a distant branch of Renaissance painting![24]

Although unable to document the connection, Nishimura attributed the exotic appearance of Genki's portraits to early training in Nanban techniques.[25] In an article published eleven years later, however, he abandoned this theory.[26] Nonetheless, this did not prevent other scholars from adopting it, wholly or in part, and the notion of Western influence became deeply ingrained in studies of Ōbaku portraiture.[27]

Most subsequent scholars of Ōbaku portraiture have recognized the significance of the fact that the émigré monks arrived in Japan at a time when the importation of Western artifacts was restricted and the practice of Christianity banned. Ōbaku's florescence in Japan is in fact conveniently sandwiched between two eras of Western-style art – the era of Nanban-school painting of the "Christian century" (ca. 1542-1639) and the era of Dutch-school painting that followed renewed European contact (from ca. 1720). However, while some scholars continued to maintain that Ōbaku portraiture was a "transformation" of Nanban art,[28] others soon proposed that Ōbaku portraits (and other images) were transmitted from China to Japan already incorporating

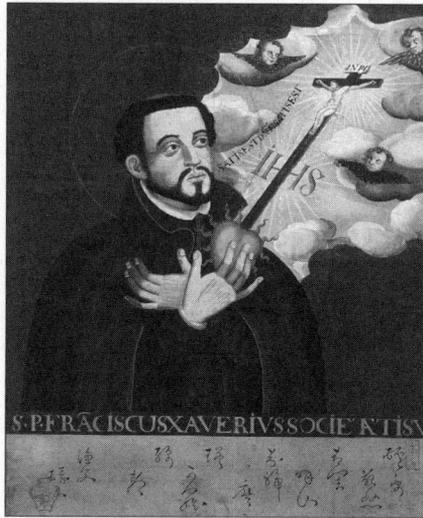

Figure 9.5. Unknown artist (Japanese), *Portrait of St. Francis Xavier* (Jesuit missionary, 1506-52). First half of the seventeenth century. Framed panel, ink and colours on paper, 61.0 x 48.7 cm. Kobe City Museum. (Photo: Kobe City Museum)

features of Western painting methods, and were therefore entirely independent of the residue of Nanban painting in seventeenth-century Japan.[29]

Taniguchi Tetsuo proposed that Ōbaku portraiture be regarded as a Chinese-Western blend: Western techniques for facial depiction and modelling in light and shadow were added to what he described perfunctorily as an indigenous Chinese tendency towards realism in painting.[30] Such techniques were believed to have been derived from Western painting models brought to China with Matteo Ricci and the Jesuit missions, and subsequently transmitted to Japan. He argued that Ōbaku portraiture revitalized a stagnant tradition of Western-style painting in Nagasaki, that it was "a ray of light in the dark ages of Western-style painting in Japan."[31]

By the 1940s, scholars had introduced the single most important figure in the prehistory of Ōbaku portrait paintings, the seventeenth-century portraitist Zeng Jing (1564-1647; Figures 9.6 and 9.7). The Zeng Jing style was believed to have been transmitted to Nagasaki from the southern regions of China, and included the painters Zhang

Figure 9.6. Zeng Jing (Chinese, 1564-1647), *Portrait of Pan Qintai* (b. ca. 1560). Artist's inscription dated 1621 (winter). Hanging scroll, ink and colour on paper, 116.5 x 58.5 cm. The University of Michigan Museum of Art, Ann Arbor, Michigan. (Photo: E. Sharf)

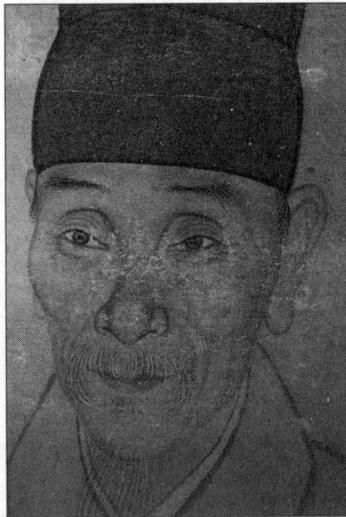

Figure 9.7. Detail of Figure 9.6. (Photo: E. Sharf)

Qi,[32] Fan Jue,[33] Yang Daozhen,[34] and Chen Xian.[35] Zeng Jing, whose work was believed to incorporate European painting techniques, was identified as Kita Genki's forebear.[36] I shall return to Zeng Jing's contribution below.

In the 1980s, Nishigori Ryōsuke began to point out the inadequacy of earlier accounts of Western influence on Ōbaku portraiture, disputing the observation that Genki and others used a kind of oil paint following Nanban traditions in Japan.[37] He argued that although many scholars have noted the presence of pigments with high colour saturation (*saido no takai enogu*) and of a slight surface sheen (*kōtaku*), no one has produced scientific confirmation that oil pigments were indeed used. Although a surface lustre may be observed in Ōbaku portraits, Nishigori explains that this could result from the admixture of animal glue. Regardless of whether oil was used as a binder instead of animal glue (*nikawa*), or whether an "oily" sheen (*abura jimi*) was incidentally produced, the pigments in early Western-style painting can be identified for the most part as traditional Japanese pigments used in non-traditional ways to effect a resemblance to imported European paintings.[38]

Nishigori disagrees that the modelling method of early Western-style painters such as Nobukata (active late sixteenth to early seventeenth century) resembles that found in Ōbaku portraits, stating that Nobukata's shading method is far more Westernized in style than that of Genki and his predecessors, and of a completely different quality. For example, although sometimes bluntly applied, shading reflects the presence of a fixed light source; the role of descriptive line is also largely disregarded (Figure 9.5). Moreover, colours of greater intensity (*meido*) are used, and the way highlights are created is different.[39] Furthermore, after Nobukata, and up to the late seventeenth and early eighteenth centuries, figure paintings bearing a direct relationship to the early Western-style (Nanban) paintings were produced (only a small number, largely depictions of Bodhidharma, are extant; Figure 9.8). Although painted at the same time as Ōbaku portraits, these do not employ Taniguchi's blended Chinese-Western style.[40]

Citing Sakamoto Mitsuru, Nishigori adds that most early Western-style painters in Japan were trained in Western pictorial methods from the beginning of their careers, and were not originally trained in traditional Japanese techniques. In contrast, Kita Genki and other Ōbaku portraitists employ a brushline that only artists trained in

Figure 9.8. Unknown artist (Japanese), *Bodhidharma*. Eulogy by Kangen Dōkō dated 1702 (spring). Hanging scroll, ink and colours on paper, 77.2 x 36.7 cm. Kobe City Museum. Detail. (Photo: E. Sharf)

traditional East Asian methods would use. Had Genki been trained in early Western-style painting, this would surely be evident, yet there is absolutely no evidence of such training.

Nishigori dismisses the Nanban theory for lack of evidence, pointing out that, although the names of numerous early Western-style painters are recorded, their paintings, and therefore, their styles, are lost; of extant "Japanese Western-style" works, there are almost none that postdate the mid-seventeenth century – only a handful of later Western-style images of Bodhidharma survive (Figure 9.8).

In contrast, points out Nishigori, many early Ōbaku paintings have been preserved in Japan, including portraits of patriarchs and paintings of arhats and other figure subjects. These works were painted either in China, by artists such as Chen Xian, or in Japan by Chinese émigré artists such as the Zeng Jing-school painter Yang Daozhen; these works have thus far received little attention. If one looks at the close relationship between the portraits painted by Kita Dōku (Chōbei; Genki's predecessor and supposed father) and those by Yang Daozhen, there is no need to posit influence from Nanban painting on Ōbaku portraiture in Japan.[41]

Nishigori believes that in the late sixteenth and early seventeenth centuries (after Matteo Ricci introduced European art to China), there appeared in China painters who incorporated Western modelling techniques as "an effective means for the expression of volume and the fine depiction of facial features."[42] These Chinese painters, according to Nishigori, adapted techniques of Western painting to traditional methods, thus (following Taniguchi) giving birth to the Chinese-Western blend detectable in portraits by Genki and his predecessors. In particular, Nishigori describes the new method as one in which the traditional linear "bone-method" (bokkotsu) is combined with the careful application of traditional shading methods (kumadori) influenced by new Western techniques.[43] Nishigori believed that Chinese portraitists were singularly responsive to the stimulus of Western-style techniques. He regarded Western influence as particularly feasible because the émigré artists, and/or the imported art, largely originated in the area of Fujian in south China, a hub for foreign trade. Through the introduction of these paintings to Japan (and of painters trained in this technique), a tradition of Japanese Ōbaku portraiture was inaugurated. Nishigori proposed to take advantage of the wealth of extant early material in order to survey the techniques found there, something not hitherto attempted. He criticized previous scholars for straying from the analysis of concrete techniques and for using the term "Western style" as though it had a fixed meaning when it was in fact used in a variety of conflicting and imprecise ways.

While arguing convincingly that the issue of Western influence is best left to studies of Genki's predecessors, Kita Dōku (Chōbei) and Yang Daozhen, as demonstrated by his own research on these artists, Nishigori nonetheless undertook a long overdue reassessment of the stature and contribution of Kita Genki.[44] In the course of sorting out the identity and career of the artist, however, Nishigori was also compelled to address the claim of Western influence in Genki's corpus.

Native reactions to the vivid illusionism both in European paintings available for view in China and in Zeng Jing's paintings have been recorded from the seventeenth century, and the remarkable similarity of such contemporary responses has fuelled the case for European influence there. Nishigori argues that the same is true for Kita Genki, whose reputation as a prolific painter of strangely vivid portraits is recorded in nineteenth- and early-twentieth-century accounts, as seen in the following excerpts:

The depiction of the face evokes the feeling of confronting a living person.[45]

Many portraits of various patriarchs within the [Ōbaku] lineage are haunted by the master's hand.[46]

The Buddhist layman Kita Genki attained a mysterious quality in the depiction of figures ... his portraits of various Ōbaku monks are the most numerous.[47]

Nishigori also quotes a longer and purportedly more precise comment on Genki's painting style found in Watanabe Shūjitsu's *Nagasaki gajin den*[48] and concludes that Watanabe is equating Genki's painting method *(densen)* with an abundant use of an abstract shading method resembling that found in Western-style painting *(yōfūgateki na kumadori o tayō shita)*. In reading the original excerpt, however, I do not find a specific reference to Western-style painting; instead, I find the fresh observation of something strikingly new and animated in Genki's work: "Kita Genki, also known as Chōbei, is skilled in portraiture and there is a new flavor/idea in his painting technique *[densen]* ... occasionally in those passages where he is copying from life there is a profoundly mysterious [capturing of the subject] without a single discrepancy [from life]."[49]

Finally, Ro Senri's *Kiyō senmin den*, dating from either 1731 or 1819,[50] is quoted by Nishigori as saying that "Genki skillfully used an eclectic blend of Chinese and Western painting methods *[kaban no gahō]* in painting portraits."[51] This line provides the earliest textual source for Nishigori's own assessment of Genki's style, and is also the first recorded mention of Genki. The source was written sometime during the period known as the "second phase of Western painting" in Japan, which began with the 1720 relaxation of the ban on foreign books. Since the European pictorial imagery imported by the Dutch at this time was fairly accessible, however, one might argue that, to an eye acquainted with such imagery, perhaps Genki's work did indeed appear to have a "Western" element.

As one last consideration, Nishigori cites an entry in the *Kiyō senmin den* on the Kanei-era (1624-43) painter Ikushima Saburōsa.[52] Nishigori believes that this account may indicate that Nanban painting was taught in Satsuma. This may be relevant to a study of Kita Genki because Genki's father, known to be in Satsuma at the time, may have encountered Nanban painting there. Nishigori, however, does not

know whether or not any connection to Nanban painting can be drawn from this or from the fact that Genki's father took his son to Nagasaki, where Nanban painting is well attested. Nishigori, has, in any case, rejected Nishimura's theory of influence from Nanban painting traditions on other grounds.

Despite the sophistication of Nishigori's account, and his sensitivity to the artistic accomplishments of Ōbaku portraitists – a sensitivity to which all subsequent assessments of Ōbaku painting are fundamentally indebted – I shall argue that the rubric of Western influence is laden with ideological preconceptions that ultimately hinder rather than further our appreciation of the contribution of the Ōbaku portraitists.

The Zeng Jing Link

The struggle to delineate European influence in the realm of portraiture can be seen clearly in the case of Zeng Jing, a well-connected professional artist in late Ming China who was often commissioned to paint portraits of the learned men among his friends and acquaintances.[53] A native of Fujian, his career brought him to Zhejiang and Nanjing, where he died in 1647. It is not surprising that a new look in portraiture is attributed to Zeng Jing's adaptation of pictorial techniques of Western art. Lending weight to this conclusion are the simple facts of his biography: that he worked in an area of China close to the European trade, that Flemish-style paintings had already been produced by Chinese artists, and that some of his colleagues had direct contact with the missionaries, including Matteo Ricci. Zeng Jing even wore eyeglasses! In addition, portraitists are thought singularly responsive to the stimulus of European-style techniques.

Hsiang Ta, building on the work of earlier Chinese and Japanese scholars, believed portraiture to be the first painting tradition to exhibit the influence of the imported European pictures, and Zeng Jing the first portraitist to feature European painting techniques in his work.[54] Hsiang argued that Matteo Ricci arrived in Nanjing while Zeng Jing was residing there, and therefore the artist could have encountered Christian pictures in a Nanjing Jesuit church, as did several of his acquaintances. According to Hsiang, modern scholars detected evidence of European influence in Zeng's method of layering washes "often tens of times," a modelling technique believed to be unprecedented in China. Such scholars convincingly portrayed Zeng

Jing as an innovator who combined Chinese and European elements with such success that he engendered a new school of portraiture. His approach remained, however, a Chinese one, with "engrafted Western methods." Zeng Jing's style dominated subsequent portrait making in China, even when, with the arrival of increasing numbers of European art objects, there emerged in the early Qing dynasty painters "who used purely Western methods to do portraits."[55]

In a brief treatment of the artist, James Cahill focused on Zeng Jing's exposure to two tendencies in the early seventeenth century: "an increased concern with the individual, and the introduction to China from European sources of the artistic means for capturing individuality, more than before, in pictures." To Cahill, Zeng Jing's portraits were "strikingly more realistic than any that had preceded them in China." As evidence for Zeng Jing's Westernized manner, he cited remarkably similar contemporary accounts of reactions to Zeng Jing's portraits and to European pictures in which human figures are described as so strikingly real that they appear to be reflections in a mirror.[56]

Nishigori Ryōsuke agreed with other scholars that Zeng Jing probably had the opportunity to view and study the imported works in Nanjing. Following earlier studies by Yonezawa Yoshiho, he argued that Zeng Jing could adopt a Western modelling method precisely because he was a professional painter.[57]

Nishigori explained that the mainstream painters of the day were literati who, as a result of emphasizing "spirit-resonance" (Japanese: kiin, Chinese: qiyun), tended to despise, or think little of, "formal likeness" (Japanese: keiji, Chinese: xingi). He argued that this did not mean that European techniques that involve the pursuit of formal likeness, such as modelling and perspective methods, were entirely ignored by literati society. The traditional goal of East Asian portraiture, as expressed in the terms "transmitting the spirit and rendering the light" (Japanese: denshin shashō), or "rendering the truth" (Japanese: shashin), had been to transmit the life and living spirit (Japanese: seimei seishin) of the portrait subject. This aim was achieved only by the objective depiction of the countenance of a portrait subject. Thus, portrait painters were constrained, at the very least, to wholeheartedly embrace realism in the depiction of the face. Furthermore, most portrait painters were of a class lower than that of the scholar-officials and thus did not share the same bias against formal likeness.

Nishigori concluded, however, that because of Zeng Jing's

associations with men of letters his works had a strong grounding in the structural method of traditional Chinese brushwork. The artist adapted techniques of European shading but stopped short of abandoning the traditional emphasis on line. The resulting style was praised by Zeng's contemporaries, and, because of this acceptance, continued to be widely practised by his followers.

Lu Suh-fen challenged the common assumption of European influence in the work of Zeng Jing. Lu balanced Zeng Jing's sojourn in Nanking, his association with acquaintances of Ricci, the evidence of Zeng's eyeglasses, and the like against the evidence that Zeng Jing's circle included Ming men of letters, and, late in life, Buddhist monks. European elements are shown to comprise only a minor part of his known, albeit skeletal, biography.

In an analysis of Zeng Jing's style based on thirteen extant paintings, Lu argued that the 1610s saw the production of portraits entirely traditional in style. In the 1620s, according to Lu, Zeng Jing perfected a shading technique that exhibited a better understanding of anatomy, as seen in eight paintings that display his technical progress (Figures 9.6 and 9.7). Lu compared actual techniques in Zeng's portraits with those in contemporary European paintings (because none from Ricci's day survive, she used surviving examples from Japan) and concluded that Zeng Jing developed a shading technique "not far from that of conventional Chinese art." His achievement, therefore, was the "perfect combination of traditional and innovative techniques" such that the portraits remained acceptable to his patrons.[58]

Finally, Marshall Wu highlighted two points: (1) Zeng Jing's own training as a portraitist had a basis in local, long-established traditions of portraiture in Fujian, traditions encompassing portraits of ancestors and portraits of Chan Buddhist abbots; and (2) the artist at a young age was already well connected in the Jiangnan area, China's cultural heartland, perhaps because of his early training as a portraitist in Fujian. Wu identified two local traditions of portrait painting: (1) the linear tradition of Zeng Jing's youthful home, Fujian; and (2) the colour wash tradition of the Jiangnan region. He found in Zeng Jing's skillful blending of the two traditions the key to the artist's contribution as a portraitist. His careful analysis of Zeng Jing's corpus led him to believe that significant influence of European painting techniques on Zeng Jing was unlikely.[59]

Despite these differences of opinion, it remains a possibility – however likely or unlikely – that Zeng Jing had access to European

pictures and modified his work accordingly. Yet, as I shall argue, the assertion of European influence in Chinese and Japanese painting has deeper and far more tenacious roots.

The Imposition of Orthodoxy

A scholarly tradition upholding the arts of poetry and calligraphy as models for the accomplishment of painting evolved in China beginning at least as early as the Northern Song dynasty and reaching a highwater mark in the Yuan dynasty. This amounted to an exaltation of the tools and techniques of the art of calligraphy and the rejection of traditional materials and methods of professional painting. Ink, paper, and light colour washes were favoured over silk and bright colours. Spontaneity, directness, and an "antique flavour" (Chinese: *guqi*) attained through a deliberate awkwardness of brushwork were nurtured, and conscious borrowing from the works of certain ancient masters authorized. Practitioners of this tradition represented the mainstream of the governing Chinese elite; they emphasized antiquity, favoured the awkward over the elegant, and painted works with a certain aloof purity. By the seventeenth century, the distinction between scholar-amateur and professional painter was canonized in the theoretical writings of the artist-critic Dong Qichang (1555-1636). In spite of the numerous modern critical appraisals of Dong's theoretical position, the orthodox views he represents have greatly influenced the approach of modern scholars to the study of Chinese painting.

The influence of the orthodox tradition can be seen in the degree to which we are still reinscribing certain normative valuations that are, at base, reflections of a class interest – the long-standing prejudice against professional painters among the elite scholar-official class.[60] To the literati, professional paintings are not so much works of art as they are decorative furnishings.[61] This prejudice has resulted in a reluctance to give critical recognition to the techniques, materials, and processes mastered by the professionals. The fact that the aesthetic nature of literati painting seems to coincide with certain aesthetic predilections of the twentieth-century West reinforces our tendency to be seduced by it.

The lofty central position accorded the literary arts of poetry, calligraphy, and painting by some modern scholars has left them with the problem of where to place the non-literary, professional traditions of Chinese painting. They find themselves in the uncomfortable position of ignoring or rejecting whole traditions ordinarily subsumed

by the rubric "Chinese painting," or having to resort to such phrases as "pure Chinese painting" or "the central painting tradition" to describe the literati tradition. When departures from linear draftsmanship are occasionally brought to critical attention, they more often than not are attributed to foreign influence, a move that reinforces the orthodox exaltation of line.

One manifestation of this is the critical classification of Chinese painting into traditions identified with individuals characterized as men of genius and success. Artistic developments are seldom illuminated with reference to an anonymous collectivity,[62] and it is rare that a painter is lauded for his shading technique.[63] Typical of this classificatory scheme is the nearly exclusive association since the Song and Yuan periods of fine-line linear traditions with the Six Dynasties painter Gu Kaizhi (ca. 344-406), and calligraphic linear traditions with the figural art of the painter Wu Daozi (active ca. early to mid-eighth century),[64] an association originating in a broad distinction of two major linear brushwork styles recorded as early as the Tang in Zhang Yanyuan's *Lidai minghua ji* (preface dated 847).[65]

Although the exaltation of line in traditional and modern accounts is supported by the evidence of many Chinese paintings, the visual record also reveals a continued strong emphasis on colour and shading. In pre-Han and Han traditions, painting is grounded in the play of line on the flat surface of the picture plane, and sometimes little else is employed to create pictorial illusion. In Han tomb mural painting, however, colour is often applied as local colour with a lively folkish disregard for outline. Even where the basic structure of a pictorial composition relies on line, the abundant use of colour and even what a few describe as "indigenous" shading techniques are featured.

Although in much of the extant pictorial art of the Six Dynasties period line remains pre-eminent, some works make conspicuous use of colour or colour shading; these works include well-known attributions to the celebrated artist Gu Kaizhi and related archeological material in media such as lacquered wood. Although colour is, on the whole, applied with restraint as washes of flat, local colour or as occasional colour shading, its contribution to the achievement evident in individual compositions is not insignificant.

Judging from extant paintings, Tang and Song artists (and later artists working in Tang and Song traditions) employed a liberal use of both colour and shading to capture the illusion of the vivid presence of real or imagined forms – in many instances, they far exceeded artists

of earlier periods. The depth or three-dimensionality attained was fundamentally dependent on linear draftsmanship, but the application of shading enhanced the corporeality of the human figure with much the same effect as a deepening of skin tone. The figure painter was aware of shading and colour as a means of refining the image – of engendering warmth, life, and the reality of a living, breathing individual. Without it, the image might appear flat, cold, or dull.

It is true that even where modelling techniques are routinely employed, as in Chinese Buddhist painting, shading (like dark colouring) is often reserved for subsidiary figures and figures of foreign origin (Figure 9.9) – flanking attendants or arhats, for example – and is regarded as inappropriate for idealized, central figures, as though reflecting an aesthetic aversion to shading. Indeed, the literati aesthetic views lack of restraint in the use of shading as somewhat vulgar, and typically associates it with foreign influence – often from India or Europe, but also from Central and West Asia.

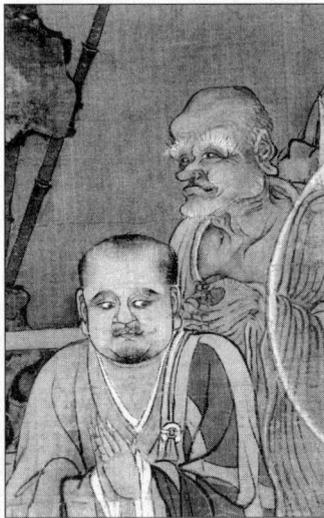

Figure 9.9. Zhou Jichang and Lin Tinggui (both active ca. 1178), *Arhat Manifesting Himself as the Bodhisattva Eleven-headed Guanyin.* One of a set of 100 paintings depicting the Five Hundred Arhats. Dedicatory inscription by Yishao (abbot of the monastery Huianyuan, Zhejiang, ca. 1175) dated 1178. Hanging scroll mounted on panel, ink and colours on silk, 111.5 x 53.1 cm. Museum of Fine Arts, Boston. Detail: head of flanking arhat. (Photo: Denman Waldo Ross Collection, Museum of Fine Arts, Boston)

Most modern scholars, in fact, follow traditional Chinese aesthetics in their association of the application of shading from at least the sixth century AD onward with Buddhist painting. They generally have in mind ancient abstract shading techniques transmitted from India to China and evident in extant paintings at Buddhist cave sites such as Ajanta in India and Dunhuang in China. The extant evidence for shading techniques in pre-Buddhist Chinese paintings is generally presented as episodic. Well after Buddhism has been assimilated in Tang and Song China, the liberal use of shading is, more often than not, ignored entirely.

There are exceptions, however, to this dominant trend. Wen Fong's instructive paper focusing on the evolution of a tradition of "receding-and-protruding" painting (Chinese: aotuhua) at the cave site of Dunhuang is one important example.[66] His article represents a modern reiteration of the orthodox view that yet offers significant place to at least one technique of shading in the history of Chinese painting.

We may raise the issue of whether the emphasis on shading in Ōbaku portraiture is indeed European or in part Indic – as mediated through many centuries of the Chinese appropriation of an Indian technique. Two approaches to this issue have, in fact, appeared in the scholarly literature on Ōbaku painting. The first is found in a study of the painter Chen Xian (active ca. mid-seventeenth century) by Aschwin Lippe.[67]

Chen Xian was a maker of Buddhist images closely associated with the Ōbaku school in Japan. His paintings have been implicated in the search for routes of European influence on Ōbaku portraiture and figure painting. He is, like Kita Genki, a well-known artist directly associated with the émigré community whose figure paintings also exhibit a heavy, abbreviated shading technique typically labelled as "Western" (Figure 9.10).

In his short, informative article on the artist, Lippe argues that the "Western influence" identified as European in a handscroll of arhats by Chen Xian was "a thousand years older and not European but Indian." Lippe dismisses the possibility of significant contact with European pictures by artists active in Fujian. Instead, he argues that Chen Xian, as a Zhe-school artist, was heir to a figure painting tradition of facial and bodily shading that had survived in religious paintings in China since the time of its appearance in the wall paintings of Dunhuang. It remained "strong and alive" in the art of the Six Dynasties and the Tang periods, and (although it survived in later

Figure 9.10. Chen Xian (active ca. mid-seventeenth century), *Bodhidharma*. Appended inscription by Tesshin Dōhan (1641-1710) dated 1709. Hanging scroll, ink and light colours on paper, 122.8 x 57.4 cm. Kobe City Museum. (Photo: E. Sharf)

Buddhist painting and portraiture) "disappeared in the secular amateur painting which was to dominate the following centuries."[68]

Forced to confront the argument for European influence in seventeenth-century China, Lippe adopts, like most Western scholars of Chinese art in his day, the orthodox view that the "Western influence" originated in ancient techniques of Buddhist painting introduced from lands west of China, lands thought to have received, in some degree, influence from Western culture as represented by Greco-Roman civilization.

Lippe was not the only one to claim that there was a family resemblance to ancient Buddhist art in the technique of shading used in Ōbaku figure painting; this observation appears in some Japanese scholarship as well.[69] In fact, in an argument concerning the development of the artist's mature style, Nishigori applies the term for abstract but heavy shading (Chinese: *aotuhua*; Japanese: *ōtotsuga*) to the modelling method utilized by Kita Genki.[70] Nishigori likens Genki's mature shading technique to the method of abstract shading that, he says, has been known in China since the Tang dynasty. Following Suzuki Kei, he claims that if we consider "receding-and-protruding

painting" to have influenced the development of portrait painting in Ming China, we need not postulate the influence of newly imported European painting methods.

Nishigori, however, utilizes the resemblance to "receding-and-protruding painting" of the shading technique in Genki's late paintings not to dispute the influence of European pictures in the Ming (as did Lippe) and in Ōbaku portrait painting in Japan but to explain why Genki's works are indeed rather "traditional." Here Nishigori accepts the ancient technique as a fully East Asian pictorial tradition and notes that its role as a source of Western influence was limited by an overly schematic application of light and shade, one that had virtually abandoned the role of modelling and, at any rate, had been forgotten over the centuries. He describes the ancient technique as it survived in East Asia as a method of simple colour shading (Japanese: *bokashi*) applied in harmony with a clear outline.

Nishigori states that, consciously or unconsciously, Genki's mature style incorporated a technique striking in its similarity to the ancient method – a technique that astonished in its illusionistic effects, but also repelled those unfamiliar with stylized and heavily applied shading (Figures 9.3 and 9.4). Ironically, in the revival of the ancient shading method, Genki's work signalled a change in emphasis from shading to line and a return to traditional formal means. It also destroyed the particular way in which the Chinese and European elements had been blended by the Ming portraitists among Genki's immediate precursors. Nishigori concludes that the crude impression one has of Ōbaku painting can be attributed to the cacophonous quality of a now inharmonious blend of line and shading.[71]

The heavy application of shading in Ōbaku portraits is still linked in Nishigori's account, therefore, to the inherited European influence found in Ming portraiture. Nishigori claims that European painting imported to late Ming China focused attention anew on the relationship of light and shade. This stimulated the use of European-style shading as "an efficient means of achieving three-dimensionality."[72] The result was not, however, a uniform shading method based on a single fixed light source but an abstract shading technique without direct relationship to light. Chinese painters preserved the traditional linear bone method as indispensable in capturing the inner spirit of the portrait subject, but suppressed the power of line by exchanging line for shadow in an effort at harmonizing the two. This three-dimensionality drawn from European shading methods produced a

facial depiction unlike, in its realistic flavour, that of contemporary or earlier Japanese portraits, hence its origins are firmly Ming. This particular blend of Chinese and European methods was introduced to Japan via imported paintings and émigré artists and established the format and style of early Ōbaku painting.[73] It is this, as opposed to Lippe's, theory that remains the most widely accepted explanation of the "Western elements" perceived in Ōbaku portrait painting.

Coming this far in the discussion, we have seen that there is an overriding tendency on the part of scholars to link the incidence of shading techniques throughout the history of East Asian painting with Western influence of one sort or another. In fact, this is the case whether or not a particular scholar adheres to the orthodox view of Chinese painting, or attempts to nuance it with respect to techniques of shading ordinarily labelled foreign. If Nishigori's (as opposed to Lippe's) position is representative of current Ōbaku painting scholarship, it is ultimately Europe (and not India) that persists as the immediate source of "Western influence" in the seventeenth century.

The Prestige of the Renaissance

"The Chinese ... have not at all acquired the skill of Europeans ... They know nothing of the art of painting [in] oil or of the use of perspective in their pictures, so their productions have no life in them at all." Thus wrote Matteo Ricci, who nonetheless was sufficiently impressed with the Chinese to say: "I am of the opinion that the Chinese possess the ingenious trait of preferring that which comes from without to that which they possess themselves, once they realize the superiority of the foreign product." Joachim von Sandrart, the first European art historian to mention China, wrote along the same lines when he stated that the Chinese "through their natural exquisite taste" would make considerable use of European techniques if given the opportunity to master them.[74]

Some modern art historians, fully aware of the old European habit of elevating European painting techniques over those of other civilizations, nonetheless also claim European inspiration for elements almost all of which have precedents in Chinese painting. They acknowledge precedents in Chinese painting but deny them the status of significant contributing factors.[75]

This identification of European influence in late Ming and early Qing painting has elicited considerable criticism from some modern

Chinese scholars. Even in the seventeenth century, as noted earlier, the Chinese confronted the claims of the Europeans with claims of their own. Gu Qiyuan, a scholarly acquaintance of Matteo Ricci, wrote: "The European Matteo Ricci says that [their] painting uses the method of concavities and convexities, and that there is no one today [in China] who understands this." Gu countered this claim with evidence gleaned from ancient texts that illusionistic shading techniques were introduced from the West in ancient times, well before the introduction of European pictures to China. He specifically described how the three-dimensional rendering of flowers on the portals of a Buddhist temple by the sixth-century painter Zhang Sengyou deceived the viewer into believing that the flowers were actually fashioned in sculpturesque relief. Gu thereby claimed considerable antiquity for the Chinese mastery of three-dimensional modelling techniques.[76]

We have also seen, however, that not a few modern scholars support the notion of European influence; for many, perhaps, the Renaissance remains a hidden but nonetheless potent force underpinning the claim of European influence.

Until the 1930s (and again in the 1970s), claims of European influence in late imperial China were of modest significance. They involved lesser-known professional artists who either imitated, struggled to emulate, or crudely exploited European traditions. Such professionals included copyists in Jesuit ateliers in China and Japan, eighteenth-century court artists in China, and nineteenth-century Chinese artists fuelling the souvenir market. The modesty of such claims made all the more exciting the discovery of European influence, bolstered by accounts of intense popular interest in European pictures, in elite Chinese artists of the seventeenth century. Those who asserted influence on elite artists could be assured of making significant claims. They cited the "intellectual sophistication" of Matteo Ricci and his confreres and the fact that converts were made in "high places." The prestige of the High Renaissance (hence, of realism, perspective, and chiaroscuro) also elevated the seventeenth-century achievement to the detriment of Chinese pictorial traditions. Inadvertently, perhaps, the West garnered credit for all advances in shading technique.

On the other hand, descriptive naturalism, experimental method, and visual realism, it was argued, are not fundamentally Chinese. They bloom in China only to wither and die. These particular practices rely on mere skill: manual skills in draftsmanship, manual

skills in preparing materials, manual skills in achieving illusionistic effects, and so on. In contrast, facility with the flexible brush, the mastery of the art of calligraphy and its symbolic language, were critically sanctioned in China. Representational effects are not fundamentally Chinese; the pursuit of appearance is Western. Therefore, the "vulgar" effects of strong shading in Chinese portraits are the result of Western influence.

Claims of Western influence on Chinese painting are thus ideologically laden. They arise from certain preconceptions concerning the nature of mainstream Chinese painting. In cases where a technique is thought "new and innovative" (Figures 9.6 and 9.7), claims of Western influence are generated by preconceptions concerning Renaissance and post-Renaissance painting. Renaissance painting, in short, lays claim to the fundamental artistic insight that by suppressing line, the modelling of solids in three dimensions enhances the illusion of volume. Chinese painting, with its assumed reliance on line, is characterized as a tradition without commerce in plasticity. Only when stimulated by strikingly different European pictures in the era of the Jesuit missions, so the characterization goes, did Chinese artists begin to set foot on a well-trodden Western path.

In the case of Ōbaku portrait painting, claims of Western influence seem to arise from an aversion to heavy shading rather than from admiration of volumetric form. Western influence, be it European or Indic in origin, is called in to explain the single most exotic (and disturbing) feature of the paintings. There is a sense in which the focus on Western influence, arising as it does from an analysis of Genki's late style, leads ultimately to the disparagement of Ōbaku portrait painting as a pictorial tradition in East Asia. Ōbaku portraitists emerge as passive and sometimes inept technicians struggling to emulate an alien achievement.

In questioning this standard treatment of Ōbaku portrait paintings, I do not mean to argue for or against the notion of Western influence per se. Ultimately, I am not interested in substantiating or refuting claims of such influence but rather, following Michael Baxandall's well-known observation that "'influence' is a curse of art criticism,"[77] my concern is to move the discussion away from a preoccupation with what may turn out to be a red herring.

A New Appraisal

An informed selection of portraits of Ōbaku monks that predate Kita Genki as well as portraits by Genki reveals far more going on than a clumsy fusion of traditional Chinese line and heavy Western shading. Beginning with the Zeng Jing manner as seen in paintings by such artists as Zhang Qi and Yang Daozhen, portraitists combined skillful draftsmanship with a strikingly sensitive shading method. They captured infinite and minute differences in physiognomy and feature: the underlying facial structure, the warmth and pliability of skin, and the texture of facial and head hair. They painstakingly blended modelling strokes, subtle washes, and suppressed lineaments, and achieved a strong sense of personality and vitality (Figures 9.11 and 9.12).

In its transmission to the émigré community in Japan, the Zeng Jing manner was imitated and then transformed. Kita Genki and his immediate predecessor, Kita Dōku (Chōbei), evolved a new style of portraiture; they generated a relatively large number of carefully executed paintings featuring dramatic new modelling methods, bright

Figure 9.11. Yang Daozhen (active ca. 1656-57 and ca. 1663), *Portrait of Yinyuan Longqi Seated on a Lion*. Eulogy by Huimen Rupei (1615-64). Artist's inscription dated 1657 (third month, sixteenth day). Hanging scroll, ink and colours on paper, 117.9 x 56.1 cm. Tenshinin, Manpukuji, Kyoto Prefecture. Detail. (Photo: E. Sharf)

Figure 9.12. Yang Daozhen (active ca. 1656-57 and ca. 1663), *Portrait of Yinyuan Longqi at Sixty-Six*. Eulogy by Huimen Rupei (1615-64). Artist's inscription dated first day of the first lunar month (1657?). Hanging scroll, ink and colours on paper, 114.9 x 53.6 cm. Manpukuji, Kyoto Prefecture. Detail. (Photo: E. Sharf)

Figure 9.13. Kita Dōku (Chōbei) (active ca. 1657-63), *Portrait of Yinyuan Longqi*. Central scroll of a triptych with Muan Xingtao (1611-84) and Jifei Ruyi (1616-71). Self-eulogy dated 1668 (fourth month). Seal: "Chō." From a set of three hanging scrolls, ink and colours on paper, each 112.5 x 44.9 cm. Kobe City Museum. Detail. (Photo: E. Sharf)

colours, skillful draftsmanship, pleasing new compositions, and attractive designs for the chairs, robes, and regalia of high monastic office. Kita Dōku's little-known corpus, its significance to Kita Genki's

Figure 9.14. Kita Dōku (Chōbei) (active ca. 1657-63), *Portrait of Jifei Ruyi*. Left scroll of a triptych with Yinyuan Longqi and Muan Xingtao. Self-eulogy. Seal: "Chō." From a set of three hanging scrolls, ink and colours on paper, each 112.5 x 44.9 cm. Kobe City Museum. Detail. (Photo: E. Sharf)

artistic development as yet relatively unrecognized, established a highwater mark for Ōbaku painting in Japan. Kita Dōku's immaculate, clean-cut surfaces, sensitive washes, symmetries, and adroit brushwork, converged in the achievement of a convincing and harmonious three-dimensional rendering of the portrait subject's face. Kita Dōku initiated what would become characteristic in Kita Genki's work: a reliance on line and geometry that created a mood of reserve and replaced in large measure the warmth and intimacy of the earlier Chinese portraits (Figures 9.13 and 9.14).

In Kita Genki's early works, he achieved a delicate balance between the Zeng Jing manner and his own singular artistic sensibility (Figures 9.15 and 9.16). Subtle, naturalistic detail, however, gradually gave way to the bold presentation of stylized form. In his best-known works, Genki made use of higher contrasts of light and shade, stronger symmetries, and more obvious surface patterns (Figures 9.1 and 9.17). Building on Kita Dōku's characteristically cosmetic surfaces, Genki endowed his portrait subjects with youthful vigour and robust physiques, in the process rendering them more imposing. Strength and prowess replace frailty and age. Eventually, this style hardened into one featuring the application of extremely heavy linear shading and a dramatic stylization of form (Figures 9.3, 9.4, and 9.19). This is

Figure 9.15. Kita Genki (active ca. 1664-1709), *Portrait of Wang Xinqu* (1594-1678). Eulogy by Qiandai Xingan (1636-1705) dated 1679. Seal: "Genki." Ca. 1667(?). Hanging scroll, ink and colour on paper, 99.2 x 43.0 cm. Kobe City Museum. (Photo: E. Sharf)

explainable in part, perhaps, with reference to the existence of a workshop. It may also be interpreted as the result of a Japanization of a Chinese tradition: a sweeping away of the infirmity of age in the images of émigré monks who have attained, surprisingly swiftly, national prominence in Japan. This transformation of the relatively modest Zeng Jing manner can perhaps best be explained by the desire to achieve imagery of greater power and prestige. Interpretations based largely on stylistic analysis, however, must remain speculative.

Underlying this rarely observed transformation of Ōbaku portraits is the long institutional history of the Buddhist portrait. A brief example must suffice.

A Portrait of Miyun Yuanwu at Age Sixty-Eight

In the Ōbaku family of monks, Miyun Yuanwu (1566-1642)[78] and Feiyin Tongrong (1593-1661),[79] stand in the positions, respectively, of "grandfather" and "father" to Yinyuan. That is, Yinyuan's lineage places Miyun and Feiyin, respectively, in the thirtieth and thirty-first

Figure 9.16. Kita Genki (active ca. 1664-1709), *Portrait of Duli Xingyi* (1596-1672). Self-eulogy dated 1671 (spring). Seal: "Genki." Hanging scroll, ink and colour on paper, 111.5 x 50.2 cm. The Cleveland Museum of Art; Purchase, Mr. and Mrs. William H. Marlatt Fund. Detail. (Photo: The Cleveland Museum of Art)

Figure 9.17. Kita Genki (active ca. 1664-1709), *Portrait of Jifei Ruyi*. Self-eulogy dated 1671 (first month, fifteenth day). Seal: "Genki." Hanging scroll, ink and colours on paper, 208.0 x 93.8 cm. Manpukuji, Kyoto Prefecture. Detail. (Photo: E. Sharf)

generation after Linji, the ninth-century Chan master, and Yinyuan in the thirty-second generation. Given the formative roles played by Miyun and Feiyin in Yinyuan's monastic career, and their patriarchal

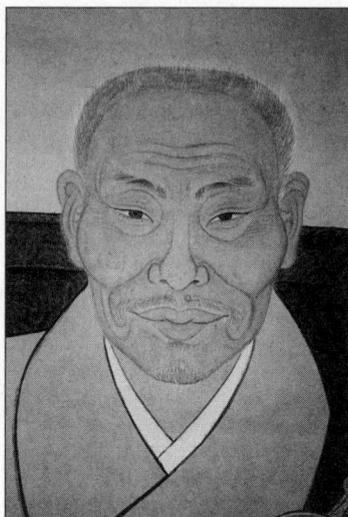

Figure 9.18. Attributed to Yang Daozhen (active ca. 1656-57 and ca. 1663), *Portrait of Miyun Yuanwu* (1566-1642). Central scroll of a triptych with Feiyin Tongrong (1593-1661) and Yinyuan Longqi. Eulogy by Yinyuan Longqi on separate sheet of paper pasted to painting. Ca. 1656. From a set of three hanging scrolls, ink and colours on paper, each 164.0 x 66.5 cm (paintings: 121.0 x 66.5 cm; eulogies: 42.0 x 66.5 cm). Manpukuji, Kyoto Prefecture. Detail. (Photo: E. Sharf)

status as venerable ancestors, it is instructive to note that portrait triptychs of Miyun flanked by Feiyin and Yinyuan, several of which survive, are featured in the first years of Yinyuan's stay in Japan (Figure 9.18); soon, however, their place is usurped by triptychs of Yinyuan flanked by his top two Dharma heirs, Muan Xingtao and Jifei Ruyi, reflecting both Yinyuan's assumption of the role of founder of the Dharma lineage and the role of the portrait triptych in displaying lineage claims. As we will briefly note, it is the various ritual functions of abbot portraits, often overlooked in the study of Ōbaku portraiture, that dictate their production and use.

In 1993, Nishigami Minoru introduced a startling discovery by Ōtsuki Mikio of several entries in the recorded sayings of the Chan master Muchen Daomin (1596-1674) relating how a portrait of the grand prelate Miyun painted by Zeng Jing came to be presented to the Qing emperor Shunzhi (1638-61) in 1659.[80]

Ōtsuki Mikio's fortunate discovery as deciphered by Nishigami Minoru teaches us a number of things about Chan abbot portrait paintings in the seventeenth century. First, the link between Zeng Jing and Chan abbot portraiture, suspected since the 1940s,[81] can now be confirmed; indeed, for most modern scholars of Ōbaku art and culture, this textual proof of an actual abbot portrait by the celebrated master is perhaps the most exciting aspect of the find. It is possible that extant images of Miyun (Figure 9.18) reflect Zeng Jing's original composition, of which we appear to have lost trace. If so, this would bring us even closer to Zeng Jing and an aspect of his painting career that is largely unresearched.

For others, however, myself included, it is a most felicitous discovery precisely because it provides rich details concerning Yinyuan's immediate predecessors and their consumption of the abbot portrait. In this regard, the mention of Zeng Jing is noteworthy less for any intrinsic interest in the artist's career but because we have a famed portraitist at work on an eminent abbot portrait that came to be coveted by an emperor – reflecting both the status of abbots in general and Miyun's national stature at the time.[82]

Nishigami's reading of the content of these entries follows (comments in brackets are mine):

The monk Muchen Daomin was summoned in 1659 by the emperor and proceeded to the northern capital [Beijing]. He lectured at court on the Dharma and was granted the title "Chan master" and given an honorary name. At this time, the emperor received Muchen Daomin as an intimate friend. When the topic of conversation turned to Miyun Yuanwu, the emperor regretted that Miyun and he were not alive at the same time. Upon hearing this, Muchen Daomin took out a portrait painting [Chinese: *daoying*, Japanese: *dōei*] of Miyun painted by Zeng Jing to show the emperor. The emperor greatly rejoiced, and ordered the court painter Wang Guocai to copy the portrait and make two scrolls and affix mountings of extreme splendor. These were dedicated to Tiantongshan Jingdesi [the south Chinese monastery where Miyun had served as abbot, and where Muchen, one of Miyun's top Dharma heirs, was then abbot]. The original scroll was kept in the custody of the imperial palace for the performance of memorial services. Zeng Jing's portrait painting [Japanese: *chinzō*] of Miyun seems to have been inscribed by both Miyun and Muchen Daomin [since the emperor had the court painter Wang read the two inscriptions, and questioned Muchen Daomin about the

authenticity of the Miyun inscription[83]]. The depiction of the portrait subject's appearance was extremely detailed and precise, and caused the emperor to be deeply moved. Muchen Daomin showed the emperor the original scroll in the ninth month of 1659, but already by the last day of the tenth month splendid mountings for two copies were prepared. Early in the next year, 1660 (first month, third day), the copies were ready. The emperor personally accompanied the scrolls to Tiantongshan. Reaching the abbot's quarters, he opened and hung the scrolls and showed them to Muchen. The disciples who had followed Muchen to the capital were also invited to witness the unveiling. The emperor pointed to the area of the folds of the robe painted in the copy and told them that he himself had added the ink to the whole area – the deep emotion felt by all became boundless [end of account].

Nishigami also found in Miyun's recorded sayings one autograph-eulogy addressed to Muchen Daomin that gives us 1633, when Miyun was still alive and Zeng Jing in his prime, as the likely date of execution of the original portrait.[84]

For what purpose was Miyun's portrait carried to the capital? We do know that it was brought out at the mention of the deceased abbot, and was a good-enough substitute to gladden the emperor, who was regretting Miyun's death. Perhaps it was anticipated that the emperor would want to possess the portrait on seeing it; perhaps the portrait was brought along as a gift – in any case, the portrait was presented to the emperor during the visit, and the emperor was noticeably moved by it; two copies of considerable quality and expense were commissioned by the emperor as though in exchange; and the portrait was left at the palace for memorial services to be performed. The portrait was impressive as a likeness, and painted by the most celebrated portraitist of the region. The copies, themselves painted by a court painter and given considerable attention in their decorative mountings, were also embellished by the emperor himself, who painted the folds of the robes in ink. By adding his hand to the work, did the emperor wish to aggrandize the copies themselves, to make up for the fact that he kept the master's original portrait? Why did the emperor, obviously moved by the likeness, consciously add his own hand (presence) to that of the portrait subject? Was the original portrait unmounted? To what extent was it a finished painting? Although Nishigami does not explicitly state this, it seems from the text that the original Zeng Jing portrait also received a splendid mounting at the

emperor's expense, and was displayed next to the emperor's throne;[85] if it is the very portrait mentioned in Miyun's recorded sayings, then it was already inscribed; but why was it remounted?

We may never know the specific intentions of the portrait-makers, or the answers to these questions, but the obvious interest given this cluster of Miyun portraits – in their production, display, and veneration – is unmistakable. This should not be surprising. Recent research by T. Griffith Foulk and Robert H. Sharf has shown that portraits of medieval Chan abbots were venerated as sacred icons of charismatic figures who ritually enacted the role of the Buddha in the ceremonial life of the monastery. In their widespread but mistaken adherence to the notion that Zen abbot portraits functioned as certificates of enlightenment bestowed by masters on disciples, modern art historians have overlooked the abbot's primary institutional role, and the primary function of the abbot portrait as proxy in the abbot's own funeral and death anniversary rites. Abbot portraits were funerary articles and commemorative icons – items commissioned in numbers and distributed widely. They were enlivened by autographed inscriptions, and after the abbot's death they served not only to assert the abbot's status as a venerable descendant in a sacred lineage but to affirm his continued presence in the world. Moreover, Chan and Zen funeral rites for abbots parallel Confucian memorial rites for ancestors, thus the portraits of eminent Buddhist abbots used in these rites constitute a subgenre of ancestor portraiture.[86]

Ōbaku portraits are, in fact, closer in style and iconography to later Chinese ancestor portraiture than to any East Asian tradition of European-style painting (Figure 9.19). Both traditions feature the strict frontal view, the full figure with pendant legs, naturalistic facial detail, the disjunction in style between the treatment of the face and the body, a decorum of expression, conservative formulaic poses, colourful robes, abundant shading, and lavish detail in the depiction of attire, attribute, and furnishings. They are alike in the great numbers produced.

Ōbaku portraits and ancestor portraits are also comparable in that both are regarded as functional arts, lacking in the lofty, aesthetic concerns of literati painting. For this reason, both receive little attention by modern scholars. The literati bias against portrait painting is reflected in the dearth and nature of extant Chinese portrait paintings. For example, portraits of medieval Chan abbots survive not in China but in Japan, where they are widely esteemed. And yet, as we have seen, Ōbaku portraits are marginalized within the venerable

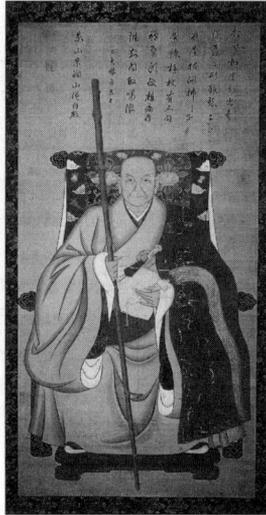

Figure 9.19. Kita Genki (active ca. 1664-1709), *Portrait of Donglan Zongze* (1640-1707). Self-eulogy dated 1695 (twelfth month, first day). Seals: "Kita shi" and "Genki." Hanging scroll, ink and colours on silk, 163.0 x 78.5 cm. Fukusaiji, Nagasaki Prefecture. (Photo: E. Sharf)

medieval tradition of Chan and Zen portraiture in Japan. We should not, however, find ourselves perpetuating the normative judgments of either the literati or the mainstream Rinzai Zen traditions.

In the end, what may be most interesting about the discovery of Zeng Jing's portrait of Miyun is that bits of recorded narrative confirm that the meanings and functions of the medieval Chan abbot appear to have survived into early modern times. It is tantalizing to think how much information of this nature resides undisturbed in the eulogy sections of the recorded sayings of the Ōbaku abbots and their Chinese forebears.

Conclusion

We cannot fully appreciate the internal stylistic evolution of Ōbaku portrait paintings without knowledge of their institutional context. Modern scholars of Ōbaku portrait paintings, however, virtually dismiss any such considerations. They typically begin by merely noting that Ōbaku portraitists duplicate the dominant compositional

formats of Chan and Zen abbot portraits since medieval times, the most typical being the formula of presenting the eminent prelate in full regalia seated on the high seat. This is generally followed by a brief evocation of Zen ideals vis-à-vis master-disciple relationships and the attainment of enlightenment. Obvious stylistic deviations from tradition are noted – the *en face* pose foremost among them. Then the discussion turns quickly to the only feature deemed significantly different and therefore worthy of investigation – the incorporation of European painting techniques.

Together with the habit of dismissing considerations other than style, modern scholars tend to view Ōbaku portraits as oddities in the larger tradition of Chan/Zen abbot portraiture. The strange look of Ōbaku portraits when compared with well-known, and comfortably pleasing, masterpieces of medieval Chan/Zen portraiture gives rise to a marked ambivalence. On the one hand, one or two Genki portraits are included in surveys of Zen art as early modern examples of Zen portraiture. On the other hand, scholars express surprise at the great numbers of extant Ōbaku portraits, and prefer to refer to them using the generic Japanese term for portrait *(gazō)* rather than the conventional modern term for Zen abbot portrait *(chinzō)*. It is as though the Ōbaku portraits have become secularized. Underlying this ambivalence is the widespread modern notion that portraits of Chan and Zen abbots are cherished mementos of master-disciple relationships, certificates of enlightenment bestowed on worthy disciples by enlightened masters. Such precious items could be extant only in limited numbers, as indeed the well-published but relatively small corpus of medieval Chan and Zen abbot portrait paintings seems to be (despite the actual numbers extant and known from historical documents). In comparison, Ōbaku portrait paintings are simply too numerous to be regarded as mainstream *chinzō*.

The abbot of a Chan/Zen monastery was regarded *ex officio* as a living Buddha around whom revolved the religious, social, and institutional life of the monastery. The émigré Chinese Ōbaku abbots, in the seventeenth and eighteenth centuries, were, moreover, the living embodiments of southern Chinese literati culture; they were agents for the transmission to early modern Japan of the scientific, technological, religious, and artistic achievements of the late Ming and early Qing; their portraits partook of their charisma and as such were highly esteemed objects of religious devotion.

That their portraits also served as vehicles for the expression and

transmission of new visual ideas – ideas whose place in the history of Japanese figure painting is yet to be fully understood – does not necessarily indicate a change in meaning or function. One perceives in the depiction of the abbot's visage an ongoing attempt to mediate between two alternative representational strategies – one emphasizing line and the other volumetric form. Although modern scholars feel pressed to link this attempt to the appearance of Europeans in seventeenth-century China, the situation, as we have seen, is more complex, and far older, than that.

Acknowledgements

This chapter could not have been written without the painstaking research of Nishigori Ryōsuke, as will have been seen throughout. I am also indebted to the work of Helen Baroni, Ōtsuki Mikio, and Nishigami Minoru. Finally, this chapter is an outgrowth of my PhD dissertation, "Ōbaku Zen Portrait Painting: A Revisionist Analysis," University of Michigan, 1994. For their guidance and support over the course of this study, I wish to acknowledge Karen Brock, T. Griffith Foulk, Phyllis Granoff, Sasaki Johei, Robert Sharf, Koichi Shinohara, and Marshall Wu.

End Notes

1 The term "Ōbaku sect" (or "Ōbaku school"), supposedly a translation of *Ōbakushū* or *Ōbakuha,* is commonly used to refer to Yinyuan's lineage in Japan. We must keep in mind that there was no independent Ōbaku "sect" in China (just as there was no independent Rinzai or Sōtō "sect" in China; recent research by Jiang Wu, however, reveals the considerable attempt by Yinyuan and his immediate forebears in China to reinvent their own lineage as the authentic Linji lineage and exclude other Chan lineages from the fold: "Orthodoxy, Controversy, and the Transformation of Chan Buddhism in Seventeenth-Century China," PhD dissertation, Harvard University, 2002). While the term *Ōbakushū* was used as early as the mid-seventeenth century, Ōbaku was not officially recognized as an independent sect in Japan until 1876. In reality, the early émigrés preferred to laud themselves as *Rinzai shōshū* ("The Authentic Rinzai lineage"). For simplicity's sake, however, I will follow standard convention and use the term "Ōbaku" or "Ōbaku school" to refer to the

monastic émigré community established in Japan by Yinyuan Longqi and his Dharma heirs.

For a succinct account of the evolving institutional status of Yinyuan's line over the course of the three and a half centuries of its existence in both China and Japan, see Helen Josephine Baroni, "Buddhism in Early Tokugawa Japan: The Case of Ōbaku Zen and the Monk Tetsugen Dōkō," PhD dissertation, Columbia University, 1993, 1, 15-18, 17 n. 7. For another recent critical account of the Ōbaku community in a Western language, see Dieter Schwaller, *Der japanische Ōbaku-Monch Tetsugen Dōkō: Leben, Denken, Schriften* (Berne/New York: Peter Lang, 1989).

2 Helen J. Baroni writes: "In some cases, [Japanese Rinzai monks] found the Chinese practices and styles abhorrent, apparently for their very foreignness ... For their part, the Chinese masters maintained aspects of life known to them in China that an outside observer might tend to classify as culturally rather than religiously significant, including the language used in ritual, the design of monastic robes and shoes, clerical hairstyles, and the like": *Ōbaku Zen: The Emergence of the Third Sect of Zen in Tokugawa Japan* (Honolulu: University of Hawai'i Press, 2000), 10; see also 98-101.

3 From Dapeng Zhengkun, *Jiin matsujichō* (Circular of monasteries and branch temples), 1745; cited in Ōtsuki Mikio, "Shoki Ōbaku no gasō itsunen shōyū ni tsuite," *Zen bunka* 78 (1975): 72; see also Hirakubo Akira, *Ingen,* Jinbutsu sōsho 96 (Tokyo: Yoshikawa kōbunkan, 1962), 261-62.

4 The Ming style, originally reflecting late developments in the long history of Buddhist painting in China, was widely imitated in religious painting in Japan. In addition, subsequent innovative depictions of the human figure by Japanese artists working largely in non-Buddhist traditions could not have been created without the precedent of Ming Buddhist painting.

5 In contrast to Ming Chan Buddhism, Japanese Zen was thought to preserve Tang and Song Chan ideals. For an in-depth and balanced history of the reception of the émigré monks in Japan, see Baroni, *Ōbaku Zen.*

6 Modern ambivalence towards Yinyuan's lineage can be linked to a variety of factors from the Edo period to modern times. In the seventeenth century, as already mentioned, certain Japanese Rinzai monks perceived Yinyuan and his lineage as a threat; they effectively blocked the attempt to install Yinyuan as abbot of Myōshinji, a major Rinzai monastery in Kyoto. They rejected Yinyuan and his lineage in part because their own prestige, authority, and financial resources were at stake, and in part because of cultural differences. In addition to such political and social factors, the Japanese had misgivings about the

doctrinal and meditative teachings espoused by the Chinese monks.

In spite of this virulent opposition, however, Yinyuan's lineage ultimately succeeded in gaining legitimacy in Japan. This was due in large part to the success of the campaign, led by sympathetic Japanese Rinzai monks, to win the support of the Tokugawa shogunate. After the restoration of imperial rule in the Meiji period, however, this close association with the disempowered military government became a serious political liability. The Ōbaku school and its sectarian historians subsequently concealed the extent of the association and instead successfully touted the considerable connections of the Ōbaku monks to the Emperor Gomizuno-o. In addition, after losing much of its financial resources with the upheavals of early Meiji, the school was successful in establishing a wide base of popular support by promoting the Pure Land features of its Zen practice (Baroni, "Buddhism in Early Tokugawa Japan," 5-7, 165-70).

Despite the survival of the school into modern times, it has yet to receive much attention from scholars of Japanese art history and religion. The neglect of the school is due in part to the uncritical acceptance by scholars of the early Rinzai caricatures of Ōbaku as a syncretic, if not degenerate, form of Zen. Modern scholars may also have been predisposed to view Edo-period Buddhism as a mere shell because of the manner in which it had been appropriated by the Tokugawa shogunate; see Paul B. Watt, "Jiun Sonja (1718-1804): A Response to Confucianism within the Context of Buddhist Reform," in *Confucianism and Tokugawa Culture,* ed. Peter Nosco (Princeton: Princeton University Press, 1984), 213 n. 116; and Neil McMullin, *Buddhism and the State in Sixteenth-Century Japan* (Princeton: Princeton University Press, 1984). We should also bear in mind the intellectual legacy of the nativist or "national learning" *(kokugaku)* movement of the eighteenth and nineteenth centuries; see Martin Collcutt, "Buddhism: The Threat of Eradication," in *Japan in Transition: From Tokugawa to Meiji,* ed. Marius B. Jansen and Gilbert Rozman (Princeton: Princeton University Press, 1986), 146 n. 3. Modern scholars unwittingly perpetuate the anti-foreign and anti-Buddhist program of the nativists by emphasizing the relative isolation of Japan in the Edo period and neglecting the impact of the cultural forms and ideas that continued to flow in from the continent; see Marius B. Jansen, *China in the Tokugawa World* (Cambridge, MA, and London: Harvard University Press, 1992). In addition, when scholars do investigate foreign contacts in the Edo period, they tend to study the European visitors to Nagasaki and not the Chinese, even though the Nagasaki Chinese community constituted the largest foreign settlement

in Edo Japan; see Aloysius Chang, "The Chinese Community of
Nagasaki in the First Century of the Tokugawa Period (1603-1868)," PhD
dissertation, St. John's University, 1970; Miyata Yasushi, "Chūgoku
keishi no seiyō henchō: genin wa Meiji irai no kyōiku hōshin?" *Asahi
shinbun* (22 April 1986); and Jansen, *China.* The investigation of these and
other factors underlying the neglect of Ōbaku is long overdue.

7 See *Ōbaku: Zen Painting and Calligraphy,* introduction and catalogue by
Stephen Addiss with the assistance of Kwan S. Wong (Lawrence, KS:
Helen Foresman Spencer Museum of Art, 1978), for an early,
representative approach to the study of Ōbaku monks and Edo culture.
A fuller investigation of the Ōbaku role in the evolution of literati arts in
Japan can be found in Joan Stanley-Baker, *The Transmission of Chinese
Idealist Painting to Japan: Notes on the Early Phase (1661-1799),* Michigan
Papers in Japanese Studies 21 (Ann Arbor: Center for Japanese Studies,
University of Michigan, 1992). Literati culture in Japan is a field of study
with its own persistent modern history of ambivalence, from Ernest
Fenollosa's dismissal at the turn of the century of literati painting as
"hardly more than an awkward joke," to its neglect by numerous
historians of art, literature, and culture who elevate other, often earlier,
artistic achievements; see Ernest F. Fenollosa, *Epochs of Chinese and
Japanese Art,* 2 vols. (New York: n.p., 1913), 165. The modern indifference
towards literati pursuits in Japan has roots in the anti-foreign nativist
sentiments of the Edo period mentioned above, and also in the
subsequent deprecation of the Edo period as a cultural dark age by Meiji
intellectuals (see n. 6).

8 Nishimura Tei, *Ōbaku gazō shi* (Kobe: Sōgensha, 1934).

9 Such scholars traditionally classify Ōbaku-school painting as the oldest
of five schools of "Nagasaki-school painting" *(Nagasakiha kaiga),* that is,
of painting fostered in Nagasaki between the mid-seventeenth and the
mid-nineteenth centuries. Iwasaki Yoshikazu lists the following five
schools: Ōbaku painting *(Ōbakugaha),* Chinese painting *(kangaha),* Shin
Nanpin school *(Nanpinha),* literati painting *(bunjingaha),* and Western-
style painting *(yōfūgaha).* To this he further adds a category for prints
(hanga) produced in Nagasaki. According to Iwasaki, painters associated
with Nanban painting *(nanban kaiga)* are known only via documents,
having left no works extant, and for this reason they are not usually
included under the rubric of the Nagasaki school. Iwasaki further
collapses the five schools of painting into three: Ōbaku painting; the
school of the bureau for the appraisal of painting, which comprises the
schools of Chinese painting and Shin Nanpin *(karaemekikiha);* and
Western-style painting; see Iwasaki Yoshikazu, "Nagasakiha kaiga no

tenkai," in *Kyūshū no kaiga to tōgei,* Kyūshū bunka ronshū 5, ed. Fukuoka Unesco kyōkai (Tokyo: Heibonsha, 1975), 273-74. Other schemes that analyze "Nagasaki-school painting" into constituent schools commonly include Ōbaku as the oldest, usually with Yiran Xingrong (1601-68; Japanese: Itsunen Shōyū; *OBJJ* [see n. 10], 17-18) as founder. Iwasaki's scheme is repeated in Asano Tōru, Ozaki Masaaki, and Tanaka Atsushi, *Shajitsu no keifu I. Yōfūhyōgen no dōnyū – edo chūki kara meiji shoki made* (Tokyo: Tokyo kokuritsu kindai bijutsukan, 1985), 144. Others classify the development of art in Nagasaki variously as follows: *nanban bijutsu* (Nanban art), *Ōbaku kei kaiga* (Ōbaku painting), *Nagasaki kei kaiga* (Nagasaki painting), and *Nagasaki hanga* (Nagasaki prints); or *nanban bunka* (Nanban culture), *Ōbaku bunka* (Ōbaku culture), and *kōmō bunka* (Dutch culture); see Etchū Tetsuya and Sugase Tadashi, eds., *Furusato ni kaetta – nanban kōmō bijutsuten zuroku* (Nagasaki and Kōbe: Nagasaki seinen kaigijo and Kōbe seinen kaigijo, 1971).

10 Ōtsuki Mikio, Katō Shōshun, and Hayashi Yukimitsu, eds., *Ōbaku bunka jinmei jiten* (Kyoto: Shibunkaku shuppan, 1988); hereafter cited as *OBJJ.*

11 Nishigori Ryōsuke's major articles featuring Ōbaku artists are: "Ōbaku gazō sakka yōdōshin," *Kokka* 1064 (1983): 32-37; "Ōbaku gazō sakka yōdōshin – ge," *Kokka* 1065 (1983): 5-15; "Ōbaku shōzō gaka kita sōun to chōbei – jō," *Bukkyō geijutsu* 158 (1985): 83-100; "Ōbaku shōzō gaka kita sōun to chōbei – ge," *Bukkyō geijutsu* 160 (1985): 88-97; "Kita genki kō," *Bukkyō geijutsu* 165 (1986): 48-74; "Kokura-fukujuji shozō itsunen hitsu ressozu no keifu," *Bukkyō geijutsu* 166 (1986): 65-78; "Hanshaku hitsu jūhachi rakan zukan," *De Arte* 3 (1987): 99-111; "Itsunen to gabō tōroan," *Nagasaki dansō* 74 (1988): 77-85; "Kenkyū shiryō: chinken – sakuhin to shiryō – jō," *Kokka* 1141 (1990): 33-42; "Kenkyū shiryō: chinken – sakuhin to shiryō – ge," *Kokka* 1142 (1991): 32-39.

12 Kyoto National Museum, ed., *Ōbaku no bijutsu: Edo jidai no bunka o kaeta mono* (Kyoto: Kyoto National Museum, 1993). See esp. Nishigami's lead article in this volume, "Ōbaku no bijutsu to sono genryū – gazō o chūshin ni," 7-13.

13 See nn. 1 and 2.

14 The Bunkaden was built on the grounds of the monastery of Manpukuji, in Uji, Kyoto Prefecture, in 1972 in commemoration of the 300th anniversary of Yinyuan's death. It is a museum of Ōbaku culture, erected for the preservation and display of Manpukuji artifacts, documents, and temple treasures.

15 Japanese: *fusō,* a common metaphorical reference to Japan.

16 Translated by Robert Sharf.

17 Ages are given following Chinese and Japanese custom.

18 *"Genki izen ni sude ni rippa ni Genkifū gazō no yōshiki to shuhō o shimeshite
 iru"* (Nishimura, *Ōbaku gazō*, 16, 18). Nishimura discusses Kanō-school
 artists, Nagasaki artists, and Ōbaku monk-painters, specifically those
 whose signatures and seals are known. He mentions Yiran Xingrong,
 Yang Daozhen, Kita Sōun, and Dōki (whose identities were later sorted
 out by Nishigori; see n. 11), Kita Genki, Kanō Yasunobu, Hōkyō Tokuō,
 Sadatsuna, and other Kanō-school painters; also, monk-artists such as
 Jifei, Duzhan, Baiyan, and others who painted and executed inscriptions
 as well. He ends with mention of a less well known Ming Chinese artist
 noted in the *Zoku honchō gashi* as having painted Ōbaku portraits
 (Nishimura, *Ōbaku gazō*, 15-18).

19 The well-published portraits of medieval Chan masters preserved in
 Rinzai monasteries in Japan exemplify this stylistic tradition. One
 prominent example is the portrait of Wuzhun Shifan in Tōfukuji, Kyoto,
 inscribed by the portrait subject in 1238; reproduced in Kyoto National
 Museum, *Zen no bijutsu* (Kyoto: Hōzōkan, 1983), pl. 14.

20 *"Akushumi (gashō ni wa arazaru)"* (Nishigori, "Ōbaku gazō sakka
 yōdōshin," 32). Genki's work was not universally disparaged; those who
 most often hold Genki in highest esteem are scholars with a special
 interest in the history of Japan's Western-style painting; see, for example,
 Etchū and Sugase, *Furusato ni kaetta*.

21 This account is based on Nishigori's "Ōbaku gazō sakka yōdōshin,"
 "Ōbaku shōzō gaka kita sōun to chōbei – jō," and "Kita genki kō."

22 Specifically, in this case, Nishimura is referring to that aspect of Nanban
 painting that comprises the art of Japanese Christian painters trained in
 academies of Jesuit missionary artists of sixteenth- and early-
 seventeenth-century Japan.

23 For brief accounts of this artist, see Sakamoto Mitsuru, "Kirishitan
 bijutsu to kyūshū," in Fukuoka Unesco kyōkai, *Kyūshū no kaiga to tōgei*,
 205-6; and John E. McCall, "Early Jesuit Art in the Far East," *Artibus
 Asiae* 10 (1947): 225-33.

24 According to Nishigori Ryōsuke, "Kita Genki kō," n. 20, a number of
 scholars have asserted the use of some kind of oil medium in Ōbaku
 portraiture. Koga Jūjirō, "Kita sōun kita genki oyobi sono gakkei," in
 Nagasaki kaiga zenshi (Hokkō shobō, 1944), wrote that there were oil
 paintings among Kita Genki's oeuvre and cited titles. Nishigori could
 not ascertain the whereabouts of these paintings, yet points out that
 none bore a Genki seal. Nishigori believes that scholars are led to this
 observation by the high saturation of colour and surface sheen of Ōbaku
 portraits but states that confirmation of the use of oils must await
 chemical analysis. Among the works surveyed by Nishigori, only one, a

portrait of Inaba Masanori (1623-96) painted in 1693 and in the collection of the monastery Kōfukuji (Tokyo Prefecture), appeared to contain passages where the adhesiveness of the pigment was tangible and in which rough areas showed clusters of wrinkles resulting from the drying process. Yet the materials used in these isolated passages are clearly distinct from the pigments used in other Genki portraits. According to Nishigori, a determination as to whether the use of oils, or of some other medium such as tempera, is indicated in this particular portrait must also await the findings of chemical analysis.

25 Nishimura, Ōbaku gazō, 56-58.

26 See Nishigori, "Ōbaku gazō sakka yōdōshin," 32; and Nishimura, "Kita genki oyobi genki fū sakka" in Nishimura, Nihon shoki yōga no kenkyū (Kyoto: Zenkoku shobō, 1945), 266-321.

27 Etchū Isamu, "Ōbaku gazō to yōfūgaka to no setten (I)," Nagasaki kenritsu bijitsu hakubutsukan kenkyū kiyō 3 (1977): 35-44, maintained Nishimura's interpretation. Iwasaki ("Nagasakiha kaiga no tenkai") was the principal scholar to develop it. Nishigori, "Ōbaku gazō sakka yōdōshin," 32.

28 Iwasaki, "Nagasakiha kaiga no tenkai," discussed in Nishigori, "Ōbaku gazō sakka yōdōshin," 33 and"Ōbaku shōzō gaka kita sōun to chōbei – jō," 90 n. 14. Iwasaki's theory is repeated in Asano et al, Yōfūhyōgen no dōnyū, 144.

29 Major early studies of Ōbaku portraits exhibiting a focus on the routes of Western influence include Yoshinaga Setsudō, "Genki no gazō," Ōbaku 15 (Ōbakudō, 1929); Hayashi Genkichi, "Shōzōgaka kita genki," Nagasaki dansō 14 (1934): 60-66 (first published in 1926 in Chūō bijutsu 12 [7]); Nishimura, Ōbaku gazō; Koga Jūjirō, Nagasaki gashi iden (Nagasaki: Taishōdō shoten, 1943; drafted 1934); Koga, "Kita sōun kita genki"; Taniguchi Tetsuo, Nishi nihon gadan shi – kindai bijutsu e no michi (Fukuoka: Nishi nihon bunka kyōkai, 1981; first published in 1959-60 in Asahi shinbun seibuban rensai); Iwasaki "Nagasakiha kaiga no tenkai"; and Etchū, "Ōbaku gazō to yōfūgaka to no setten (I)." See Nishigori's "Kita genki kō," 49-51, and "Ōbaku gazō sakka yōdōshin," 32-34 for an in-depth discussion of these and other studies.

30 Taniguchi, Nishi nihon gadan shi. Taniguchi's views, first published in 1959-60, are repeated in Etchū and Sugase, Furusato ni kaetta.

31 Taniguchi, Nishi nihon gadan shi, 132- 33.

32 Japanese: Chōki (fl. ca. 1642); OBJJ, 235; see also Nishigori, "Ōbaku gazō sakka yōdōshin."

33 Japanese: Hanshaku (fl. ca. 1664); OBJJ, 312; see also Taniguchi, Nishi nihon gadan shi, 127-28; and Iwasaki, "Nagasakiha kaiga no tenkai," 277.

34 Japanese: Yōdōshin (fl. ca. 1657); *OBJJ*, 368-69; see Nishigori,"Ōbaku gazō sakka yōdōshin," and "Ōbaku gazō sakka yōdōshin – ge."

35 Japanese: Chinken (fl. ca. 1636); *OBJJ*, 239; see also Nishigori, "Kenkyū shiryō: chinken – jō," and "Kenkyū shiryō: chinken – ge."

36 This alternative route of "Western influence" was proposed by Okamura Sen'ei, "Nisshi ryōkoku ni okeru yōga no hattatsu ni tsuite," *Nihon shogaku kenkyū hōkoku* (1945): 168-78; Nishigori, "Ōbaku gazō sakka yōdōshin," 33.

37 See especially Nishigori, "Ōbaku gazō sakka yōdōshin," 32-34, and "Ōbaku shōzō gaka kita sōun to chōbei – jō," 83-84, 90-91.

38 See, however, Sugase's earlier assertion that "although the paper and pigments appear to have been Japanese, glue and the white-of-egg were used as a binding agent, a technique we associate with tempera"; Tani Shin'ichi, and Sugase Tadashi, *Namban Art: A Loan Exhibition from Japanese Collections* (International Exhibitions Foundation, 1973), 23.

39 A set of screens in the style commonly attributed to Nobukata on the basis of the presence of the Nobukata seal were discovered in 1882 in the mortuary temple of the Nanbu family of Morioka (Tani and Sugase, *Namban Art*, fig. 4). For reproductions of three paintings carrying the seal of Nobukata, see Tani and Sugase, *Namban Art*, figs. 5-7. For the association of paintings attributed to Nobukata and early Edo-period Western-style depictions of Bodhidharma, see Miwa Hideo, "Yōfūgahō ni yoru darumazu ni tsuite," *Bijutsu kenkyū* 311 (1979): 1-15.

40 See Miwa, "Yōfūgahō ni yoru darumazu," 7, cited in Nishigori,"Ōbaku gazō sakka yōdōshin," 91 n. 15.

41 See Sakamoto Mitsuru, "Shoki yōfūga," *Nihon no bijutsu* 80 (1973).

42 Nishigori,"Ōbaku gazō sakka yōdōshin," 33.

43 Nishigori, "Ōbaku shōzō gaka kita sōun to chōbei – jō," 84.

44 Nishigori, "Kita genki kō," 49-53.

45 *"Sono menbō ikiru hito ni tai suru ga gotoshi."* This passage is from Sakurai Sūgaku's *Sūgaku gadan* (Sūgaku's talks on painting), published ca. 1833-35. See Nishigori, "Ōbaku shōzō gaka kita sōun to chōbei – jō," 85, and "Kita genki kō," 49 n. 3.

46 *"Shūnai shoso no shōzō ōku wa shi no shuseki ni tsukareru."* This passage is from Shiseki Renshu's *Ōbaku shiso ryakuden bassui* (1906; Excerpts of biographical sketches of Ōbaku monks and laity). This hand-copied book by Shiseki Renshu (1842-1914; *OBJJ*, 144-45), forty-third abbot of Manpukuji, was once in the possession of Ōbaku scholar Yoshinaga Setsudō (1881-1964); at present its whereabouts are unknown (Nishigori, "Kita genki kō," 20 n. 4).

47 *"Kita Genki koji ... jinbutsu o egaku ni myō ari ... Ōbaku shosō no shōzō o*

egaku koto mottomo ōshi." This passage is from Yoshinaga Setsudō's *Ōbaku shōzōga* (Ōbaku portraiture), a set of handwritten field notes; the notebook consists of excerpts from primary sources and a record of painting inscriptions on portraits Yoshinaga inspected first-hand (Nishigori, "Kita genki kō," 21 n. 5).

48 Watanabe Shūjitsu (Kakushū) published *Nagasaki gajin den* (Biographies of Nagasaki painters) in Nagasaki in 1851; Nishigori, "Ōbaku shōzō gaka kita sōun to chōbei – jō," 85, and "Kita genki kō," 49. See also Iwasaki, "Nagasakiha kaiga no tenkai," 275 n. 4.

49 "*Kaiji wa denshin [shōzōga] o yokushi, densen [gahō] ni mata shini ari ... ōō shasu tokoro tenki myōe ni shite ichii nashi*" (Watanabe Shūjitsu, *Nagasaki gajin den*). See Nishigori "Kita genki kō," 49. Note that Nishigori reads this passage as "*kaiji wa denshin o yokushi* [as for painting, he was skilled in portraiture]," whereas Watanabe punctuates it to read: "*kaiji wa shin o tsutaeru* [in painting, he transmits the spirit]"; see Nishigori, "Kita genki kō," n. 2.

50 Ro Senri's *Kiyō senmin den* (Biographies of Nagasaki worthies) was published in 1731, according to Nishigori ("Ōbaku shōzō gaka kita sōun to chōbei – jō," 85, and "Kita genki kō," 48). According to Iwasaki, the preface of 1731 is by Ro Sōsetsu; later, in 1819, Ro Senri edited and published the work ("Nagasakiha kaiga no tenkai," 274 n. 2).

51 Nishigori, "Kita genki kō," 48.

52 Ibid., 58. This entry can be translated as follows: "He was good at Nanban painting. For a little while he travelled in Satsuma and there he trained under a Nanban man in painting method, and obtaining that mystery, made a name for himself in the world." Also noted in Nishimura, *Ōbaku gazō*, 55. See also Sakamoto, "Kirishitan bijutsu to kyūshū," 205, who notes that the name of this artist is found in Japanese records only, and not in Jesuit records, and that no extant works can be attributed to him with any confidence.

53 Outside of Ōbaku studies, Japanese art historians who have asserted European influence on Zeng Jing include Omura Seigai, Kanehara Shōgo, Nakamura Fusetsu, and Komuro Suiun; Chinese art historians include Chen Shizeng (*Zhongguo huihuashi*), Zheng Wuchang (*Zhongguo huaxueshi*), and Hsiang Ta (see n. 54). See Lu Suh-fen, "A Study on Tseng Ching's Portraits," MA thesis, University of Michigan, 1986, 38-39 n. 2.

54 Hsiang's account of Zeng Jing features several contemporary descriptions, none of which mention Europe; his linking Zeng Jing's style with European methods derives from modern Chinese and Japanese scholarship. Hsiang Ta, "European Influences on Chinese Art of the Later Ming and Early Ch'ing Period," trans. and annotated by

Wang Dezhao, in *The Translation of Art: Essays on Chinese Painting and Poetry (Renditions 6),* ed. James Watt (Hong Kong, Seattle, and London: Centre for Translation Projects, Chinese University of Hong Kong, and University of Washington Press, 1976), 152-78; first published in 1930 in *Dongfang zazhi* 27 [1]: 19-38, 164-65.

55 Well after Zeng Jing, according to Hsiang Ta, the use of European methods of portrait painting grew increasingly prevalent. As evidence, he cites an early-eighteenth-century record concerning one early Qing portrait painter: "His method was essentially Western oriented, which, without giving first a structure by brush strokes, used only washes, shades and surface lines to make a picture. His portrait painting always closely resembled the real person and one who saw the picture could easily tell whom it was depicting." Hsiang considers this, and not Zeng Jing's method, to be "entirely" Western (Zhang Geng, *Guochao huazheng xulu,* vol. 1, biography of Man Guli; cited in Hsiang, "European Influences on Chinese Art," 165-66).

56 James F. Cahill, *The Distant Mountains: Chinese Painting of the Late Ming Dynasty, 1570-1644* (Tokyo and New York: Weatherhill, 1982), 120, 213, 216.

57 Nishigori,"Ōbaku gazō sakka yōdōshin," 34.

58 Lu, "A Study on Tseng Ching's Portraits," 18, 23, 25-26, 30-32.

59 Marshall P.S. Wu, *The Orchard Pavilion Gathering: Chinese Painting from the University of Michigan Museum of Art,* 2 vols. (Ann Arbor: University of Michigan Museum of Art, 2000), 1: 114-23, 260. For his views on European influence and Zeng Jing, see especially 2: 50 n. 46.

60 This long-standing prejudice is attested in Tang and Song texts on painting; Charles Lachman, *Evaluations of Sung Dynasty Painters of Renown: Liu Tao-ch'un's Sung-ch'ao ming-hua p'ing,* Monographies du T'oung Pao 16 (Leiden: E.J. Brill, 1989), 4-5.

61 This is true despite the fact that scholarly admiration for particular professional painters frequently appears in the textual record.

62 Silbergeld mentions the need for a re-evaluation of the reputations of the "great" early figure painting masters, given that archeological evidence antedating these masters reveals technical developments traditionally attributed to them (Jerome Silbergeld, "Chinese Painting Studies in the West: A State-of-the-Field Article," *Journal of Asian Studies* 46, no. 4 [1987]: 851). See also Jan Fontein and Wu Tung, *Han and T'ang Murals Discovered in Tombs in the People's Republic of China and Copied by Contemporary Chinese Painters* (Boston: Museum of Fine Arts, 1976).

63 One prominent exception is Zhang Sengyou.

64 In the Gu tradition, line is typically a fine, often continuous bounding line; in the Wu tradition, line fluctuates in breadth – "thickens" and

"thins" – and features lively broken contours. These two linear styles have roots at least as old as the Han dynasty (206 BC to AD 220). The fine-line style, in fact, is said to have emerged as early as the Eastern Zhou (770-256 BC), based on the evidence from extant fragments of painting on silk. A fine, continuous line executed with care may also be found in the threadlike pictorial imagery of extant Sichuan reliefs dating to the Han; see Lucy Lim, "Form and Content in Early Chinese Pictorial Art," in *Stories from China's Past: Han Dynasty Pictorial Tomb Reliefs and Archaeological Objects from Sichuan Province, People's Republic of China,* ed. Lucy Lim (San Francisco: Chinese Culture Foundation of San Francisco, 1987), 52. In other extant Han pictorial compositions – for example, the engraved stone designs for the shrines of the Wu family (inscribed AD 145-68) – the sense of the depicted form lies in its silhouette, which performs a graphic function similar to that of fine, even line. If it is a human figure, the silhouette contains the information regarding gender, class, action, and attribute. If there are details within the outline of the silhouette, an economy of even line approximates the natural form. On the other hand, in other extant works of Han pictorial art, the calligraphic sweep of line suggests a freer, speedier execution. Broken linear contours fluctuating in breadth cause lively forms to occupy a fictive space. This is the linear style later associated with Wu Daozi.

65 Richard M. Barnhart, "Survivals, Revivals, and the Classical Tradition of Chinese Figure Painting," in *Proceedings of the International Symposium on Chinese Painting* (Taibei: National Palace Museum, 1972), 143-46. Most often cited as a faithful echo of Wu Daozi's style is the bodhisattva in ink on hemp in the collection of the Shōsōin, Tōdaiji, Nara Prefecture, Japan; see Laurence Sickman and Alexander C. Soper, *The Art and Architecture of China* (Harmondsworth: Penguin Books, 1971), 174.

66 Wen C. Fong, "*Ao-t'u-hua* or 'Receding-and-Protruding Painting' at Tun-huang," in *Proceedings of the International Conference on Sinology. Section of History of Arts* (Taibei: Academia Sinica, 1981), 73-94. Other exceptions are Mary H. Fong, "The Technique of 'Chiaroscuro' in Chinese Painting from Han through T'ang," *Artibus Asiae* 38, no. 2/3 (1976): 91-127; Peter Glum, "Meditations on a Black Sun: Speculations on Illusionist Tendencies in T'ang Painting Based on Chemical Changes in Pigments," *Artibus Asiae* 37 (1975): 53-60; and Fontein and Wu, *Han and T'ang Murals.*

67 Aschwin Lippe, "Ch'en Hsien, Painter of Lohans," *Ars Orientalis* 5 (1963): 255-58.

68 Ibid., 258.

69 See, for example, Asano et al., *Yōfūhyōgen no dōnyū,* 144-45, and Nishigori, "Kita genki kō."

70 Nishigori, "Ōbaku gazō sakka yōdōshin – ge," 13, and "Kita genki kō," 64-72.

71 Nishigori, "Ōbaku gazō sakka yōdōshin – ge," 13.

72 Ibid.; Nishigori, "Ōbaku shōzō gaka kita sōun to chōbei – jō," 84.

73 Nishigori, "Ōbaku gazō sakka yōdōshin – ge," 13 n. 9; "Ōbaku shōzō gaka kita sōun to chōbei – jō," 84; "Kita genki kō," 52-53, 64, 67.

74 Michael Sullivan, "The Chinese Response to Western Art," *Art International* 24, no. 3-4 (1980): 8-10.

75 See, for example, James F. Cahill, *The Compelling Image: Nature and Style in Seventeenth-Century Chinese Painting* (Cambridge, MA, and London: Harvard University Press, 1982), 91-98.

76 Ibid., 87-91. Cahill notes numerous other instances in which seventeenth-century Chinese painters or critics credit long-dead Chinese forebears with techniques otherwise claimed by the Europeans, or with techniques that Cahill himself regards as European in inspiration.

77 Michael Baxandall, *Patterns of Intention* (New Haven, CT, and London: Yale University Press, 1985), 58-59.

78 Japanese: Mitsuun Engo. Born, Jiangsu province, Changzhou prefecture, Yixing county, 1566, eleventh month, sixteenth day; died, the monastery Tiantaishan Tongxuansi, Zhejiang province, Taizhou prefecture, Tiantai county, 1642, seventh month, seventh day, age seventy-seven. *OBJJ*, 341.

79 Japanese: Hiin Tsūyō. Born, Fujian province, Fuzhou prefecture, Fuqing county, 1593, fifth month, twenty-fourth day; died, the monastery Fuyansi, Zhejiang province, Jiaxing prefecture, Chongde county, 1661, third month, twenty-ninth day, age sixty-nine. *OBJJ*, 316.

80 Nishigami Minoru, "Ōbaku gazō no genryū – Sogei ippa no chinsō seisaku ni tsuite," in *Kokusai kōryū bijutsushi kenkyūkai, dai jūnikai kokusai shinpojiumu – Tōyō bijutsu ni okeru shajitsu* (Toyonaka: Kokusai kōryū bijutsushi kenkyūkai, 1994), 54-60. For more on the monk Muchen Daomin, his stature at court, and his relationship to Miyun Yuanwu, see Jiang Wu, "Orthodoxy, Controversy, and the Transformation of Chan Buddhism," 88 n. 78, 118, 165-66, 198-99.

81 Heretofore, it has been a portrait of Feiyin executed in 1642 by Zhang Qi (see note 32), a follower of Zeng Jing, and imported to Japan by Yinyuan that was our closest link to Zeng Jing. Note that Muchen Daomin, whose record divulges the Zeng Jing portrait of Miyun, is Feiyin's elder Dharma brother.

82 Jiang Wu's recent dissertation, "Orthodoxy, Controversy," demonstrates the heretofore little-understood achievements of Miyun and his disciples.

83 I thank Amanda Goodman and Juhn Ahn for reading the original text and discovering this detail.

84 He writes: "According to Miyun's biography (*Miyun chanshi yu lu*, quan

12, ed. Ruxue), the eulogy dates to 1633, when Miyun, age 68, was abbot of Tiantongshan. If we assume that Zeng Jing's execution of the painting was completed shortly before the inscriptions were added then we can guess that Zeng Jing went to Tiantongshan in 1633 to paint Miyun's portrait there. Zeng Jing's original painting was inscribed by both Miyun and Muchen Daomin, and there is a strong possibility that this single autograph-eulogy preserves the autograph-eulogy on the original Zeng Jing portrait presented by Muchen Daomin to the emperor." Nishigami, "Ōbaku gazō no genryū."

85 Again, thanks to Amanda Goodman and Juhn Ahn for pointing out this detail from the original text.

86 T. Griffith Foulk and Robert H. Sharf, "On the Ritual Use of Ch'an Portraiture in Medieval China," *Cahiers d'Extrême-Asie* 7 (1993-94): 149-219.

Bibliography

Asano Tōru, Ozaki Masaaki, and Tanaka Atsushi. *Shajitsu no keifu I. Yōfūhyōgen no dōnyū – edo chūki kara meiji shoki made*. Tokyo: Tokyo kokuritsu kindai bijutsukan, 1985.

Barnhart, Richard M. "Survivals, Revivals, and the Classical Tradition of Chinese Figure Painting." Pp. 143-247 in *Proceedings of the International Symposium on Chinese Painting*. Taibei: National Palace Museum, 1972.

Baroni, Helen J. "Buddhism in Early Tokugawa Japan: The Case of Ōbaku Zen and the Monk Tetsugen Dōkō," PhD dissertation, Columbia University, 1993.

–. *Ōbaku Zen: The Emergence of the Third Sect of Zen in Tokugawa Japan*. Honolulu: University of Hawai'i Press, 2000.

Baxandall, Michael. *Patterns of Intention*. New Haven, CT, and London: Yale University Press, 1985.

Cahill, James F. *The Distant Mountains: Chinese Painting of the Late Ming Dynasty, 1570-1644*. Tokyo and New York: Weatherhill, 1982.

–. *The Compelling Image: Nature and Style in Seventeenth-Century Chinese Painting*. Cambridge, MA, and London: Harvard University Press, 1982.

Chang, Aloysius. "The Chinese Community of Nagasaki in the First Century of the Tokugawa Period (1603-1868)," PhD dissertation, St. John's University, 1970.

Collcutt, Martin. "Buddhism: The Threat of Eradication." Pp. 143-67 in *Japan in Transition: From Tokugawa to Meiji*, edited by Marius B. Jansen and Gilbert Rozman. Princeton: Princeton University Press, 1986.

Etchū Isamu. "Ōbaku gazō to yōfūgaka to no setten (I)." *Nagasaki kenritsu bijitsu hakubutsukan kenkyū kiyō* 3 (1977): 35-44.

Etchū Tetsuya and Sugase Tadashi, eds. *Furusato ni kaetta – nanban kōmō bijutsuten zuroku.* Nagasaki and Kōbe: Nagasaki seinen kaigijo and Kōbe seinen kaigijo, 1971.

Fenollosa, Ernest F. *Epochs of Chinese and Japanese Art,* 2 vols. New York: n.p., 1913.

Fong, Mary H. "The Technique of 'Chiaroscuro' in Chinese Painting from Han through T'ang." *Artibus Asiae* 38, no. 2/3 (1976): 91-127.

Fong, Wen C. "*Ao-t'u-hua* or 'Receding-and-Protruding Painting' at Tunhuang." Pp. 73-94 in *Proceedings of the International Conference on Sinology. Section of History of Arts.* Taibei: Academia Sinica, 1981.

Fontein, Jan, and Wu Tung. *Han and T'ang Murals Discovered in Tombs in the People's Republic of China and Copied by Contemporary Chinese Painters.* Boston: Museum of Fine Arts, 1976.

Foulk, T. Griffith, and Robert H. Sharf. "On the Ritual Use of Ch'an Portraiture in Medieval China." *Cahiers d'Extrême-Asie* 7 (1993-94): 149-219.

Glum, Peter. "Meditations on a Black Sun: Speculations on Illusionist Tendencies in T'ang Painting Based on Chemical Changes in Pigments." *Artibus Asiae* 37 (1975): 53-60.

Hayashi Genkichi. "Shōzōgaka kita genki." *Nagasaki dansō* 14 (1934): 60-66. First published in 1926 in *Chūō bijutsu* 12, no. 7.

Hirakubo Akira. *Ingen.* Jinbutsu sōsho 96. Tokyo: Yoshikawa kōbunkan, 1962.

Hsiang Ta. "European Influences on Chinese Art of the Later Ming and Early Ch'ing Period." Translated and annotated by Wang Dezhao. Pp. 152-78 in *The Translation of Art: Essays on Chinese Painting and Poetry (Renditions 6),* edited by James Watt. Hong Kong, Seattle, and London: Centre for Translation Projects, Chinese University of Hong Kong, and University of Washington Press, 1976. First published in 1930 in *Dongfang zazhi* 27, no. 1: 19-38.

Iwasaki Yoshikazu. "Nagasakiha kaiga no tenkai." Pp. 273-309 in *Kyūshū no kaiga to tōgei,* Kyūshū bunka ronshū 5, edited by Fukuoka Unesco kyōkai. Tokyo: Heibonsha, 1975.

Jansen, Marius B. *China in the Tokugawa World.* Cambridge, MA, and London: Harvard University Press, 1992.

Koga Jūjirō. *Nagasaki gashi iden.* Nagasaki: Taishōdō shoten, 1943 (drafted 1934).

–. "Kita sōun kita genki oyobi sono gakkei." In *Nagasaki kaiga zenshi.* N.p.: Hokkō shobō, 1944.

Kyoto National Museum. *Zen no bijutsu.* Kyoto: Hōzōkan, 1983.

–, ed. *Ōbaku no bijutsu: Edo jidai no bunka o kaeta mono.* Kyoto: Kyoto National Museum, 1993.

Lachman, Charles. *Evaluations of Sung Dynasty Painters of Renown: Liu Tao-ch'un's Sung-ch'ao ming-hua p'ing.* Monographies du T'oung Pao 16. Leiden: E.J. Brill, 1989.

Lim, Lucy. "Form and Content in Early Chinese Pictorial Art." Pp. 51-53 in *Stories from China's Past: Han Dynasty Pictorial Tomb Reliefs and Archaeological Objects from Sichuan Province, People's Republic of China,* edited by Lucy Lim. San Francisco: Chinese Culture Foundation of San Francisco, 1987.

Lippe, Aschwin. "Ch'en Hsien, Painter of Lohans." *Ars Orientalis* 5 (1963): 255-58.

McCall, John E. "Early Jesuit Art in the Far East." *Artibus Asiae* 10 (1947): 225-33.

McMullin, Neil. *Buddhism and the State in Sixteenth-Century Japan.* Princeton: Princeton University Press, 1984.

Miwa Hideo. "Yōfūgahō ni yoru darumazu ni tsuite." *Bijutsu kenkyū* 311 (1979): 1-15.

Miyata Yasushi. "Chūgoku keishi no seiyō henchō: genin wa Meiji irai no kyōiku hōshin?" *Asahi shinbun* (22 April 1986).

Nishigami Minoru. "Ōbaku no bijutsu to sono genryū – gazō o chūshin ni." Pp. 7-13 in *Ōbaku no bijutsu: Edo jidai no bunka o kaeta mono,* edited by Kyoto National Museum. Kyoto: Kyoto National Museum, 1993.

–. "Ōbaku gazō no genryū – Sogei ippa no chinsō seisaku ni tsuite." Pp. 54-60 in *Kokusai kōryū bijutsushi kenkyūkai, dai jūnikai kokusai shinpojiumu – Tōyō bijutsu ni okeru shajitsu.* Toyonaka: Kokusai kōryū bijutsushi kenkyūkai, 1994.

Nishigori Ryōsuke. "Ōbaku gazō sakka yōdōshin." *Kokka* 1064 (1983): 32-37.

–. "Ōbaku gazō sakka yōdōshin – ge." *Kokka* 1065 (1983): 5-15.

–. "Ōbaku shōzō gaka kita sōun to chōbei – jō." *Bukkyō geijutsu* 158 (1985): 83-100.

–. "Ōbaku shōzō gaka kita sōun to chōbei – ge." *Bukkyō geijutsu* 160 (1985): 88-97.

–. "Kita genki kō." *Bukkyō geijutsu* 165 (1986): 48-74.

–. "Kokura-fukujuji shozō itsunen hitsu ressozu no keifu." *Bukkyō geijutsu* 166 (1986): 65-78.

–. "Hanshaku hitsu jūhachi rakan zukan." *De Arte* 3 (1987): 99-111.

–. "Itsunen to gabō tōroan." *Nagasaki dansō* 74 (1988): 77-85.

–. "Kenkyū shiryō: chinken – sakuhin to shiryō – jō." *Kokka* 1141 (1990): 33-42.

–. "Kenkyū shiryō: chinken – sakuhin to shiryō – ge." *Kokka* 1142 (1991): 32-39.

Nishimura Tei. *Ōbaku gazō shi.* Kobe: Sōgensha, 1934.

–. "Kita genki oyobi genki fū sakka." Pp. 266-321 in Nishimura Tei, *Nihon shoki yōga no kenkyū.* Kyoto: Zenkoku shobō, 1945.

Ōbaku: Zen Painting and Calligraphy. Introduction and catalogue by Stephen Addiss with the assistance of Kwan S. Wong. Lawrence, KS: Helen

Foresman Spencer Museum of Art, 1978.

Okamura Sen'ei. "Nisshi ryōkoku ni okeru yōga no hattatsu ni tsuite." *Nihon shogaku kenkyū hōkoku* (1945): 168-78.

Ōtsuki Mikio. "Shoki Ōbaku no gasō itsunen shōyū ni tsuite." *Zen bunka* 78 (1975): 66-73.

Ōtsuki Mikio, Katō Shōshun, and Hayashi Yukimitsu, eds. *Ōbaku bunka jinmei jiten.* Kyoto: Shibunkaku shuppan, 1988.

Sakamoto Mitsuru. "Shoki yōfūga." *Nihon no bijutsu* 80 (1973).

–. "Kirishitan bijutsu to kyūshū." Pp. 175-218 in *Kyūshū no kaiga to tōgei,* Kyūshū bunka ronshū 5, edited by Fukuoka Unesco kyōkai. Tokyo: Heibonsha, 1975.

Sharf, Elizabeth Horton. "Ōbaku Zen Portrait Painting: A Revisionist Analysis," PhD dissertation, University of Michigan, 1994.

Sickman, Laurence, and Alexander C. Soper. *The Art and Architecture of China.* Harmondsworth: Penguin Books, 1971.

Silbergeld, Jerome. "Chinese Painting Studies in the West: A State-of-the-Field Article." *Journal of Asian Studies* 46, no. 4 (1987): 849-97.

Stanley-Baker, Joan. *The Transmission of Chinese Idealist Painting to Japan: Notes on the Early Phase (1661-1799).* Michigan Papers in Japanese Studies 21. Ann Arbor: Center for Japanese Studies, University of Michigan, 1992.

Sullivan, Michael. "The Chinese Response to Western Art." *Art International* 24, nos. 3-4 (1980): 8-31.

Tani Shin'ichi, and Sugase Tadashi. *Namban Art: A Loan Exhibition from Japanese Collections.* N.p.: International Exhibitions Foundation, 1973.

Taniguchi Tetsuo. *Nishi nihon gadan shi – kindai bijutsu e no michi.* Fukuoka: Nishi nihon bunka kyōkai, 1981. First published in *Asahi shinbun seibuban rensai,* 1959-60.

Watt, Paul B. "Jiun Sonja (1718-1804): A Response to Confucianism within the Context of Buddhist Reform." Pp. 188-214 in *Confucianism and Tokugawa Culture,* edited by Peter Nosco. Princeton: Princeton University Press, 1984.

Wu, Jiang. "Orthodoxy, Controversy, and the Transformation of Chan Buddhism in Seventeenth-Century China," PhD dissertation, Harvard University, 2002.

Wu, Marshall P.S. *The Orchard Pavilion Gathering: Chinese Painting from the University of Michigan Museum of Art,* 2 vols. Ann Arbor: University of Michigan Museum of Art, 2000.

Yoshinaga Setsudō. "Genki no gazō." *Ōbaku* 15 (Ōbakudō, 1929).

10

Ritual and Image at Angkor Wat

ROBERT L. BROWN

What ritual might have been performed at Angkor Wat, and how were images used there? While these questions appear extremely simple, particularly considering that Angkor Wat is probably the most famous monument in Southeast Asia and the focus of extensive scholarship, the answers are anything but clear. Indeed, I want to argue that many of the assumptions regarding the organization of the monument, as well as the meaning of the reliefs and the possible location of the images associated with it, are incorrect and misleading.

One assumption regarding how ritual took place at Angkor Wat is that the monument was worshipped through some type of circumambulation. Specifically, it is assumed that people moved around the monument through the galleries. The purpose and direction of the circumambulation are associated most particularly with the famous relief sculptures that are carved around the inside of the lowest gallery, focusing on the south wall that shows the king Sūryavarman II, the builder of the monument, in what are argued to be historical scenes. I will suggest below, however, that the monument was not intended to be circumambulated, and that the Sūryavarman reliefs are not historical narratives. Rather, I will suggest that the galleries may have been used as halls for the placement of free-standing images, the model (perhaps) for the later surrounding image galleries seen in Buddhist Wats in Thailand, Cambodia, and Laos. My

arguments are based on the architectural and artistic evidence and the inscriptions. We have almost no historical (that is, textual) references as to how Angkor Wat, or in fact any of the monuments at Angkor, were used.

Angkor Wat is a temple-mountain, basically a tiered pyramid with a central tower on top surrounded by four corner towers (Figures 10.1 and 10.2). It has three tiers, the central tower rising forty-two metres above ground level. Each level is defined by rectangular or square pillared galleries, with the relief carvings on the inner wall of the lowest gallery. The monument is oriented towards the west, accentuated by an enormous raised stone entrance causeway 350 metres long, which runs across the surrounding rectangular moat, a body of water about 1,500 by 1,300 metres and 190 metres wide, creating an island on which the monument is placed. The land enclosed by the moat and surrounding the monument must have been covered with buildings in wood, including the king's palace.

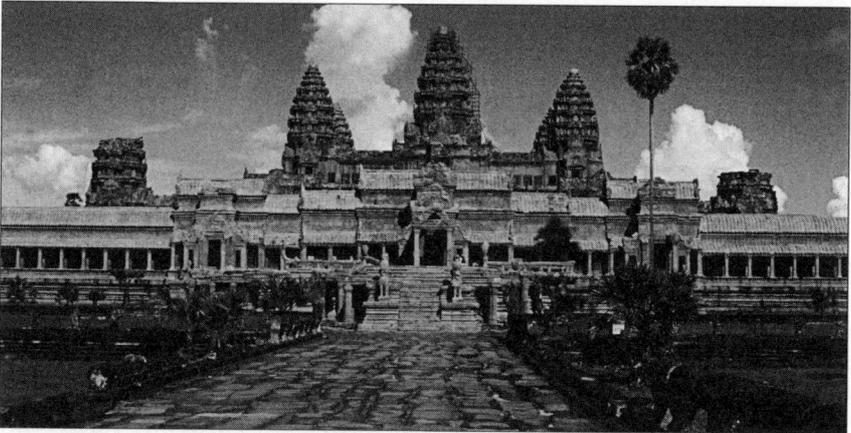

Figure 10.1. Angkor Wat (twelfth century). A view of the temple looking towards the east. The view is from the elevated stone promenade after passing through the western entrance gate.

Two characteristics of the building in particular have suggested to scholars that it was intended to be circumambulated, namely, its western orientation and the reading of the reliefs of the Southern Gallery as a narrative moving from the west to east.[1] Both of these

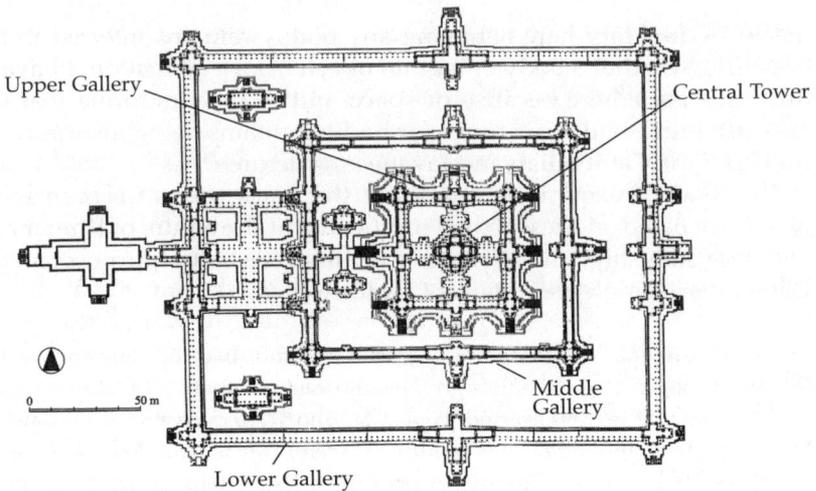

Figure 10.2. Ground plan of Angkor Wat. Relief carvings are in the lower gallery.

characteristics are used to support an interpretation of the monument as a tomb, the place of burial of Sūryavarman, an interpretation that has generated extensive and ongoing controversy. In that most of the monuments at Angkor face east, the western orientation of Angkor Wat stands out as being unusual,[2] and such western-facing structures in India are often argued to be sepulchral in nature. The ritual performed at such structures is that of counterclockwise circumambulation (prasavya), with the person's left side to the monument. This is the way in which a person would walk at Angkor Wat if the southern reliefs are read going from west to east, confirming that a counterclockwise movement was intended (Figure 10.2).

Just a word needs to be said about the controversy of Angkor Wat being interpreted as a tomb. The debate was most ardently carried on between George Coedès and Jean Przyluski, with Przyluski arguing that Angkor Wat was different from other temples at Angkor and was a mausoleum, while Coedès felt it was both a temple for the worship of the deity and a funerary monument (for the king, who upon death was considered an aspect of the god).[3] The controversy has been raised anew by the publication in 1995 of an English translation of Soekmono's doctoral dissertation on the Javanese candi, which devotes a chapter to the Cambodian monuments and concludes that neither they nor the Javanese monuments had a funerary function.[4] What is

meant by funerary here is having any bodily remains interred in the structure, whether a body or a grain of ash from a cremation. I have to drop this issue here because of space, but it appears to me that the circumstantial evidence argues for bodily remains being incorporated into both the Cambodian and Javanese structures.[5]

The issue of using bodily relics of the kings opens up even more heavily debated and researched topics, that of the nature of Khmer and Javanese kingship, the *devarāja* cult, and the very purpose of the Cambodian temple-mountains. Coedès writes:

> The monuments ... were temples as well as tombs because they enclosed divine images, and even though the cult practiced there was funerary, in the sense that it was directed to people who were deceased, it was also divine since the images worshipped were Devas and Bodhisattvas. Angkor Wat was the final habitation of a being who enjoyed certain divine prerogatives during his life, and whom death had transformed into a god. It was a "funerary temple."[6]

I will accept this as a simple yet accurate definition (that has, to be sure, been elaborated and debated by hundreds of articles and books) that will orient us for the following discussion.

Returning now to the possibility that ritual at Angkor Wat involved counterclockwise circumambulation, one might ask whether the other temple-mountain structures at Angkor were worshipped by clockwise circumambulation *(pradakṣiṇa)*. I see no evidence for this. Indeed, just reviewing the development of the temple-mountain type up to Angkor Wat shows that they were not intended to be circumambulated, whether clockwise or counterclockwise. While they rise in tiers, these levels were not for circumambulation. Most of the temple-mountains have four directional stairs, although they clearly face in one direction. These stairs are extremely steep and each stair can be very high, often purposely made narrower as they go up to increase the impression of the height of the pyramid. At the least, they do not accord with a stately or ritualistic ascent.

The Angkor Wat reliefs are in a pillared gallery. The way in which this gallery developed on the Khmer temple-mountains can be traced, and this development shows that the Angkor Wat gallery is a major change from its predecessors. The earliest of the temple-mountains is Ak Yum, which dates to the seventh century.[7] The magnificent Bakong, Indravarman I's temple-mountain dedicated in 881, sets the type,

including shrines both on the ground around the pyramid and – in this case – on the fourth tier. Shortly thereafter, what Claude Jacques calls "long halls" occur on the ground around the pyramid, such as at Pre Rup (961). It is not clear what these halls were used for, although Jacques says that they housed images.[8] I think he is probably correct, but they must have been more for storage of the images than for their worship or ritual use, as they are narrow and were probably windowless. It is from these long halls that the galleries develop, appearing for the first time in about 1000 at such temples as Ta Keo around the periphery of the second tier. At Ta Keo, the galleries cannot even be entered, however; they are actually for show only and must have been empty. At about the same date, in the small pyramid of the Phimeanakas in the area of the Royal Palace, there is an enclosing gallery moved to the top of the three tiers. While it can be entered, it is so narrow and low that it could not be used for people to move along but must have held lines of images. The enormous Baphuon, built in the second half of the eleventh century, now has galleries on each of its three tiers, although even here the top gallery appears too small to be usable by worshippers.

This, then, brings us to Angkor Wat, built during the first half of the twelfth century. The galleries at Angkor Wat are enormous in comparison with those of earlier monuments, wide enough for several people to walk abreast (Figure 10.3). Also, the outer wall of the lower gallery consists of a double colonnade that is open to the exterior; the inner wall, i.e., that closest to the centre of the temple, is adorned with two-metre-high carvings in low relief. My point is that if circumambulation was a part of the ritual at the Angkor temple-mountains, it appears to have begun with Angkor Wat.[9] This seems extremely unlikely, and I want to propose that these galleries were used as the previous ones were, for lining up and storage of images. That the images now could be seen more easily is true, but not, I think, in some ritual of circumambulation.

What about the second evidence for counterclockwise circum-ambulation of the lower gallery, the southern reliefs of Sūryavarman II? We should begin with a brief overview of these reliefs (Figure 10.4). There are two sections, the first (going from west to east) shows Sūryavarman twice, once on a mountain seated on his throne and the second time riding on his elephant in a line of his generals; the second section is a scene of Yama's judgment of the good and the bad, with the good going on to reside in the heavens, represented by aerial palaces,

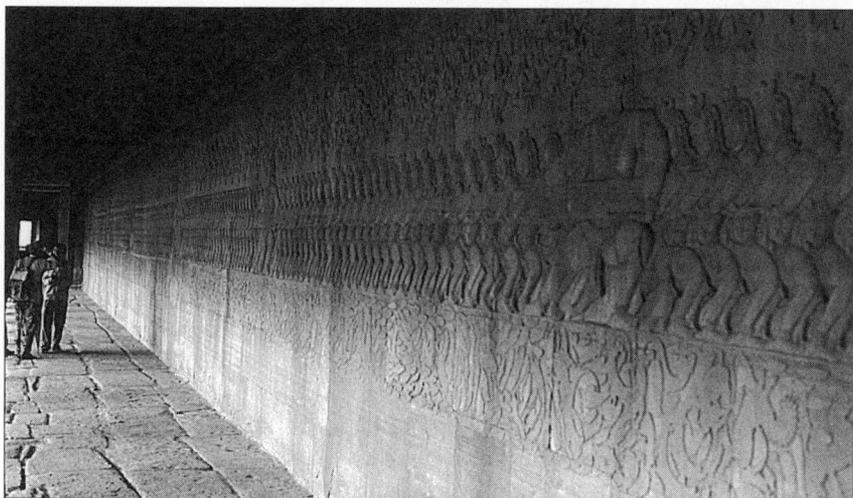

Figure 10.3. Lower gallery with two tourists. The reliefs, on the southern half of the east side, are of the Churning of the Milk Ocean.

and the bad being cast into one of the thirty-two hells. The combined length of the two relief panels is 160 metres (94 + 66 metres). There is no question that the movement of the figures in both reliefs is from west to east: the elephants and army march in this direction, and the line of the judged moves towards the east. Furthermore, there are several short inscriptions along with the reliefs that actually identify certain figures, including Sūryavarman, and each of the thirty-two hells. This is how we can be certain that it is Sūryavarman depicted. Thus, the historical nature of the reliefs seems clear, and in this regard the reliefs are an innovation at Angkor Wat.

Most scholars have thus understandably attempted to associate the relief scenes with what we know of Sūryavarman and his reign, assuming they are telling a story that runs in the direction that the figures are moving. They then assume that this section of the king's story must continue in the other reliefs, those on the west, east, and north. The reliefs on these walls are incredibly complex battle scenes taken from the Mahābhārata, Rāmāyaṇa, and the purāṇas, while one panel shows the Churning of the Milk Ocean (Figures 10.3 and 10.4). These are thus mythological in content, but given the historical nature of the southern reliefs, scholars try to read them as history during

1 Battle of Kurukṣetra
 (from the *Mahābhārata*)

2 Sūryavarman II on Mt.
 Śivāpada

3 Sūryavarman II in
 procession with his army

4 Heavens and hells

5 Churning of the
 Milk Ocean

6 Viṣṇu's Victory
 over the Demons

7 Kṛṣṇa's Victory
 over Bāṇa

8 Battle of the Gods
 and Demons

9 Battle of Laṅkā
 (from the *Rāmāyaṇa*)

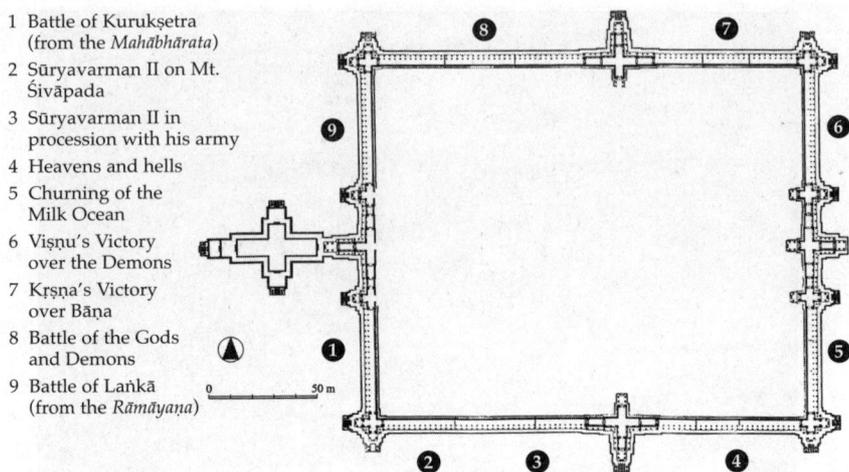

Figure 10.4. Lower gallery with topics of relief carving.

Sūryavarman's reign being recorded metaphorically.[10] Thus, a worshipper would enter the gallery from the west and, with his left side towards it, would begin moving around the gallery, reading the reliefs as narrating in some way Sūryavarman's story. The focus on the king and the counterclockwise movement of the viewer also bolster the interpretation that the monument is the king's mausoleum.

Let us return to the southern reliefs, however. The king is sitting on a throne (Figures 10.5 and 10.6) on top of a mountain, with different groups of men – soldiers and religious groups – while at the foot of the hill is a line of women being carried in palanquins and hammocks. There are two religious groups immediately to the king's right (Figure 10.7), differentiated by their hair and dress. One group has their hair in a high cone on top of their heads, which is covered with cloth with floral designs, and wears loin cloths. The second group has their hair wound into a circle, from the centre of which two loops of hair extend, and wears some type of elaborate lower garment. Both groups have beards. There is an inscription in Khmer that reads "the gift of the honourable pandits."[11] It is not clear whether or not the word "pandit" refers to both groups.

The next inscription identifies the king himself, reading: "the Supreme, Sacred Feet, His Lordship Paramaviṣṇuloka on Mount Śivāpada

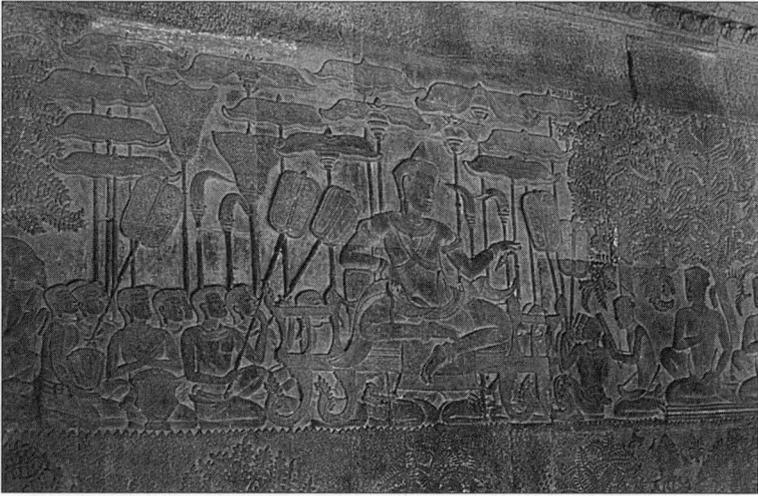

Figure 10.5. King Sūryavarman II on his throne on Mt. Śivāpada. He is surrounded by retainers holding umbrellas, fans, and fly whisks. To the king's left sit four of his generals (see Figure 10.6).

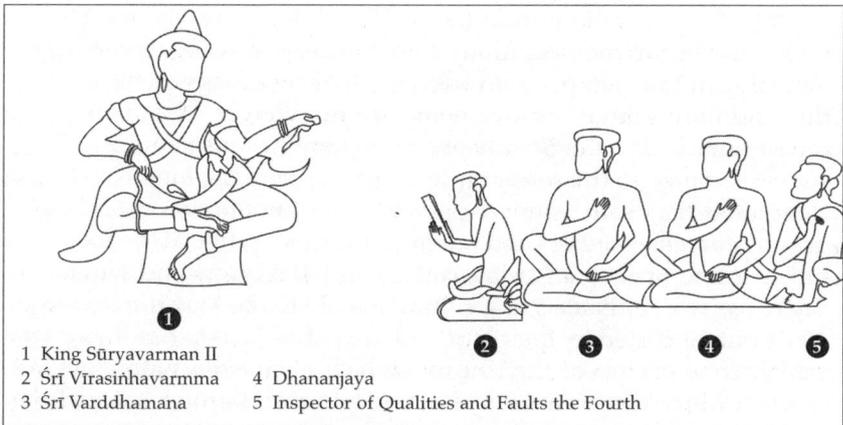

1 King Sūryavarman II
2 Śrī Vīrasiṅhavarmma 4 Dhananjaya
3 Śrī Varddhamana 5 Inspector of Qualities and Faults the Fourth

Figure 10.6. King Sūryavarman II and four generals.

receiving homage from his troops," (or perhaps, "bestowing [Śiva's power] from above upon the troops"). Thus, the mountain is identified as Mt. Śivāpada, although where to locate it in Cambodia is not known.

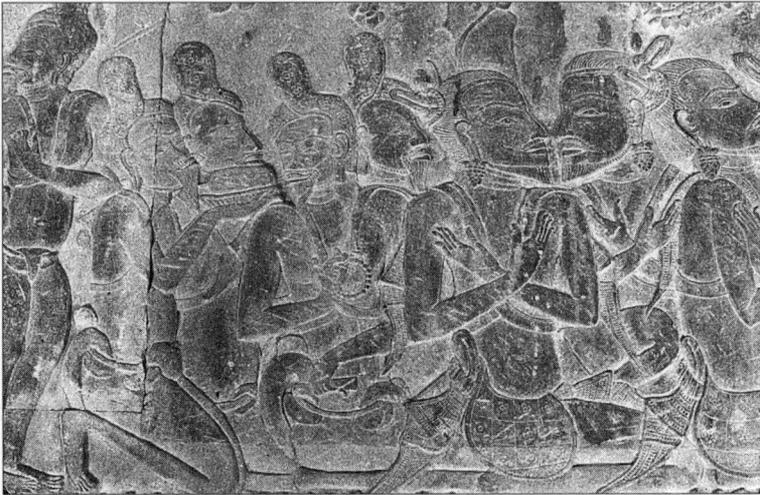

Figure 10.7. Detail of the two groups of religious specialists present on Mt. Śivāpada with King Sūryavarman II. The group on the proper right are ascetics with their matted hair in high cones (possibly the *ācāryas*). Those on the left wear their hair in elaborate twists and loops (possibly the brahmans).

Also, Sūryavarman is identified by his posthumous name, Paramaviṣṇuloka (or, [he who is in] the highest heaven of Viṣṇu). The use of his posthumous title might suggest that Angkor Wat was built, or at least completed, after Sūryavarman's death (ca. 1150). I have not seen any scholar propose that only the inscriptions are what might have been added after his death, given that they are written in very small letters and that the reliefs leave blank areas of background, but the possibility is there. Also, given that Sūryavarman was a devotee of Viṣṇu, to whom Angkor Wat is dedicated, the calling upon Śiva here is noteworthy.

In front of the king kneel four men (Figures 10.5 and 10.6). One appears to read from a manuscript, while each of the other three holds a hand to his chest. All four are dressed and adorned very simply, particularly in contrast to the king. Each is identified by an inscription (from left):

(1) His Lordship the saint *(vrah kamraten an)* Śrī Vīrasiṅhavarmma
(2) His Lordship *(kramraten an)* the First (of four), Śrī Varddhamana
(3) His Lordship *(ka)*, Dhananjaya
(4) His Lordship the saint *(vka)*, Inspector of Qualities and Faults the Fourth.

The soldiers are shown descending from Mt. Śivāpada and then the remainder of the relief shows the king with nineteen of his generals, each identified by an inscription, riding in a line on their elephants. Two of the generals on the mountain reappear (Dhananjaya no. 11 and Varddhamana no. 14), and several others can be identified further as individuals in other Angkor inscriptions. The king is twelfth in line with the inscription "Sacred Feet His Lordship Paramaviṣṇuloka" (or "the Holy Feet of His Lordship Paramaviṣṇuloka"). The line of troops ends and, across the middle pavilion, the judgment scene begins, the second of the great southern reliefs.

Coedès in 1911 suggested that what was happening on Mt. Śivāpada was the administering of an oath.[12] While this was recognized so early, scholars (including Coedès) have assumed that the remainder of the southern reliefs relate in some narrative fashion to a historical oath taking. Coedès, for example, wonders which particular moment of the king's career was being depicted. He asks if the army was departing for a distant expedition.[13] Not all scholars accept or accentuate the oath taking. F.D.K. Bosch does not mention the oath, but suggests that the scene shows the dead king Sūryavarman descending with his army to the country of the dead ("dans le pays des morts") to be judged by Yama, the god of death, in the following scene, where Sūryavarman's loyal generals will ascend to one of Viṣṇu's heavens.[14] Some current commentators, such as Jacques and le Bonheur, appear to refrain from any interpretation other than a description.[15] Eleanor Mannikka recently presented a truly new reading of the entire monument that relies on almost overwhelming data of measurements and astronomy.[16] There are, in other words, a plethora of interpretations.

Coedès and other scholars, in raising the possibility of an oath, have made the obvious connection to an oath the text of which we have in several inscriptions.[17] This oath was administered to a group of soldiers (at least two hundred are named in the inscriptions) giving their fealty to King Sūryavarman I in 1011 (and thus about a century earlier than Angkor Wat), who were assembled in the Royal Palace in Angkor. It reads in part:

> This is the oath which we, belonging to the body of tamvrac [lictor] of the first (second, third, or fourth) category swear all, without exception, cutting our hands, offering our lives and our devotion gratefully, without fault, to H. M. Śrī Sūryavarmadeva, who has been in complete enjoyment of sovereignty since 924 c [AD 1002], in the presence of the sacred fire, of the holy jewel, the brahmans and the *ācāryas*. We will not revere another king.

And it goes on, towards the end saying:

> If we hide ourselves in order not to keep this oath strictly, may we be reborn in the thirty-second hell as long as the sun and moon shall last ... and may we obtain the recompense of people devoted to our masters, in this and the other world.[18]

My proposal for the interpretation of the south wall reliefs has specifically to do with the oath. Indeed, I feel they are not a narrative but are in fact, in their entirety, a visual and elaborate representation of the oath. They are the words, the promises, and the consequences of the oath made into a stunning visual form.

My argument for this interpretation is as follows:

(1) The oath is administered to the *tamvrac*, which is made up of four categories. The Khmer word means "inspector" – and there were apparently four royal administrative units, perhaps associated with the four directions.[19] It appears that the four men receiving the oath from Sūryavarman II on Mt. Śivāpada are the heads of these four units (Figures 10.5 and 10.6), and are so identified using the numbers 1 and 4, with the fourth called "inspector of qualities and faults" (*guṇadoṣa ta pvana*).

(2) The oath calls on two groups of religious specialists to be present, brahmans[20] and *ācāryas*. It appears that there are two groups depicted at Angkor Wat, and I would propose that the group closest to the king would represent the brahmans and the more ascetic group was that of the *ācāryas* (Figure 10.7). At the least, two distinct groups of religious teachers are present.

(3) Also present at the oath were the sacred fire and the holy jewel. Both of these remain extremely mysterious; we do not know how they were used or why. The sacred fire is, however, depicted in the Angkor Wat relief, and is the only representation known. It is identified by the inscription *vrah vlen* (sacred fire) (Figures 10.8, 10.9, and 10.11) and is being carried on a palanquin by a group of ascetics, one of whom is being carried in a hammock and is identified by an inscription as *rājahotā* (*rāja hotar*, or head priest) (Figures 10.10 and 10.11). This is, indeed, a very strange little group, and without the inscription we would have no idea that it is the sacred fire being carried. Blowing horns, ringing bells, beating gongs, and juggling flags, the group with the *rājahotā* (barely clearing the ground in his cloth-sling hammock) marches along.[21] No apparent fire is present. Rather, it is a domed cover or object of some sort, which Bosch suggests is a liṅga (Figure

Figure 10.8. Group of ascetics (possibly *ācāryas*) carrying the palanquin with the sacred fire *(vrah vlen)*.

Figure 10.9. Detail of Figure 10.8, showing the container for the sacred fire.

10.9). He also illustrated in his study a drawing of a liṅga in a relief at the Bayon that has a jewel at the top that he compares to the Angkor

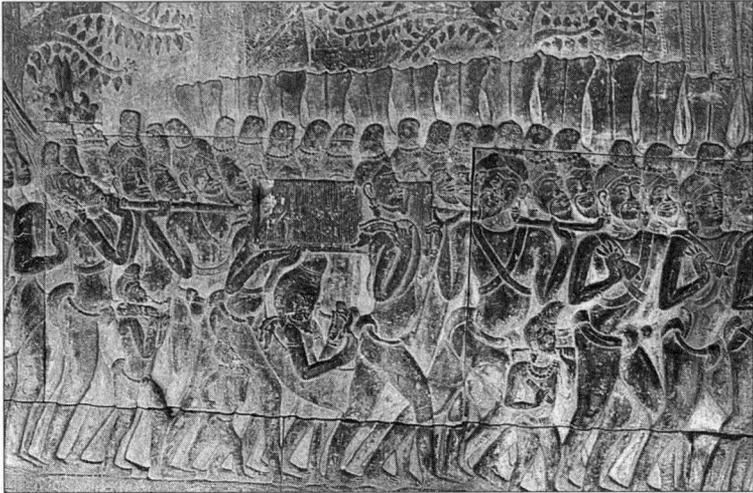

Figure 10.10. Group of ascetics (possibly *ācāryas*) carrying the head priest *(rāja hotar)* in a hammock behind the group carrying the sacred fire seen in Figure 10.8.

Figure 10.11. Drawing showing the two groups: the *rāja hotar* and the sacred fire.

Wat sacred fire, which has some design on the top, so that the jewel mentioned in the oath may be present as well. The group of ascetics and its leader, the *hotar,* appear to be the same group as that shown on Mt. Śivāpada, which I suggest may be the *ācāryas.*

The oath asks that the oath takers cut their hands. Giving blood is not, as far as I know, mentioned in any other Khmer inscriptions, but Coedès has made the interesting suggestion that the blood may have

been mixed with water and given to be drunk as part of the oath.[22] I was not aware of Coedès's proposal when I wrote on the topic of drinking oaths in Southeast Asia, but find it extremely suggestive.[23] It is interesting that three Thai kings (King Mangrai, King Ngam Muang, and King Ruang), who ruled kingdoms in northern Thailand during the late thirteenth and early fourteenth centuries, took an oath of fealty by drinking their blood mixed together. According to the *Chiang Mai Chronicle*:

> King Mangrai then staged a mutual oath-taking, that hereafter the three kings would be truthful to each other throughout the rest of their lives. Whoever professed his loyalty and was unfaithful would be destroyed and lose his throne through various calamities.
> With a knife, each of the rulers then cut his own hand, and the blood was mixed and each drank it from a cup, sealing the close bond between the three.[24]

(4) The consequence of failing to keep the Khmer oath is rebirth in one of the thirty-two hells, each of which is depicted and carefully labelled in the second panel of the south wall reliefs. At this point, I am not sure how exactly to interpret this evidence. The hells are not shown in the art of Angkor, as far as I know, except at Angkor Wat. While the hells are mentioned in inscriptions, they are usually brought up only at the end as a warning regarding what will happen to those who might disturb a particular endowment; usually only the Avīci Hell is mentioned by name.[25] Mannikka makes the point that "the thirty-two hells depicted here are not in Hindu cosmology, which has no hells: they are the only instance of a definite Buddhist representation at Angkor Wat."[26] Although hells do exists in Hindu cosmology, the specific mention and identification of each of the thirty-two do appear to be unique to the oath and the Angkor Wat reliefs. And certainly ending up in one as a consequence of breaking an oath (or being unfaithful to the king) is found only in the oath itself and the Angkor Wat carvings.

(5) Finally, the inscriptions that accompany the relief images are unique to Angkor Wat; no other relief images have identifying inscriptions. Why? If we list the images that are identified, we in fact find most of the important elements of the oath: the pandits, the king, the four leaders of the four administrative units, each of the important generals, the sacred fire and the *hotar*, and the thirty-two hells. The

attempt appears to be to expand and visualize the oath's elements – the words of the inscriptions paralleling those in the oath itself.

Thus, the major characteristics of the subject of the south wall reliefs can be explained by reference to the oath of allegiance and need not read like a story. Indeed, the organization of all of the Angkor Wat reliefs argues against their being read by walking by them. The basic organizing principle is centripetal, so that each panel has the most important section, person, or event in the centre or in multiple centres (Figure 10.12). There are eight large panels, two to each wall – and five of them show battle scenes, with the two opposing armies coming in towards the centre or, for the north wall west relief, with several centres each with opposing armies moving inward. The Churning of

1 The armies move in opposite directions and meet in the centre at the figure of Arjuna.

2 The movement of the south wall reliefs is consistently towards the east. However, the person of Sūryavarman II is the focus towards the beginning of the relief.

3 Sūryavarman II, standing on his elephant, is at the centre of the south wall, west relief.

4 Yama and his two helpers are the focus one-third of the way from the beginning of the south wall, east relief.

5 The Gods and Demons pull in opposite directions, with Viṣṇu at the centre.

6 The armies move in opposite directions and meet in the centre at the figure of Viṣṇu.

7 Movement is in a series of clashes between opposite facing armies.

8 Movement is in a series of clashes between opposite facing armies, each centred on one of the twenty-one gods.

9 Movement is generally towards the centre and focuses on Rāma, although there is a series of duals between opposite facing foes.

Figure 10.12. Centripetal organization of relief carvings.

the Milk Ocean has the mountain at the centre of two opposing groups, the Gods and the Demons. In fact, the south wall reliefs also follow this centripetal pull while simultaneously moving towards the east. In the first relief, the king is at the centre of his marching line of troops, and in the second relief it is Yama and his two assistants (Dharma and Citragupta) who are at the centre. In other words, the reliefs are not organized to be read by circumambulation.

In conclusion, the reliefs of the lower gallery at Angkor Wat were not intended to be circumambulated or to be read as the telling of a narrative of Sūryavarman II's life. The gallery was probably used for housing images of the gods. These images were perhaps mostly in wood and bronze. It would, I agree, require a great number of images – even if we do not demand that the gallery be packed with images. We have some information in inscriptions from about fifty years later, from the time of Jayavarman VII, about the number of images dedicated to a particular temple. There were 260 images given to Ta Prohm (AD 1186) and 282 to Preah Khan (AD 1191).[27] These are only the official or royal dedications, and there must have been hundreds more given by the elite. We also know that they were ringed around a central image. (It is true that these are Buddhist structures, and this needs to be kept in mind.) Furthermore, unlike Indian temples with niches in which images were placed, Khmer architecture does not use niches for statues. Images were set up in shrines. This explains in part why Indian images tend to be steles, while Khmer images tend to be made in the round. I will leave it only as a suggestion that there may be some connection between the galleries as they developed at Angkor and the use of galleries to house rows of images in Buddhist Wats today in Cambodia, Laos, and Thailand.[28] These galleries, of course, face inward, although they are usually the inside of the surrounding wall, while the outward-facing gallery of Angkor Wat is not part of a surrounding wall.

If I am correct, what was the purpose of the reliefs? They are all expressions of military success and power. They are all representations of opposing groups, the good and the bad, and of the heroes and gods who win and dominate over the enemies and demons. If there is a story of Sūryavarman here, it is that he is one with these heroes, as he is one with Viṣṇu.

End Notes

1 Also its location outside the previous limits of the city of Angkor, and in a southeastern location, suggests the possibility that it was funerary.

2 Two Preah Pithu temples and Preah Khan also face west: Michael Freeman and Claude Jacques, *Ancient Angkor* (Trumbull, CT: Weatherhill, 1999), 48-49.

3 See George Coedès, "Angkor Wat, temple ou tombeau?" *Bulletin de l'École Française d'Extrême-Orient* 33 (1933): 303-9; "Discovery of the Sacred Deposit of Angkor Wat," *Annual Bibliography of Indian Archaeology* 10 (1935): 43-47; "La destination funéraire des grands monuments Khmèr," *Bulletin de l'École Française d'Extrême-Orient* 40 (1940): 315-43; *Angkor: An Introduction* (Hong Kong: Oxford University Press, 1963), 34-38. For Jean Przyluski, see "Pradakṣiṇa et Prasavya en Indochine," in *Sonderdruck aus Festschrift für M. Winternitz zum Siebzigsten Geburtstag,* ed. Otto Harrassowitz (Leipzig: Otto Harrassowitz, 1935), 326-32; "Is Angkor Wat a Temple or a Tomb?" *Journal of the Indian Society of Oriental Art* 5 (1937): 131-44.

4 R. Soekmono, *The Javanese Candi: Function and Meaning* (Leiden: E.J. Brill, 1995).

5 For example, "temple" and "tomb" may not be so clearly differentiated in the Hindu and Buddhist context as Soekmono suggests. *Candis* not only are temples in which deities manifest, but are also where the dead king (and queen) take form, in a merging with the deity, usually in the form of an icon. Soekmono knows this, of course, and says, "In the candi we are confronted with the fusion of the worship of a god and an ancestor cult" (*The Javanese Candi,* 102). The dead king and queen also, according to Soekmono, use deposits *(pripih)* to focus their essence. It seems to me, however, of little importance whether the manifestation of the ancestor is done through some of the ash of a cremated body or through some other substitute material. Indeed, the form Buddhist bodily relics took can be described in Buddhist inscriptions and texts as looking like pearls, bubbles, crystals, or golden flowers, and so on. And as the reliefs on Borobudur show, the body relics were worshipped in relic caskets apparently made of precious metals and long since melted down. A pinch of ash could hardly be expected to be easily identified in any context, let alone that of the often deep Hindu *candi* pits, where quantities of charcoal, burnt animal bones, and even a human skeleton (as at Prambanan) are mixed with earth. My point is that what a body relic looks like is highly ambiguous, its size can be minuscule, and its placement varied.

6 Coedès, *Angkor: An Introduction*, 38.

7 I will not attempt to give references for each of the temples I mention below, as I am giving such a brief treatment of each. Most have been repeatedly illustrated, although not in any detail and with little analysis. Three recent publications with excellent photographs, all with text by Claude Jacques, have been published: with Michael Freeman, *Ancient Angkor* (Trumbull, CT: Weatherhill, 1999); *Angkor* (Cologne: Könemann, 1999); and *Angkor: Cities and Temples* (Bangkok: River Books, 1997).

8 Jacques, *Angkor*, 77, and Jacques, *Angkor: Cities and Temples*, 100.

9 The now very ruined Beng Mealea may have actually introduced some of these gallery features, but it dates to about the same time as Angkor Wat. See Lawrence Palmer Briggs, *The Ancient Khmer Empire* (Philadelphia: American Philosophical Society, 1951), 184. Jean Boisselier's detailed study places the two monuments at the same time, both built by Sūryavarman II ("Ben Mala et la chronologie des monuments du style d'Angkor Vat," *BEFEO* 46 [1952]: 187-226).

10 See, for example, the interpretations of Donatella Mazzeo and Chiara Silvi Antonini, *Monuments of Civilization: Ancient Cambodia* (New York: Grosset Dunlap, 1978), 124, and Przyluski, "Is Angkor Wat a Temple or a Tomb?" 133-34.

11 The inscriptions on the south wall are all in Khmer. See Etienne Aymonier, *Le Cambodge: III Le Groupe d'Angkor et l'Histoire* (Paris: Ernest Leroux, 1904), 250-81; George Coedès, "Les bas-reliefs d'Angkor Vat," *Bulletin de la Commission Archéologique Indochinoise* 11 (1911): 170-220; Albert le Bonheur, *Of Gods, Kings, and Men: Bas-reliefs of Angkor Wat and Bayon* (London: Serindia Publications, 1995), 18-22 (whose English translations I am using here).

12 Coedès, "Les bas-reliefs d'Angkor Vat," 201.

13 Ibid.

14 F.D.K. Bosch, "Le temple d'Angkor Vat: La procession du feu sacré," *Bulletin de l'École Française d'Extrême-Orient* 32 (1932): 7-21.

15 Jacques (see n. 7) and le Bonheur (see n. 11).

16 Eleanor Mannikka, *Angkor Wat: Time, Space, and Kingship* (Honolulu: University of Hawai'i Press, 1996).

17 George Coedès, *Inscriptions du Cambodge*, vol. 3 (Paris: E. De Boccard, 1951), 205-16, and "Le serment des fonctionnaires de Sūryavarman I," *Bulletin de l'École Française d'Extrême-Orient* 13 (1913): 11-17.

18 The English translation is from Briggs, *The Ancient Khmer Empire*, 151; see also Coedès, "Le serment des fonctionnaires de Sūryavarman I."

19 See Sachchidanand Sahai, *Les Institutions politiques et l'Organisation*

Administrative du Cambodge Ancien (Vie-VIIIe siècles) (Paris: Publications de L'Ecole Française d'Extrême-Orient, 1970), and Coedès, *Inscriptions du Cambodge*, 205-7.

20 Varṇa (or caste) in Cambodia was not as in India. The Cambodian Varṇa system was made up of elite categories of people according to their function among the royal or elite population. Varṇas were granted by the king. See I.W. Mabbett, "Varṇas in Angkor and the Indian Caste System," *Journal of Asian Studies* 36, no. 3 (May 1977): 429-42.

21 Bosch, "La procession du feu sacré," 9.

22 Coedès, *Inscriptions du Cambodge*, 209 n. 1.

23 Robert L. Brown, "The Miraculous Buddha Image: Portrait, God, or Object?" in *Images, Miracles, and Authority in Asian Religious Traditions*, ed. Richard H. Davis (Boulder: Westview Press, 1998), 44-48, where I also speak of the possible connection of the famous Emerald Buddha image now in Bangkok with the holy jewel of Angkor.

24 David K. Wyatt and Aroonrut Wichienkeeo, trans., *The Chiang Mai Chronicle* (Chiang Mai: Silkworm Books, 1998), 27-28.

25 See, for example, M. Barth, *Inscriptions sanscrites du Cambodge*, Notices et Extraits des Manuscrits de la Bibliothèque Nationale, tome 27, 1er fascicule (Paris: Impremerie Nationale, 1879), 111-12, and M. Abel Bergaigne, *Inscriptions sanscrites du Cambodge*, Notices et Extraits des Manuscrits de la Bibliothèque Nationale, tome 27, 2e fascicule (Paris: Impremerie Nationale, 1893), 342.

26 Mannikka, *Angkor Wat*, 155.

27 See George Coedès, "La stèle de Ta Prohm," *Bulletin de l'École Française d'Extrême-Orient* 6 (1906): 44-81, and "La stèle de Prah Khan d'Angkor," *Bulletin de l'École Française d'Extrême-Orient* 41 (1942): 255-302.

28 I have not found any sources that argue how early the Buddhist Wat galleries might have appeared. As these would probably have been in wood, discovering their beginnings may be difficult.

Bibliography

Aymonier, Etienne. *Le Cambodge: III Le Groupe d'Angkor et l'Histoire*. Paris: Ernest Leroux, 1904.

Barth, M. *Inscriptions sanscrites du Cambodge*. Notices et Extraits des Manuscrits de la Bibliothèque Nationale, tome 27, 1er fascicule. Paris: Impremerie Nationale, 1879.

Bergaigne, M. Abel. *Inscriptions sanscrites du Cambodge*. Notices et Extraits des

Manuscrits de la Bibliothèque Nationale, tome 27, 2e fascicule. Paris: Impremerie Nationale, 1893.

Boisselier, Jean. "Ben Mala et la chronologie des monuments du style d'Angkor Vat." *Bulletin de l'École Française d'Extrême-Orient* 46 (1952): 187-226.

Bosch, F.D.K. "Le temple d'Angkor Vat: La procession du feu sacré." *Bulletin de l'École Française d'Extrême-Orient* 32 (1932): 7-21.

Briggs, Lawrence Palmer. *The Ancient Khmer Empire*. Philadelphia: American Philosophical Society, 1951.

Brown, Robert L. "The Miraculous Buddha Image: Portrait, God, or Object?" Pp. 44-48 in *Images, Miracles, and Authority in Asian Religious Traditions*, edited by Richard H. Davis. Boulder: Westview Press, 1998.

Coedès, George. "La stèle de Ta Prohm." *Bulletin de la Commission Archéologique Indochinoise* 6 (1906): 44-81.

–. "Les bas-reliefs d'Angkor Vat." *Bulletin de la Commission Archéologique Indochinoise* 11 (1911): 170-220.

–. "Le serment des fonctionnaires de Sūryavarman I." *Bulletin de l'École Française d'Extrême-Orient* 13 (1913): 11-17.

–. "Angkor Wat, temple ou tombeau?" *Bulletin de l'École Française d'Extrême-Orient* 33 (1933): 303-9.

–. "Discovery of the Sacred Deposit of Angkor Wat." *Annual Bibliography of Indian Archaeology* 10 (1935): 43-47.

—. "La destination funéraire des grands monuments Khmer." *Bulletin de l'École Française d'Extrême-Orient* 40 (1940): 315-43.

–. "La stèle de Prah Khan d'Angkor." *Bulletin de l'École Française d'Extrême-Orient* 41 (1942): 255-302.

–. *Inscriptions du Cambodge*, vol. 3. Paris: E. De Boccard, 1951.

–. *Angkor: An Introduction*. Hong Kong: Oxford University Press, 1963.

Freeman, Michael, and Jacques, Claude. *Ancient Angkor*. Trumbull, CT: Weatherhill, 1999.

Jacques, Claude. *Angkor: Cities and Temples*. Bangkok: River Books, 1997.

–. *Angkor*. Cologne: Könemann, 1999.

Le Bonheur, Albert. *Of Gods, Kings, and Men: Bas-reliefs of Angkor Wat and Bayon*. London: Serindia Publications, 1995.

Mabbett, I.W. "Varṇas in Angkor and the Indian Caste System." *Journal of Asian Studies* 36, no. 3 (May 1977): 429-42.

Mannikka, Eleanor. *Angkor Wat: Time, Space, and Kingship*. Honolulu: University of Hawai'i Press, 1996.

Mazzeo, Donatella, and Antonini, Chiara Silvi. *Monuments of Civilization: Ancient Cambodia*. New York: Grosset Dunlap, 1978.

Przyluski, Jean. "Pradakṣiṇa et Prasavya en Indocine." Pp. 362-32 in

Sonderdruck aus Festschrift für M. Winternitz zum Siebzigsten Geburtstag,
edited by Otto Harrassowitz. Leibzig: Otto Harrassowitz, 1935.

–. "Is Angkor Wat a Temple or a Tomb?" *Journal of the Indian Society of Oriental Art* 5 (1937): 131-44.

Sahai, Sachchidanand. *Les Institutions politiques et l'Organisation Administrative du Cambodge Ancien (Vie-VIIIe siecles).* Paris: Publications de l'École Française d'Extrême-Orient, 1970.

Soekmono, R. *The Javanese Candi: Function and Meaning.* Leiden: E.J. Brill, 1995.

Wyatt, David K., and Wichienkeeo, Aroonrut, trans. *The Chiang Mai Chronicle.* Chiang Mai: Silkworm Books, 1998.

Index